COMPENDIUM

COMPENDIUM
Handbook of the Leica-M System

by Jonathan Eastland

HOVE
BOOKS

Leica-M Compendium
Handbook of the Leica-M System
Jonathan Eastland

First English Edition May 1994

British Library Cataloguing-in-Publication Data
A catalogue record for this book is available from the British Library

ISBN 1 897802 05 6

Copyright © 1994 by Hove Books and Jonathan Eastland.

The right of Jonathan Eastland to be identified as author of this work has been asserted by him in accordance with the Copyright, Designs and Patents Act 1988.

Front and back covers photographed by the author

Editor: *Dennis Laney*

Design and typesetting: *Facing Pages*

Printed in *Wales by Macdermott & Chant Ltd., Welshpool*

All enquiries to the Publishers:

Hove Books
34 Church Road, Hove
East Sussex BN3 2GJ, England

except for:

U.K. Book Trade to:

Fountain Press Ltd.
2 Gladstone Road
Kingston-upon-Thames
Surrey, KT1 3HD

U.S.A. to:

The Saunders Group
21 Jet View Drive
Rochester, N.Y. 14624-4996
Fax: (716)328-5078

Canada to:

Amplis Foto Inc.
22 Telson Road
Markham, Ontario L3R 1ES
Fax: (416)477-2502

Acknowledgements

A great deal of previously published data has been drawn on to compile the detailed technical specification lists and tables in this work. In particular I am indebted to Dennis Laney whose *Leica Collectors Guide* has been a constant companion, full of intrigue and fascination. My thanks must also go to Jeff Griffen, Technical Services Manager at Leica Camera UK Ltd., who was always there when I needed clarification or confirmation, to Peter Melder and Philip Bass, also of Leica UK Ltd., for the loan of equipment.

I am sure too that the patience of Hans-Gunter von Zydowitz and his colleagues at Leica Camera GmbH, Solms, has been over extended on innumerable occasions in endeavouring to answer my persistent and often detailed questions. My thanks to him and his colleagues for their continued support. Thanks are due to R. Hiesinger and G. Carter at Karl Muller in Memmingen for their help in unravelling important aspects of the glass story and for keeping my trusty Novoflex on the road for so long. To Tom Abrahamsson in Vancouver for his detailed contribution; to Nigel Grundy who freely gave special access to a wonderful library of reference material; to my son Adam for making many of the excellent prints used in this volume and to my father, Raymond, for his unceasing support and interest in all of my fanatical endeavours. Finally, to my wife Caroline and daughter Jessica, who have endured months of seemingly endless upheaval while this book was in preparation, a special kiss.

My Publisher joins me in thanking Leica Camera GmbH for use of their registered trademarks:

ABSORBAN ®
ELMAR ®
ELMARIT ®
FOCOSLIDE ®
LEICA ®
LEICAFLEX ®
LEICAMETER ®
LEICAVIT ®
NOCTILUX ®
SUMMARIT ®
SUMMARON ®
SUMMICRON ®
SUMMILUX ®
TELEVIT®
TELYT ®
VISOFLEX ®

PHOTOGRAPHY

Except where otherwise credited, all photographs in this work are the copyright and property of the author.

Contents

Introduction

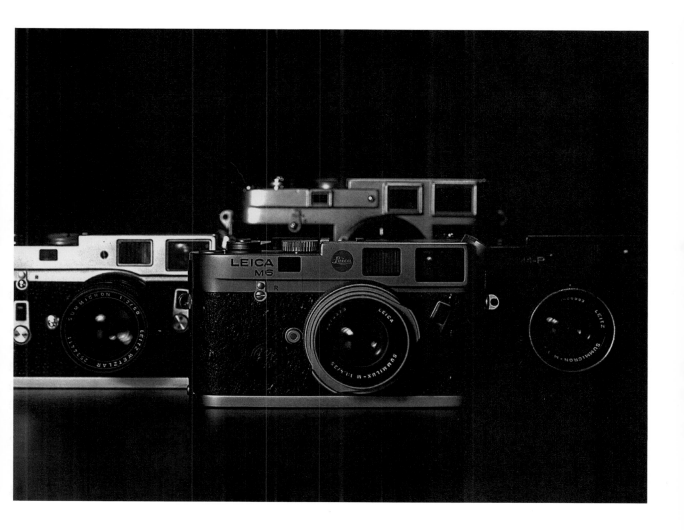

 The name 'Leica' is synonymous with quality. Outside of the fickle, fanatical and obsessive world of photography, it is recognized by thousands of people from all walks of life who otherwise have no interest in photography. Derived from an amalgam of 'Leitz', the surname of Ernst, son of the founder of the company, Optisches Institut von Ernst Leitz (est.1869), and 'camera', the name represents a product which is still the supreme choice for that type of artifact. Strictly speaking, it was not until 1925 when the Leica I went into full scale production at the Wetzlar factory that a trade name for Oskar Barnack's invention was given serious thought. Although briefly advertised as 'Barnack's Kamera' the name was soon changed to 'Leca', which because of its confusion with another camera having a similar sounding name (Kraus Eka), was changed again to include the first three letters of the Leitz surname.

Several 35mm-format cameras by other manufacturers existed before Oskar Barnack's UR-prototype appeared. Barnack was a young and extremely knowledgeable engineer of precision optical instruments who had been effectively head-hunted by Ernst Leitz II from the firm of Carl Zeiss. His early work at the Leitz factory in Wetzlar was mostly concerned with improving the quality and manufacture of cine cameras, which until the advent of his all-metal 'Barnack Cinematographic Machine' were mostly constructed from wood and liable to frequent breakdowns.

Another aspect concerned improvements to existing instruments for obtaining reliable exposures in cine work. In those days, the only really accurate method available to cinematographers required short lengths of 35mm cine film to be exposed and then processed. Barnack, who had already modified several larger format cameras of plate size to accept strips of 35mm film for exposure testing purposes, set about designing a more compact and versatile camera. The result was the UR, (after *urbild* – prototype) or UR-Leica as it became known. Although successful as a cine film still-frame exposure tool, more work was required on the focalplane shutter mechanism before the camera could become the versatile and reliable ancestor of current models. Several other prototypes followed before a limited number of about 30 'O' series cameras based on the UR design were produced. It seems that either no great effort was made to promote this camera or that interest was minimal. Samples found their way to New York, to South America and London but it was to be another two years before Leitz introduced the Leica I at the Leipzig Spring Fair of 1925. It received much critical acclaim in the photographic press and went on to sell nearly 1,000 units in its first year. In the eyes and hands of other manufacturers, camera shape and styling has continued to change in tandem with technological progress, often with dramatic results. The Leica camera has undergone considerable modification and model changes in this same seventy years of almost continuous manufacture, but the design origins and concept of the current M6 Leica camera can be easily traced back through the various models to the UR prototype and 'O' models.

How good a product is can often be gauged by its imitators – if any. In the case of the Leica rangefinder camera, more than 300 look-alike versions produced by other manufacturers around the world have come and gone from the dealers shelves. To my knowledge, not one has ever equalled the engineering quality of a Leica and certainly none has ever surpassed it. In 99% of non-Leica examples, this aspect has not even come close to worthwhile scrutiny. In the 1% balance, several marques have achieved recognition largely because of the quality of lenses and the finish of certain body parts, but a critical examination of even this generous balance reveals flaws in the engineering side which to the connoisseur can be irritating to say the least and to the serious user who craves reliability above all else, the cause of a frustrating and uncertain neurosis.

Of course, as with virtually all things made by man, even Leicas have their occasional malfunctions. In almost 20 years of using Leica rangefinder cameras, I have not encountered one breakdown because of mechanical failure; but in contrast, I know of several photographers who have. Interestingly though, the cause in each of these cases has invariably been traced to what is known in another trade, as 'pilot error'. Could it be that I do not use mine hard enough, that they are only used with kid gloves and kept away from the kind of environments which have little respect for high quality products? A large percentage of my work is carried out at sea, in all kinds of weather conditions, on vessels of all shapes and sizes. Salt water is one of the quickest acting causes of corrosion in most types of metals; over the years, many of my other marque cameras have succumbed to its intrusion to the extent of having to be written off. My Leicas have continued to work, but that is possibly because they are less prone to intrusion as a result of more efficient design. In spite of this inherent robustness, often overlooked because of the finesse of the product, the natural instinct of some photographers is to be more protective, to take precautions which encourage longevity.

The very high standard of finish, milling and machining of castings, body panel fittings, plating, engraving, smoothness and quietness of operation have always been the keynote of Leitz and Leica products. Anyone with an eye for highly skilled engineering can appreciate this in a Leica rangefinder camera of any age. It is particularly evident in the last of the screw thread type, the Leica IIIg, as well as the M-series cameras with which this book is mainly concerned and which will celebrate their 40th anniversary as this work is published.

It is this appreciation which over the years, has spawned a worldwide interest in the marque to the extent that serious collectors established Leica historical societies in Europe and North America. The Leica Historical Society of America is particularly active to the extent of commissioning specially engraved models to mark the various anniversaries of the type, or to mark special occasions in which Leica products have been involved. When these cameras eventually find their way onto the general market through auction or private sales, high prices are assured because of their relative rarity.

But these societies represent only a fraction of the collecting fraternity. Nor are they the only organisations to produce special models, some of which latterly have become 'instant' collectors items commanding seemingly exorbitant prices. Anyone with the inclination can become a collector and on any scale. The size of a collection is essentially irrelevant in my view and in any case, as with all forms of collecting, much depends on the funds available to support it. There are some who would advocate only the purchase of equipment which is in mint condition. Since even the most numerous of certain Leica models are relatively few, mint or near mint examples tend to be scarce. The older the model, the less likelihood of finding one in such condition, and when they do turn up condition is reflected in the price. To put this aspect in perspective it will be as well to note that the annual production of the current M6 varies between 6,000 and 10,000 units a year. Until the early 1960's, the entire output of Leica rangefinder cameras since 1925 amounted to no more than just over 1 million units. In the three decades since, allowing for a period of at least three years of non-production between cessation of the M4 and commencement of M4-2, one could be generous in allowing for a further 150,000 to 200,000 units to be added. This is a lot of cameras, but it is a mere fraction of the total output of one well known Japanese company which recently celebrated the manufacture of more than 70 million units!

Price of course is always negotiable, and while we may expect to pay dearly for an example in fine condition, those which have seen a busy life frequently change hands for more reasonable sums. A well used Leica which has the patina and brassiness of time can be just as charming in its way as an unused model. A working example will still exhibit all the high qualities of engineering previously described. If it is not working, there is little doubt a Leica service engineer will be able to make it work.

Having accepted the costs involved, the interest inspired by fascination opens the door to a world of minutiae and detail the likes of which are perhaps more commonly associated with philately. It is not the intention of this book to cover every variation of each model and the vast range of accessories and lenses manufactured. Several comprehensive catalogues already exist for that purpose. However, like many other working photographers who use Leica cameras, I have favourites and the hope of acquiring one tends to spur us on.

Any of the black paint M-models would be welcome additions to my own humble collection. However, I have always felt that the demise of the straight pull rewind knob of the M3, M2, M1 and earlier screw models in favour of the canted lever of the M4 was an aesthetic mistake. Somehow, the earlier models exhibit more neatness. The black painted Leica IIIf and IIIg as supplied to the Swedish Army and Air Force, engraved on body and lens with the three crowns symbol, are particularly attractive. From the users point of view, the IIIg with its improved viewfinder, is still a functional and well used camera.

For looks alone, the Zeiss M4 'Fundus' camera takes a lot of beating. These were mostly motorised versions of the M4 with the drive coupling mechanism removed. A white paint filled circle on the top plate of the camera obscured the 'MOT' part of the M4 MOT designation. The combination of black enamel Leitz body finish, chromed shutter release and guard and Zeiss detailing of the f/1.4, 35mm Summilux lens with red and white painted distance numerals, chromed front and milled chrome fitting rings sets the camera off beautifully. Zeiss took delivery of approximately 100 modified M4 MOT cameras in 1971. The camera was also fitted with the special data strip base of the MDa model.

An often voiced opinion concerning the cost of Leica equipment – its supposedly high cost that is – can be frequently heard coming from those who neither own nor use the equipment. In certain countries, the USA for example, the cost of new Leica equipment is, relatively speaking, about the same as for other marques in certain parts of Europe. In the U.K. prices have been traditionally higher than for other types, but closer inspection over a number of years reveals that even these prices are not excessively higher. However, whereas most other marques lose their value very quickly, Leica equipment not only maintains its price when compared with inflation rates, but in most cases appreciates. Naturally, more desirable models, those with unusual engravings or type variations, simply increase in value because of their scarcity.

Amongst true aficionados of the marque, this distasteful topic is not a matter of much concern. As a Rolls Royce salesman once said to a prospective customer who had baulked on being told the price, 'If you have to think about it Sir, you cannot afford it'. Over the years, E.Leitz were not backward in promoting the benefits of investment in their equipment in their advertising copy. This philosophy is still apparent in present day attitudes to sales. And why not? The company is obviously proud of its products and as I have already stated, one would be hard pushed to find better quality. So whether you are a prospective user or novice collector, the thing to remember is that your investment probably represents the best value for money to be had in its field.

The task of choosing the right model from the apparently huge range of camera variations, lenses

and accessories might be a daunting prospect to some photographers new to Leica rangefinders. However, since the introduction of the M3 type bayonet lens mount in 1954 only eight other models, not including special editions, special finishes and various type variations, have been introduced. Compared with other manufacturers, this is a remarkably small number.

Each one of the different discontinued models, which are specified in detail in the following chapters, can, by today's standards of modern 35mm photography, be considered a perfectly usable, rapid handling, functional photographic tool capable of producing the highest technical standards of black-and-white, colour print or colour transparency photograph. The only limitations to the standards of photographic excellence which can be achieved with Leica rangefinder equipment, rest squarely with the individual and the choice of basic materials – i.e. film.

There should be no delusion though. The acquisition of a rangefinder camera does not a photographer make. Rather, it makes one a camera owner. However, the Leica rangefinder is intended to be used to make great works and in practice the way in which certain tools are used to achieve this end requires a certain commitment to learning by the student. Those used to single lens reflex cameras will find the rangefinder very different. The biggest single effect perhaps, will be found by some in the way in which the rangefinder liberates visual thinking. Whereas the reflex, because of its relative complexity and bulk, encourages this thinking to be done when actually looking through the viewfinder, the rangefinder does just the opposite. Its light weight, ease of focus and viewing and the fact that the nature of the camera encourages one toward a broader view because longer telephoto lenses are mostly an impractical encumbrance for a great

deal of the work the camera will do, tends to encourage the user to manipulate the camera in a way which allows the human eye and mind to do more of the looking.

This book will attempt to show the newcomer many of the shortcuts to successful picture making, but I cannot over-emphasize that the degree of success will rate differently for each individual. A lot will depend on one's dexterity and willingness to relearn some of the fundamentals which, until now, will have only pertained to using a reflex camera. For example, in photographing moving subjects, exposure timing is a crucial factor. Even experienced photographers can get that wrong, often because they are fumbling with focus or exposure correction or both. The very nature of the reflex camera encourages the user to check and then check again all which is visible on the screen. The rangefinder, as already mentioned, frees the mind from a lot of this angst; with focus and exposure values having already been committed to the camera, it only remains for the user to point the lens and shoot, composing the final image in the mind's eye as the camera is aimed. If you can accept the idea that the rangefinder camera is a fairly unsophisticated box for carrying film, but which in the case of the Leica is as quiet as a mouse, you will find using it a simple delight.

The current Leica M6, introduced as a replacement for the M4-P in 1984, is the only mechanical and manually operated 35mm format rangefinder camera produced in the world. In this age of advanced autofocus and micro-chip cameras, the design of which seem to be progressing at a relentless pace toward the truly instant image making machine, the M6 may seem something of an enigma. In its time, I dare say that those who were familiar with the very early models held them with the same regard as contempo-

rary aficionados of the current model. Over the years, Barnack's design has been modified and improved, its appearance changed in line with engineering progress and style of the times, but the original concept and philosophy which made the UR possible is still essentially embodied in the M6.

In a way, it is difficult to see how the M6 could be improved further and indeed the stated policy for the time being of Leica Camera GmbH is to improve and add to the lens and accessory range rather than introduce an M7. That said, there are some photographers whose great love is the first 'M' model, the M3. In recent years, there has been steady pressure on Leica to produce an additional wide-angle lens for the M-system and this will almost certainly be realised in the not too distant future by the introduction of a 24mm lens. I would have personally preferred something closer to 17mm but I suspect the optical engineering problems to achieve a sufficiently compact design might be almost insurmountable.

Since the Visoflex viewing system was discontinued some years ago, there has also been a steady clamour for its return in the shape of a more compact and ergonomic design by purists who would occasionally like to use other lenses for telephoto and close-up work. There is no indication that a new Visoflex will come from Leica and since the company manufactures a comprehensive single lens reflex system, there would seem to be little point.

Modifications to the light metering system of the M6 to incorporate additional electronic circuitry permitting TTL flash exposure would not in itself be enough to warrant production of a new model, nor would the addition of another viewfinder brightline frame. A vertical run shutter with metal or epoxy blades would open up further possibilities for the use of electronic flash.

In time, and possibly with the advent of smaller 35mm film cassettes, the abolition of perforations and the introduction of magnetic striping, a new camera may evolve if the market demands. It is more likely however, that development along this hybrid electronic path will continue in the area of compact cameras, of which Leica Camera GmbH have two. In the meantime and certainly for the foreseeable future, the M6 is set to become the longest running Leica rangefinder camera in production. Sales are healthy and more and more photographers seem to be discovering the joys of ownership and the pleasure to be gained from using this and other models in the range.

This *Leica-M Compendium* has been written primarily for the photographer. The collector and the collector-user will find that some accessories which are widely listed in other works are not featured here. The reason for this is that while many of these items are interesting, they have little practical value in modern photography. I have for example, made no reference to the range of bulb flashguns which Leitz once made. I will occasionally use bulbs to light an expansive or distant scene when I want the special quality its light can give me in relation to the cloth focal plane shutter; for the most part however, the modern and highly sophisticated electronic flash gun is a better tool for 99.9% of assignments. Leica GmbH does not manufacture these items, but I have nonetheless given the subject some space.

Not all of the M-fitting lenses are discussed. In addition to current models, I have selected a few older versions which are still widely available on the used market. This does not mean that first generation examples are inferior in optical quality. Far from it. The 135mm Hektor f/4.5 manufactured between 1933 and 1960 is still an excellent lens even by today's standards. The 15mm Hologon f/8, which is based on a Zeiss design first fitted in the Zeiss camera of that name, is omitted because of its rarity. Those lucky photographers who own one can only be envied because, in spite of its extreme angle of view, the 15mm can be a most useful lens for the press photographer.

Third party manufacturers of specialist items, such as the Novoflex Rapid Follow Focus equipment and Tom Abrahamsson's copy of the Leicavit trigger winder, are given special mention because this equipment can be of real value to the Leica photographer in obtaining photographs for which the opportunity might otherwise be lost. The purist rangefinder user will, I hope, recognize that temporarily converting the Leica-M into a reflex camera does not denigrate its purpose; rather it enhances it and yet again proves the value of a true 'system' camera.

Whichever kind of Leica-M photographer or collector-user you are, my hope is that this book will prove to be a valuable aid in raising the awareness of what can be achieved with a very basic outfit and how that can be expanded into a reliable and comprehensive system capable of undertaking the most complex and sometimes arduous of assignments. Long term users will already know this; to the newcomer let me say one thing – welcome to a new world of photography.

Jonathan Eastland.
Hamble River, England,
December 1993.

Leica-M Rangefinder Cameras

HISTORY, STANDARD MODELS AND VARIATIONS

1.1 Leica M3

The introduction of the Leica M3 in 1954 was a milestone in the history of Leitz production, for the camera and its associated lenses represented a major design departure from the previous screw-threaded types. The last of these was the Leica IIIg, which was launched after the M3 and continued in production for several years. Other than shape and size of the main body casting, little of the top plate and protuberances of the IIIg's predecessor, the IIIf, had been carried through to the IIIg.

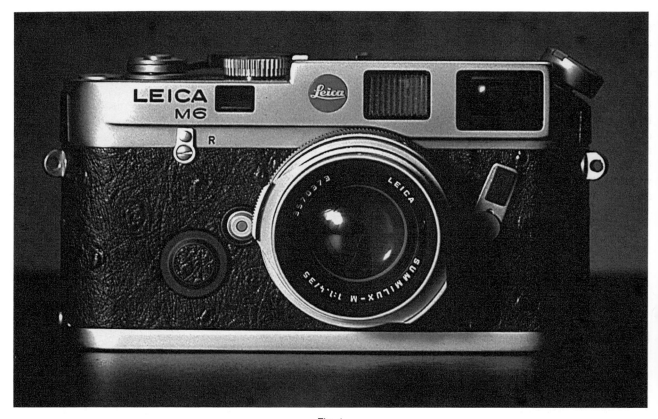

Fig. 1

The M3 sported a fully enclosed viewing and rangefinder system modelled as an integral part of the overall body plan. A rapid film wind-on lever, instead of a knob, was incorporated, along with a self-zeroing film exposure counter enclosed behind a small circular magnifying lens in the top plate. The film rewind knob was of the pull-up variety common to all the screwthread models. In early versions, the slotted head of the knob's retaining pin provided an indication to users that film had been correctly loaded and was winding on. The slot was filled with red paint. This was changed in later models, first to a red dot and then two red dots.

The major innovation in the M3 was the bayonet mount for the lenses. This lens mounting system has remained exactly the same for forty years, enabling virtually all bayonet fitting lenses manufactured since 1954 to be fitted and used with all of

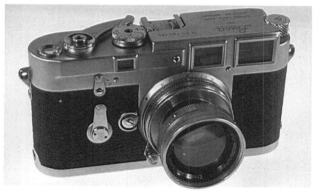

Fig. 2: An early production M3. Pre-selector levers became standard above body ser. nr. 785801.

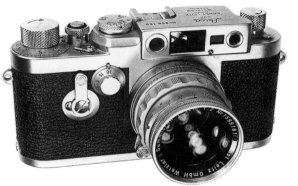

Fig. 3: Leica IIIg, last of the screw thread rangefinder models. It began life after the introduction of the M3.

(Photo: Hove Collectors Books Archive)

the M-series cameras from the M3 to the M6. A more detailed examination of which lenses can be used with what bodies is contained in Chapter 2.

While the screw mount system had survived without apparent problem for more than 30 years, its major disadvantage was the time required to change lenses. To photographers in a hurry this was irksome. There was also the added danger that just once in a while careless fitting of a lens could result in cross threading. The new bayonet system was the result of several years of research. Wear and tear on the camera lens mount and the lens mounting flange are reduced to a minimum through the use of chromium plated brass. A simple spring-loaded lens lock/release button, incorporating a tiny spigot which engages in a milled slot on the rear face of each lens mounting flange, ensures a secure lock with audible confirmation as the lens is inserted into the camera body throat and turned through a short 30° clockwise arc. This button on the M3 was enclosed within a cast, raised finger guard to prevent accidental release, but was a feature absent from all subsequent models until the M6. Each lens has a tiny dome-shaped red plastic alignment marker which is enough, in the hands of practised users, to enable the lens to be fitted accurately by feel alone. Wear in the mount of an M3 which has seen forty

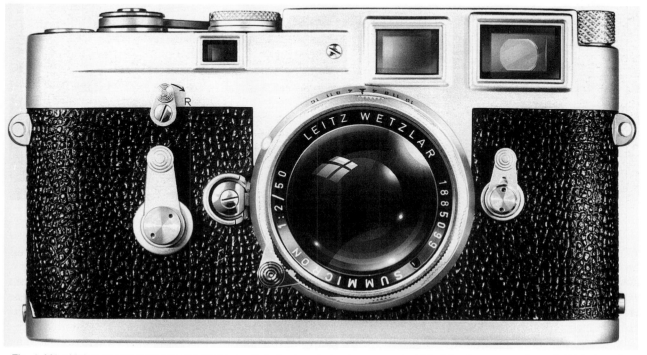

Fig. 4. M3 with levers and semi-circular strap lugs. Note the lens-lock release guard which did not appear again until 1984 when the M6 was launched.

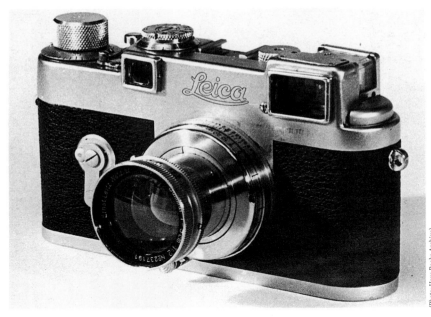

(Photo: Hove Books Archive)

Fig. 5. The experimental Leica IV which was well advanced in terms of range/viewfinder design as early as 1935. The camera did not go into production.

years of hard use is unlikely to be evident.

A number of other equally important innovations were standard fitments to the M3. These include three projected, parallax-corrected, bright-line viewing frames for 90mm, 135mm and 50mm. The latter as fitted to this model is still probably the best of all M-series cameras. As an interesting aside, potential purchasers of older M-cameras will be reassured to know that projected bright-line viewing frames tend to retain their practical efficiency by remaining bright and easy to see for many years, whereas the type of reflective semi-silvered bright-line frame employed in some models of other marques fades with time. A number of competing manufacturers experimented with silver toning techniques in efforts to counter the deteriorating effects of continued exposure to light. The M3's different viewing frames are mechanically linked to their respective lenses via a spigot housed immediately behind, and to one side of the camera lens mount, which engages with a spe-cially shaped cam portion of the bayonet mounting flange on each lens.

Later models of the M3 (from ser.nr. 785801) were additionally fitted with a frame pre-selector lever which permits individual viewing of the viewing frames without changing a lens. Early models did not have this facility, but many were subsequent fitted with it by Leitz Service Centres. A more accurate, longer base (than on the screw Leica cameras) coincident and split-image rangefinder was also fitted and incorporated into the viewing system. This gives an almost life-size image (0.91x). A sharply defined small rectangle of lighter tone than the surrounding viewfinder image indicates the rangefinder measurement field. Compared with other camera viewing systems of the period, the M3 provided an extremely bright image.

Later models of the M-cameras have undergone minor improvements to the viewing system, but it is essentially the same as in the M3 and capable of being used accurately in light levels well below the minimum practicable levels associated with electronic autofocus systems.

As much as anything, it was this combination of sophisticated viewing and focus system, visible through a single viewfinder eyepiece, which endeared the camera to users.

A single non-rotating shutter speed setting dial, incorporating the slow speeds, replaced the twin dial system of screw mount cameras. A notch milled in the dial engages with a spigot on the base of the **M3 Leicameter** which slots into the accessory shoe on the camera top plate. The accessory shoe stop pin of early M3's is D-shaped, while on later ones it is a threaded chromed brass pin. The M3 was the first Leica to have the option of a partially coupled meter. The user sets the shutter speed on the camera and transfers the meter indicated f/-stop to the lens aperture ring. This system, with variously improved meters manufactured by Metrawatt, makers of the famed Gossen range of photographic meters, remained in use with all models up to and including the M4-P.

Provision for the automatic synchronization of both bulb and electronic flash was another feature introduced with the M3. A removable hinged flap on the back of the camera body, in combination with the removable base plate, dramatically improved the speed at which films could be loaded and removed. The backflap is fitted with a film speed DIN/ASA reminder dial. Three different versions were fitted during the production life of the camera.

Inevitably, with more than 225,000 M3's eventually produced, there were several major variations. Early models (to ser.nr. 844001) were fitted with glass film pressure plates. Later models had metal plates and, as with the addition of pre-selector mechanisms to some earlier models, so some glass pressure plates were replaced by metal versions.

Had it not been for the war years (1939-45), during which Leitz production was much reduced and con-

Fig. 6. The Albada type viewfinder of Leica-M cameras permits rapid and accurate focusing under very low light levels.

fined mainly to the supply of cameras for military use, it is likely that the M3, or a camera very much like it, would have been launched sooner. Certain aspects of the M3 were incorporated in the Leica IV prototype of 1935 which can be seen in the factory museum at Solms. Development work on this camera began again in the early post-war years and culmi-

nated with the release of approximately 65 pre-production M3's in 1952 for field evaluation.

These cameras, as well as standard production models up to serial nr. 915251, have a double-action film transport and shutter cocking lever wind. A single frame advance required two complete strokes of the lever, whereas later models required

only one stroke. A pair of the pre-production M3D's were given to the well known American photo journalist David Douglas Duncan by Ludwig Leitz. Duncan used them for many assignments, including coverage of the Vietnam war. His previous Korean exploits with Leica IIIc's fitted with Nikkor lenses had been well documented in the New York

Times by Jacob Deschin, and Duncan's M3D's, which had been specially fitted with the Leicavit rapid winder base, likewise became legendary. Contrary to popular Leica mythology, the 'D' engraved on Duncan's cameras did not stand for 'doublewind'; it was simply his initial.

Duncan, a highly acclaimed *Life* magazine photographer of the 1940's, 50's and 60's, probably did as much as anyone to publicise the qualities of the M3 and establish its reputation as one of the most reliable and virtually indestructible photographic instruments. Outside the arena of armed combat, the M3 continued the reputation of its predecessors in being the quietest camera available to photographers engaged in reportage. This combination of reliability, discreteness, ease of use and toughness, coupled with outstanding lens quality, was more than enough to ensure its longevity well after production ceased.

Leica M3: Technical Specifications And Variations

Date of Launch: 1954. (65 pre-production models released in1952.)

Date Discontinued: 1966. (additional 38 olive-painted models produced in 1967 for German Armed Forces.)

Type: 35mm format, interchangeable bayonet-mount lens, coupled rangefinder camera.

Body: *Construction.* One-piece diecast zinc with bright chromed brass top and bottom plates 0.8mm thick; some batches finished in black paint (see below). Removable hinged, cast zinc back flap.

Size. 138mm x 77mm x 38mm.

Weight. 595 grams (body only). 815 grams fitted with f/2, 50mm Summicron lens.

Viewfinder. *Type*. Automatic parallax corrected, projected bright-line viewing frames incorporating coupled rangefinder measuring field.

Rangefinder Base Length. 68.5mm

Magnification. 0.91x

Viewfinder Display. Projected viewing frames for 50mm, 90mm and 135mm focal lengths. 50mm frame converted to 35mm when used with a 35mm lens fitted with auxiliary conversion oculars. Suspended bright, central field, focus measuring rectangle.

Manual Frame Selection. Pre-selector lever fitted to later models [1955 on]

Other. Depth of field indicator bracket incorporated in rangefinding rectangles [1958 on.]

Modifications. Film advance lever converted from original double stroke to single stroke [1958 on, from ser.nr.919251]. Film pressure plate changed from glass to metal type [1957 from ser.nr.844001].

Shutter Type. Horizontal run, rubberised cloth focal plane.

Speeds: B, 1, 1/2, 1/5, 1/10, 1/25, 1/50, 1/100, 1/200, 1/500, 1/1000. to1957, changed thereafter to: B, 1, 1/2, 1/4, 1/8, 1/15, 1/30, 1/60, 1/125, 1/250, 1/500, 1/1000.

Flash Synchronisation. electronic; 1/50th sec.[increased to 1/60th sec. after 1955]. Flash bulbs, from 1/25th to1/500th sec. depending on bulb type.

Metering Type. Optional accessory. Photoelectric, Leicameter-M (1955), Leicameter-MC (1957), Leicameter-MR (1966).

Camera Type Variations: First 450 cameras had different top plate design distinguished by less refined curve of plate above rewind release catch. Four retaining screw heads were visible, but missing in later models. Triangular-shaped body strap lugs changed for semi-rounded type. The bayonet lens mount ring was initially secured with four set screws. A fifth was added at twelve o'clock which also served to secure the top plate. This fifth screw is recessed and the resulting hole filled with a black composite paste. Some official Leitz service engineers

adopted the procedure of marking the composite with various Greek letters once a repair was complete. The marks are easily visible under a loupe. A black enamel paint version was introduced in 1959 at ser.nr. 959401. Total production 226,178, of which 3,010 were black versions.

1.2. Leica MP

The Leica MP, which was launched in 1956, was a development of the early prototype M3's fitted with a trigger operated mechanical base winder, called 'Leicavit' (see Chapter 5). Several of these prototypes were given to a number of well known photographers of the time as described above.

The MP was a camera demanded by and designed for professional photojournalists and press photographers. It featured many of the M3's attributes and lacked some others. The winding shaft of the M3 was initially too short to connect with the Leicavit, which had been developed earlier for the Leica IIIf, and had to be lengthened. The winding gears for film transport and shutter cocking in the M3 were made of brass. Hardened steel was used in the MP. The film exposure counter of the M3 was changed to a manually-set dial located on the top plate under the wind-on lever. The same type of dial was used in the M2, released a year later. Some 400 MP's were produced and most of these were based on the double-wind film transport mechanism of the M3. Some were converted to single stroke. The viewfinder/rangefinder rectangle lacked the depth of field indicator present in the M3. The delayed action timer was also absent, but the pre-selector lever was fitted to most models. Finally, the larger triangular strap lugs of early M3's were fitted to the ends of the MP body instead of being angled outward from the rounded corners.

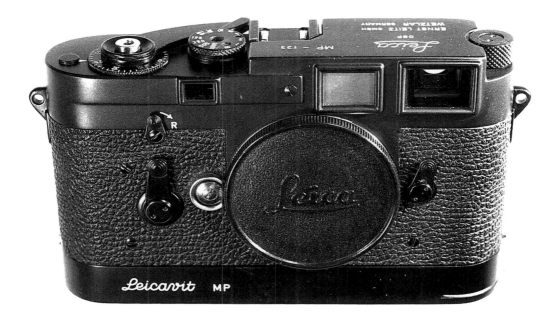

Fig. 6a. Black Leica MP, ser. nr. 123

The camera is easily recognized by the Leicavit MP base, which considerably extends the height of the camera, in addition the production model was engraved on the top plate with the letters 'MP' followed by its production number. The letter 'P' (for 'professional') could also be found inside the camera, together with its production number on the base of the shutter crate.

The camera was in production for only two years, its fate sealed by the arrival of the M2.

Leica-MP. Technical Specifications and Variations

Type: Modified M3 fitted with rapid wind Leicavit MP base.

Body. *Construction*. One-piece, diecast zinc, chromed or black enamel brass top and bottom plates. Hardened steel gear train.

Viewfinder: *Type*. Combined automatic parallax corrected view/coupled rangefinder type as M3.

Rangefinder Base Length. 68.5mm

Magnification. 0.91x

Viewfinder Display. Projected bright-line viewing frames for 50mm, 90mm and 135mm focal lengths.

Manual Frame Selection. Preselector lever fitted as standard.

Other. Manually set exposure counter dial.

Modifications. Factory conversions from double to single stroke wind-on.

Shutter: *Type*. As M3 production model.

Speeds. As M3 production model.

Variations. None.

Flash Synchronization. As M3 production model.

Metering: *Type*. As M3.

Camera Type Variations: Several MP's were returned to the factory to have the deleted refinements of the M3 production model added. According to one source, 311 MP's were finished in chrome and 138 in black enamel. This makes a total of 449, which is close to the official Leitz records. According to van Hasbroeck however, only 402 were made. After production of the MP

ceased, several M3's were produced fitted with the Leicavit MP winder and modified in most respects to MP specification. These models were designated M3 on the top plate and MP on the front of the winder base plate.

1.3. Leica M2

Production of the M2 began in 1958. The thinking behind its introduction was two-fold. Leitz wanted to be able to offer an M-type camera to a wider market; it was felt that a less expensive model than the M3 would meet this requirement. It was hoped that the addition to the range would also increase the popularity of the marque amongst serious users.

The difference in cost between the two models at the time was about 20%. Some of the features found on the M3, like the selftimer, were deleted from the M2. There was no finger guard around the lens release catch and the film exposure counter had to be manually reset whenever a new film was loaded. Early models sported a button-type clutch release for the film advance sprockets, but

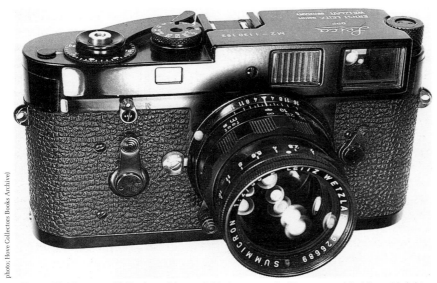

Fig. 7. Black enamel M2, the 'wide-angle' Leica, so called because of its biased bright-line projection frames.

some users confused this with a shutter release. It was also easy to trip the rewind mechanism accidently so this item was changed to the M3-type lever.

Press photographers were immediately impressed with the M2 because of its modified frame finder configuration. Instead of being biased towards the 50mm and longer focal lengths, the image magnification ratio was reduced from 0.91 to 0.72 in order to accommodate a 35mm focal length frame. Because the theoretical base length of the rangefinder was reduced, it became less efficient at the telephoto end of the scale. Consequently the 135mm

frame was dropped and the sequence in the M2 became 35mm, 50mm and 90mm. The frames changed automatically to match the focal length of lens employed. Only the frame in use showed in the viewfinder, unlike the M3 which retained the 50mm frame irrespective of the lens used. A depth of field indicator was added to the rangefinder rectangle. Separate wide and narrow notches were visible on the top and bottom edges of the rectangle. Subjects not exactly measured in focus, but contained within the wide or narrow notch band, came within the useful depth of focus margins set by the choice of aperture. The narrow notch

represented a stop of f/5.6, the wider one, f/16. The user would always have a clear indication of the depth of field provided the minimum aperture set was not less than f/5.6. The M2 became widely known as the 'wide angle Leica' and was preferred by some photographers to the M3.

Leica-M2 Technical Specifications and Variations

Type: As M3.

Body: *Construction* One-piece, diecast zinc, chromed brass top and bottom plates 0.8mm thick.

Size. 138mm x 77mm x 36mm.

Weight. 580 grams (body only)

Viewfinder: *Type*. Combined automatically corrected parallax view/rangefinder.

Rangefinder Base Length. 49.3mm

Magnification. 0.72x

Viewfinder Display. Projected bright-line viewing frames for 35mm, 50mm & 90mm focal lengths, central bright tone rangefinder measuring field with depth of field indicators.

Manual Frame Selection. Pre-selector lever fitted as standard.

Other. Manual reset film exposure counter dial.

Modifications. Film rewind clutch button deleted in favour of lever as on M3. Selftimer added from ser.nr. 1004151. provided as optional

Fig. 8. Rewind button on an early M2; later replaced by standard lever.

Fig. 9. This unusual designation on the top plate of an M2 indicates that it is fitted with the Leica speed film loading system of an M4.

factory modification for previous models. All M2's could accept the Leicavit rapid winder. In 1966, some 275 motorised versions of the M2 were factory produced and designated on the top plate with the letters 'M2-M'. Approximately 2000 produced in 1969 were fitted with the three-pronged rapid film take-up spool as found on the M4. These cameras were factory redesignated 'M2-R' and mainly sold through the U.S. network of Leitz dealers.

Shutter: *Type*. Rubberised cloth horizontal run focalplane.

Speeds. B, 1, 1/2, 1/4, 1/8, 1/15, 1/30, 1/60, 1/125, 1/250, 1/500, 1/1000.

Variations. None.

Flash Synchronization. electronic and bulb. 1/50th &1/25-1/500th sec.

Metering: Photo-electric optional extra Leicameter and Leicameter MC.

Camera Type Variations: First 500 were not factory fitted with a self-timer. From ser.nr. 949101, the self-timer was fitted. Some early examples fitted with USA-made electric motor but not engraved. These should not be confused with about 15 made in 1959 which were fitted with electric motors and designated 'MP2'. The M2M was manufactured in Wetzlar, 275 units in 1966. It was fitted with a motor but could be used without. Several hundred bodies were manufactured by E.Leitz, Canada (ELC), as were M3's. Various batches finished in black paint. M2-R (see M2 text above) initially manufactured for US Army procurement as KS-15(4). An overrun was distributed to the public through E. Leitz, New York.

1.4 Leica M1

The philosophy behind producing a less expensive companion to

the M3 proved so successful that Leitz decided to go one step further in 1959 by launching an even cheaper model. At first glance, the M1 seemed identical in most respects to its predecessors. A closer inspection soon revealed that the rangefinder focusing unit was missing, although the M1 was fitted with automatic parallax correction for the 35mm and 50mm projected brightline frames provided, which are constantly in view irrespective of the lens in use. No frame preselector lever was therefore fitted.

In all other respects, the M1 is very similar in specification to the M2 and approximately 9,517 (the actual figures stated by Leica historians and Leitz factory records are at variance between 9,392 and 9,756) were produced between the years 1959 and 1964. The camera type designation is marked clearly in the blanked-off rangefinder window in

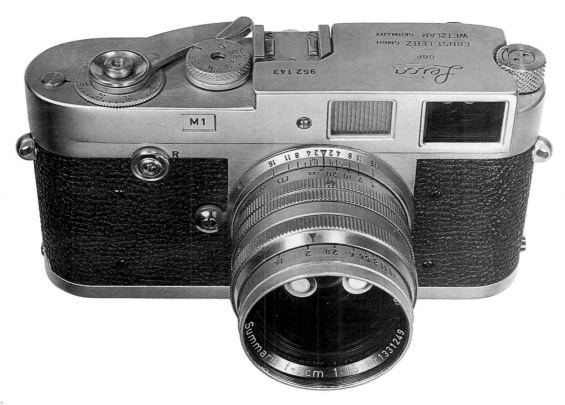

Fig. 10. The Leica M1, easily recognized by the model designation which appears in the viewfinder window, here fitted with the substantial 5cm Summarit f/1.5. The two tool key recesses in the centre of the rewind knob are filled with red paint to enable easy film advance recognition, a feature also of the M3, M2 and MD.

the front of the top plate. No model number appeared on the top plate next to the body serial number.

For certain applications, such as when using the camera with a Visoflex reflex housing, or for industrial and scientific work, the lack of a rangefinder was of no consequence. Being the least expensive of the three M-type cameras so far produced also made it attractive to certain government departments and private industries operating strict purchasing budgets. A German military version of the camera was produced having viewing frames for 50mm and 135mm focal lengths and finished in olive green. The top plate of the camera is engraved with the focal lengths in centimetres. For the individual requiring a back-up camera the M1 was ideal for use with standard or wide-angle lenses. Accurate focus was achieved simply by judging the subject distance and setting it on the camera lens.

Leica-M1 Technical Specifications and Variations

Type: 35mm viewfinder camera. No rangefinder fitted.

Body: *Construction*. One-piece, diecast zinc with chromed brass top and bottom plates 0.8mm thick.

Size. 138mm x 77mm x 36mm

Weight. 545 grams (body only)

Viewfinder: *Type*. Viewfinder incorporating parallax corrected projected viewing frames.

Rangefinder Base Length. None fitted.

Magnification. n/a

Viewfinder Display. Projected bright-line viewing frames for 35mm and 50mm focal lengths in standard production model; 5cm & 13.5cm (50mm & 135mm) in military model.

Manual Frame Selection. No preselector fitted.

Other. No selftimer fitted.

Modifications. Button type film sprocket rewind clutch replaced by standard lever type at ser.nr.966730.

Shutter: *Type*. As M2.

Speeds. As M2.

Variations. None.

Flash Synchronization. As M2.

Metering: *Type*. As M2.

Camera Type Variations: See M1 text. A short production run of 32 cameras was modified by Alos AG, a Swiss company, for the German Post Office. These cameras were fitted with a fixed-focus 35mm, f/3.5 (later f/2.8) Summaron lens for recording telephone meter readings onto a modified 24mm x 27mm film format in the ratio 1:12.7. The camera was known as the 'M1 Post Leica'.

1.5. LEICA MD

This camera was a further development of the M1, mainly for scientific and special applications work. No rangefinder or viewfinder was fitted, direct focus being measured by attaching the Visoflex, by fitment to a microscope or by accurately mea-

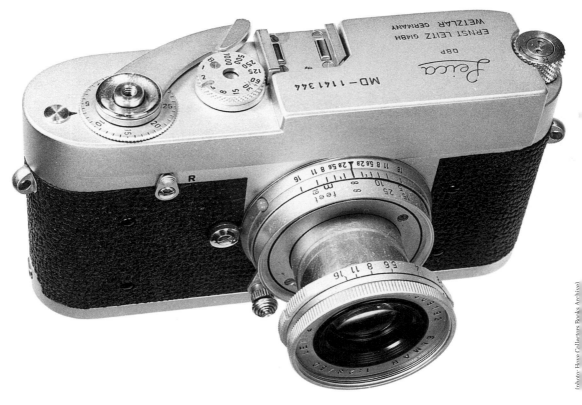

Fig. 11. Leica MD, first of the bayonet lens-mount cameras for special applications, which replaced the M1 in 1965.

[photo: Hove Collectors Books Archive]

Fig. 12. The Leica MDa used the canted rewind lever of the M4, which it preceded.

suring the subject-to-film distance and setting the lens accordingly. Direct viewing could also be obtained by fitting one of the many separate viewfinders in the accessory shoe and a matching lens. In particular, in this form, the MD, MDa and the later MD-2 become ideal, rapid handling, extreme wide-angle cameras when fitted with the 15mm Hologon, the 21mm, f/4 or f/3.4 Super Angulon or current 21mm, f/2.8 Elmarit-M and the appropriate viewfinder.

A special base plate enabled 4mm-wide strips of clear plastic to be inserted through a light trap and placed over the film frame at the edge of the film gate, thus effectively reducing the format to 24mm x 32mm. Information written on the strips could then be recorded as necessary whenever a frame was exposed.

The MD was introduced in 1965 and replaced the M1. Production ceased in 1966 when the MD was replaced by the improved MDa version which was fitted with the rapid loading three-pronged take-up spool, the canted, lever operated film rewind mechanism and film counter exposure window of the M4. The MDa remained in production for eleven years before being superseded by the MD-2. The latter is essentially the same camera as the MDa but with additional features taken from the M4-2 (see technical specification below).

Leica-MD, MDa. Technical Specifications and Variations

Type: 35mm camera for special applications. No rangefinder or viewfinder fitted.

Body: *Construction.* One-piece, zinc diecast body fitted with chromed brass top and bottom plates 0.8mm thick.

Size. 138mm x 7mm x 36mm

Weight. 495 grams (body only)

Viewfinder: *Type.* None fitted.

Rangefinder Base Length. n/a.

Magnification. n/a.

Viewfinder Display n/a.

Manual Frame Selection. n/a.

Other. Could be used as a normal camera by sliding separate lens matched viewfinder into the accessory shoe on the top plate.

Modifications. n/a.

Shutter: *Type.* Rubberised cloth focal plane.

Speeds. As M2.

Variations. None.

Flash Synchronization. As M2.

Metering: *Type.* As M2.

Camera Type Variations: MD's were finished in chrome but the factory produced a small batch in metallic grey paint to match Leitz microscopes. The MDa was updated to include features taken from the M4.

1.6. Leica MD-2

Leica MD-2 Technical Specifications and Variations

Type: As MD,MDa.

Body: *Construction.* As M4-2.

Size. As M4-2.

Weight. 460 grams (body only)

Viewfinder: *Type.* None fitted.

Rangefinder Base Length. n/a.

Magnification. n/a.

Viewfinder Display. n/a.

Manual Frame Selection. n/a.

Other. n/a.

Modifications. n/a.

Shutter: *Type* As MD, MDa.

Speeds. As above.

Variations. n/a.

Flash Synchronization. As M4-2.

Metering: *Type.* Leicameter MR and Leicameter MR-4.

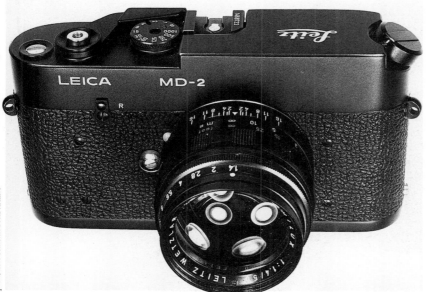

Fig. 13. The MD-2, launched in 1980, was the last of the special Leica cameras without range- or viewfinder. The body, which is fitted with an electronic flash hot shoe, is ideally suited for use with the Visoflex type mirror box.

Camera Type Variations: The MD-2 was the last of the M-type cameras produced for special applications. It was essentially the same as the MDa but not launched until 1980, three years after the demise of the MDa, and was based on the M4-2 rangefinder model. It had some of the latter's features. The camera body was fitted with a flash hot shoe on the top plate as well as twin flash PC sockets on the rear of the top plate for electronic and bulb flash. The MD-2 will also accept the M4-2 power winder without modification.

The camera accepts the MD and MDa special recording strip baseplate. An aluminium film speed reminder disc, which can be written on, is fitted to the hinged back. All models were finished in black chrome.

1.7. LEICA M4

The M4, which was first produced in 1967, was the result of the company's policy of continual product improvement. This new camera combined the best features of both the M3 and the M2 series while adding a few of its own. In a way, it was yet another fairly radical step forward in rangefinder camera design and for some, still epitomises the peak of styling elegance, finesse and beauty. This was to be carried through all of the M4 models to the current M6.

The body size remained the same as its predecessors. The camera's appearance was dramatically changed however by replacing the pull-up rewind knob of the M3/2/1 and MD models with a cranked lever film rewind mechanism canted at 40° to the top plate. The lower middle front section of the top plate, which surrounded the lens mount of earlier cameras, was also done away with. From the M4 onward the lower edge of the top plate is flush straight across the body under the range- and viewfinder windows. This modification, together with the canted rewind lever, gives the apparent effect of lengthening the body, though in essence it remains the same at 138mm. Other new features included the black plastic-tipped self timer and projected frame

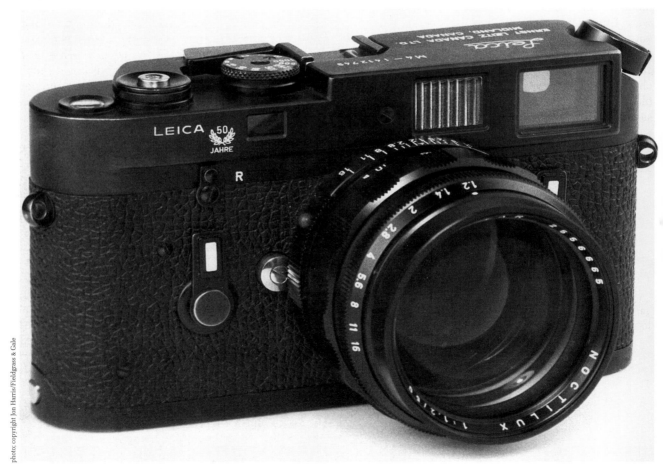

photo: copyright Jon Harris/Fieldgrass & Gale

Fig. 14. The elegant lines of the Leica M4 are clearly apparent in this black chrome example of the '50 Jahre' anniversary model fitted with matching, scalloped barrel, 50mm Noctilux f/1.2.

Fig. 15. The petal shaped three-pronged film take-up spool first featured in the M2-R and then became the standard rapid loading device in all subsequent M-models.

counter, set behind a magnifying window.

The three-pronged rapid film take-up spool, as fitted first to the M2R, was also fitted to the M4. The three prongs slot into a spoked wheel located in the camera base plate, thus ensuring a more positive film loading action. Leitz claimed in the M4 sales literature that if one was able to operate a door knob, 'you can load an M4'. A photograph of the camera being loaded with chunky leather-gloved hands was a feature of Leitz advertising of the period. From a purely practical point of view, the new 'Leitzspeed' film loading design was a major improvement, but in the wrong hands it is easy to misjudge the exact length of leader required to get near automatic and very rapid loading and instead end up with 36 frames of nothing before the mistake is realised! The same system is used in the current M6, but it is difficult to see how this could be improved without radically changing the overall design concept.

preselector levers, which being identical in shape, added further symmetry to the camera. These levers were fitted on some models with key-slotted machine screws and on others with headless fittings. In each case, the black plastic inserts changed in design and on some later black chromed models the central section is filled with white paint.

The film transport and shutter cocking lever was redesigned. Instead of being the elegant and gently curved solid metal arm seen on earlier M-types, it was now wider, more sharply angled to the shutter release axis and given a hinged plastic tip. A further improvement over the M2 was the addition of the M3-type self-zeroing film exposure

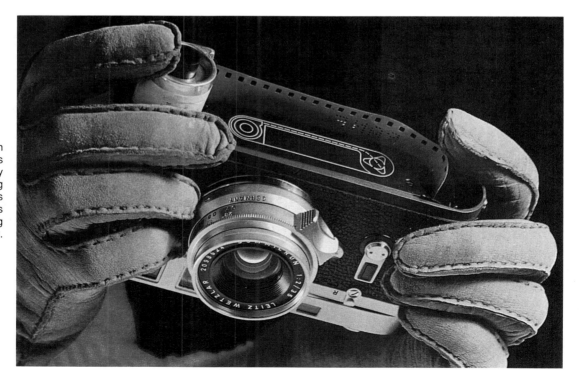

Fig. 16. An early 1970's Leitz publicity photo featuring the advantages of the M4's rapid loading facility.

Fig. 17. An M4 with special significance for collectors; the 'Camera Still Picture KE-7A', fitted with the 50mm Elcan f/2 lens.

photo: Hove Collectors Books Archive

Four different projected bright-line frames are fitted to the M4 for 35mm, 50mm, 90mm and 135mm focal lengths. The 35mm and 135mm frames appear together. The frames are automatically parallax corrected as in earlier M-models. Leitz brochures originally claimed that six rangefinder-linked frames were fitted, but one must assume that some advertising licence had been given over to the fact that both the 28mm and 21mm lenses each required separate viewfinders placed in the top plate accessory shoe. To obtain accurate focus with these lenses the user operates the coupled rangefinder in the normal way and then recomposes the photograph to be taken through the separate viewfinder. The M4, like the M2, has a viewfinder magnification ratio of 0.7 and can focus accurately from infinity to 28 inches. It was originally factory supplied with the 50mm Elmar f/2.8, the 50mm Summicron f/2, or the 50mm Summilux f/1.4.

The camera was mainly manufactured in Germany at the Wetzlar factory and finished in chrome,

although some batches were finished in black enamel paint. Towards the end of its life, production was mainly concentrated at the Midland, Ontario factory where a black chrome finish was applied. Over 900 units were also built to suit the motor drive being made by E.Leitz, New York. These cameras were finished in black enamel.

An M4 which has special significance for the collector and which now commands exceedingly high prices is the version made for the U.S. Army and engraved 'Camera Still Picture KE-7A' on its top plate, where the normal M4 engraving and serial number were placed, and on the right hand rear of the top plate. This camera was specially winterized and capable of operating in temperatures as low as -20°C. It was also moisture and dust proofed. A special lens, the 50mm Elcan f/2, was produced at the Canadian factory to meet the U.S.Army requirement for a less highly specified lens than the 50mm Summicron f/2. Aside from these features, which at least as far as the body is concerned would make

the KE-7A a superlative professional tool, one of the features appealing most to collectors is the U.S.Army instruction and repair manual issued with each camera. Contained in this document are the explicit and detailed instructions for destruction of the camera in the event of the user's imminent and unavoidable capture. The instructions include methods of smashing the camera and lens with a heavy object or blowing it to pieces with explosives to prevent its falling into enemy hands!

Having reached the pinnacle of rangefinder design with this model, Leica rangefinder camera sales were being seriously affected by the inroads into the world market being made by Japanese single lens reflex manufacturers. Leitz were marketing two different models at this time, with a third on the drawing board. The M5, launched in 1971, was equipped with through-the-lens metering and it affected demand for the M4. In addition, Leitz themselves had already launched two models of the Leicaflex camera and were concentrating much of their effort in

this direction. Reluctantly, in 1971 production of the M4 itself was suspended, although a handful of KE-7A's were manufactured during 1972. Production of the M4 was resumed in 1974 after considerable world-wide pressure from professional and amateur users, but was finally discontinued in 1975. It was during 1975 that the anniversary M4 model, engraved with '50 Jahre' and coupled oakleaves was issued, bringing the total number of units to almost 60,000.

Leica M4 Technical Specifications and Variations

Type: 35mm viewfinder coupled rangefinder camera.

Body: *Construction*. One-piece, diecast zinc body with 0.8mm thick brass top and bottom plates.

Size. 138mm x 77mm x 36mm

Weight. 600grams (body only).

Viewfinder: *Type*. As M3.

Rangefinder Base Length. 48.5mm.

Magnification. 0.72x.

Viewfinder Display. Projected bright-line viewfinder frames for 35mm, 50mm, 90mm and 135mm focal lengths with coupled rangefinder bright-tone central measuring field.

Manual Frame Selection. Preselector lever fitted.

Other. Self timer fitted. Canted, lever operated film rewind. 'Leitz speed' film loading system (see M4 text).

Modifications. None.

Shutter: *Type*. Rubberised cloth blind horizontal run focalplane.

Speeds. As M2.

Variations. n/a.

Flash Synchronization. Electronic and bulb flash through standard co-axial PC sockets.

Metering: *Type*. Cds battery operated Leicameter MR.

Camera Type Variations: The main variations during the life of this

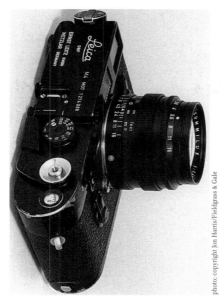

Fig. 18. Black enamel M4 MOT which accepted the E.Leitz, New York, motor

photo: copyright Ion Harris/Fieldgrass & Gale

camera were concerned with the type of finish. The majority were in chrome; black enamel and black chrome were reserved for some 9,000 units. A tiny batch of 31 M4's were painted olive green in the 1969 run. The KE-7A as described above was produced specially for the US Army. Service cameras were engraved with the Leitz contract number in addition to the service designation. Over supplies did not have the contract number and were mainly distributed through a handful of Leitz dealers. Motorised versions of the camera were also produced and finished in black paint. These were fitted with the electric motor manufactured by E. Leitz, New York. The camera was designated 'M4-MOT' or 'M4M' on the top plate. A batch of the latter were specially produced for Carl Zeiss and fitted with the 35mm Summilux f/1.4 and base plate of the Leica MDa. This model is often referred to as the 'Fundus' model.

1.8. Leica M5

This camera was another radical departure in design for the company. The inclusion of TTL metering required a larger body. The M5 bears a vague resemblance to earlier M-types. It is both longer and taller and slightly tapered at each end. Both feel and handling are very different from say, the M4. The shutter speed setting dial is

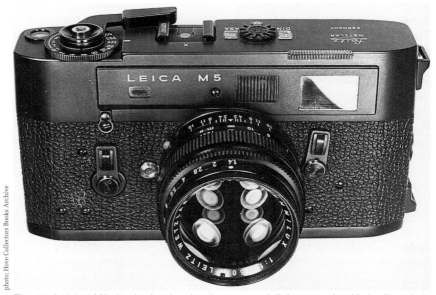

photo: Hove Collectors Books Archive

Fig. 19. A '2-lug' M5 clearly showing the shutter speed dial concentric with the film wind-on lever and the film speed setting dial on the top plate. The accessory shoe is fitted with an electronic flash connection.

positioned beneath the shutter release on the same axis as the wind-on lever. The edge of the dial protrudes slightly over the front of the camera; this was to allow the user to change speeds rapidly without removing the camera from the eye while adjusting the exposure meter. In practice, however, the set shutter speed can easily be changed accidentally whenever the camera is shoulder slung or the dial brushed by a sleeve, finger or some other part of the anatomy. Some later models were factory fitted with a stiffer shutter speed dial click-stop spring which went some way towards rectifying the problem. Originally, the M5 began life as an M4. Leitz had been working for several years on perfecting a through-the-lens metering system. A Cds meter on a stalk, which was activated by a lever on the body of the camera to rise directly in front of the filmgate, was first seen on a modified M3 in the late 1960's. The M4 was launched in 1967, but that was at least two years after the existing M5 shape had been built as experimental M4's.

In the production model of the M5, the Cds meter employs a double photo-resistor, 8mm in diameter, which is fixed to the end of a stalk. This is raised into the light path and the power to the meter switched on as the shutter is cocked and the film wound on. Optical compensation is applied for the 8mm distance of the measuring cell from the film plane. A needle visible in the viewfinder window, together with a pointer indicating the shutter speed set, is adjusted to coincide for correct exposure by resetting the aperture or shutter speed. A slight first pressure on the shutter button releases the Cds stalk from its raised position and allows it to fall out of the light path into a well in the base of the camera. A second, almost instantaneous pressure releases the shutter, but there is a noticeable delay between the two actions and this was another factor

of some irritation to professional users.

In practice, the metering system works well and is very accurate, especially for colour work. Readings taken through a polarising or other filter need no compensation. Because of its narrow angle of acceptance, it is possible to use the M5 TTL meter almost as one would a spot meter, and in the several years I owned and used one of these cameras, I could not fault the meter. When a standard 50mm lens is used the angle of the measured field is 10.4°. The field is narrowed to 3.6° with a 135mm lens and widened to 22.6° when the 28mm is fitted. Ascertaining an apparent spot reading, even when using the wide-angle lenses, is discussed in Chapter 7.

However, the camera is a strange beast; one either likes it or not. At 700 grams, the body alone is heavier than many SLR types. Its size was another factor against it, particularly when all one wanted at times was a discreetly hidden M2. Fitted with a standard 50mm lens, or the heavier f/1.4 Summilux, the camera is badly balanced when carried in the conventional horizontal position, so the first batch of M5's were fitted with carrying strap lugs on the right hand side of the camera which allowed it to be slung vertically. In this position, the camera behaved in a more orderly manner but the position is impracticable for many photographers. Leitz recognized this and added a third lug at the top left of the body so that it could be carried in the conventional manner.

The M5's viewfinder has the same range of projected viewing frames as the M4. A small horizontally placed barrel shaped outline in the centre of the frame provided an indicator as to the metered area when used with a 50mm lens. The shutter speed scale lacked the 1 second of earlier models and began at 1/2 second. The speed range was visible along the base line of the viewfinder, together with the

shutter speed pointer and meter indexing needle. The bottom frame edge of the viewfinder was also the baseline of the 35mm focal length finder.

The DIN/ASA film speed setting dial can be found on the top plate next to the accessory shoe, which is fitted with a hot shoe. The lever cranked film rewind mechanism is recessed into the base of the camera, but in most other respects the M5 retained the improvements of the M4. The frame preselector lever also doubled as the meter battery check lever when pushed to the right. In addition to the hot shoe, two 3mm co-axial sockets for electronic and bulb flash were fitted to the rear of the top plate. The camera has a removable hinged back and uses the 'Leitz Speed' film loading system described above for the M4. The film exposure counter was as the M4.

Collapsible lenses could only be used on the camera in the fully extended mode. Some Leitz dealerships offered a modification service whereby a preventer collar could be fitted to this type of lens. Neither the 28mm Elmarit nor the f/4 nor f/3.4, 21mm Super Angulon could be used below certain serial numbers (see Chapter2) because the extent of rear element back projection was more than 15mm and it collided with the meter stalk.

Leica M5 Technical Specification and Variations

Type: 35mm Through-The-Lens meter coupled rangefinder camera.
Body: *Construction.* Die cast zinc body with silver or black chromed top and bottom plates.
Size. 150mm x 87mm x 35mm.
Weight. 700grams (body only).
Rangefinder Base Length. 68.5mm
Magnification. 0.72x.
Viewfinder Display. Combined range/viewfinder, automatic parallax correcting projected bright-line frames for 35mm, 50mm, 90mm, and 135mm; Central rangefinder

measuring field. Metering measurement area indicator. Full range of shutter speeds with automatic pointer. Meter needle pointer.

Manual Frame Selection. Preselector lever fitted.

Other. Self timer mechanism fitted. Preselector lever activates battery check.

Modifications. None.

Shutter: *Type*. Rubberised cloth horizontal run focal plane.

Speeds. B, 1/2, 1/4, 1/8, 1/15, 1/30, 1/60, 1/125, 1/250, 1/500, 1/1000. Slower speeds of 2, 4, 8, 15 and 30 seconds were marked but were manually operated in conjunction with the 'B' setting.

Variations. Shutter speed setting dial of later models was factory modified with stiffer click-stop spring.

Flash Synchronization. 1/50th sec for electronic. Up to 1/500th for bulb depending on type used.

Metering: Through-the-Lens (TTL) Cds. A first for Leitz.

Camera Type Variations: M5's were finished in black or silver chrome. Approximately 30,000 were produced during the camera's short life and of these the black versions are most common. A few were engraved with the '50 Jahre' and double oak leaves symbol in 1975. The camera was marked 'LEICA M5' on the front left hand side above the rangefinder window and in Leitz script on the top plate. No special models were made and the camera could not be coupled to a motor drive unit.

1.9. Leica CL

'CL' stands for Compact Leica. It was the result of the technological co-operation between E.Leitz, Wetzlar and the Japanese firm of Minolta in Osaka. The CL was designed by Leitz and manufactured to their specification by Minolta. For a while the Japanese company marketed its own identical version of the CL

Fig. 20. The diminutive Leica CL which employed the Cds 'stalk' metering system of the M5.

designated 'Leitz Minolta CL'. Minolta later designed and produced another version called the 'Minolta CLE'. This was of a different shape and featured a centre-weighted TTL metering system coupled to an electronic focal plane shutter. All three models were fitted with the Leica-M lens mounting system and, although they were marketed with special lenses (see chapter 2), these compact cameras could accept most of the existing range of lenses.

The philosophy behind the production of the Leica CL partly had to do with flagging sales of the M5. But its life was short and it was discontinued in 1976, although approximately 65,000 units were produced. The Minolta CLE continued in production in Japan until the early 1980's.

The overall styling of the CL was vaguely reminiscent of the M5. Indeed, it could be said to be a compact version of that camera because it contained nearly all of the larger model's features, including the TTL metering system. It even had the vertical twin strap lug carrying arrangement.

The camera came complete in a kit with 40mm Summicron-C f/2 and a 90mm Elmar-C f/4 lens. Both lenses were manufactured in Wetzlar. The Minolta CL was fitted with a 40mm Rokkor lens similar in design to the Summicron, but the 90mm Rokkor was in fact a 90mm Elmar-C made at Wetzlar. It was the only Leitz lens to be sold under another name.

Projected viewing frames were fitted covering the 40mm, 50mm and 90mm focal lengths. Parallax correction was automatic, as in all other M-models. The familiar central rangefinder rectangle field was fitted, although the base length of the rangefinder itself was considerably shorter at 31.5mm than in the camera's bigger brothers. The viewfinder magnification ratio was only 0.6x. Shutter speeds, the range of which was the same as on the M5, are shown at the top of the viewfinder running from left to right. A red pointer indicated the speed selected, while the meter needle was balanced into a notch on the right hand side of the viewing frame.

The meter measuring system adopted by Leitz had by now become known as 'selective' metering. In the CL, a Cds cell 7.5mm in diameter and utilising the same stalk mechanism, measures an area approximate to that covered by the rangefinder rectangle when employing a 90mm lens, approximately 7% of the total frame area. It is very accurate and simple to use.

A new vertical focal plane shutter, running from top to bottom, was developed for the camera. It is speeded from B through 1/2 second to 1/1000th second. The shutter

(photo: Hove Collectors Books Archive)

Fig. 21. This photo clearly shows the stalk-mounted Cds cell in the Leica CL. It drops to the side as the shutter button is depressed. The M5 cell drops into a well in the base of the camera.

speed setting dial is located on the front of the camera on the left hand side at top, immediately below and slightly to one side of the shutter release. Compared to other M-models, the shutter noise was more distinctive and sharper, but still a great deal quieter than an SLR of the period. The film speed setting dial is also contained within the shutter speed dial. The camera was fitted with automatic hot shoe flash synchronization at a speed of 1/60th second; 1/30th second when used with flash cubes.

A novel feature of the camera (for a Leica) was that the whole of the camera back and base is removed for film loading. The base is fitted with a standard 1/4 inch tripod bush and the recessed film lever operated rewind mechanism. The leatherette covered body of the camera is die cast metal and fitted with black chromed top and bottom plates.

Leica CL Technical Specification and Variations

Type:

Body: *Construction*. Diecast metal body, chromed brass top and bottom plate. One-piece removable back and bottom plate.

Size. 120mm x 75mm x 32mm.

Weight. 365 grams (body and 40mm Summicron lens)

Viewfinder: Eye level, combined view/rangefinder with automatic parallax corrected frame projection.

Rangefinder Base Length. 31.5mm

Magnification. 0.6x.

Viewfinder Display. Projected bright-line frames for 40mm, 50mm and 90mm focal lengths combined with central rangefinder measurement field. TTL match-needle pointer at right centre of frame, shutter speed scale and red pointer at top edge.

Manual Frame Selection. None fitted.

Other. Leica bayonet lens mount with automatic bright-line frame finder mechanical linkage.

Modifications. None.

Shutter: *Type*. Vertical run, top to bottom, cloth focal plane.

Speeds. B, 1/2 sec to 1/1000th second as M5.

Variations. None.

Flash Synchronization. Hot shoe X-contact in accessory shoe.

Metering: Cds, selective field measurement type covering approximately 7% of picture area.

Camera Type Variations: Minolta CL designated 'Leitz Minolta CL' supplied with Minolta Rokkor lenses instead of Summicrons. The body of this model was discontinued by Minolta in favour of their own CLE design which accepted the same Leica M-fitting lenses as for the Leica CL and Leitz Minolta CL cameras.

The middle years of the 70's were financially worrying for Ernst Leitz GMBH. Rangefinder camera sales were dwindling worldwide and the cost of producing what was undoubtedly the world's finest single lens reflex camera, the Leicaflex SL and SL2, was prohibitive. In some quarters it was claimed that the camera cost more to make than it could be sold for.

Production of the M5 and Leica CL had already ceased in 1975 and although a further batch of nearly 2,000 M4's was made in the same year, none were made in 1976. Examples of the new Leica M4-2, the M4's intended replacement, had already been made however, and the camera was exhibited that year at the Photokina exhibition.

Perhaps this was a ploy to test the market, for the camera did not actually go into production until late 1977 and was not generally available until the following year, by which time there was some pressure from Leica-M users and collectors for Leitz to restart production.

At this juncture it should probably be said that one of the main reasons for the continued survival of both the Leica M-type and R-type cameras towards the end of the millenium rests firmly in the hands of the universal network of aficionados. Doubtless, Leitz' other activities in the scientific field provided some financial support to the camera division in times past, but Leica Camera GmbH is now largely autonomous and must show that it can be profitable if it is to continue.

1.10. Leica M4-2

After the hiatus in production of the M4 and its reappearance by popular demand, Leitz decided to continue the M-camera line and introduced the M4-2. At first glance it differed little from the M4, and indeed was essentially the same camera without the self timer mechanism. Since much of the pressure to continue production had come from professional quarters however, Leitz had taken note of the 'ideal' requirements of photojournalists and in this respect it could be said that the M4-2 was, when launched, probably the finest model to have come from the Leitz stable. Its main attraction was the modification to the main film transport drive shaft and the installation of electrical switching circuits which allowed ready fitment of a specially made compact motor winder – the **Leica Winder M4-2**. One simply removed the normal base plate and attached the winder unit. No further engineering was required by Leitz specialists to ensure the camera functioned.

Other features included the addition of a hot shoe X-synch. contact in the accessory shoe, the same as had been installed on the M5. The two 3mm co-axial sockets on the rear of the top plate for electronic and bulb flash were also retained in this model.

During the three short years of production, only 17,000 M4-2's were

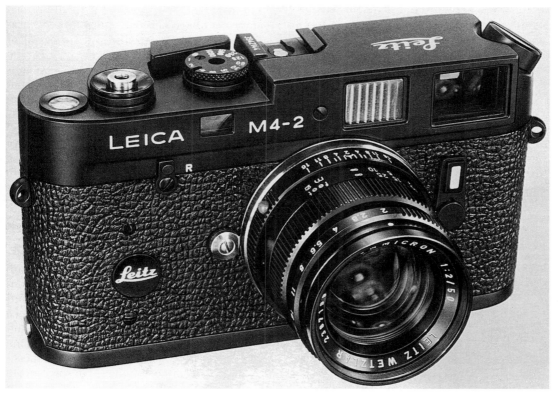

Fig. 22. An early Leica M4-2 fitted with 1969-1979 period 50mm Summicron f/2 lens. Only a small number of M4-2's were made fitted with the circular red Leitz logo.

produced and 1,000 of these were special 24-carat gold-plated models celebrating the 100th anniversary of the birth of the Leica's inventor, Oskar Barnack. Finished in light brown lizard skin, the rear top plate of these cameras carried an engraving of Barnack's signature and the dates of the anniversary.

From a collector's point of view, the camera is interesting not only because it represented the new breed of professionally orientated M-type cameras, but also because it carried several different types of engraving designation, even though it was short lived. Additionally, early production models [ser.nrs. 1468001 – 1468091] were fitted with the red 'Leitz' logo disc in place of the self timer unit. Some later models were factory fitted with additional projection frames for the 28mm and 75mm focal lengths.

The camera was finished in the black chrome style with only a few being made in silver chrome with matching silver chrome lenses to

special order. The M4-2 was produced by the Midland, Ontario factory in Canada.

Leica M4-2. Technical Specification and Variations

Type: As M4.

Body: *Construction*. One-piece, diecast zinc body with black chromed 0.8mm-thick brass top and bottom plates.

Size. 138mm x 77mm x 36mm (138mm x 133mm x 36mm with LEICA-WINDER M4-2 fitted)

Weight. 525 grams (body only), 895 grams (body and winder).

Viewfinder: *Type*. Combined view/rangefinder with automatic parallax correction for projected viewing frames.

Rangefinder Base Length. 48mm

Magnification. 0.72x

Viewfinder Display. projected bright-line frames for 35mm, 50mm, 90mm and 135mm focal lengths. Central rangefinder measurement field.

Manual Frame Selection. Preselector lever fitted.

Variations: n/a

Modifications. 28mm and 75mm projected viewfinder frames in later models. Modification to earlier models possible by Leitz service engineers.

Shutter: *Type*. Rubberised cloth horizontal run focal plane.

Speeds. As M4.

Variations. n/a.

Flash Synchronization. Accessory shoe mounted X-synch hot shoe 1/60th second. Two 3mm co-axial PC type sockets for electronic and bulb flash.

Metering: *Type*. Optional extra. Leicameter MR. Later Leicameter MR-4 could be used. Hinged removable back plate fitted with aluminium DIN/ASA conversion disc with note pad.

Camera Type Variations: 100 M4-2's produced with Leitz red circle logo fitted at self timer position. 1000 24-carat gold-plated Oskar

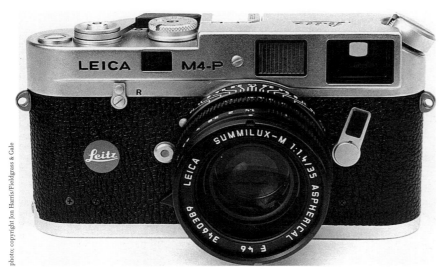

photo; copyright Jon Harris/Fieldgrass & Gale

Fig. 23. The Leica M4-P (Professional), fitted with a 35mm Summilux-M Aspherical f/1.4. It lacks the integral TTL meter of the M6, but nonetheless is regarded by many as the most tough and functional of the M-series.

bers 10349 and below could not be used on certain M4-P models (see table M-Winders). The mechanical design of early winder versions could not be modified to the more efficient version which later had the designation 'M4-P'.

Leica M4-P Technical Specification and Variations

Type: As M4-2.

Body: *Construction*. As M4-2.

Size. As M4-2.

Weight. 545 grams (body only), 740 grams (when fitted with 50mm Summicron-M f/2.)

Viewfinder: *Type*. As M4-2.

Rangefinder Base Length. 48mm.

Magnification. 0.72x.

Viewfinder Display. Provision for six automatic parallax corrected projected bright-line frames, 28mm, 35mm, 50mm, 75mm, 90mm and 135mm, arranged in pairs, combined with central rangefinder measurement field.

Manual Frame Selection. Preselector lever fitted.

Other. No self timer.

Modifications. n/a.

Shutter: *Type*. As M4-2.

Speeds. As M4-2.

Variations. None.

Flash Synchronization. As M4-2.

Metering: LEICAMETER MR-4 covering 7% of frame field.

Camera Type Variations: The M4-P was launched in standard form in 1981 and remained in production until 1987. The camera was finished in silver or black chrome, the latter having the larger production run. All units were manufactured by Leitz, Canada. About 200 M4-P's were issued in 1982 to mark the successful scaling of Mount Everest by a Canadian expeditionary team and engraved on the top plate with a mountain shaped logo. To mark the anniversary of the UR Leica of 1913, some 2,500 M4-P's were released in 1983. These cameras were engraved

Barnack anniversary models produced in two lots of 500 units. Later models factory fitted with 28mm and 75mm projected viewing frames in addition to M4 viewing specification. Five different M4-2 factory designations engraved on top and back plate. Production ceased in 1980 at 17,100 units. An olive coloured M4-2 model of unspecified quantity was supplied to the Tank Division of the Israeli Army together with 35mm Summicron f/2 and 50mm Summicron f/2 lenses. (Leica Collection, Nakamura.)

1.11. Leica M4-P

The M4-P was yet a further refinement of the M4-2 in that the viewing system now incorporated six fully usable projected bright-line viewing frames. Optical engineering ingenuity permitted the frames to appear in pairs; viz, 28mm & 90mm, 50mm & 75mm, 35mm & 135mm. The two wide-angle lengths were given priority over the 50mm which, although only occupying some 50% of the total frame area, has a large clear space around the frame allowing the user to survey the subject area outside the projected frame with ease.

A new optional extra light meter, the Leicameter MR-4 was introduced as a companion to the camera. This is of the push-on variety, fitting into the accessory shoe as in previous models and coupling with the shutter speed dial. It's effective metering area is about 7% of the viewed field, the same area covered when using a 90mm focal length lens.

The M4-P ('P' standing for 'Professional') coupled with an improved, faster acting, M4-2 Winder. The early versions of this winder, manufactured for the M4-2, permitted automatic shutter wind and film transport at a rate of up to 2 frames per second. The camera could only be operated manually if the 4 AA-type cells were exhausted or the winder disconnected. In the improved version, the firing rate was increased to 3 frames per second and a switch fitted which allowed the M4-P to be operated manually without removal of the power winder. The power requirement was the same as for early versions; in addition the winder could be operated using Ni-Cad rechargeable batteries and had a full power capacity for exposing up to 2,000 frames. The **Leica Winder M4-2** with serial num-

Fig. 24. Standard coaxial PC flash synch. M and X sockets are fitted to the M4-P in addition to the hot shoe flash contact, which is clearly seen in a rear view of this UR-Anniversary model.

'1913-1983' in addition to an issue number combined with one letter from the name 'LEICA'. e.g. L125. Some variations in the engraving were contained on those M4-P's sold in kit form comprising a combination of meter, standard lens and winder or with additional lenses in a special 'Combi' case. Lenses in the 28mm to 90mm focal length range were available with the anniversary engraving.

Later standard models of the M4-P are sometimes fitted with M6-type windows, that is to say, having a front viewfinder window which is flush with the top panel extrusion of the camera and having the extreme lower portion of the frame slightly semi-silvered. In the M6, this permitted positive viewing of the red LED metering arrows. In the M4-P there is no practical advantage because no meter is built into the camera. It would seem that since production of the M6 began several years before the M4-P was discontinued, it made sense to have only one set of viewfinder windows held in stock in the production department. M6 windows fitted to the M4-P give the camera a slightly more refined

appearance. Some late models are also fitted with black plastic anti-strap-rubbing inserts on the body of the camera immediately above the strap lug fixing points.

1.12. Leica M6

Much loved though the M-series cameras were, and still are, the main gripe of the majority of professional users was the lack of some form of TTL metering. This aspect was remedied up to a point in the M5 and Leica CL, but neither camera met with unqualified approval, largely for the reasons already described. The M6 solved all of these problems in the shape of a traditional M-series camera and became an immediate success.

The M6 camera is based on the M4-P. It retains the mechanical shutter mechanism of the latter and is indeed the only rangefinder camera in the world to do so. Improvements in electronic metering technology, employing silicon photodiodes, permitted Leica Camera engineers to incorporate a compact TTL system into the camera which in no way changes its basic appearance from previous models. Furthermore, the

meter is the only electronic aspect of the M6; should battery power fail, the camera remains usable in all other respects.

The M6 was first launched to wide acclaim in 1984 and is the current flagship of the Leica Camera GMBH rangefinder line. All cameras are now produced at Solms in a new factory which uses computer assisted machines for machining the solid diecast bodies. The brass top plate of earlier M-types has been replaced by one made of pressed zinc alloy 0.8mm thick, which is said to be more resilient to knocks than brass. However, initially there was some difficulty experienced in maintaining uniformity of shape in pressing the zinc. This may account for why some M6 examples can be seen with a slight warp in the rear face of the top plate. This anomaly is virtually undetectable to the inexperienced eye and is not present in late examples.

Apart from the circular red Leitz, later Leica, badge placed slap over the lens axis, and which ought to be replaced by a black one, only minor details indicate the differences between this and earlier M-types.

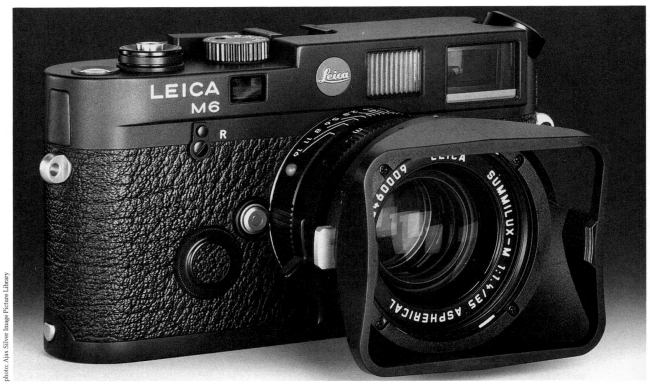

photo: Ajax Silver Image Picture Library

Fig. 25. The appeal of a classic all-black chrome M6 cannot be denied. Note the full depth milled-edge shutter speed dial, anti-strap-rub inserts, lens lock button guard and battery compartment cover.

Each end of the body is fitted with plastic inserts above the strap lugs to prevent rubbing of the camera body. A finger guard around the lens release button, first used on the M3 and subsequently dropped from all other models, makes a welcome return. The main body of the M6 is covered with a smoother, larger grained, simulated leatherette fabric.

A battery compartment on the front of the body is covered by a small milled-edge, screw-in cap, roughly where the self timer would have been. This compartment also houses the electronics for the silicon diode light meter. A raised dial on the hinged door in the camera back allows the operator to set a variety of ISO speeds from 6 – 6400, with intermediate settings. The dial is pushed in, reset, and released to lock its position. The information is transmitted to the meter circuitry via three gold-plated sprung-pin connections on

the body when the back is firmly closed.

The silicon diode sensor lens is fixed inside the top of the body and aimed at a small white patch painted onto the front side of the first shutter curtain. The meter is activated by lightly depressing the shutter release button when the shutter is in the fully tensioned position. This action lights a pair of triangular LED's visible in the viewfinder. Correct exposure for any subject is achieved by equally balancing the brightness of the LED's. Variations up to one full stop over- and underexposure can be made in the viewfinder by altering aperture or shutter speed settings until the required degree of brightness in one or other of the LED's is seen.

As with its earlier brother, the M5, the correct exposure for any given subject is rapidly arrived at and measured by adjusting the aperture. Similarly, the area measured

effectively approximates to that of a selective meter covering some 13% of the framed subject area.

The measuring base of the split and coincident-image rangefinder of the M6 has been increased from the already long 48mm of the M4-P to 49.9mm, which makes the system extremely accurate, especially when using the medium and longer tele-photo lenses. The front viewfinder and rangefinder windows of the M6 are flushed with the front of the top plate. The eyepiece ocular is rubber rimmed with the viewfinder automatically compensated for parallax. Projected bright-line frames can be selected manually by moving the preselector lever, conveniently located where the left thumb tends to rest naturally when not adjusting the aperture ring. This is useful when metering difficult or contrasty subjects using wide-angle lenses. Flicking up a 90mm frame immediately overcomes the problem of

Fig. 26. The diecast main body section of an M6 which has been machined and drilled, receives final de-burring and polishing treatment before assembly.

extraneous light in the viewfinder or confusion to the viewer caused by too much subject in frame.

The M6 shutter speed dial is slightly taller than in previous models, with a more easily gripped milled rim. This feature was possible because the optional Leicameter of previous models is no longer required. The top is also less fussy; the white figures are easily read, while an orange symbol identifies the electronic flash synch speed at about 1/50th between the 30th and 60th of a second slots. A single flash PC socket on the rear of the top plate replaces two sockets on earlier cameras.

To meet further requirements of professional users, Leica Camera launched a titanium version of the M6 at the 1992 Photokina exhibition. More resilient coatings for earlier M-type cameras had been developed in 1968 when anodizing

Fig. 27. M6 rangefinder cameras in the final process of assembly at the Solms factory in Germany.

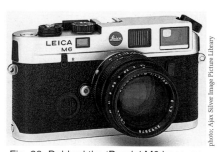

Fig. 28. Dubbed the 'Panda' M6 because of its black top plate fittings, this version has some rarity value, but not as much as the specially commissioned versions.

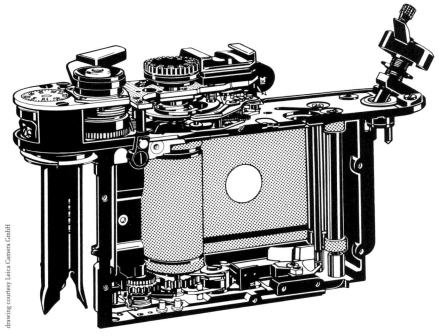

drawing courtesy Leica Camera GmbH

Fig. 33. This complex drawing clearly shows several substantial and intricately engineered aspects of the M6, including the shutter tensioning and film transport mechanism (top left and bottom), the shutter speed control unit (top centre), film rewind mechanism (top right) and shutter curtains. The range/viewfinder unit is omitted for clarity, but see second page of the colour section.

finish, but that is not to say that they will not be produced.

The Leica Winder-M is the current drive unit for the M6 and is an updated version of the M4-P winder. It has an improved battery compartment housing and 1/4-inch tripod mounting bush. It can be used on all standard models and special versions of the M6, M4-P and M4-2.

Leica M6. Technical Specification and Variations

Type: 35mm coupled view/rangefinder camera with selective TTL metering.

Body: *Construction*. One-piece, diecast zinc alloy body. Zinc alloy top plate, 0.8mm thick. Brass bottom plate.

Size. 138mm x 77mm x 38mm.

Weight. 560 grams (body only)

Fig. 29. M6G 'Elmar' gold badge.

instead of paint was used on the Leicaflex models. The black chrome finishes are extremely hard wearing; a camera which is worked hard however, soon begins to lose its shine. Titanium alloys are difficult to work into complex shapes and therefore cannot be used to form camera body parts of existing designs without enormous costs being incurred on retooling. The solution is to anodize the required finish onto existing designs and materials.

Several manufacturers have produced 'titanium' versions of certain cameras over the years with varying degrees of success. The Leica M6 Titanium uses the same metals as the standard model. To minimize finger printing, the top and bottom plates are finely sand blasted before being prepared and coated with several substrate layers before being anodized with titanium.

The result is a warm tinted, light grey metallic finish which is highly scratch resistant and which with

normal usage is likely to stay in near perfect condition for many years. The body of the camera is covered with genuine leather. A 35mm Summilux f/1.4 lens, also finished in titanium, is available as a companion to the body. At the time of writing, no other lenses are available in this

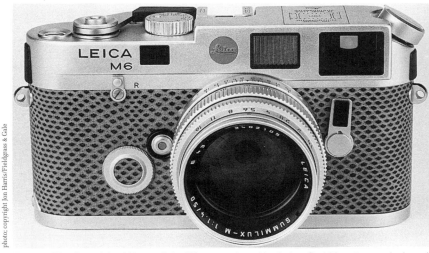

photo: copyright Jon Harris/Fieldgrass & Gale

Fig. 32. The first of the M6 special editions produced by Leica GmbH, not commissioned by a third party, was the Platinum M6 with matching Summilux-M f/1.4, 50mm lens.

Viewfinder: *Type*. Combined parallax corrected view/rangefinder with TTL measurement.

Rangefinder Base Length. 49.9mm.

Magnification. 0.7x

Viewfinder Display. Projected bright line frames for 28/90mm, 35/135mm and 50/75mm focal lengths. Automatic parallax correction. Exposure metering red LED arrows at the base of the viewing frame.

Manual Frame Selection. Preselector lever fitted.

Other. n/a.

Modifications. Semi-silvered strip added to bottom edge of viewfinder window.

Shutter: *Type*. Rubberised cloth, horizontal run focal plane.

Speeds. As M4-P

Variations. None.

Flash Synchronisation. Hot shoe X-synch. 3mm coaxial PC socket on rear of top plate for electronic flash synchronization from B to 1/50th sec.

Metering: *Type*. Silicon photodiode through-the-lens selective measurement covering approximately 13% of the frame field. Aperture or shutter priority control. No shutter speeds or aperture settings visible in viewfinder. Red LED arrows accurately vary in brightness range to indicate one full stop over or under exposure.

Camera Type Variations: The M6 began production at the Leitz factory in Wetzlar in 1984. Early in 1988 production was moved to the new Leica Camera GmbH factory at Solms. At the same time production of the M4-P, which had been based at ELC in Midland, Ontario, ceased. Some 32,000 M6 units were produced at Wetzlar and these are marked accordingly on the top plate of the camera 'Ernst Leitz Wetzlar GMBH'. The company's red disc logo found at top centre of the front face had the word 'Leitz' on it during the Wetzlar period.

Since 1988, production was marginally increased to meet demand. Including the Wetzlar production figures, some 90,000 Leica M6 camera bodies were manufactured up to January 1994. The annual rate varies between 8-10,000 per year. The engraving on Solms made models is variously either 'Leica GmbH Germany' or simply 'Leica Germany'. The red logo disc is retained but marked 'Leica'.

A number of special editions of this camera exist. One of the first was a limited edition of 1250 platinum plated M6's issued to mark the 75th anniversary of Leica photography. Each one was engraved with a letter of the Leica name and a lot number between 1-250. A special matched platinum plated 50mm Summilux f/1.4 was fitted to the camera, which came in a wooden presentation box. The cameras were engraved '1989'

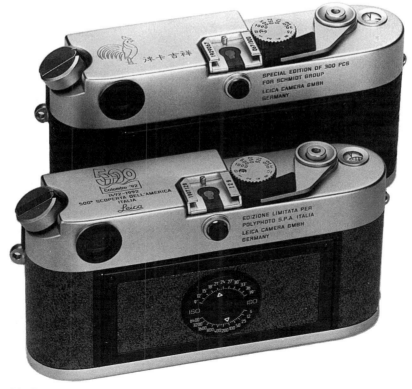

Fig. 30. M6 'Rooster' produced for Taiwan dealer (top) and 'Colombo 500' version for Italian dealer.

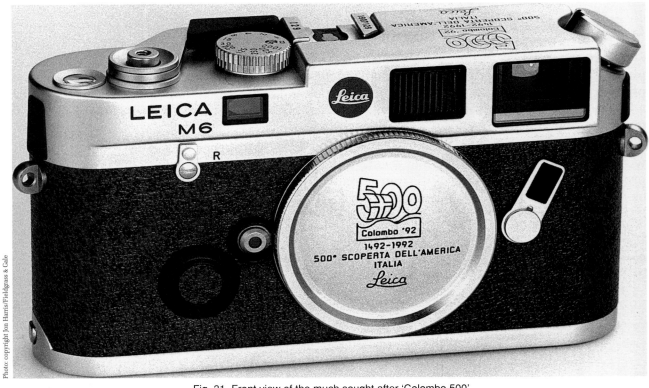

Fig. 31. Front view of the much sought after 'Colombo 500'.

the year of the anniversary, contained within a special symbol incorporating the 35mm format film frame with perforations, and engraved above with the words '150 Jahre Photographie' and below '75 Jahre Leica Photographie'. The body of the camera was covered with Karung leather.

100 Leica M6G's were produced for the Leica Photographic Center of Zurich, Switzerland, during the Wetzlar production period. These cameras were engraved with the schematic optical plan of the 50mm Elmar f/2.8 on the top plate and numbered on the base of the shutter crate in addition to the standard production serial number found on the accessory shoe. The Leitz red disc logo was replaced with a gold plated one. Silver and black chrome versions of this model were available and supplied to customers with a certificate of authenticity.

In 1988, a special edition marking the 20th anniversary of the founding of the Leica Historical Society of America [LHSA] was offered to members. The association's LHSA logo is engraved on the camera top plate with the anniversary dates at either side.

The proliferation in special edition models of recent years has to a large extent been instigated by international dealers intent on cashing in on the exorbitantly high premium collectors are willing to pay for specially engraved models. A model celebrating the explorer Christopher Columbus was commissioned by an Italian dealer in 1992; another celebrating 'The Year of the Rooster' was ordered by the official Taiwanese dealership in 1993.

The danger is that almost any excuse for a special edition can be found. The issue of such models accompanied by an invariable over-inflated price tag has the effect of prematurely raising the cost of quite ordinary secondhand models to a level which may be prohibitive to many potential users. This is a short-sighted practice. In the long run it can only benefit the investing collector, but there is the danger it will have a detrimental effect on the sales of new equipment.

Standard production models of the M6 are finished in black chrome, silver chrome with anodized black fittings (shutter speed dial, preselector lever, rewind clutch release, film rewind mechanism and anti-rub inserts), dubbed 'Panda' models; all silver chrome, and the titanium version discussed above. A reversion to silver chrome finishes for some lenses was introduced in 1993. Other titanium finished lenses are planned for the future.

CHAPTER 2

Leica-M Lenses

Throughout the course of photographic history generations of amateur and professional photographers have debated who makes the best lenses and which ones they are. Every photographer I know has had some firm opinion on this subject at one time or another. It is a highly subjective topic and it is difficult at times to be objective, even in the realm of technical journalism.

One of the aims of this book is to introduce the photographer, who may be unfamiliar with Leica but has heard enough of the myth and legend surrounding the company's products to be more than curious, to practical and useful information. Whereas the camera body, no matter how sophisticated or well engineered, is merely a box which holds film, the lens holds the key to final image quality.

Fig. 34. Leica manufactures an M-type lens to suit all demands of the photographer who is concerned with image making. They are compact, light and assembled with painstaking care to the highest possible standard.

It is this quality, equally shared perhaps with picture content, which concerns many discerning photographers. In this day and age, you may say, lens design and engineering must have reached its peak. The tangible differences between the quality produced by one manufacturer's piece of glass and another must surely be so insignificant as to be of no consequence? From the mass of technical information pertaining to just about every type and focal length of lens manufactured in the last 40 years, it can be seen that differences do exist from one manufacturer to another. These largely have to do with the resolving power of a lens and its ability to produce images of a certain level of contrast, a variable factor which has a direct effect on apparent and actual sharpness, in itself another factor only loosely linked to the resolving power of a

lens. That is, its ability to render fine detail in recognisable form in the final print as seen from the normal viewing distance of 12 inches (30cms). This ability is governed by the degree of sophistication of optical design and the type of glass used in construction. Under scientific conditions, a range of lenses of the same focal length can be measured and shown to have different characteristics.

But this information alone is only partially useful to photographers. In the most commonly accepted published form – the ubiquitous MTF (Modular Transfer Function) chart, itself a one third part of the Optical Transfer Function (OTF) measurement – seen in magazines, is invariably misleading. It is worth remembering that the majority of popular photographic magazines could not exist without the support of advertisers. Consequently, some of these publications have a vested interest in publishing superficial and virtually useless 'advertorial' information. To get a true picture of the capability of any photographic lens, the measured figures need to be used in conjunction with the results gained from elaborate field testing, employing a range of film emulsions, processing chemicals and techniques and final image supports.

Until the mass import of 35mm-format Japanese lenses into western society in the late 1940's, it had been generally accepted in photographic circles that lenses capable of the highest picture quality were of German origin. English, French and some American lenses were equally regarded but it was generally conceded that Leitz or Zeiss designs were superior.

The reader should remember that at this time colour photography was in its infancy, was relatively expensive, and required expert knowledge to achieve good results. The final arbiter of lens quality was not electronic testing equipment or computer simulation, but the quality of a black-and-white photographic negative or print which could be measured with reasonable accuracy for resolution and contrast. With this information to hand, experts, much as they do today, simply compared prints of a like size of the same subject and selected what, in their opinion, was the best.

This non-scientific approach invariably works well, and whenever eminent photographers recommended a lens product in the past, acceptance was generally guaranteed. A particular brand would become widely acclaimed and widely used, often at the expense of other brands known in some quarters to be better, or at least as good, but which had somehow missed the public relations hype.

In my experience, few photographers have the wherewithall, the time or desire to experiment with different brands of photographic equipment. As with any other product, the buyer is invariably influenced by the trends set by colleagues and peers and by the claims of the market itself through advertising. Today, the emphasis of some manufacturers has shifted away from optical performance and leans more towards the benefits available from electronically engineered hardware (the film box). The optical information is available to those who want it, but one frequently has to scratch beneath the surface to find anything meaningful. For the reader considering a tentative dip in these heavily mined waters, it is analogous to buying a computer. The prospective customer soon discovers that a salesman's only concern is to shift as many units as possible, irrespective of brand or quality.

In researching this section of the book I have spent several years accumulating and comparing different brands of photographic lens. The nature of my work as a marine photographic specialist has taken me down many different avenues in order to find the hardware most suited to the marine environment. Because certain Japanese manufacturers changed models almost as fast as they changed their socks, the problem of spares and repair became so acute at times that on switching to another brand, one that was willing to provide efficient service back-up in the event of disaster, made more sense than to continue flogging a dead horse.

Over a period of nearly three decades I have now owned and used several different makes of 35mm equipment (and tested and reviewed many others for the photographic press), operating each type on a regular daily basis for several years at a time. From an optical point of view, there has been little to choose between any of these where black-and-white photography was concerned. Marginal differences were noted between lenses of a like focal length, and only one brand showed a consistent edge-to-edge sharpness across the range of lenses available. The same film emulsion, processing chemicals and techniques were standard for many years. Contrast levels in the resulting negatives and prints were marginally higher than that experienced with my Leitz lenses, of which for much of the time I had only two, a 50mm Summicron f/2 and a 135mm Elmarit f/2.8 for use with my M2.

In recent years, the demand for black-and-white photography has greatly diminished and, although I have always shot colour alongside the black-and-white for library purposes, I'd never really taken a serious interest in it. That all changed after shooting a force 10 gale in the Channel one day with the Leica, in itself a departure from my normal practice of using another camera on the high seas. On viewing the resulting Kodachrome transparencies it became immediately clear that a cer-

Fig. 35. Extreme wide-angle lenses can be used to make effective images when used correctly. 21mm Super Angulon f/3.4

tain quality of colour I had not previously experienced was present.

To some readers it may sound ridiculous, but I was so fascinated by the gale pictures, their absolute clarity and depth, that I determined to discover if it was just a fluke, or whether in fact, Leica had something I had been missing for years.

The first task was to sift through some 50,000 colour transparencies and separate all those that had been shot with a Leica lens. There were not many. Next, I sorted the remainder into other brands and from this edited the best specimens with regard to colour saturation, contrast and sharpness. Comparing these against the 50 or 60 edited Leica pictures which had, like the others, been taken over a period of years and in different parts of the world, I was of a mind to destroy the majority.

Although always conscious of the fact that colour transparencies from the Leica exhibited a marked differ-

ence from the bulk of the work done, I had not previously examined these in any great detail and had certainly never had the inclination or the time to delve deeply into the complex issue of why there was such a significant difference.

In six years I have managed to cover a very small percentage of this field. It is a complex subject which has so far involved hundreds of hours of study and practical work. To get to the point, the result of exposing virtually every conceivable type of 35mm colour transparency film manufactured as suitable for professional use, through forty or fifty different brands of lenses, has shown one thing clearly; Leitz and Leica lenses produce a result which is different, and in my view better than all the rest.

There is a resonance to the quality of colour which is lacking in lenses of Japanese origin. In at least two cases of the latter, some material could not be considered because of the predominant casts caused by the lens coating employed. It should be mentioned at this stage that whenever a filter was used, it was one manufactured by the lens maker and therefore presumably computed to match his brand of lens. In the case of Leica lenses, filters are not required to block ultraviolet rays; the special 'thin-film coating' applied to their lens elements already acts as a filter. Leica UVa filters are used only to protect the front element of the lens.

In each case of comparison the overall quality produced by other brand lenses was found to be excellent; in particular sharpness and contrast were very good, and in one or two individual cases, superb. What these types lacked however was the ability to produce an almost indefinable roundness and depth of colour while at the same time maintaining outstanding differentiation

photo: copyright Adam Eastland

Fig. 36. This and Fig. 37 demonstrate two diverse but excellent examples of how Leica lenses can cope with extreme lighting situations. Here the scene is entirely backlit from a setting sun, clearly defined as a perfect undiffused circle to the left centre. The original print displays a range of ten full tones of grey from black and near black through to base white, which are easily discernable.

Fig. 38. (Left) Leica uses special 'thin film' coatings on all of its lenses which obviate the need for additional ultraviolet absorbing filters and provide a high level of contrast and light transmission. Fig. 39. (Right) Early screw mount lenses can be used on all Leica M-type cameras with adaptors. Such optics are only available on the used market and should be carefully examined before purchase. Many will be found with uncoated front and rear elements, or, in the case of coated examples, severe blooming, breakdown of the coating and scratching from years of cleaning. Examples in such a sorry state of repair can still produce sharp images, even if of a lower contrast. They are ideal for use in the creative interpretation of colour objects.

Fig. 37. displays an equally acceptable tonal range made under available light from two small portholes in a steam crane cab

in shadow areas. In the case of Leica, these characteristics are maintained across the whole range of lenses. They differ only marginally between some older and newer lens designs, a phenomenon which I have exploited in interpreting the colours of some subjects.

What does all of this prove, if anything?

The honest answer is not much, except that for my own satisfaction I have evaluated some of the claims made by the manufacturer for the product and found them to be truthful in as far as it is possible to do so in everyday professional photography. From a subjective point of view, Leica lenses meet my notion of perfection better than the majority of other types for some requirements when a high standard of colour photography takes commercial priority.

This notion is manifested not only for the reasons already described. There are other, more tangible considerations, not least of which is the matchless quality of engineering and finish, the materials used, and the mechanical design which enables rapid and virtually faultless operation in all kinds of weather conditions. One feature of Leica-M lenses that users appreciate is the perfect circle described by the diaphragm

photo: Ajax Silver Image Picture Library

Fig. 40a. The multi bladed metal diaphragms of all Leica-M lenses form a near perfect circle when stopped to any aperture. This is the business end of a 90mm Elmarit f/2.8.

Fig. 40b. Effect created by an objective fitted with a near circular diaphragm.

of each lens and the effect this has on out-of-focus backgrounds. Where background is required to remain out of focus, it remains just that in a Leica photograph. There are no distracting double images or oddly shaped highlights formed by irregular or minimal diaphragm configurations.

Another is the silky smooth feel of a really well made helicoid used in the focus mechanism of each lens. Parts are machined to exceptionally fine tolerances from hardened brass-on-brass or special aluminium alloys which permit expansion and contraction at the same rate under varying temperatures and which require only the smallest amount of lubrication. The same precision is applied throughout the lens construction, from providing a solid and stable barrel for lens element mounting to

the finish of the lens-to-camera mount.

I have frequently come across Leica lenses that look gnarled and worn, yet they still function perfectly. Such a high degree of precision and attention to detail may seem unnecessary to some. But Leica products are not ordinary and nor are they always used in ordinary environments. The demands of defence forces in many countries require specifications for hardware which are way above the levels experienced in civilian life. These requirements are the result of decades of practical field experience, working under difficult conditions in the toughest of environments where men and machines are tested to limits most of us have difficulty conceiving. The demands of European and American space programmes are equally tough. Since the beginning Leica has been able to meet the demands of such customers time and time again. Where products are not available off the shelf, they can be built. This attitude has a direct benefit for the ordinary customer because it is reflected in Leica's effort to continuously improve, refine and update its products.

In modern Leica lenses, epoxy resin technology has been perfected and allows some parts that were previously metal to be replaced, thus reducing weight. Research into this technology continues, as it does into the technology of using certain plastics for lens elements. Plastics suitable for lens construction have certain advantages over glass; one of these is that they can be moulded more easily into more complex shapes, enabling lens designers to eliminate the last vestiges of some aberrations inherent in all-glass constructions.

Thousands of photographers around the world benefit from Leica's commitment to quality and precision engineering. It's a commitment based on a reputation

established with the very first Leica cameras and which grew into a legend. Along the route however, the legend acquired myth, which if not in need of dispelling, certainly needs some clarification. Users and non-users have frequently been led to believe that Leica lenses are and have been manufactured from optical glass made on the factory premises at Wetzlar and Solms. How this bit of mythology took root is difficult to explain, but it has in part been perpetrated by the company in previously published product literature.

The facts are that neither Leica nor Leitz has ever made its own optical glass for production purposes (see Appendix for Leica statement on the subject). A glass research laboratory was set up by Ernst Leitz III in 1949 for the purpose of finding new thorium-free optical glasses. Thorium is mildly radioactive. Some very special glasses were smelt in this laboratory and used for experimental purposes in constructing prototypes of some photographic lenses and microscopes.

It has been claimed by some photographic experts and historians that Leitz was also responsible for the discovery of rare earth glasses, such as lanthanum, used in the elements of the famous 50mm Summicron lens of 1950, and later in the f/1.2 Noctilux. As early as 1935 a British patent was filed on behalf of Eastman Kodak of America describing the use of rare earth oxides in certain smelts in the search for optical glasses with a high refractive index. Amongst these, several containing lanthanum from compositions devised by geochemist George W. Morey were considered worthy of further development. Kodak supported Morey's experimental work and by the late 1930's that company had developed several lenses containing lanthanum for special applications; one of these was the famous Kodak Aero Ektar used in aerial reconnaissance work. Jena Glasswerke in Germany took

the 1935 patent a stage further in 1939. Jena was the home of the Schott glassworks and of Carl Zeiss before WWII, but there is no record of either company having perfected lanthanum crown glass at this time. Leitz's contribution in post-war years seems to have been in further improving Morey's work by adding lithium fluoride to the melt. In modern lens technology there is hardly a lens produced which does not contain lanthanum.

The Leitz laboratory was sold in 1989 to Corning Glass of the USA. Currently, Leica Camera GmbH purchases glass blanks from Schott Glasswerke of Mainz, Germany, Corning Glass in France (previously Souvirel) and the USA, and Hoya and O'Hara in Japan.

Some special glass made to Leica specifications is supplied in the form of rough blocks or sheets and this has first to be cut and ground to shape. To cater for the very special final shapes and sizes required, the company uses machinery and tools designed and built by its own technicians, as well as modified commercially available units. After initial grinding, elements are checked for centring and often individually reground to meet the very high Leica specifications of accuracy. Polishing, employing equally meticulous techniques is followed by ultrasonic cleaning of the elements before the process of lens coating can begin.

Sophisticated coating techniques for optical glass elements have proved to be one of the most effective weapons in the constant battle towards perfection. The designer's basic aim in an ideal world would be to produce a lens with 100% light transmission. But all glass reflects from its surface a tiny percentage of the light which strikes it. Ordinary window glass may reflect between 4% and 8%. Optical glasses have much lower figures, about 1.5% is common. The more glass compo-

Fig. 41. Glass blanks being ground to precision at the Leica works in Solms.

photo: courtesy Leica Akademie

nents (elements) contained in a lens, the higher the accumulated proportion of reflected light; leading to a reduction in the effective speed of the lens. Since glass reflects light from both front and rear surfaces, multiple element lens constructions cause an additional problem – a phenomena known as flare – in which the reflected portion of light from each element is bounced around the inside of the lens barrel. In Leica lenses this is controlled effectively by the use of specially blackened baffles to trap the superfluous light.

Flare is frequently used in photography as a device to soften an image by reducing the apparent resolving power of a lens. In portraiture, for example, flare can be deliberately induced by wiping the periphery of a filter, such as one used to protect the front element, with a small amount of grease, such as Vaseline, or some other proprietary substance. Its effect is to create a more flattering photograph of the sitter by lowering contrast and thus softening minute details such as skin wrinkles. The natural flare in an uncoated lens, or in one where the lens coating has been seriously damaged so as to be virtually non-existent, causes

additional problems; ghosting and double images are common manifestations.

Leica lenses earned an early reputation for clarity and the ability to resolve fine detail when Max Berek designed the first Anastigmat (later Elmax) lenses for the Leica I. A process of coating lens elements was devised by Zeiss in 1935; a single layer of magnesium fluoride enabled lens designers to increase the number of elements in lens design. Being relatively soft however, and easily subject to damage, these thin-film transparent coatings were not initially used on exposed front and rear elements. Leitz's 5cm, f/2 Summitar of seven element design, introduced in 1939, was made possible as a direct result of the coating process. Designed specially to cater for users of the (then) new Kodachrome colour film, this lens remained in production until 1955; examples in excellent optical condition can still be found and it is interesting to note the very high quality of colour obtainable from modern film emulsions when using it. In the mid-1960's, a Californian company developed multiple layer coating techniques to further increase light transmission

Fig. 42. The 5cm Summicron f/2 of 1950 was a breakthrough in modern lens design, an equally superb performer at short and long distances.

and colour fidelity, and to reduce flare. Nowadays, nearly all len manufacturers use the multi-coating process, employing a variety of materials to improve lens performance.

The process is not complex. It uses absorption-free coatings which are evaporated onto the surface under vacuum, computer controlled to very fine tolerances. Leica is one of the few exceptions to this general rule of multi-coating. The company uses such special glass that no coating at all may be necessary on some elements. Where it is, usually at the front and back, Leica have developed their own 'thin film' coating techniques to reduce internal lens reflections, increase light transmis-

sion, reduce flare and protect exposed elements from 'soft' damage such as might be caused by finger printing.

By coating lenses, the amount of light lost to reflection can be dramatically decreased, in some cases to as little as 0.2%, resulting in 99.8% light transmission. If we know the number of elements used in the construction of a lens, it is relatively simple to calculate the actual values for that lens. A six-element construction might be 98.8% effective.

The actual f/-number engraved on a lens has no direct bearing on its transmission values in percentage terms. Nor does it tell the photographer very much about its construc-

tion. Are these figures important? To the optical scientist yes. To the photographer less so, except that if we can rely on the fact that factory given transmission values for a certain lens are accurate, he can be sure that under certain lighting situations, given accurate exposure readings, the indicated maximum aperture of a lens can be relied on. In the case of Leica, light transmission will not be affected, or fall off at the edges, when it is most needed.

Aberrations

Modern coating techniques can reduce some of the effects caused by aberrations, which are present to a

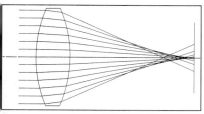

Fig. 43. Spherical aberration

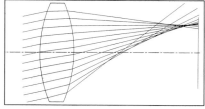

Fig. 44. Coma

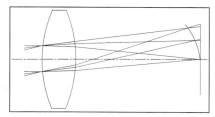

Fig. 45. Curvature of field.

greater or lesser degree in the individual glass elements used to fabricate all photographic lenses. These can be detrimental to the final quality of a photographic image in several ways, affecting sharpness, shape, contrast and the colour rendition of the object photographed. In complex lens construction, for example in extreme flat-field wide-angle lenses, many elements are used simply to negate aberrations, adding to production costs and subsequent expense to the photographer.

Aberrations affecting lens design can be broadly defined as follows;

Spherical aberration results through the inability of a lens to focus rays falling on the centre and periphery of a lens at the same point, resulting in images which lack sharp focus. Improvements can be made by stopping down the lens. Some less expensive lenses often suffer from this fault.

Coma is caused by unsymmetrical refraction of rays of light entering the lens at an oblique angle. It is manifested in the form of unnatural shapes in the photographic image. e.g. a point source of light represented in the shape of a pear drop. The problem can be compounded in a lens in which the closed diaphragm shape is irregular.

Astigmatism is the inability of a lens to bring horizontal or vertical lines to a point of sharp focus in the same plane at the top, bottom or side of the image field. Stopping down a lens reduces the effect of this aberration.

Curvature of field is present when the points of focus of a flat object at the outer portions of the field assume a different position relative to the point of focus of the field centre. The effect is noticeable in wide-aperture long focus lenses (see Novoflex 400mm).

Distortion. The two most common effects are known as barrel and pincushion distortion. In both cases the photographic image is not a true representation of the shape of the object. The vertical walls of a house may be represented as curved instead of straight. Concave distortion is known as pincushion, convex as barrel.

Chromatic aberration, which more acutely affects colour photography, is manifested in the different points of focus at the film plane for the different colours of the spectrum. On entering the lens, each colour, or wavelength, is refracted at a different angle. Shorter wavelengths (at the blue end) are brought to focus nearer to the plane of the lens, and longer wavelengths (at the red end) further away. By employing elements of both low and high dispersion, e.g. a convex crown glass paired with a concave flint glass, or a negative flint sandwiched between positive crowns, chromatic aberration can be effectively reduced whereby two primary colours, usually blue and green, can be made to focus at the same point. The lens construction is known as an *achromat* and the majority of photographic lenses are corrected in this way. But this leaves a residual amount of uncorrected light at the red end in a secondary spectrum.

In a colour photograph taken with a moderately priced multi-coated lens and enlarged to approximately A4 size, viewed from the normal position without optical aids, detecting the presence of chromatic aberration would be difficult for most people. The image will appear acceptably clear and sharp. But further magnification, to say 11 x 14 inches, will begin to show chromatic aberration through the presence of one or more coloured, usually violet or red, lines as an additional outline to the image. This is called colour fringing. It becomes more noticeable with long focus lenses above 180mm and in wide-angle lenses of less than 20mm.

In printed reproduction the problem is compounded by the quality of the separation negatives and size of the dot screen used in making screened positives required for the printing plates. The poorer the negatives and coarser the screen, the more pronounced the reproduction of lens aberration; its effect is clearly apparent when giant reproductions such as posters, murals and hoarding reproductions are made. It is this need to meet the demands of advertising and publishing colour requirements which has persuaded some photographic lens manufacturers to design apochromatic long focus lenses.

In the graphics industry, which is concerned with photographic reproduction, apo lenses have been used in process cameras for many years. In field photography they were largely restricted to formats of 5 x 4 or larger until the late 1970's when some Japanese manufacturers began to produce fluoride and ultra-low dispersion glasses which were successfully used in high quality, wide-

Fig. 46. The longest focal length available for Leica-M cameras without employing the Visoflex mirror box is 135mm. Two examples are available, both highly corrected. 135mm Elmarit f/2.8, Leica M2, Stockholm.

Fig. 47. All Leica-M lenses can be used at their maximum aperture without fear of the aberrations or distortions discussed in the text. If they do exist at all, they are so small as to be of no practical significance. 5cm Summarit f/1.5, wide open. Bordeaux.

aperture telephoto lenses for the 35mm format. These had been designed in response to many requests from sports photographers who frequently encountered problems in covering major international events in low light levels. Today, there is a wide range of exotic high speed lenses available from camera manufacturers and independent companies. Some of these pretend to be more than they really are, but like everything else in this industry, there is something to suit most pockets.

Leica GmbH make three apochromatic lenses for the R-series single lens reflex cameras, but they are not suitable for use with M-type cameras. A reflex device, the Visoflex housing, used to be made by Leitz in three models. Production of the Visoflex III was discontinued in 1985 but it and the first two are still widely available as secondhand items. Combined

with various adapters, an extensive range of Leica and non-Leica made lenses of quite exotic construction can be used by the rangefinder camera owner (see Chapter 3 & 4.2).

Leica did once make a wide-aperture long focus lens especially for use with the rangefinder cameras in conjunction with Visoflex. This was the 180mm Tele-Elmarit f/2.8 of 1965. It was not an apo-lens as such, and only about 400 were manufactured and sold through outlets in the USA. It was, however, a highly corrected lens. The current line up for the M-series cameras includes 13 lenses ranging in focal length from 21mm to 135mm. As this book was going to press, several new editions of some of these lenses, some with slight optical design modifications and some of current models with new exterior finishes were still at pre-production stage. There was no evidence at this

time from Leica to support rumours of the imminent arrival of an additional focal length in the range (24mm), although a prototype M-lens of this size has been considered.

Current Leica-M Lenses

The lenses can be split into three groups, covering the wide-angle, standard and short to medium telephoto ranges. Specifications for each lens are as follows.

2.1. Elmarit-M 21mm, f/2.8.

MINIMUM APERTURE. f/16
ANGLE OF VIEW. 92°
NUMBER OF ELEMENTS. 8.
FILTER SIZE. E60
INTERNAL THREAD. M60 x 0.75mm.
FOCUSING RANGE. 0.7m to inf.
SMALLEST OBJECT FIELD. 705 x 1058mm.

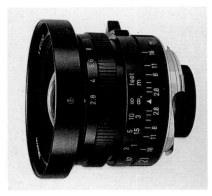

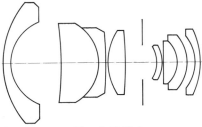

Fig. 48. 21mm Elmarit-M f/2.8

Fig. 49. Buildings in confined spaces are difficult subjects for photographers who require an accurate record. The use of an extreme wide-angle lens tends to distort vertical planes and reduce apparent height. In this sloppy attempt shot from a moving car, the oddly angled roadway has the effect of reducing extreme distortions.

Fig. 50. The rangefinder camera imposes limits on architectural photographic technique. Effective illustrations can be made, however, provided care is taken to ensure that vertical and horizontal planes are so depicted. 21mm Super-Angulon f/3.4.

Fig. 51. A difficult subject, creatively interpreted by choosing a low, close viewpoint made possible by the 21mm Elmarit's wide angle of view.

LENS HOOD. Clip-on.
LENS CAP DIAMETER. 62mm.
DIMENSIONS. length 46.5 x diam 62mm.
WEIGHT. 290 grams.
BARREL/HELICOID/MOUNT.
Aluminium alloy, hardened brass,
chromium plated brass.
VIEWFINDER. Independent, fits in hot
shoe. Focus and metering through
rangefinder window.
FINISH. black 'Eloxal' epoxy.
PRODUCT CODE. 11 134.

The 21mm Elmarit-M was introduced in 1980 when it replaced the previous model of this length, the 21mm Super-Angulon f/3.4. Early production examples had a smaller front element than the current model and the barrel was parallel. The current model fits all M-series cameras, including the M5 and CL.

The problem with all wide-angle lenses, and more particularly with extreme focal lengths such as this, is

that in the wrong hands image distortion is easily accomplished. This is an ideal lens for certain aspects of architectural photography, in recording interiors for example, but great care should be taken to ensure that the horizon is placed as far as possible at dead centre of the image field in both the horizontal and vertical positions.

It is usually impractical to photograph the exteriors of most buildings from the correct position unless the lens axis can be shifted relative to the film plane. The correct position would be on a plane at half the building height at a distance which enables both the top and bottom of the building to be encompassed in the frame. With the camera in a perfectly vertical position, this 21mm Elmarit-M lens would produce distortion free photographs. However,

this is frequently an impractical proposition for the photographer unable to gain height, and in the case of very tall buildings, nigh impossible in the confines of city streets.

Reasonably accurate record shots of some buildings can be made by placing the base of the building on a plane at or near the middle of the frame. The exact positioning will depend on the size of the building and the photographer's distance from it.

The 21mm is also an ideal lens for intrusive and highly intimate reportage. It can be prefocused to take advantage of its extreme depth of field to cover most eventualities. In fast moving situations all of the photographer's concentration will be focused on subject content and its compositional arrangement. The expert will endeavour to anticipate

the decisive moment of exposure. Any time spent on attempting to focus and refocus the unfolding event will be entirely wasted and is unnecessary with this lens.

The variety of subjects for which this lens can be used is vast, and how it is used largely depends on the photographer's creative ability. In landscapes for example, it can be used to exaggerate the size of foreground objects relative to more distant ones. Given an arid landscape of cracked earth, deceptive interpretations can be made with the 21mm lens. From the point of view of expressing the grandeur of scale in landscape, architecture and industrial views, a lens of longer focal length is more suitable.

2.2. Elmarit-M 28mm, f/2.8

MINIMUM APERTURE. f/22
ANGLE OF VIEW. 76°
NUMBER OF ELEMENTS. 8
FILTER SIZE. E46.
INTERNAL THREAD. M46 x 0.75.
FOCUSING RANGE. 0.7m to inf.
SMALLEST OBJECT FIELD. 533 x 800mm (approx 1:22)
LENS HOOD. Clip-on rectangular.

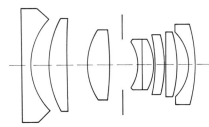

Fig. 52. 28mm Elmarit-M f/2.8.

LENS CAP DIAMETER. 48mm.
DIMENSIONS. Length 41.4mm x dia.53mm.
WEIGHT. 260 grams.
BARREL/HELICOID/MOUNT. Aluminium, hardened brass, chromium plated brass.
VIEWFINDER. M6 installed in viewfinder. M4-P installed in viewfinder, but only usable from lens ser.nr. 2411001. Independent accessory shoe type available for all M-cameras (product code 12 009). Late M4-2's fitted with M4-P/M6 type projection frames.
FINISH. Black 'Eloxal' epoxy.
PRODUCT CODE. 11 809.

The 28mm Elmarit-M f/2.8 specified above is the fourth version of its type and was introduced in the spring of 1993.

The lens has a modified retrofocus design with the distinctive feature of a large, slightly concave front element. The rear element, a dispersing meniscus, is also large, permitting excellent, even illumination over the entire field.

The performance of this lens is outstanding; contrast and resolving power are excellent. As with all Leica lenses, performance at full aperture over the full focusing range is superb. Coma is minimal at the widest aperture but is eliminated on reaching f/4. The lens can be relied on especially in heavily backlit situations or in dealing effectively with subjects in which light sources are a dominant feature.

The 28mm focal length is an ideal size for photojournalists who prefer a slightly wider field of view than that provided by the next lens in this group, the 35mm. The travel photographer too will appreciate its performance, particularly at the close focus range in photographing intricate details which need to be depicted in a recognisable environment. A understanding of the principles of depth of field and hyperfocal distance give the photographer tools which can be used effectively in combination with this excellent lens.

Summilux-M 35mm, f/1.4

MINIMUM APERTURE. f/16
ANGLE OF VIEW. 64°
NUMBER OF ELEMENTS. 7.
FILTER SIZE. Series 7.
INTERNAL THREAD. M36 x 0.5
FOCUSING RANGE. 1.0m to inf.
SMALLEST OBJECT FIELD. 630 x 950mm.
LENS HOOD. clip-on.
LENS CAP DIAMETER. 42mm.
DIMENSIONS. Length 28mm x dia.53mm.
WEIGHT. 200 grams.
BARREL/HELICOID/MOUNT. Aluminium, hardened brass, chromium plated brass.
VIEWFINDER. M1, M2, M4, M5, M4-2, M4-P, M6; incorporated in view/rangefinder. Special ocular attachment version for M3. Independent accessory shoe mounted type available.

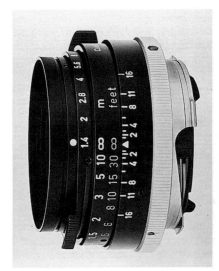

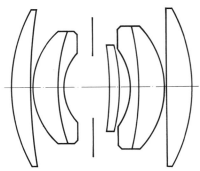

Fig. 53. 35mm Summilux-M f/1.4 with schematic diagram.

FINISH. Black 'Eloxal' epoxy. Titanium finish version for M6T introduced in 1992.
PRODUCT CODE. 11 870. (11 871 for M3).

The lens specified here was first introduced for M-cameras in 1961. The length of time that it has been in production is an indication of its success. The lens was designed by Dr.Walter Mandler who, from 1950, was in charge of lens development at the Midland, Ontario plant in Canada. It has undergone several minor changes in appearance, being reduced in diameter from its original 46.5mm to 42mm, slight changes to the mount flange and in having no infinity lock on later models.

The lens is of seven element construction based on an earlier 35mm Summicron f/2. The design uses special Leitz glass and was recomputed in 1966 (from ser.nr. 2166702) with a marked improvement in image quality.

2.4. Summicron-M 35mm, f/2.

MINIMUM APERTURE. f/16.
ANGLE OF VIEW. 64°
NUMBER OF ELEMENTS. 7.
FILTER SIZE. E39.
INTERNAL THREAD. M39 x 0.5.
FOCUSING RANGE. 0.7m to inf.
SMALLEST OBJECT FIELD. 430 x 640mm.
LENS HOOD. Clip-on.
LENS CAP DIAMETER. 42mm.
DIMENSIONS. Length 26mm x dia. 52mm.
WEIGHT. 150 grams. (Chrome finish; 250 grams).
BARREL/HELICOID/MOUNT. (Black version) Aluminium, hardened brass, chromium nickel on brass. (Chrome version introduced 9/93) Turned brass barrel/lens mount. Chromium nickel on brass mount.
VIEWFINDER. M1, M2, M4, M5, M4-2, M4-P, M6; incorporated in view/rangefinder. Discontinued version with ocular attached for M3. Independent accessory shoe mount viewfinder available.
FINISH. Black 'Eloxal' epoxy or, chrome on nickel brass from 9/93.

PRODUCT CODE. 11 310 (black). 11 311 (chrome).

The current 35mm Summicron f/2 is the fourth version of this lens, which was first introduced in 1958 in both screw- and M-mount with an eight-element construction. This has been reduced in the current version to seven elements, starting from ser.nr. 2974251. Until 1989, this model was largely manufactured in Canada. It is worth noting here that collectors frequently argue over the quality of products made in the Canadian and German plants. From the user's point of view, this argument holds no water. The products are identical in all respects except the engraving indicating place of origin. The optical quality of this 35mm lens is renowned world-wide and because of its size, weight (black version) and cost, it is one of the most popular of all M-lenses.

Straight enlargements to 20 x 16 inches are easily possible with no noticeable diffusion of image quality.

A chrome version of the lens was made available in 1993. Because aluminium cannot be chromed successfully, the barrel of the new model is made of turned brass which is then fine sand-blasted before being nickel coated. This 1/100mm layer of nickel is designed as an anti-corrosion measure, in addition to providing an excellent substrate for the final chromium plate. Leitz developed their own special plating techniques many years ago and this partly accounts for the very fine quality of finish.

2.5. Summilux-M Aspherical 35mm, f/1.4

MINIMUM APERTURE. f/16
ANGLE OF VIEW. 64°
NUMBER OF ELEMENTS. 9 (2 aspherical surfaces).
FILTER SIZE. E46.

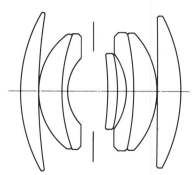

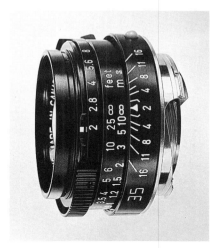

Fig. 54. 35mm Summicron-M f/2.

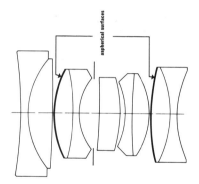

Fig. 56. The exotic 35mm Summilux-M Aspherical f/1.4.

Fig. 55. The 35mm Summicron-M f/2 is one of the most popular and useful of Leica-M lenses for the rangefinder. Negatives obtained with it are easily enlarged to double the size of this book with no apparent loss of image quality.

Figs. 57 & 58. Typical examples of how subjects can be approached with the 35mm focal length. Great depth of field, even at wide apertures, coupled with the Leica-M's relative lightness and virtual silence, allow the photographer an intimacy not possible with conventional SLR types.

INTERNAL THREAD. M46 x 0.75mm.
FOCUSING RANGE. 0.7m to inf.
SMALLEST OBJECT FIELD. 630 x 420mm.
LENS HOOD. Clip-on.
LENS CAP DIAMETER. 49mm.
DIMENSIONS. Length 44.5mm x dia. 53mm.
WEIGHT. 275 grams.
VIEWFINDER. Activates projection frame in range-/viewfinder of all M-models except M3, for which special ocular attachment is required. (see 35mm Summilux f/1.4 above. Independent accessory shoe mount type available.
FINISH. Black 'Eloxal' epoxy.
PRODUCT CODE. 11 873.

When this exotic piece of hardware was launched in the spring of 1990 it immediately became the standard to which all other lenses in its class were compared. It is the most expensive in the current Leica-M lens range, costing a whopping 87% more than its nearest rival, the tita-

nium plated 35mm Summilux f/1.4, which the new aspherical version was designed to improve on.

The lens has nine elements arranged in five groups, comprising four cemented pairs and one single element in the centre. The front and rear pairs each have a bi-concave negative lens as the outer element, which gives the lens surface its unusual shape. The configuration is unique to all Leica lenses, including those in the reflex range, as well as with regard to all other brands.

The two aspherical surfaces are on the inner face of the rear cemented pair and the outer surface of the second front pair. Needless to say, the performance of this lens is truly outstanding at all apertures as well as across the entire focusing range. The slight coma which exists in the less expensive 35mm Summilux

f/1.4 at full aperture is completely eliminated in this lens. The other main characteristics are its brilliant contrast, superb resolution and total freedom from curvature of field. Production reportedly limited to 2,000 units.

2.6. Noctilux-M 50mm, f/1

MINIMUM APERTURE. f/16
ANGLE OF VIEW. 45°
NUMBER OF ELEMENTS. 7.
FILTER SIZE. E60.
INTERNAL THREAD. M60 x 0.75mm.
FOCUSING RANGE. 1.0m to inf.
SMALLEST OBJECT FIELD. 410 x 620mm.
LENS HOOD. Clip-on.
LENS CAP DIAMETER. 62mm.
DIMENSIONS. Length 62mm, dia. 69mm.
WEIGHT. 580 grams.
BARREL/HELICOID/MOUNT. Anodised aluminium; stainless steel/bronze, nickel chromium brass mount.

VIEWFINDER. All M-models, including CL, projection frame in range/viewfinder.
FINISH. Black anodised chrome.
PRODUCT CODE. 11 821.

This lens again set new standards when it was first introduced in 1966 as the 5cm Noctilux f/1.2. This version contained aspherical surfaces and was the first such lens to be commercially produced. Ten years later,

the current version was launched, redesigned by Dr.Walter Mandler, eliminating the aspherical lens components and increasing the maximum aperture to f/1.

It is claimed that this is the fastest production lens in the world because other makers' equivalent lenses sometimes proved to be slower than their indicated value. In recent years

however, other makes have come to the market which could compete on a speed-for-speed basis. Leica claim not to make 'prestige' aperture lenses, but if there is one in the whole range that could be classified under that heading, the Noctilux f/1 is it. Nevertheless, some photographers do have a use for its maximum aperture. Its performance at this setting is outstanding for a lens of its type, and this is further enhanced on stopping down to f/1.4. It would be the ideal lens for the night duty press photographer who needs to photograph in dimly lit surroundings as surreptitiously as possible.

2.7. Summilux-M 50mm, f/1.4

MINIMUM APERTURE. f/16
ANGLE OF VIEW. 45°
NUMBER OF ELEMENTS. 7.
FILTER SIZE. E43.

Fig. 59. 50mm Noctilux f/1.

Figs. 63 & 64. The 50mm focal length is one of the most useful and versatile for the 35mm format. All three of the Leica-M types are characterized by high resolution and excellent contrast.

Fig. 60. 50mm Summilux-M f/1.4.

INTERNAL THREAD. M43 x 0.5mm.
FOCUSING RANGE. 1.0m to inf.
SMALLEST OBJECT FIELD. 410 x 620mm.
LENS HOOD. Clip-on.
LENS CAP DIAMETER. 44mm.
DIMENSIONS. Length 46mm x dia. 53mm.

WEIGHT. 320 grams.
BARREL/HELICOID/MOUNT.
Aluminium, hardened brass, chromium plated brass.
VIEWFINDER. Incorporated in all M-model view-/rangefinders.
FINISH. Black 'Eloxal' epoxy.
PRODUCT CODE. 11 114.

The 50mm Summilux f/1.4 is the high speed companion to the 35mm lens of the same name. It has excellent resolution and contrast and is widely considered by experts to be one of the finest of its type produced by any maker.

When the 50mm Summilux was originally introduced in 1959, the optical design was based on that of the 50mm Summarit f/1.5. of 1949, which was essentially a slightly modified, coated f/1.5 Xenon, the design of which had been originated in England by H.W.Lee of Taylor, Taylor and Hobson in the early 1930's. By 1961 however, a new design using the new Leitz lanthanum glass but retaining the seven elements of the original design, was introduced and this is the lens currently in production.

Leitz made no announcement at the time of the change over and it was some years before the new design was listed in the product catalogue. Lenses before serial nr. 1844001 are of the earlier type. Some modifications were made to the barrel of the lens in 1966. The scalloped focusing ring became a milled type to match the aperture ring and the finish was changed to the now standard black epoxy.

2.8. Summicron-M 50mm, f/2.

MINIMUM APERTURE. f/16
ANGLE OF VIEW. 45°
NUMBER OF ELEMENTS. 6.
FILTER SIZE. E39.
INTERNAL THREAD. M39 x 0.5mm.
FOCUSING RANGE. 0.7m to inf.
SMALLEST OBJECT FIELD. 277 x 416mm.
LENS HOOD. Clip-on.
LENS CAP DIAMETER. 42mm
DIMENSIONS. Length 42mm x dia. 52mm.
WEIGHT. Black version 195 grams. Chrome version 295 grams.
BARREL/HELICOID/MOUNT.
Aluminium, hardened brass, chromed brass. New chrome version introduced 1993; turned, nickel coated, chromed on hardened brass. Mount; as black version.
VIEWFINDER. Incorporated in all view/rangefinders of M-models.
FINISH. Black 'Eloxal' epoxy or chrome silver.

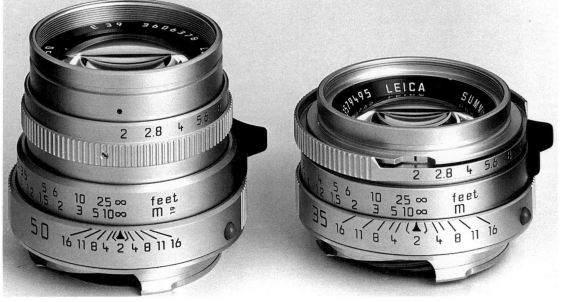

Fig. 62. Two examples of the re-introduced silver-chrome finish on a 50mm Summicron-M f/2 (left) and 35mm Summicron-M f/2, two of the most popular focal lengths for Leica-M cameras.

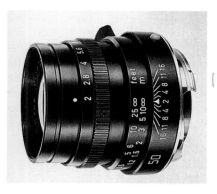

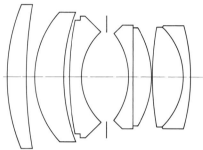

Fig. 61. 50mm Summicron-M f/2.

designs. Much depends on the subject matter of the photograph and whether one is using colour or black-and-white. From the colour photographer's point of view, the slightly lower contrast of the early versions permits marginally lower colour saturation and softer shadow detail, a device which can be used to effect in some lighting conditions. It should be remembered, however, that the desired effect and the result are two different things. Some experimentation is usually necessary to establish the basic parameters.

Fig. 65. 75mm Summilux-M f/1.4

PRODUCT CODE. 11 819. (chrome 11 825).

It would probably be true to say that this lens, more than any other type, size or make, is the lens upon which the reputation of contemporary 35mm photography was firmly established. The 50mm Summicron f/2 was a revolutionary design when first introduced in 1953, employing the special Leitz lanthanum glass (LaK9). Several prototypes, made under the guise of the 'Summitar*' had been handed out to a number of photographers by the factory in 1950 for evaluation. Since then, it has undergone only two optical redesigns, in the first having the number of LaK9 elements increased from three to four, but the overall number of elements reduced from 8 to 6. In 1980, the element shapes were recomputed and the lens appeared in a smaller, more compact aluminium mount.

There has always been some discussion amongst users of this lens as to which is the best of the three

Practitioners of black-and-white who prefer a higher contrast negative, will find the improvements made in the second and current versions of this lens of some benefit, but again, the lower contrast characteristics may also be of some advantage under certain conditions. The optical differences between the second and current versions are so minute as to be of little consequence. The several variations of the first model abound on the used market and as all of the M-lenses occupy so little room in a gadget bag, I have often found it useful to have an example available for when the occasional need arises.

This is undoubtedly one of the best all round lenses for the Leica-M user for a wide variety of subjects. The newcomer to the system in a dilemma about which focal length to start with should give this lens serious consideration. With regard to angle of view, perspective and scale of things normally seen, the 50mm focal length more closely approximates to the characteristics of the human eye than any other length.

2.9. Summilux-M 75mm, f/1.4.

MINIMUM APERTURE. f/16
ANGLE OF VIEW. 31°
NUMBER OF ELEMENTS. 7.
FILTER SIZE. E60.
INTERNAL THREAD. M60 x 0.75mm.
FOCUSING RANGE. 0.75m to inf.
SMALLEST OBJECT FIELD. 192 x 288mm.

LENS HOOD.Collapsible, built-in.
LENS CAP DIAMETER. 68mm.
DIMENSIONS.Length 80mm x dia. 68mm.
WEIGHT. 625 grams.
VIEWFINDER. M4-P/M6 incorporated in camera body view-/rangefinder.
FINISH. Black anodised chrome.
PRODUCT CODE. 11 815.

This lens falls into the group of short to medium telephoto focal lengths which are ideally suited for a wide variety of subjects from landscape and industrial work to portraiture and detail close-ups to indoor sports and theatre work.

The 75mm Summilux was introduced to the Leica-M range in 1980, some 20 years after the demise of the 85mm Summarex f/1.5. It offers the advantage of speed in low-light situations, combined with a useful gain in focal length over the standard lens. Not all sports halls are bathed in halogen light and the standard of lighting can vary immensely from one theatre to another. In some situations, use of the 75mm's extra speed may mean the difference between using a practicable shutter speed for hand-held work or being hampered by a monopod or tripod in order to

maintain a high enough shutter speed to stop the action.

In coverage of indoor table-top sports events particularly, access to vantage points is often restricted to a small area; in this case, a camera support is often desirable because of the frequently long periods necessary in maintaining the same angle and height of view. In theatre, dance and film stills work, the photographer is given more freedom to move, albeit within the confines of a stage or set and this usually only during rehearsals.

In more general terms, this lens is ideal for wide-aperture portraiture where it is necessary to keep the main subject boldly separated from any cluttered background while maintaining the use of the highest practicable shutter speed to ensure the elimination of camera shake and subject movement. The length of this lens and its minimum focus distance of less than a metre permits just enough distance between photographer and subject to obtain tight head and shoulder shots without the risk of exaggerating facial proportion.

2.10. Elmarit-M 90mm, f/2.8.

MINIMUM APERTURE. f/22
ANGLE OF VIEW. 27°
NUMBER OF ELEMENTS. 4.
FILTER SIZE. E46.
INTERNAL THREAD. M46 x 0.75mm.
FOCUSING RANGE. 1m to inf.
SMALLEST OBJECT FIELD. 220 x 330mm. (1:9)
LENS HOOD. Collapsible, built-in.
LENS CAP DIAMETER. 54mm.
DIMENSIONS. Length 76mm x dia. 56.5mm.
WEIGHT. 380 grams.
VIEWFINDER. Incorporated in view-/rangefinder of M3, M4, M4-2, M4-P, M5, LEICA-CL, M6. Independent accessory shoe mounted viewfinder obtainable (codeword SGVOO) through used dealers.
FINISH. Black anodised chrome.
PRODUCT CODE. 11 807.

The 90mm Elmarit-M f/2.8 was introduced in 1989 as a successor

and replacement for the 90mm Tele-Elmarit-M f/2.8. The new lens is of four-element construction, similar in configuration to the 90mm reflex version, and employs the latest Leitz researched optical glass in its construction.

The 90mm focal length is one of the most popular for portraiture, permitting a respectful distance to be maintained between photographer and sitter at the closest focus distance. It is the ideal lens for the travel photographer who generally has no need for the extra two stops of the 75mm Summilux. The increased focal length is an added benefit here in allowing the photographer to access detail which might otherwise be more politically sensitive to shoot with a lens of shorter focal length. The 90mm Elmarit f/2.8 is a lens with excellent contrast and resolution, even at full aperture; stopped down to between f/4 – f/5.6 the all round performance increases marginally to an exceptional level. A compact and handy lens suitable for many tasks.

2.11. Summicron-M 90mm, f/2.

MINIMUM APERTURE. f/16
ANGLE OF VIEW. 27°

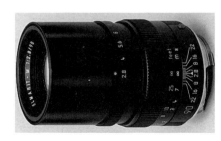

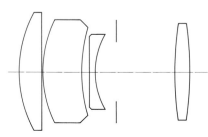

Fig. 66. 90mm Elmarit-M f/2.8.

NUMBER OF ELEMENTS. 5.
FILTER SIZE. E55.
INTERNAL THREAD. M55 x 0.75mm.
FOCUSING RANGE. 1m to inf.
SMALLEST OBJECT FIELD. 220 x 330mm
LENS HOOD. Collapsible, built in telescope type.
LENS CAP DIAMETER. 62.5mm.
DIMENSIONS. Length 77 X dia. 62.5mm.
WEIGHT. Black 460 grams. Chrome 690 grams.
VIEWFINDER. As for 90mm Elmarit-M f/2.8 above.
FINISH. Black anodised chrome. Silver chrome on brass.
PRODUCT CODE. Black 11 819, chrome 11 137.

The introduction of the silver chrome version of this lens in 1993 turned the clock back to the first model of 1957, which had remained in the catalogue in the same optical configuration for 22 years. Originally with six elements, a new design was formulated, employing higher quality glass, comprised of five elements. This began production in 1980 and is the current lens. The new chrome version is actually heavier by 10 grams than the first 1957 silver chrome model, and much of this additional weight is contained in the

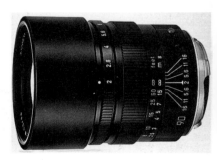

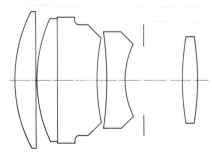

Fig. 67. 90mm Summicron-M f/2.

substantial turned brass barrel. The lens is heavy, compared with others in its class, but this is compensated for by its optical quality and fast aperture.

The first version of the 90mm Summicron f/2 had a removable lens head which could be used, coupled with a focusing mount adapter, with

Fig. 68. 90mm is the classic Leica portrait lens.

the Visoflex mirror boxes. The new lens cannot be used in this way; the lens head is a permanent fixture. Leica-M photographers who also have a regular need for the features of a reflex camera will turn to the type when the need arises. However, since Leitz discontinued production of the Visoflex III in 1985, there has always been a dedicated band of photographers who prefer to maintain a fully comprehensive Leica-M system

in which the Visoflex plays an important part.

2.12. Tele-Elmar-M 135mm, f/4.

MINIMUM APERTURE. f/22
ANGLE OF VIEW. 18°
NUMBER OF ELEMENTS. 5.
FILTER SIZE. E46.
INTERNAL THREAD. M46 x 0.75mm.
FOCUSING RANGE. 1.5m to inf.

Fig. 69. 135mm Tele-Elmar-M f/4.

SMALLEST OBJECT FIELD. 220 x 330mm.
LENS HOOD. Collapsible, built in telescopic type.
LENS CAP DIAMETER. 56mm.
DIMENSIONS. Length 107mm x dia. 57.5mm.
WEIGHT. 550 grams.
VIEWFINDER. Incorporated in all Leica-M models except M2.
FINISH. Black 'Eloxal' epoxy.
PRODUCT CODE. 11 861.

In 1985, E. Leitz (Instruments) Ltd., announced that the predecessor of the above lens was to be discontinued and that Leica-M owners would, if they wanted a lens of this focal length, have to divert their attentions to the faster 135mm Elmarit-M f/2.8. This was the one lens in the range at the time which, because of its faster speed and larger size, did not fit comfortably with a lot of photographers, in spite of Leitz claims, because of the cumbersome ocular attachment necessary to improve the focusing. Mounting the f/2.8 version on an M2 brings up the 90mm projected frame and converts it to the 135mm field; on the M3 and M4 the image size is multiplied by a factor of 1.4, thus improving the rangefinder accuracy. Excellent though the lens is, it cannot compete with the handiness of the new version specified above, or its predecessor which required a separate clip-on hood, and which did not, after all, cease production.

The earlier 135mm Tele-Elmar-M f/4, introduced in 1965, is of true telephoto construction, employing five elements in three groups. The new version has an identical arrangement. The lens is unsurpassed in its class for optical performance and at full aperture it is still one of the best lenses in the entire Leica system.

Stopping down produces no significant improvement in performance. The lens is free of coma and 'ghosting' – easily seen in the halo effect some lenses have on point sources of light.

The new lens does not have a removable head and cannot therefore be used with the Visoflex mirror box. As frustrating as this may be for some owners, it has to be said that, used in combination with the TTL metering of the M6, the new lens is a perfect gem from an ergonomic point of view. Leica's policy of modernising and standardising barrel shapes and the position of focus rings has greatly improved the handling characteristics of some lenses in the range.

The 135mm focal length is preferred by many photographers over the shorter telephoto lengths and this

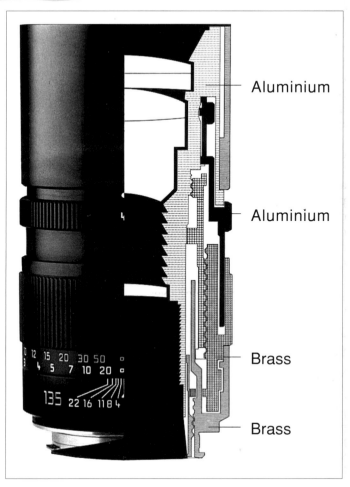

Fig. 70. Cutaway view of the 135 Tele-Elmar-M f/4 showing mechanical and optical construction.

Aluminium

Aluminium

Brass

Brass

example, being of true telephoto construction, produces an image quality which is difficult to match. For everyday shooting under average light level conditions, the relatively slow (compared with the shorter telephotos) maximum aperture should not be problematic. To put this in its right perspective, using Kodachrome 64, it is possible to expose frames at 1/500th at f/5.6 at an EV of approximately 13.5. Light levels need to drop more than two full stops before the photographer has to employ the full lens aperture at 1/250th sec. In the steady hands of experts, 1/60th sec. can be used without the need for a support, representing a full four stops of light loss.

But a support of any description using the lower shutter speed range is desirable to maintain the highest possible level of overall image sharpness, so I am not advocating that you do without; simply making the observation that it is possible to use this lens under a wide variety of light conditions to produce excellent results. Using film emulsions with higher ISO ratings dramatically increases the potential of this lens.

Combined with an M6 and lenses of 35mm and a 50mm focal length, the 135mm Tele-Elmar-M f/4, forms an ideal and lightweight traveller's package which can be comfortably carried in the ready to use position or in the pockets. An additional body could also easily be carried without the need for a bag, though inevitably, once the accessories and film start to pile up, pockets can become overcrowded.

2.13. Elmarit-M 135mm, f/2.8.

MINIMUM APERTURE. f/32
ANGLE OF VIEW. 18°
NUMBER OF ELEMENTS. 5.
FILTER SIZE. E55.
INTERNAL THREAD. M55 x 0.75mm.
FOCUSING RANGE. 1,5m to inf.
SMALLEST OBJECT FIELD. 220 x 330mm.

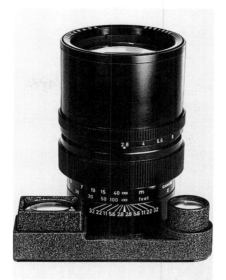

Fig. 71. 135mm Elmarit-M f/2.8.

LENS HOOD. Collapsible, built in telescopic type.
LENS CAP DIAMETER. 62.5mm.
DIMENSIONS. Length 114mm x dia. 66mm.
WEIGHT. 735 grams.
VIEWFINDER. All Leica-M type cameras have built-in projection frame for 135mm focal length except M2.
FINISH. Black 'Eloxal' epoxy.
PRODUCT CODE. 11 829.

The problem of rangefinder inaccuracy when using focal lengths of 135mm with the Leica-M was resolved when this lens was introduced in 1963. Its optical composition is five elements in four groups and is identical to the version first

produced for the Leicaflex cameras. An ocular attachment fitted to the lens mount converts the 90mm viewing frame of the M2 to the correct field size for 135mm, while on all other Leica-M models the attachment has the effect of magnifying the rangefinder image by a factor of 1.4x in the first version and by 1.5 in the second.

The optical design was recomputed in 1968 but the second version, launched in 1975, is the same as current R-type lenses, still with five elements but in a different configuration. The lens head can also be removed and used with the Visoflex.

The reflex model of this lens is widely appreciated for its excellent resolving power and contrast. The 135mm Elmarit-M f/2.8 equals this performance in every way and is the ideal telephoto for the photographer who frequently has a need for the extra speed. Sports photographers and those engaged in other fields where low ambient light levels are frequently encountered will find the increased rangefinder magnification particularly useful.

Other Leica Lenses For Use With The Leica-M Camera

Film manufacturers are constantly striving to produce new and better emulsions to give photographers ever finer grained and sharper images coupled with higher ISO speeds. In tandem with these developments, the research into optical glass and plastics suitable for photographic lens making continues at a faster pace. In due course, the existing range of Leica-M lenses will gradually be improved still further, replaced with entirely new models as well as having extra ones added to the list.

While these two aspects are inextricably linked, the photographic student should not lose sight of the fact that for the purpose of virtually all

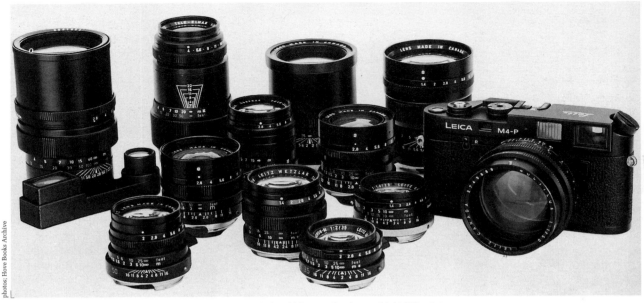

Fig. 71a: The Leica-M lens selection, mid-1980's vintage.

everyday photography, the capability of some of the very earliest photographic lenses exceeds the capabilities of the most modern film emulsions by a very wide margin. The aim of the lens designer and that of the optical glass researcher is essentially one and the same; to produce optics which are free of all known aberrations. The initial beneficiaries of any development in the area of precision tools is not the public, but industry, science, medicine, space, and defence markets. When products do become available to the public, one can be assured, certainly where established higher class goods are concerned, that it will have inherited many, if not all, of the advances made up to that point. Some of these advances include materials and methods of production which enable the manufacturer to fabricate to a price. Leica (and Ernst Leitz before) have always had a policy of fabricating to the highest standards. Price has invariably taken a back seat to this philosophy.

Photographers familiar with a particular system tend to gravitate naturally to the best lenses in a brand range. 'Best', invariably means those lenses which are sharpest, or which have a particular characteristic which meets specialist needs. In the case of older Leica-M lenses, and even some screw mount types, a high degree of image sharpness has always been assured. The main differences between these and other makes, as well as newer Leica versions, is in the area of contrast, colour rendition, tonal separation and colour differentiation.

The creative photographer cognisant of these subtle characteristic differences may occasionally have a need for such special tools. Used in combination with certain types of emulsion, very special effects can be created in which the subtle nuances of colour and tone can be enhanced, changed or reduced in certain ways. The more impecunious student with a desire to use the system, but who cannot afford current new prices, will gain confidence from the fact that Leitz and Leica lenses of all periods, types and focal lengths are in regular everyday use by professional and amateur photographers all over the world.

Many earlier examples of Leica-M-fitting lenses can be found on the shelves of secondhand dealers; at specialist photographic auctions and through the classified sections of the photographic press. The collectible factor has tended in recent years to push prices of some examples to very high levels, but on the whole, the price of items in excellent condition remains stable. Certain Leitz lenses are still relatively cheap because they are no longer collected or not fashionable or thought to be inferior. Whatever the reason, it is invariably the case that quite the opposite is true of the latter.

Some of the most commonly available older lenses are described below.

2.14. Elmar 50mm, f/3.5.

DATE. 1954 – 1961.
NUMBER OF ELEMENTS. 4.
FILTER SIZE. A36, E39.
VIEWFINDER. Projected bright-line frame, all M-models.
FINISH. Silver chrome.
COMMENTS. This is the lens with the highest production figures. It started life in 1925, replacing the earlier Elmax. Elmars with bayonet mounts are of the later optical design of 1951 and all have coated elements. Still an excellent lens for snapshot photography.

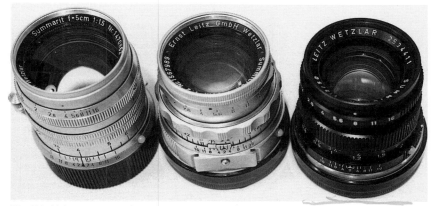

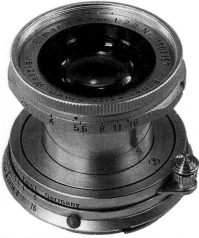

Fig. 74. Little gems; a selection of older M-type 50mm lenses, each with their own very subtle differences – see colour section. From left, 5cm Summarit f/1.5, 5cm Near Focus Summicron f/2, in which the mount for the separate ocular is clearly seen, and the predecessor of the current Summicron, the 50mm Summicron-M f/2

Figs. 72 & 73. The famous 5cm Elmars, f/3.5 (top) and f/2.8 (below). Both of these are in collapsible M-mounts and, apart from the lens mounting locating pip on the f/2.8 version, are similar in appearance.

2.15. Elmar 50mm, F/2.8.

DATE. 1958 – 1974.
NUMBER OF ELEMENTS. 4.
FILTER SIZE. E39.
VIEWFINDER. Projected bright-line frame in all M-model cameras.
FINISH.Silver chrome.
COMMENTS. The original Elmar recomputed and incorporating two elements of lanthanum glass in its four-element construction. An excellent performer, particularly in its close focusing range. Like its predecessor it was only available in a collapsible mount.

2.16. Summicron 50mm, f/2.

DATE. 1954 – 1968, first year of M-mount production.

1956 – 1968, dual range, near focus model.
1969 – 1979, second optical design.
NUMBER OF ELEMENTS. originally 7 and later 6.
FILTER SIZE. E39.
VIEWFINDER. Incorporated bright line in all M-camera models.
FINISH. Silver chrome, later black.
COMMENTS. The new lanthanum glass which Leitz had developed was used in a redesign of the Summitar lens to produce this, the most outstanding 50mm lens for the 35mm format. A dual range version capable of focusing down to a mere 19 inches became very popular. It has a special removable ocular attachment (code SDPOO/14002) which was sold separately from the lens, hence the reason why lens examples are often found for sale without it. A great lens for general purpose photography with excellent resolving power and good contrast.

2.17. Summarit 50mm, f/1.5.

DATE. 1954 – 1960. (M-mount only)
NUMBER OF ELEMENTS. 7.
FILTER SIZE. E41.
VIEWFINDER. Projected bright line incorporated in all M-model cameras.
FINISH. Silver chrome & nickel.
COMMENTS. Essentially the same configuration as the 50mm Xenon, the design and performance was improved by coating. Contrast is on the low side, which makes it excellent for some colour applications. Unfortunately the lens hood, being rectangular, adds

considerable bulk to the lens, but a useful addition nonetheless.

2.18. Summilux 50mm, f/1.4.

DATE. 1959 – 1961. (first type, see above for current version)
NUMBER OF ELEMENTS. 7.
FILTER SIZE. E43.
VIEWFINDER. Projected bright line incorporated in all M-model cameras.
FINISH. Silver chrome; a few in black paint to match M2, M3, MP cameras of the same finish.
COMMENTS. A fast, excellent lens for low light work. Very sharp when stopped down to about f/4 – f/5.6. Gives a lovely mellow roundness to colours with excellent tonal differentiation.

2.19. Noctilux 50mm, f/1.2.

DATE. 1966 – 1975.
NUMBER OF ELEMENTS. 6.
FILTER SIZE. E48.
VIEWFINDER. Projected bright line frame incorporated in all M-model cameras.
FINISH. Black anodised chrome.
COMMENTS. Some professionals still maintain that of the two types of this lens, the earlier version incorporating aspherical surfaces on some elements is the better performer. The production run was limited, consequently examples are not easy to find and tend to be expensive. (see chapt 4.2 for alternative non-Leica optics.)

Figs. 78 & 79. Café de la Paix, Paris (left) and in the backstreets near Rue de Javel (opposite). The 28mm focal length can be just as effective as its slightly longer 35mm sister in recording the kind of intimate motifs found on a great city's streets.

photo: copyright Jon Harris/Fieldgrass & Gale

Fig. 75. First 50mm Noctilux f/1.2, manufactured between 1966 and 1975, seen here with its proper hood [code 12503]. It used six elements, some with aspherical surfaces and mounted in solid bronze.

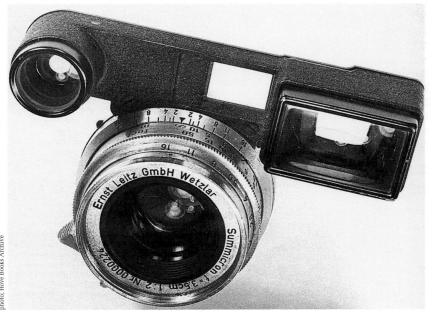

photo; Hove Books Archive

Fig. 76. 3.5cm Summicron f/2 with special M3 ocular attachment.

2.20. Summaron 35mm, f/2.8.

DATE. 1958 – 1974. (M-mount only.)
NUMBER OF ELEMENTS. 6.
FILTER SIZE. E39.
VIEWFINDER. Projected bright line in M2, M1, M4, M5, M4-2, M4-P, M6. Special ocular attachment version for M3.
FINISH. Silver chrome.
COMMENTS. An updated version of the earlier f/3.5 version using lanthanum glass. A very good all round performer.

2.21. Summicron 35mm, f/2.

DATE. 1958 – 1969, first version,(M-mount.)
1969 – 1973, second version,
1973 – 1979, third version.
NUMBER OF ELEMENTS. 8 (1st). 6 (all later types).
FILTER SIZE. E39.
VIEWFINDER. Projected bright line incorporated in all M-model cameras

Fig. 77. The same lens as in Fig 76 which was available in standard M-mount configuration, here fitted to an M4. A compact outfit for street photography

67

Fig. 80a. The 90mm focal length is ideal for undistorted portrait work where a respectable working distance between subject and photographer is necessary.

except M3, which needs special ocular attachment.

FINISH. Silver chrome or black.

COMMENTS. Several modifications exist within the range of versions listed above, mainly in the closest focusing distance for M2 and M3 cameras. A small quantity of the first version were available in screw mount factory or service centre modified by fitting a bayonet ring which is fixed with a small set screw. The six element version is more commonly available.

2.22. Elmarit 28mm, f/2.8.

DATE. 1965 – 1972, first version, 1972 – 1979, second version, 1979 – 1993, third version.

NUMBER OF ELEMENTS. 9 (1st). 8 (2nd & 3rd).

FILTER SIZE. E48/Series VII (1st), E49 or Series VII (2nd,3rd.)

VIEWFINDER. Projected bright line frame incorporated in M4-P & M6 only. Independent accessory shoe mounted viewer available.

FINISH. Black anodised chrome or black 'Eloxal' epoxy.

COMMENTS. The first two versions of this lens have similar barrels, but the optical construction is different. The third version is less fussy in appearance. Lenses below serial nr. 2314921 cannot be used with the M5 (or CL) unless modified. Lenses below this number can be mounted on an M6 but because of back projection, will not permit TTL metering. Lenses above serial nr. 2411001 automatically bring up the correct viewing frame on M4-2 cameras (with M4-P or M6 viewfinder frames only), or M4-P and M6. Early versions of these lenses will not activate the frame.

2.23. Super-Angulon 21mm, f/3.4.

DATE. 1963 – 1980.

NUMBER OF ELEMENTS. 8.

FILTER SIZE. E48 or Series VII.

VIEWFINDER. Independently accessory shoe mounted type.

FINISH. Silver chrome or black.

COMMENTS. This was not the first extreme wide-angle for Leica-M cameras. It replaced an earlier f/4 model to which it is optically superior. At its maximum aperture, under certain lighting conditions, there is just the very slightest evidence of vignetting. Some photographers use this as a device to emphasise certain pictorial aspects. The lens is very sharp with excellent contrast, making it a perfect extreme wide-angle for black-and-white or colour.

The 21mm Super-Angulon f/3.4 can be mounted on an M6 but the back projection of the rear element group interferes with the viewing angle of the meter pick-up lens. This is where a second pre-M6 Leica-M (not M5) body can be useful. If it is used most or all of the time as a special wide-angle camera fitted with the 21mm, meter readings taken with the M6 can be swiftly transferred to it for accurate results. (see also chapter 4.2)

2.24. Elmarit 90mm, f/2.8.

DATE. 1959 – 1974.

NUMBER OF ELEMENTS. 5.

FILTER SIZE. E39.

VIEWFINDER. Incorporated in view-/rangefinder of M3, M2, MP, M4, M5, M4-2, M4-P, M6 & LEICA CL. Independent accessory shoe viewer also available.

FINISH. Silver chrome and black chrome.

COMMENTS. More than 30,000 examples of this lens were made so it is perhaps not surprising that the used supply is good. The lenshead can be removed for use with the Visoflex II & III in combination with the focusing mount (code 16 464). An excellent allrounder, suitable for a wide variety of

Fig. 80b. 90mm Elmarit f/2.8, a small, compact medium telephoto lens, the last type of this focal length with removable lenshead.

applications. A number of other 90mm Leica-M fitting lenses were also made, including a special model for the Leica CL – the Elmar-C 90mm, f/4. An identical lens was manufactured by Leitz for Minolta and carries the Rokkor name. The Tele-Elmarit-M 90mm, f/2.8 was made in two versions between 1964 and 1989, the second coming onto the market when the lens specified in the table above was discontinued. This is a more compact version without the removable head.

2.25. Elmar 135mm, f/4.

DATE. 1960 – 1965.

NUMBER OF ELEMENTS. 4.

FILTER SIZE. E39.

VIEWFINDER. Incorporated in range-/viewfinder of M3, MP, M4, M5, M4-2, M4-P & M6.

FINISH. Silver chrome with black vulcanite base finger grip.

COMMENTS. The previous model of this length was the Hektor; but with a maximum aperture of f/4.5 it is just too slow for many subjects. The Elmar f/4 was an optical redesign using new glass of the period. The aperture ring has very positive click stops as well as half values and it can be relied upon to produce excellent results wide open. The lens head is removable for use on the Visoflex mirror box.

I have limited the choice of these alternative lenses on the grounds that the photographer will find them all capable of turning in superb results. Many of them also accept the commonly found E39 filter. This is not to say that other lenses, of which there is a wide variety of both M-types and earlier screw types when fitted with the correct adapter, are unsuitable. However, some of these are now very dated and being uncoated do not perform in the manner modern photographers are used to. The other reason is that many of the above lenses are still widely available. A little persistent sleuthing will soon track down the elusive ones.

CHAPTER 3

Leica-M Viewing Systems

3.1 How the Leica-M viewing system works

Veteran users of a single-lens reflex system making the transition to the range-/viewfinder system of Leica-M cameras will probably take longer to acclimatise than novice students handling a sophisticated camera of any type for the first time.

Fig. 81. London; M4-P, 50mm Summicron.

With a reflex camera, the eye sees more or less the exact image that will be recorded by the camera through the taking lens. The image is transferred to a ground glass screen via a mirror and prism so that the viewer sees a right-way-round, right-way-up image. By using a portion or all of the ground glass screen, or a central area which may incorporate a circular split image rangefinder device, or both, the photographer can com-pose and focus the image more or less simultaneously and continuously up to the moment of exposure. The mirror which diverts the image to the prism and viewing screen flips out of the way as the exposure is made and returns to its normal position immediately afterwards. The length of 'blackout' time is a mere fraction of a second, but it is at the crucial point in time of exposure that the viewed image disappears from view.

The viewing and focus system of a rangefinder camera is completely independent from the taking lens. Thus the photographer's view is never impeded, not even for a split second, of any action taking place in front of the camera.

In the Leica M6, a sophisticated rangefinder utilising prisms super-imposes a portion of identical images one on top of the other. When the lens is accurately focused on the

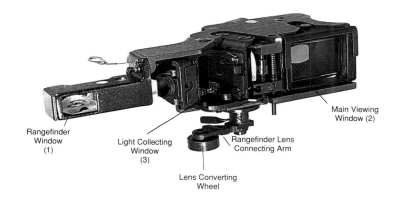

Rangefinder
Window
(1)

Light Collecting
Window
(3)

Rangefinder Lens
Connecting Arm

Main Viewing
Window (2)

Lens Converting
Wheel

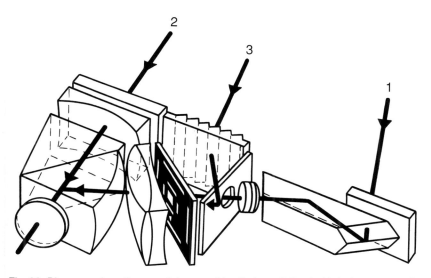

Fig. 82. Diagrams show the complete range/viewfinder unit fitted with its lens connecting arm and wheel. The key identifies the various windows which should be compared with the diagram. The unit is extremely robust; its accuracy over periods of years of hard professional use is legendary. No other rangefinder system is as complex or finely built.

prism. The distance between the two image collecting windows and the magnification factor of the lens used to collect the primary image controls the accuracy of the measuring system.

The remarkable aspect of the Leica-M rangefinder system, considering its mechanical and optical sophistication, is that it remains one of the most resilient to knocks and bumps. In reasonably considerate hands, it is unlikely to need any more serious adjustment than that received during the occasional general service.

In addition to the co-incident, or double image focusing system, all

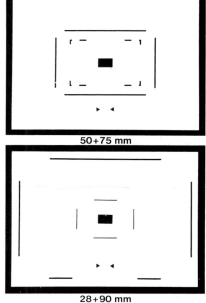

50+75 mm

28+90 mm

35+135 mm

Fig. 83a. The six projected bright-line frames of the M6 which are raised in the viewfinder as each lens is mounted on the camera.

subject, the small central-field measuring rectangle, which is slightly lighter in tone than the surrounding image, appears as a single image with no overlap at either end or top and bottom.

An arm positioned in the top of the camera body, just inside the throat of the lens mount, can be seen when the lens is removed from the camera. A wheel is fixed to the end of the arm which, when the lens is mounted, engages with the rear inner sleeve of the lens. As the lens focusing ring is rotated, the inner barrel sleeve moves forwards or backwards against the rotating wheel of the rangefinder arm. The arm is linked

to the left-hand prism of the rangefinder mechanism (as viewed from the camera front) and the image from it is projected through a tiny focusing lens, a pellicle mirror, which collects the light for the bright line projected frames, through an image magnifying double element and through another prism to the eyepiece ocular.

The diagram clearly illustrates how this is achieved. What the photographern sees through the viewfinder is the real image of the object through the left hand window (viewed from the camera rear) superimposed over the image of the same view collected by the right hand

Fig. 83b. A Leica GmbH technician checks the range/viewfinder unit being fitted to an M6 camera.

Leica-M cameras are fitted with projected bright-line viewing frames which depict the image field of the lens in use. The way in which this works, and the various frames allocated to each model, are described in detail in Chapter 1. In later camera models, six frames covering six focal lengths are fitted. With the exception of the 28mm frame, which extends to the edges of the viewfinder, a margin of viewing outside of the actual bright-line frame is permitted with all other focal lengths. Unlike the reflex systems of most cameras which actually restrict the field of view and show a smaller field than that actually being photographed, the Leica-M system allows the photographer continuous and uninterrupted viewing of what is happening immediately outside of the image frame. This is often a great assistance in being able to time the best moment of exposure more precisely.

Official Leica service centres still (at the time of writing) offer a conversion service to some older models to bring the viewing systems up to date. Leica-M cameras with all six integral viewing frames for the 28/90mm, 35/135mm and 50/75mm focal lengths are commonly referred

to in the dealers trade as having M6 'windows'. This is slightly confusing for the uninitiated. 'Windows' refers to the type used in all later versions of the M6 which feature a small portion at the bottom of the main left-hand front window which is semi-silvered. The window front is flush with the camera body, not recessed as in some early M4-P's and virtually all M4-2's. However, all M4-P's are fitted with the six bright-line frames irrespective of 'window' type. Leica-M cameras above serial

nr. 1053312, can be fitted with the current set of projected frames. This includes some M2's, all M4 and M4-2 models. This camera body serial number dates from 1962 and the connoisseur will note that the M3 is missing from the line-up.

The M3 (and some models of the M2) cannot be fitted with the newer frames because they are mounted differently in the current rangefinder unit. An M3 body casting would require considerable engineering work in the way of machining in order to fit the new unit. The amount of work involved would normally make such a proposition uneconomic (but see Fig. 195 at beginning of Chapter 10).

3.2 How to hold the Leica-M and use the view-/rangefinder

The most common mistake made by those trying it for the first time is to hold the camera the wrong way. This invariably leads to some initial frustration and disappointment because the viewing system has been totally or partially blocked by a finger or hand.

The camera should be held firmly in the right hand. A Leica-M is so well designed that most users will find a natural right-handed

Fig. 84. This is the wrong way to hold a Leica-M type camera. The left hand is partially blocking the main viewfinder and is unable to provide extra support for the camera.

Fig. 85. Landscape position. Two last fingers and palm of left hand provide additional support.

Fig. 86. Vertical or portrait position for the right eye.

Fig. 87. and for left eye use. Keep rangefinder windows clear.

Fig. 88. Alternative vertical position for right and left eyed photographers.

grip which allows the weight and shape of the camera to be absorbed comfortably. The thumb and forefinger fall naturally to the tip of the film wind-on lever and the shutter release on the top plate. The left hand forefinger and thumb should be placed under the lens so that they lightly grip the focus ring and/or the finger grip fixed to it. With a little practice, the user will soon find a natural place for the remaining three digits of the left hand under the base plate of the camera.

Now raise the camera to eye level. To ensure the right-hand rangefinder window is not covered by the top finger of the group clasping the body,

use the rewind lever as a finger stop. A beautifully clear image of the object to be photographed can now be seen. Gentle pressure in one direction or another on the lens focus ring or lever activates the rangefinder measuring-field rectangle seen in the viewfinder. An out-of-focus image is clearly seen as two separated, lighter-toned rectangles or part thereof. To obtain the correct focus, turn the lens focus ring to the left or right to bring the two images or parts of an image together – in other words until the two images are coincident.

Now all you need to do is compose the photograph and make the exposure. It takes a lot longer to

explain than it does to do! A few minutes spent practising by selecting subjects at random, both near and far, will soon assist you to attain a competent level of expertise. WITHOUT removing your eye from the viewfinder, keep the camera in its horizontal position for a while, operating the focus mechanism, composing the picture and firing the shutter. You will find that by keeping the tip of the film wind-on lever against your thumb and cocking the shutter using two or more short strokes, the camera can be kept at eye level while continuously viewing the subject and releasing the shutter.

To obtain the same degree of functional ease with the camera in the vertical or portrait positions, keep hold of the camera while raising the right elbow to turn the camera. For some, this is the more difficult position to master, even though physically more relaxed in many ways. The temptation to refocus should be avoided unless the camera position is changed. Even then, it is simpler and quicker to re-adopt the horizontal mode, refocus and then turn the camera. Experts can do this very quickly. The alternative method is to adopt the hand grip shown in Fig. 88, using the thumb for the shutter release. Lenses which have a focus lever can be adjusted quite easily in the vertical; those which do not require a little more dexterity. The one thing to watch for is that fingers of either hand do not obscure the smaller of the rangefinder windows to the right of the camera body.

One of the key factors to success in using any camera is in having sufficient confidence in it. With a reflex camera employing manual focus lenses, there is always a great temptation to continually re-focus the image on the screen. With a rangefinder camera, the temptation to fiddle continuously with the focus is diminished; the split-image or coincident system is far more positive in this respect. Once the two images are together, that's it. The photographer should then be able to get on with making the exposure, contemplating the next frame while relying on depth of field to give the required depth of sharpness in front of and behind the subject.

The cardinal sin with regard to handling of a Leica-M is to hold it in the manner shown in Fig. 84. Apart from completely blocking the view-/rangefinder window, no additional support is available for the camera body. Practise often and for as long as necessary to acquire the habit of holding and using the camera correctly, so that it becomes a simple mechanical extension of the arm, ready to shoot at a moments notice.

3.3. Independent viewing accessories for the Leica-M

Unlike some other makes, the Leica-M integral view-/rangefinder system is unquestionably superior, both from the point of view of focus accuracy and clarity of image. It does not use mirrors which can fade with

Figs. 92 & 93. Albada type independent viewfinders for 9cm and 13.5cm focal lengths which slot into the camera accessory shoe. These two both have range measuring milled rings which automatically adjust the finder for parallax correction.

Fig. 91. Grabbing the moment. See what is happening; shoot! The viewing system of the Leica-M liberates visual perception. Paris downpour, M4-P, 35mm Summicron f/2.

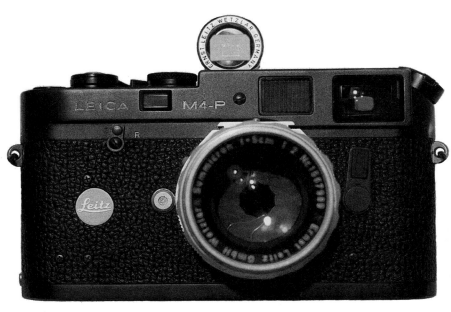

Fig 94. Leica M4-P fitted with 50mm Albada type viewer which clearly shows the axis in relation to the camera lens and built-in range/viewfinder.

time. The main viewfinder is based on the Albada type which Leitz first introduced in a series of collapsible accessory shoe mounted sports finders in 1935.

A wide variety of discontinued independent Leitz viewfinders may still be found. By far the most practical types for general use are those known as 'enclosed' Albada type first introduced in 1951 and covering a wide variety of focal lengths. These have become highly collectable items because of the varying styles of engraving found on them. But this should not deter the dedicated photographer engaged in fast breaking news stories, photojournalism, travel photography or portraiture.

The Albada viewer is a sophisticated accessory. Those suitable for focal lengths above 50mm are fitted with automatic parallax compensation, effective as the focus distance scale is set. All models, except those covering extreme wide angles, have miniature bright-line frames, engraved on the inside of the rear element, which is reflected back to the viewer from the pellicle front ele-

ment. The viewers offer a life-size image contained within the bright-line frame, with an additional area of image visible around the frame. The effect, for those who have never used this type of viewer previously, is stunning. No reflex camera can match the system for brightness or life-size effect.

The commonly used focal lengths, such as 50mm and 90mm, can be

found quite easily. Others, except current production versions, may take a little longer to track down.

The viewer is inserted into the accessory shoe on the camera top plate. It is designed to be used independently from the camera's integral system, although this can still be used without obstruction for obtaining accurate focus.

3.4. Zone focusing and depth of field

For many photographic subjects, such as in street photography where situations frequently develop unexpectedly and with amazing swiftness, this type of viewer can be a great advantage. It frees the mind completely from all technical aspects regarding focus and exposure (M5, CL & M6) details, so that the eye and the mind are concentrated only on framing and the decisive moment.

Accurate, or as near accurate focus as possible, must be judged when there is no time to stop and fiddle. The rule is, shoot first, ask afterwards. Loosely interpreted, that means it is always worth taking a chance that the focus you have already preset will be close enough for the first or second frame. Only when there is time should focus and

ALBADA ENCLOSED TYPE VIEWERS WERE MADE TO SUIT THE FOCAL LENGTHS BELOW.			
Codeword	Number	Focal Length	Availability
SBLOO/12	010	35mm	Used market
SBOOI/12	015	50mm	Used market
SGOOD/12	020	85mm	Used market (rare)
SGVOO/12	025	90mm	Used market
SHOOC/12	030	135mm	Used market
SBKOO/12	002#	21mm+	Used market (rare)
SLOOZ/12	007#	28mm	Used market
12	012 [plastic]*	21mm	Used market
12	017 [plastic]*	28mm	Used market
12	008 [plastic]*	21mm	Current model
12	009 [plastic]*	28mm	Current model

(* denotes black moulded plastic housing. Previous models all metal and finished in silver chrome or (#) black enamel. + see Chapter 4.2 for alternative 21mm viewfinder for 21mm Super-Angulon f/3.4)

Fig. 95. Depth of field, zone focusing and hyperfocal distance play an important part in a street photographer's game plan. In this photograph, the lens – a 35mm Summicron f/2 – was pre-focused to 10 feet at f/4. The picture appears to be sharp all over.

Fig. 96. However, even a slight enlargement shows that the child at left is just going out of the zone of sharp focus and the background is well out. Judging object-to-camera distances can be very deceptive and frequent re-appraisal may be required.

when there is time should focus and exposure settings be adjusted.

So how can you preset the focus. At least so that there is a good chance that most of the frames exposed will fall within the primary depth of sharpness?

A lot will depend on the focal length of lens employed. The wider the lens, the greater the depth of field available to the photographer. This

should not be confused with 'depth of focus' which is the term used to describe the very shallow depth of sharpness inside the camera at the film plane. It is of most concern to lens and camera manufacturers.

When a lens is focused accurately on an object, the actual point of focus will only be as sharp as the lens and camera design permits. Either side of this point of critical sharpness, and it can only be on a single plane, is a zone of apparent sharpness extending in front of and beyond the point of critical sharpness. The distance between the two zones, or areas of apparent sharpness, is called 'depth of field'.

The depth of field for any given focal length of lens is variable and depends entirely on the distance of the object being focused on (from the film plane) and the aperture used. Briefly, this can be summarised thus;

THE LONGER THE FOCAL LENGTH OF LENS EMPLOYED, THE MORE SHALLOW THE DEPTH OF FIELD AT ANY OBJECT-TO-CAMERA DISTANCE IRRESPECTIVE OF THE F/-STOP USED.

The student will see from this that a wide-angle lens will have immense depth of field when employed with a very small stop – its minimum aperture setting. As the object-to-camera distance decreases, so the depth of field becomes less. However, it is not accurate to say that a lens has its greatest depth of field when set at the infinity focus mark combined with its minimum aperture.

Another criterion known as 'hyperfocal distance' now enters the arena to confuse the student.

When a lens is set to the infinity mark, the point before infinity at which the object becomes acceptably sharp is known as the hyperfocal distance. This is not a fixed distance; it varies, in a similar way to depth of field, as the aperture for a given focal length lens is changed. The smaller the f/-number (the bigger the diaphragm aperture), the greater the hyperfocal distance.

To obtain the maximum depth of field for a selected aperture, find the hyperfocal distance. That is, the nearest point of sharpness to the camera. Refocus the lens on the distance shown. The zone of apparent sharp focus, or depth of field, extends from half the hyperfocal distance to infinity.

You can work out the hyperfocal distance with any pocket calculator using the formula shown in the panel.

The depth of field tables given at the back of this book are those published by Leitz. The preface to the tables indicates that the calculations are based on a circle-of-confusion of 1/30mm.

The theory of the circle of confusion relates to the possibility that a point of light transmitted through a lens will not be manifest as a single point in the resulting photograph at the plane of sharpest focus, but as a collection of concentric circles of differing tonal values. The very centre of this blob is the brightest point. Theorists argue that the minimum size of this circle of tones for a given print size is indicative of acceptable sharpness. How apparently sharp this blob is in the photograph depends entirely on whether

HOW TO WORK OUT HYPERFOCAL DISTANCE WITH A POCKET CALCULATOR

$H = F^2/NC$

where F = the focal length of the lens

N = the f/-stop for which H is being calculated,

C = diameter of circle-of-confusion (in this case 1/30mm or 0.033mm for the 35mm format for a 10 x 8inch (18 x 24cm) print viewed at normal viewing distance of 12 inches (30cms).

For example: when F = 50mm, N = f/5.6 and C = 0.033mm

then H = $\dfrac{50 \times 50}{5.6 \times 0.033}$

tap in the following keystrokes;

50		
(X)		
50	read	2500
(÷)		
5.6	read	446
(÷)		
0.03		
=	read	14880

where 14880 is = to H measured in millimetres, or 14.9m. To convert to feet multiply by 0.00328 = 48.809 or 49 feet.

Calculators with a memory can be used to store the NC value, thus,

enter	5.6	
	(X)	
	0.03	
	=	read 0.168
	(M+)	store above
enter	50	
	(X)	
	(=)	read 2500
	(÷)	
	(MR)	recalls memory value
	=	read 14880.9
	(X)	0.00328
H	=	48.80 or 49 feet.

the original point source of light has been accurately focused.

From a purely practical point of view, circles-of-confusion are irrelevant in most day-to-day photography. There are far too many other factors which can influence sharp focus and these calculations have little value in ordinary life.

The photographer concerned with absolute sharpness should carry out a simple practical test. Make a print from a negative which shows several point sources of light, such as a night street scene where the point of accurate focus is known. Enlarge the whole of the negative to approximately 10 x 8in (18 x 24cms). When the print is dry, view it under a good reading light from normal distance (12 inches, or 30cms). Select the brightest and sharpest looking point light source depicted in the print. Examine it carefully under a powerful loupe. (The 50mm, f/2

Fig. 97 (above). To obtain maximum depth of field for a given aperture, find the hyperfocal distance. In this busy scene in Orleans, France, sharp focus extends from just in front of the camera to the cathedral towers, left of centre. (Fig 98, left).

Fig. 99. Quality of light, film, lens, processing, paper finish, enlarger and enlarging lens are just a few of the factors which will determine sharpness, both apparent and absolute.

Summicron, aperture wide open, object viewed with eye to the front element of the lens will do nicely.) What you thought was a pin-sharp point of light now becomes a blob of different tones. It could be argued that had the lens aperture been stopped down further at the time of making the photograph, the blob would appear smaller, less confused, apparently sharper.

Now, if you make a larger print of the same negative, the blob size also increases but its apparent sharpness decreases. Using a formula, it is possible to calculate in advance, the aperture required for a given focal length which will result in a circle of confusion of a particular size.

In practice, photographers using the 35mm format for the type of work discussed in this volume would never make an exposure of anything if they had to think about the optimum size of a circle-of-confusion for a given print size, and even if they did, this optimum size would depend on a great many things being equal to predetermined factors. For example; film quality, camera lens quality, light quality, firmness of camera support, accuracy of focus, quality of individual eyesight, processing technique, chemicals used, quality of printing paper, paper finish, enlarger and enlarging lens quality and viewing facility, to name just a few.

3.5. Reflex photography with the Leica-M

The success of the Leica I set other designers off in search of improvements. Even in the early days, the Leica's limitations were recognized; the biggest problem being the rangefinder itself and the restriction this method of focus determination placed on the use of long focal length lenses. The answer was to design a reflex viewing attachment. Leitz introduced one in 1935 for use with the new 20cm Telyt lens, one year

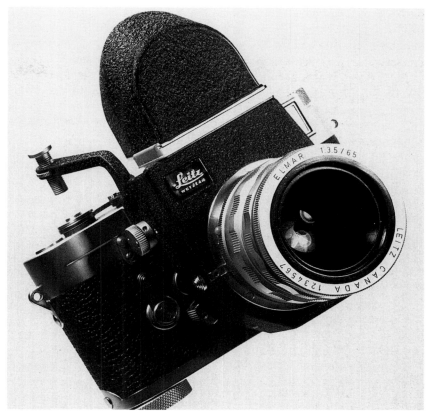

Fig. 100. Visoflex III fitted to an early M3 with the popular 65mm Elmar lens.

before the advent of the world's first 35mm single lens reflex camera, the Kine Exakta. Hugo Meyer's 'Megaflex' device actually predated the Leitz mirror reflex housing, but it had its own viewing lens and only coupled with the 50mm camera lens, so Leitz had a fair claim to the invention of 35mm reflex photography.

The codeword for the Leitz production version of the mirror reflex housing was 'PLOOT', and the name stuck. In 1951, a completely new design for the mirror reflex housing emerged in the form of the Visoflex I, followed in 1959 by the Visoflex II and in 1963, the Visoflex III. This was to be the last version. Production ceased in 1984, but it remained in the catalogue for another year.

By this time, the world had seen more than 30 years of single lens reflex camera development. Leitz themselves were at the forefront of

this technology, having painstakingly built on the limited success of the Leicaflex of 1964. The Japanese company Nippon Kogaku, with their Nikon F, had led the way, establishing a reputation for solid reliability and excellent lenses based on their earlier rangefinder cameras.

Where previously Leica had reigned supreme in the professional world of 35mm photography, by the early 70's it was very apparent that the demand for rangefinder cameras was at a low ebb (see also Chapter 1). A revolution in the style and approach of photo-reporting, which exploited the huge range of focal lengths available for 35mm reflex cameras, had been going on since the late fifties. In particular, the use of extreme wide-angle and long telephoto lenses became the norm. Despite the great success of the M3 and M2, the new breed of

photojournalists' adopted the Nikon, which went from strength to strength until the advent of Canon's EOS auto focus system in the mid-1980's.

By the time Leitz dropped the Visoflex III from their lists, it was clear that even photographers who only had an occasional use for the reflex camera, would still opt for that type. It seemed that only the dedicated gadget minded photographer had the patience to continue with the horribly slow combination of rangefinder and mirror box attachment. Well that is the way things appeared on the surface to a great many photographers. Those who know their Leica-M rangefinder as well as they know their own hand will know that nothing could be further from the truth, though I am not going to pretend that an M4-P fitted with a Leica Winder and Visoflex III can keep up with a Leica R7.

Many rangefinder camera owners will also be owners of a modern reflex camera. Some professionals have duplicated systems of both types and these are frequently used side by side, the photographer recognizing the particular merits of each and putting them to good use accordingly.

There are times however when one camera body, or at most two, and a small selection of lenses is all that is required. To keep shoulder weight to an absolute minimum whenever possible, especially when engaged in the kind of self-made assignments that require a lot of walking and hiking, the Leica-M is the ideal companion. But if you know in advance that some scenes would be better shot using a long telephoto lens, a single lens reflex body and associated lenses have to go in the bag too. Throw in a few filters and a couple of motor drives, a

lens you know you'll never need, spare batteries and a flash gun and the all-up weight is approaching the same as a marine is expected to carry on an amphibious landing.

The rangefinder purist and the connoisseur of the mirror box system has a definite advantage. The Leitz Visoflex II and III are the most functional of the three models manufactured. The units break into two parts, three if the Simple Magnifier is also used, and take no more room than a reflex 135mm lens. I have left out the Visoflex I version because, although perfectly serviceable, it is a more cumbersome piece of equipment, requiring the use of twin cables to release the mirror and shutter.

The design of the Visoflex II is more compact, the smallest mirror reflex box attachment made for any camera. With a higher aluminium content in the casting it also became a lot lighter. The shorter lens-flange-to-body-flange distance also permits lenses with a focal length of 65mm or greater to be focused at infinity.

Compared with the Visoflex I, the only drawback is the lack of a rotational facility which allowed the previous model to be swung from the horizontal to the vertical position*.

The Visoflex II had a single mirror/shutter release arm which when swung into position over the camera shutter release can be minutely adjusted by means of a screw. The mirror does not return instantly after exposure, it has to be lowered into position by means of a lever on the right hand side of the box under the shutter release arm. The front flange is fitted with a Leica-M bayonet mount.

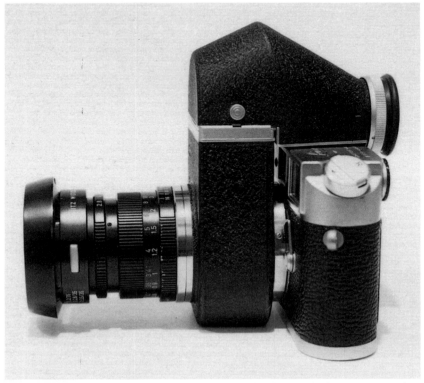

Fig. 101. Visoflex II fitted with 50mm Summicron-M f/2. It lacks the instant return mirror facility of the Viso III, but is more compact. (see extra height and gap of Viso III above top plate in Fig 108.)

* An exception to this rule is when a Leica-M body is fitted with Visoflex II, mounting earlier Novoflex lenses of 280, 400 or 650mm via the Novoflex VISLEI-P adaptor. These lenses are predecessors of the current bayonet type, their component parts connected by threaded assembly. See Chapter 4.2 for further details}

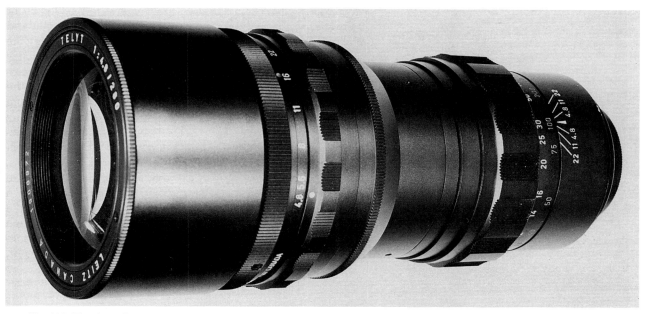

Fig. 102. The Canadian made 280mm Telyt f/4.8, a fast maximum aperture lens beautifully tailored to suit Visoflex operation.

Two types of viewer were available for the Visoflex II; a very compact 90° model with 4x magnification and adjustable ocular giving a normal right-way-round image. The second type is the chimney type Simple Magnifier already mentioned with a 5x magnification and laterally reversed image.

The introduction of the Visoflex III in 1963 saw significant changes, both in design and facility. It was slightly larger than its predecessor, partly to accommodate the instant return mirror mechanism, as well as the flange-to-camera body release lever, which permitted the whole unit to be fitted to the camera without removal of the viewing prism as must be done with the Visoflex II. The Visoflex III can utilise the chimney-type 5x vertical magnifier of the Mk II, but requires a special flush-bottomed 90° prism magnifier. This is also slightly taller than its predecessor.

The advantage of this model is the instant return mirror, plus two other settings controlled by a milled knob on the right side of the box under the camera shutter release connecting arm. The three positions are marked by coloured dots; yellow = instant return; black = slow return; red = mirror lock-up.

Several variations of this mirror box exist. There was even a modification which replaced the mirror with a semi-silvered prism, permitting vibrationless operation. Another variation could be linked to the Leica motor. The screens on early versions, like the Visoflex II, have a 1mm central circle. Later models had a larger circle of 7mm. The two charts in Appendix II show the different adaptors and lens combinations possible with each model.

Further use and applications of the Visoflex II & III can be found in the following chapter but it is worth noting two things at this point. The first is that use of the Visoflex on the rangefinder camera gives only some of the facilities likely to be found with a modern reflex camera. Although Leitz manufactured Leica-M bodies which are more suited to semi-permanent use with the Visoflex (MD, MDa, MD-2, see Chapter 1.) metering must be carried out as a separate function. Limited metering is possible with the M5 and M6, but in both cases the Visoflex mirror must be in the 'lock-up' position. Even so, it is probably best to use a hand-held spot-meter, especially when employing the longer telephoto lenses or exploring the world of macrophotography.

Despite these drawbacks, as well as the possibility that the novice may well regard the Visoflex attachment as being unfashionable because of its age and period design, it has one thing to its advantage which is lacking in modern single lens reflex cameras – screen brightness. Even the earlier PLOOT of the 1930's was a revelation. The Visoflex models discussed here, however, are remarkable. There is no image black-out or vignetting. Using comparatively slow telephoto lenses of f/5 and upwards, focusing is as straightforward as using shorter lenses of wider aperture.

Fig. 103. Arc de Triomphe, Paris. 400mm with 2x converter.

CHAPTER 4

The Visoflex in Practice

4.1. Normal and medium focal length lenses

Several lenses which can be used with the Visoflex are described in Chapter 2.13 on. The optical head of lenses such as the Elmarit 90mm, f/2.8 or the Elmar 135mm, f/4 can be removed. Once inserted into the Universal Focusing Mount (OTZFO/16 464), which is fitted to the front flange of the Visoflex, the lens can be used in the normal way. Some lenses may also be used either with a short focusing mount or with extension bellows.

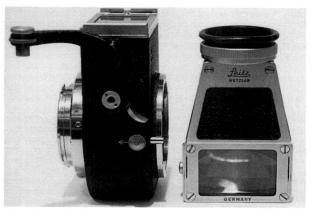 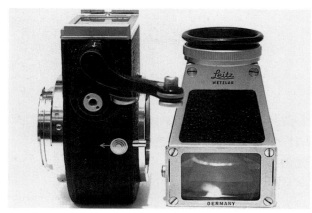

Fig. 104a (left). Visoflex II dismantled showing mirror lever in the 'down' position and shutter release coupling arm 'engaged'. Fig. 104b (right). Visoflex II with arm disengaged and mirror 'up'. The silver hole under axis of the shutter release arm is for cable release connection, and button below that is the lens release pin. Magnifier has dioptre adjusting eyepiece ocular controlled by milled silver ring.

One of the most popular lenses specially designed for use with the Visoflex is the Elmar 65mm, f/3.5 which has a focusing range of 33cm (13") to infinity. The lens remained in production from 1960 until 1984, so there is a useful selection of later all black models available on the secondhand market. The lens has an infinite capacity for macro photography. It's closest focus range would be greater but for the fact that the front element is so deeply recessed the mount touches the object before that point is reached. To overcome this, a special tube (16 471) permitted the lens to be reversed using a filter ring.

Photographers who have acquired a Visoflex II or III without the Universal Focusing Mount or extension ring adapters will find that some lenses can still be used for certain tasks. The lens-mount-to-camera-flange depth of 40mm effectively turns the mirror reflex box into a long extension tube when used with normal Leica-M series lenses. Thus, mounting a 50mm standard lens directly onto the Visoflex provides the facility for restricted close-up work.

The camera and Visoflex rig with lens attached should be mounted on a firm base, a tripod or the Leica mini-tripod or some other support which will permit slow shutter speeds to be employed when needed to take advantage of maximum depth of field. With practice, and provided there is sufficient light, some close-up work can be accomplished successfully using the rig hand held. Accurate focus is obtained by moving the rig towards or away from the object to be photographed with the lens aperture set to its maximum

f/-stop and the focus set at infinity. Once the plane of exact focus is established for the most important feature, the lens may be stopped down to obtain a more useful zone of sharp focus. This is easily done and the effect is immediately visible on the ground glass screen. Adjusting the focus using the focusing ring and turning it to a closer range changes the image size and effectively reduces the depth of field.

A practical application where the Visoflex could be useful in this form might be in photographing certain types of antique, or works of art, where a record of the whole object can be made using say, a standard 50mm lens, in the normal mode without mirror box, and detail with regard to identification marks, such as an artist's name, can be recorded using the Visoflex.

The working distance – camera to object – using this set up, is of course very short. For practical purposes it may be necessary to employ a lens of longer focal length to increase that distance in order to permit the insertion of lighting units or other equipment such as object supports. For example, using the Elmarit 90mm, f/2.8, an object measuring approximately 60mm in width (a matchbox) will adequately fill the 24 x 36mm frame with the lens head at a distance of about 24cms. Using a 50mm lens, the object to lens distance is reduced to some 5cms and the portion of the object photographed is reduced to nearly half that seen by the 90mm lens.

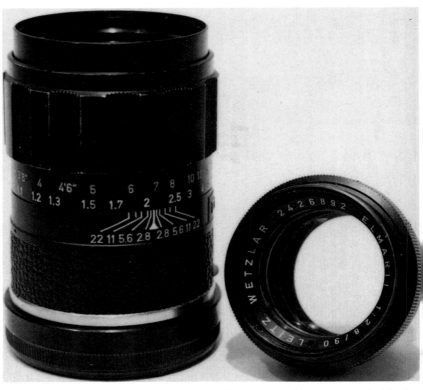

Fig. 105a. The 90mm Elmarit f/2.8 has a removable lens head which mounts on the Visoflex II & III using focusing mount adaptor, code 16 464. By additionally employing tube 16 471, a close up range between 16 to 20 ins. is obtained.

4.2. Telephoto and long focus lenses for the Visoflex

Another extremely useful lens, the Telyt-V 200mm, f/4 (the letter 'V' designating special Visoflex use) was supplied by some dealers boxed with the Visoflex II or III with the correct adaptor ring (OUBIO/16 466)] as a complete kit. That accounts for why many of these complete units are still available today. The 200mm Telyt-V was designed by Walter Mandler and built almost exclusively at the Canadian plant in Midland. It is a fairly simple four-element lens, in which later models have the diaphragm blades fitted toward the rear of the lens group instead of at the front. It replaced an earlier version of the Telyt 20mm. f/4.5 and was widely acclaimed for its excellent colour correction. It remained in production until the demise of the Visoflex III.

Some years after the above lens appeared, Leitz attempted to woo more fans to the rangefinder camp by introducing a 'prestige' lens – the Tele-Elmarit 180mm, f/2.8. A small batch of about 400 were made to fit the Visoflex II, but these were all apparently sold through a New York

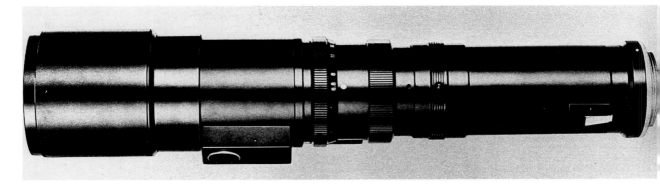

Fig 106. One of the great Leica telephotos, the 400mm Telyt-V f/6.8, which can be used with all Visoflex mirror boxes on Leica-M cameras, as well as on the R-type reflex. Push-pull focusing facilitates rapid handling and a high degree of accuracy.

Fig. 105b. The 200mm Telyt f/4 designed by Walter Mandler has extraordinary resolving power and colour correction as can be seen easily in this enlargement of a small section of the original colour transparency.

Leitz dealer in 1966 without being catalogue listed. It's a heavy lens having five elements, of which three are cemented, and of considerable bulk. The design was adapted and taken into production for the Leicaflex which had been introduced two years earlier. Perhaps Leitz marketing felt that the weight of this lens – more than a kilo – would be of no interest to users of the delicate rangefinder. How wrong they were! At the time, the lens was much sought after. Some 30 years previously, in 1936, Zeiss had recognized the need for just such a lens and introduced the 180mm, f/2.8 'Olympic' Sonnar for the games and Leni Refenstahl. The same year and for the same reason perhaps, Leica's Telyt 400mm, f/5 prototype was used

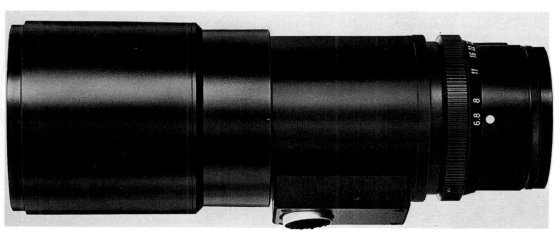

Fig. 107. The 400mm Telyt f/6.8 lens head detached. The larger 560mm can be used on the common tube.

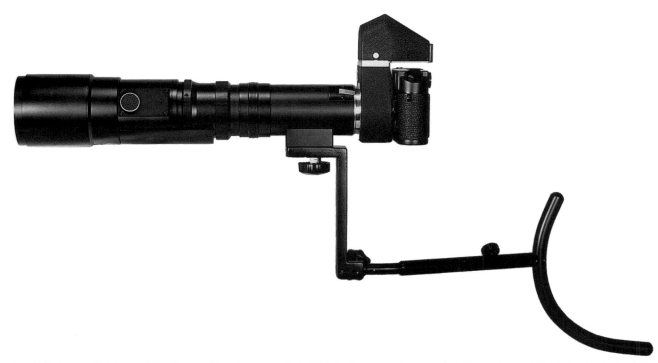

Fig 108. 400mm Telyt complete with shoulder stock mounted with tube [current order code 11905, previously 14167] fitted to a Visoflex III. Note the considerable gap between camera top plate and underside of the Viso 90° finder.

Fig. 109. The entomology specialist will find working in the field with the Visoflex simple and straightforward, the brightness of the screen permits rapid hand-held operation.

Fig. 105c. The 200mm focal length is one of the most useful for photographers covering a wide variety of subjects, especially those which cannot easily be approached or where it is important to retain proportion and apparent scale of certain objects.

Telyt 400mm, f/5 prototype was used at the Games.

But it was to be another two-and-a-half decades before a mid-range telephoto, the Telyt-V 280mm, f/4.8 became available. This is a similar 4-element design to the 200mm. It appeared in three different mount styles and was discontinued in 1984. The lenshead could be removed for use on the Televit and Focorapid quick focusing devices.

In 1966, the Telyt 400mm, f/5.6 and the Telyt 560mm, f/5.6 appeared. These were basic lens heads of achromat doublet design, i.e. not of telephoto construction, and could only be used with the Televit rapid focus device. Simple achromats like this do exhibit cur-

vature of field, which at the relatively wide aperture of these lenses was quite apparent, although it was said by Leitz that it did not affect the primary application of them in sports and wildlife photography. However, the apertures were reduced to f/6.8 for both lenses in 1971 to improve image quality across the entire field. At the same time the lenses were provided with a new rapid focus mount comprising a front lenshead barrel which slides back and forth in a parallel guide mount. A button releases the infinity lock, thus permitting the extremely light-weight push-pull action to come into play. The lens tube is common to both the 400 and 560mm lens heads and con-

tains the diaphragm unit, a filter slot and rotating tripod mounts.

The rapid focus tube is used in conjunction with the Visoflex II and III by means of a special intermediate adapter (code 14 182).

In 1973, another achromat, the 800mm Telyt-S, f/6.3, was made available. This one has three cemented elements. All three lenses were also produced for the Leica reflex system, but ceased to be available in Visoflex form in 1984.

Disregarding the special case of these two doublet achromats, where a reduction in maximum aperture reduced field curvature, the Leica user should remember that ALL Leitz and Leica lenses may be used at full aperture without risk of impaired

image quality. I know that it has long been an unwritten law in photography, especially with regard to some other makes of lens, that stopping down shows a marked improvement. This is definitely not the case with Leica lenses, although, as I have mentioned already in Chapter 2, some Leitz and Leica lenses may benefit in the marginal correction of coma or vignetting – a problem which affects all photographic lenses to a greater or lesser degree.

These longer lenses, being achromats with only two cemented elements, are not of telephoto construction, so they are nearly as long as their focal length. They are intended for wildlife, sports subjects and photojournalism where slight curvature of field would not show. For some subjects, such as architec-

ture with flat subjects filling the frame, curvature of field would be noticeable. It is certainly more noticeable in the earlier, wider aperture lenses, much less so in the newer lens heads.

4.3. M6 Metering with the Visoflex

Metering in the M6 is through-the-lens, but when the camera is used in conjunction with the Visoflex, the metering can only function with the mirror locked up. For photographers used to the fully automated facilities offered on modern SLR's, the M6/Visoflex combination will come as something of a cultural shock. To operate it effectively, some patience is required. All of the lenses described have the pre-set aperture mechanism. The photographer may

stop the lens down to the desired working aperture and adjust the meter balance by changing shutter speed up or down, or by selecting an appropriate shutter speed which is within the capability of film speed and actual EV values, then adjusting the aperture accordingly.

When an extension ring, combination of rings or bellows attachment are used with the Visoflex, an increase in exposure to compensate for the increased lens-to-film-plane distance is required. The EF – exposure factor – is normally applied when metering using a hand held meter. With the M6 metering system, accurate readings are obtained without the need to apply the EF factor, because the camera meters what it sees through the lens.

Fig. 110. Metering with the M6 fitted with Visoflex is just as accurate as with any SLR camera. When working with subjects such as this, the camera should be tripod mounted so the Visoflex mirror can be pre-released to minimise vibration during exposure.

When using telephoto and long focus lenses, the risk of camera shake is always increased: the longer the focal length, the greater is the effect of shake magnified. The highest practicable shutter speed should always be selected when ambient light levels permit. It is possible, however, to employ very slow shutter speeds with long focus lenses and obtain perfectly usable sharp photographs, without the aid of a tripod, using the camera hand-held. As the meter of the M6 measures only a small central portion of the image field (13%), very accurate exposure readings can be made of important areas. These should be noted down for really difficult subjects and integrated to provide the optimum shutter speed and aperture settings. When time is short and the photograph has to be taken quickly, the M6 meter can be relied upon to produce accurate readings under difficult back-lit conditions.

When the camera and lens are used for close-up photography, the rig should be tripod or stand mounted to obtain the most secure support. The nature of this type of photography is more meticulous and often demands more time and patience. Using the mirror lock up procedure, exposure settings can easily be noted and selected for any required result. Simple but effective tests using Polaroid instant Polapan or Polachrome film in conjunction with the table-top processor may also be employed in particularly difficult lighting situations. To make the best use of this material, accurate records should be kept which note the lighting set-up, its distance from the object photographed, types of diffuser if any, power settings of flash guns and the shutter speed and aperture used for each frame or series of frames exposed. Each Polapan or Polachrome frame can be annotated with the briefest of details to provide an accurate visual test record of the likely final result using the final film stock.

4.4. Alternative non-Leica lenses for the Leica-M

As the Leica inspired others to copy it, so it also inspired some to want to add to, modify and expand the accessory range. One firm in particular which has been closely associated with Leica for many years is that of Karl Muller of Memmingen. If that name is not familiar, the company's trade name of 'Novoflex' certainly will be. That was the name given to Muller's mirror reflex box 'Nobal' which was available to Leica users as an alternative to the PLOOT in the 1940's. Up until the early 1960's it was offered as an alternative

Fig. 111. The M6 meter measures approximately 13% of the image field at the centre. Circles in this illustration indicate the basis for metering to maintain sufficient detail in the highlight areas

Fig. 112. Novolflex 400mm f/5.6 Rapid Follow Focus-B coupled to Leica M4-P using Visoflex II with PRALEI+VISBA adaptors. (see text). The unit is also fitted with PISTOCK. Focus lock nut is clearly seen above left forefinger; diaphragm adjustment is by scalloped ring just behind lens head. This is one of the most efficient and accurate rigs for long-distance photography, perfectly hand-holdable at shutter speeds down to as low as 1/60th second.

to the Visoflex I & II. Other mirror boxes, notably the Kilfitt 'Kilarflex' were also available, and by this time, Muller had turned its attention to a wide variety of other products for the photographic world. Subsequently, the name 'Novoflex' was used for all of the company's products.

Today, Novoflex are world famous for their 'Follow Focus' long focus lenses and for their comprehensive range of automatic and manual extension bellows, which can be fitted via adaptors to a vast range of cameras. As precision instrument engineers, the company has a long-held reputation for products which are machined and finished to the highest standards. In this respect, they are well matched to the Leica-M and the user can be assured of fitment accuracy and long term reliability. As with Leica, the number of products introduced by Novoflex over the years has been considerable. In order to identify accurately all the various adapters, lens components and close-up attachments, Novoflex, like Leica, devised a system of codewords and numbers. One or two may be mentioned in the following text as examples specifically related to Leica-M use. For a fuller explanation and product code list, the reader should contact the nearest Novoflex distributor. (see address section at back of book.)

Leica-R users will be aware that the Leitz sliding rapid-focus mounts for the f/6.8, 400mm and 560mm lenses were replaced in 1990 by the Novoflex Super-Rapid-Follow-Focus grip. This is the latest version of the original 'Follow Focus' device first manufactured by Novoflex in 1956, predating the Leica Televit by ten years. The later Leica sliding mounts of 1971 were based on a design by Novoflex for medium format and 35mm cameras which was in that company's product list some 35 years ago. This was subsequently replaced by the Novoflex Rapid 'Follow Focus' Pistol grip which incorporated a comfortable slanted pistol grip housing a long focusing trigger. Squeezing the spring-loaded trigger with the left hand while holding the camera with the right changed the focus range from closest focus towards infinity. The trigger was linked through an enclosed ball-bearing-filled guide to the main lens tube, to the rear of which the camera was mounted, and to the front, the lens head. Focus could be secured at any stage by turning a milled locking nut either side of the tube just above the trigger grip. In addition, a chest pod arrangement (PISTOCK) could be mounted on a spigot under the lens tube and secured by locking nut to the base of the handgrip, thus providing an absolutely secure arrangement for hand-held photography and which enables extremely slow shutter speeds to be used with a very low risk of camera shake.

Interchangeable lens heads, similar to the Telyt type, enabled the photographer to expand the lens range without the need for changing the focus unit. Lens heads in the range from 240mm through 300mm and 400mm to 640 were available with the early models. Subsequently, the 240 and 300mm heads were replaced by a single 280mm unit. (Two other focal lengths of 240mm and 500mm with apertures of f/5.6 each were also available for medium format cameras as well as various adaptors suitable for use on a wide range of 8mm and 16mm cine cameras.)

The following is a list of older Novoflex lens heads suitable for use with the squeeze focus pistol grip [PIGRIFF].

A. Lens head Noflexar f/4.5, 240mm, focus range 2.75m to inf.
B. Lens head Noflexar f/5.6, 300mm, focus range 4.45m to inf.
C. Tele-lens head Noflexar f/5.6. 400mm, focus range 8.1m to inf.
D. Tele-lens head Noflexar f/9. 640mm. focus range 19m to inf.
E. Lens head Noflexar f/5.6, 280mm, focus range 4.2m to inf.

The same PIGRIFF focus unit is used in all cases, but various adaptors are required to allow correct infinity focus with all lenses. In the case of A, B & E, the preset diaphragm unit and control ring is set in the lens head and is not removable. With C and D, a separate diaphragm unit [PIFAS] is employed between PIGRIFF and the 400 & 640mm lens heads, and in the case of the latter, an additional extension tube [B-640] is required.

In the late 1970's, the overall design of the pistol grip unit and the lens heads which it could mount was changed from the single Luger style grip to a twin vertical grip type. The new system is called Novoflex Super-Rapid-Follow-Focus C. The essential features of squeeze focus were retained in the main grip, but several additional features were incorporated. These included a mechanical or electrical cable release facility fitted to the swivelling front grip, drop-in filter slot in the top of the lens tube, and a variable extension tube facility at the rear of the grip. This could be fixed at the infinity position or at any other position up to the closest possible focus extension of the lens in use. Focus lock is achieved by turning a single large diameter milled ring on top of the lens tube above the primary grip.

Earlier versions of the Novoflex (models B & U.) did not have the built-in close-up facility; instead, separate extension rings or the adjustable Novoflex bellows could be used for the same purpose. The PISTOCK system is still available for the new model, as are matching bayonet fitting lens hoods for each lens head.

Shortly after the new Super-C version appeared, a replacement for the earlier 240, 300 and 280mm lens heads was introduced, featuring an

Fig. 113. Canada Geese, Novoflex 400mm f/5.6, 1/500th sec. at f/6.3.

optically convertible f/3.8, 200mm lens head and pistol grip unit. Essentially similar to the first PIGRIFF type, it used a forward sloping squeeze grip which is lockable. A macro/close-up facility was offered by the introduction of a special tube [MACTUB], but instead of offering an alternative lens head to increase the focal length, Novoflex introduced a matched 1.5x tele-extender which effectively increased the length to 300mm and reduced the maximum aperture to f/5.6.

The Novoflex Rapid-Follow-Focus Lens 200/300 was an entirely separate unit, incompatible with earlier or later lens heads. It could still be used with Novoflex Universal Bellows in conjunction with a reduction tube [LEIAN-3.8] and fitted to the Visoflex II or III models with the Novoflex VISA adapter.

This lens unit is no longer in production, but second-hand or unused stock may still be available from some dealers. The technical specification is as in chart.

The reader will have noticed from the above that there is an additional 400mm lens head and two longer focal lengths listed above. To deal with these in perspective, it will be as well to understand the optical design of Novoflex lenses. They are not of telephoto design. A telephoto lens is one in which the focal length exceeds its back focus; its design is comprised of a positive front element and a negative dispersing rear element, widely separated. In

NOVOFLEX LENSES

Focal length	Type	Aperture	Angle of view	Focus range
200mm	Noflexar	f/3.8-22	12°	1.75m – ∞
300mm	200mm+1.5x	f/5.6-45	8°	1.75m – ∞

The current line up of Novoflex Super-Rapid-Follow-Focus C-type lenses is available from distributors world-wide, together with self-adhesive decals which can be used to change the overall colour of the lens and grip units. The specification is as follows

Focal length	Type	Aperture	Angle of view	Focus range
400mm *	Noflexar	f/5.6-32	6°	1.9m – ∞
400mm	T-Noflexar	f/5.6-32	6°	1.9m – ∞
600mm	Noflexar	f/8-32	4°	4m – ∞
800mm	400mm+2X	f=1:11	3°	1.9m – ∞
1200mm	600mm+2X	=1:16	2°	4m – ∞

Focal length	Length overall	Weight	Close-up image area	Ratio
400mm	40cms	2210g	132 x 88mm	1:3.6
400/3mm	43.5cms	2350g	132 x 88mm	1:3.6
600mm	58cms	2500g	195 x 130mm	1:5.4
N-600	23.5cms	650g		
TEX	4.5cms 130g			
400mm+TEX			66 x 44mm	1:1.8
600mm+TEX	97.5 x 65mm			1:2.7

* This lens head (see text) was discontinued from approx 1990.

modern telephoto lens construction, the actual distance between front lens vertex and the plane of focus can vary from 65% – 80% of the stated focal length of the lens. In the Novoflex construction, like the Leica achromats described above, the optical design comprises a positive and negative element cemented to form a highly corrected achromat lens of long focal length. i.e. a lens in which the focal length is equal to the distance from the nodal point of admission of the lens to the point at which the sharpest image is possible.

This form of construction inevitably means a comparatively long physical length for a focal length in which the telephoto equivalent would be shorter and more compact. Telephoto lenses which employ inner focusing – whereby one or more elements grouped toward the rear of a lens can alter focus by means of a sliding cam mechanism – can be made even smaller. The problem in lenses of this type is that the optical construction is so complex it calls for additional compensatory elements, which, while providing exceptionally sharp images of the main subject, can have the effect of doubling or blurring slightly out-of-focus backgrounds.

More sophisticated lenses in this category tend to be extremely expensive, those with very large maximum apertures even more so. The use of exotic modern optical glass necessary to reduce chromatic aberrations to a minimum also increases the weight significantly, in some cases to the point where the lens can no longer be hand held for more than a few seconds at a time.

I have used different examples of this type of lens over the last ten years or so to cover yachting events, football and the Olympics. My considered opinion is that 90% of photographers' needs can be covered by the 300mm focal length. At this size, large aperture apochromatic lenses have just about reached the limit of

practical hand-holding. Beyond this length, lenses with a maximum aperture of more than f/4.5 almost always need support in the way of a monopod, and once beyond the f/3.5 limit, they definitely do!

Granted, there are bound to be assignments which call for this type of lens. It will be a rare occasion if the reader sees a 'sports' photographer toting anything less than a 400mm, f/2.8 autofocus lens these days; they are *de rigeur* in the industry and no amount of persuasive argument to the contrary will persuade practitioners otherwise.

Nevertheless, there are areas in sports photography where exotic lenses of this type are not only unnecessary, but a burden, especially if they cannot be used comfortably, accurately and reliably in a hand-held situation. The Novoflex Follow Focus type has all these advantages (see also Chapter 8).

Being of simple optical design, backgrounds are rendered exactly true to life without the distracting double highlights and double imaging effects described previously. The lens head does not turn, nor does the barrel, it simply glides smoothly backwards and forwards along the optical axis. The screen image snaps in and out of focus easily; with practice, the expert can follow a bird in flight and keep it accurately focused with ease. The diaphragm unit in a Novoflex lens forms a perfect circle at whatever aperture is selected for use, thus there is no risk of misshapen backgrounds appearing in the zone of sharp focus. The whole unit is light and easily carried; it is perfectly balanced when fitted with the camera body. Hand-held exposures down to 1/60th second are possible using the 600mm lens head and extension, less with the 400mm. Early models of the Novoflex can be divided into several components for travelling. Current Super-C models have bayonet mounted components throughout.

The resolving ability of modern high speed film emulsions are such that these can be used to maintain high shutter speeds in lower light situations while making maximum use of the Novoflex apertures. Progressively slower shutter speeds permit the lens unit to be stopped down, thereby increasing depth of field. However, it should not be forgotten that these lenses with essentially the same specification, have been used by professional and amateur photographers for almost 40 years with a very high degree of success in covering sports and wildlife subjects.

While Novoflex supply the Rapid Follow Focus unit to Leica for the Telyt lens heads, they do not, and never have manufactured the lens head. These are made at Leica GmbH, Solms and employ special glass elements cut, ground, polished and coated by Leica from blocks supplied by Schott Glaswerke of Mainz. The Novoflex lens heads comprise the 400mm T-Noflexar f/5.6, which is of triplet construction to make a single long focus lens, and the 600mm f/8, which is an achromat of doublet construction. The lens heads, already fitted with polished and coated elements, are supplied to Novoflex by a specialist subsidiary of Messrs. Agfa at Altenstadt.

The reason why the Leica version of the 400mm lens is a stop slower has to do with aberrations caused by curvature of field which, in the original Novoflex doublet version, is quite pronounced at the edges of the field. Leica corrected this by reducing the maximum aperture to f/6.8. Novoflex accomplished the same effect by adding an extra element, hence the triplet. But this lens has also been available (as a more expensive alternative) to the doublet version for more than 20 years. The introduction of new coatings over the years gradually improved image quality – especially for colour photographers – to the stage where the

Paris. Two devices – isolation of colour, and camera movement
during a slow exposure – have been used to give a fairly ordinary
subject an extra dimension.

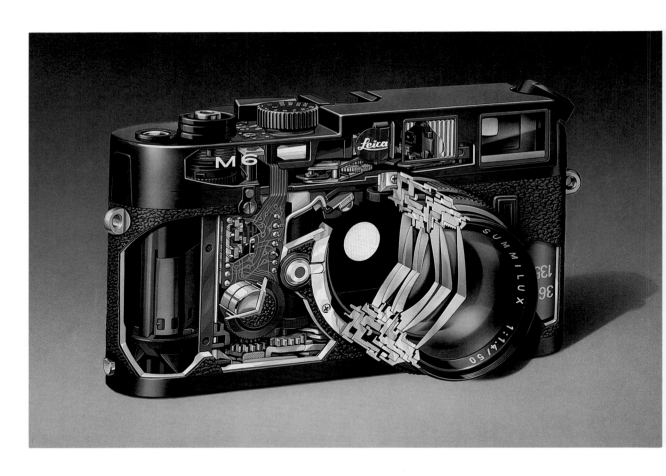

Left: This factory cutaway shows the complexity and solidity of construction of the Leica M6. The collecting lens for the meter can be seen linked to a tiny CPU and PCB film connector. A power failure or meter fault will not affect camera operation which is entirely mechanical.

A short telephoto lens like the 90mm, f/2.8 Elmarit can be a useful addition to the Leica-M users armoury. In the picture above an aperture of f/4 was used to isolate the first marine from his colleagues, effecting a strong focal point for the viewer while maintaining subject recognition over the whole frame. Opposite the same lens was used to isolate detail, providing a useful bold image in a set of pictures covering many different aspects of the subject.

Top. The difference between these two photographs is just discernable in the original Kodachromes. Colour rendition, edge-to-edge sharpness, and resolution are virtually identical; shadow detail is marginally more apparent because of slightly lower contrast in the left hand picture taken with a 5cm, f/1.5 Summarit, manufactured in 1956. A 50mm, f/2 Summicron-M was used for the right hand picture. Both exposures on same roll at ½₅₀th sec. at f/6.3.

Middle and bottom. These four pictures rely entirely on variations of the colour red, used in a more formal manner but heightened by the use of neutrally coloured surroundings in the upper pair. The lower left picture illustrates how the use of a particular colour can help create order within the chaos of geometric patterns, while in the lower right one the colours of the bike are apparently heightened when placed against one of total contrast.

Right: The Winter Palace, St Petersburg, Russia. The photographer stepped back from the facade to maintain parallel vertical planes while using the building's impressive design features in the composition. 90mm Elmarit-M, Kodachrome 64.

Top left: Force 10 Channel Gale. In these conditions, the camera will need some degree of protection from flying salt spray. 50mm, f/2 Summicron-M. Kodachrome 200.

Lower left: Paris. 35mm, f/2 Summicron-M. Kodachrome 25. A weak, hazy late afternoon light dropped exposure to 1⁄60th sec. at f/4. Detail in the chairs, even in the extremities, is phenomenal. I probably use this lens more than any other for the bulk of my work: its angle of view seems perfectly suited to the 35mm proportions of the 35mm format.

Above. Mountains at dawn. Provence. Kodachrome 64, 40cm, f/5.6. This picture was hurredly made from the hard shoulder of the motorway, with the barrel of the lens perched on a coat on the car roof. Focus was locked and several frames exposed at 1/60th sec. at f/6.3.

Overleaf. Fire-eater , Juan les Pins. 35mm Summicron-M on M6. Kodachrome 64, 1⁄15th sec. at f/4. On an evening stroll through the town I was suddenly confronted with two gentlemen forcefully ejected from a nearby drinking establishment. One was a dragon, snorting, roaring and rolling uncontrollably towards the gutter. I made two frames in quick succession, having some time earlier set the distance scale to about 7 feet. It was a case of point, shoot and hope. This was the picture from the first frame, made with the camera outstretched. The second frame was jarred by a pedestrian hurrying past, presumably endeavouring to escape the heated wrath of my subject, who subsequently tripped and rolled horizontally into his private world of fantasy.

Poppies near Cavalieres. Kodachrome 64. 135mm, f/2.8 Elmarit-M. Using the selective metering field of the M6 enabled accurate exposure of the red field while underexposing the tree trunks. Their apparent blackness helps to heighten the colour effect, while an additional gain is made from the overall geometry of vertical and diagonal shapes.

Photophantazo, Antibes. 35mm, f/2 Summicron-M. Kodachrome 64. I had been struggling to capture the character of a tiny and seedier corner of Antibes, epitomised by run-down properties, when the truck halted momentarily. Several seconds elepsed before I could see the whole picture. The plane arriving at Nice a few miles along the Riviera was a bonus.
Then my illusion was gone.

Take off. 400mm Novoflex with Visoflex II. Only one picture
during the 30-second run up to lift-off could illustrate the power
and grace of this aircraft, but there was time to get off several
frames.

Sardinian horse rider. Where all the action peaks at a fixed point,
the Leica-M and Visoflex user has time to pre-focus accurately
from a selected viewpoint.

El Puerto de Santa Maria, Spain. Kodachrome 25. Leica M6, 5cm, f/1.5 Summarit. Early morning; the grey, drizzly light conditions under which the 30-year old Summarit often excels.

Above. Painted construction site hoarding, Goteborg, Sweden.
Leica M2, 5cm, f/2 Summicron, Kodachrome II. At the turn of the
century, boat loads of Swedes departed the old country for the
New World. It evoked memories of my own dozens of departures
by sea, imagined but never seen..

Overleaf. Phaire de la Coubre, France. 21mm, f/3.4 Super-
Angulon, Leica M6. Kodachrome 64. Lighthouses fascinate, like
bridges and ships. The hike up more than 300 steps was worth it
for the view, but endeavouring to capture the seemingly endless
helix proved more difficult. Leaning out over the bulustrade to put
the camera as near to the axis as possible induced spasms of
vertigo; a situation where the use of a monopod would have
helped in providing the extra length required.

NOVOFLEX TO VISOFLEX ADAPTERS

Type of grip	Grip to Visoflex adapter	Usable lens head
PIGRIFF 400mm/[triplet]).	VISLEI-P 300mm,	400mm & 640mm.(also screw head
PIGRIFF-B	VISBA*	280mm,400mm (2 & 3 element version) & 600mm
PIGRIFF-C (1980 on)	VISA**	400mm (code:LINSE400) 400mm (code:LINSE400/3) 600mm (code:N-600) 560mm, f/6.8 Telyt+

* Later versions of PIGRIFF-B employ a bayonet mount at the rear of the grip for attachment of camera-to-lens-tube adaptor. VISBA is the correct mount for these versions. Earlier PIGRIFF-B models used the screw thread mount of the earlier PIGRIFF. For this model, PRALEI + VISBA is required. PRALEI converts the screw to standard bayonet and VISBA retains the rotating landscape/portrait facility offered by the original VISLEI-P.

** Super C models can be connected to the Visoflex II & III using this adapter. However, they will not focus at infinity. Novoflex can make the necessary modification for approximately DM300, at the time of going to press.

+ The Leica 560mm Telyt can be directly connected to the PIGRIFF-C grip and lens tube. Modification to the Novoflex part is required for infinity focus.

level for the past few years has been beyond reproach.

To increase the effective focal length from 400mm to 800mm and from 600mm to 1200mm, the special tele-extender TEX was introduced. This item has been specially computed to match the Novoflex optical design and is of the highest quality. Maximum aperture is reduced to f/11 and f/16 respectively, but there is no further need to stop down the lens.

Novoflex manufacture adaptors which permit the Rapid-Follow-Focus systems to be connected to Visoflex II & III as in table above.

4.5. The LEINIK-M widget

According to the Novoflex product list, there is no such thing as the LEINIK-M. There is, however, an adaptor ring which permits the coupling of a variety of camera lenses to the Novoflex Universal Bellows. The lens standard of the bellows has a 39mm thread, the same as the old Leica screw mount. By chance I came across an adaptor which permits Nikon lenses to be fitted to the bellows; it is called LEINIK.

I have been able to use Nikon lenses on the Leica-M for several years, initially by cobbling together a Nikon extension ring, into the back of which was fitted a Leica-M mount. It worked in as much as infinity focus was maintained, but the whole affair

was somewhat Heath Robinson with a highly suspect camera lens mount locking device. So much so that on returning home late one night with the camera around my neck, I stepped across two pontoons in a hurry. The shock must have flipped the camera upwards and as it did so, my prized 55mm Nikkor f/1.2 went for a trip to the mud – luckily the tide was out. The lens was retrieved and after a major stripdown on the galley table was soon back in service where it belonged – on an F2! Since then, I had been on the lookout for a more secure custom-made adaptor.

When the LEINIK came up, it struck me that Novoflex could help out by making an exact copy with the

appropriate Leica-M bayonet fitting. The problem was that the original LEINIK was only 16.5mm thick; to obtain the correct Nikon lens back-mount-to-Leica-filmplane distance, a mount some 18.7mm thick was required. In due course, the special mount which I have dubbed the 'Leinik-M', arrived and was put to use. It is of the highest precision engineering quality, a perfect companion for the Leica-M.

Well, I can hear the purist asking (or are they roars of disapproval?) why anyone in a right frame of mind would want to use anything but Leica lenses, especially on a range-finder. Lenses designed for other makes add a bit of extra bulk and in its present form, the Leinik-M does not permit coupled rangefinder focusing. So why bother?

This has nothing do with the quality- of Leica lenses. I have already stated my case very much in their favour. It has to do with simple preferences. When black-and-white photography formed the greater part of my daily output to newspapers and magazines, the bulk of it was shot using Nikon lenses, especially the older C and S.C. types (see Nikon Compendium, Hove Books, 1993.). I found the Leica lenses of that period

Fig. 115. Leica M4 with 55mm Nikkor S.C. f/1.2, fitted using custom made Novoflex Leinik-M adaptor.

produced a softer, lower contrast image than the one I was used to. Film processing and printing techniques were also geared in favour of the high contrast black-and-white image. Long time Leica users will insist that this kind of contrast is perfectly possible using Leica lenses, appropriate film and processing and printing techniques.

Be that as it may, I am not the first photographer to recognize the fact that Nikkor lenses have a quality all their own, just as Leica lenses do. Nowadays, I am just as likely to use the lens designed for the camera as I am the Nikon alternative. Each type has its own special characteristics

Fig 116. Black and chrome versions of the 21mm Super-Angulon f/3.4 with custom fitted oculars. The conversion can be used with Leica M4-2 and M4-P camera models fitted with the 28mm projected bright-line frame finder. Restrictions apply to the M6 (see text).

and the knowledgeable student will use these tools in a purposeful and creative manner to achieve a desired result.

4.6. The Abrahamsson 21mm Super-Angulon f/3.4 with goggles

To quote the inventor of this piece of optical wizardry, Tom Abrahamsson of Vancouver B.C., 'Everybody who uses the M-Leica gets seduced by the "ultra wide" look of the 21. Most of us love the lens and hate the finder. It keeps falling off, it breaks, it costs a fortune to replace and it forces the shooter to move the eyes from a focus to a frame position.'

Having lost, cracked and stepped on a king's ransom worth of 21mm finders, Abrahamsson set out to solve the problem once and for all. He approached Reinhold Mueller, a

Leica service expert based in Toronto. Theoretically, by taking the ocular attachment (goggles or spectacles in photographer speak) from a 35mm Summicron designed to fit the Leica M3, and mounting them on a 21mm Super Angulon, it would be possible, by changing the M-lens

Fig. 117. This illustration approximates the extent of the image field of the 28mm bright-line frame when using the Abrahamsson 21mm Super-Angulon f/3.4 ocular conversion and is approximately equal to the field of view of a 22mm focal length between left and right outer perpendiculars.

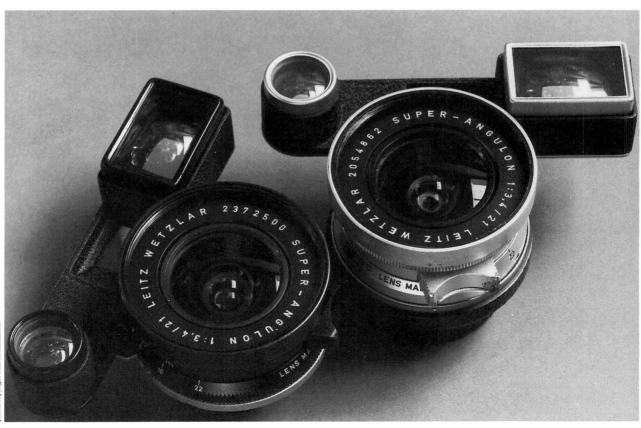

Fig. 118. It's on occasions like this, in a jostling crowd, that independent finders can be lost or damaged. 21mm Super-Angulon f/3.4.

mount on the 21mm to one which brought up the 28mm projected bright-line frame, to have the perfect 21mm viewing frame incorporated in the camera, with the added benefit of accurate rangefinder focusing.

Mueller took the idea and performed the necessary surgery, which involved quite a bit more machining than Abrahamsson had at first envisaged. Nevertheless, the finished product works perfectly with no more vignetting in the camera finder than there is in the independent version. The Abrahamsson 21mm is easier to use for the very reasons he has stated; doubtless the idea will appeal to a good many photographers who are fed up with losing or having to replace finders.

But why use a discontinued lens? The main reason is that the lenshood of the current 21mm Elmarit blocks too much of the projected bright-line frame in the window. The modification can be done however. The 21mm Super Angulon f/3.4 is the ideal choice for modification, partly because of its extremely compact size and partly, but no less importantly, because from an optical point of view, it is one of the best performers in the Leica lens range. (see chapter 2 for M6 restrictions.)

Leica-M Accessories

Considering the relatively low production runs of the Leica-M, I find it fascinating to note the extensive range of ancillary equipment manufactured by Leica and others over the years. A large proportion of accessories listed in older product catalogues have long since been discontinued, or have changed both in design and identification. Those which had short lives, and consequently fairly short production runs, have slipped into the collector's net. When they are available now, through regular dealers, price often reflects the scarcity value irrespective of condition. Curiously, some items which had longer lives would appear to have vanished altogether.

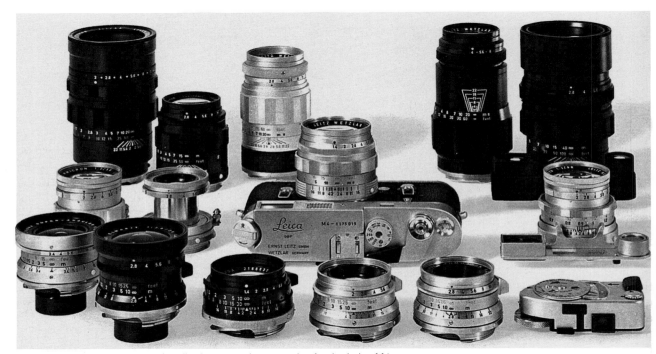

Fig. 119. A fascinating range of earlier lenses and accessories for the Leica M4.

A useful item such as the SDPOO/14 002, the detachable ocular viewing device for the 50mm Near Focus or Dual Range Summicron (see Chapter 2.) is a case in point. It would seem that huge numbers of lenses were sold without the optional extra ocular (total production 55,145 units). One supposes that Leitz made a high proportion of close-up attachments for the lenses. If they were not sold, what happened to them?

The need for such an accessory today is limited. There are other ways to get close. On the other hand, an item like the original Leicavit mechanical rapid winder, made originally in 1951 and fitted as a standard item to the Leica MP, would probably be more popular than the current electric Leica Winder. A non-Leica version of the Leicavit is currently available and being snapped up faster than production will permit. (see below.)

Some accessory items, such as independent viewfinders and reflex mirror boxes have already been discussed (Chapter 4.). The following is essentially a list of accessories currently available from Leica or third party manufacturers which may be of interest to the user. The student would do well however, to bear in mind some of the Leica rangefinder's great assets. In its simplest form, i.e. with a lens but without other bolt-on accoutrements, the camera is a fully integrated and highly sophisticated instrument with special ergonomic attributes. It is light, compact and virtually silent. Anything which is added to this concept, which must be near perfection, will not necessarily

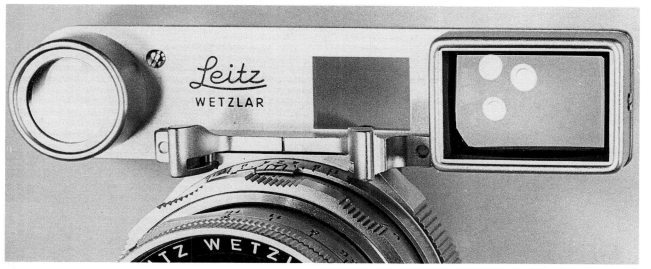

Fig. 120. SDPOO detachable ocular for the Near Focus 5cm Summicron f/2.

Fig. 121. Leicavit MP mechanical rapid winder.

improve its performance or make it more efficient in every respect.

Some items may be useful from time to time, the Leica Winder for example. But the benefit of marginally increased speed in film transportation sacrifices compactness for bulk. Special hand-grips said to improve the handling of the Leica-M are, in my view, gimmicks, but some photographers seem to like them. A more useful accessory which does not have to be permanently fitted and which can serve two purposes is the Leica Lens Carrier-M

5.1. Leicameter MR-4

The product code is 14 217, chrome, or 14 218, black chrome.

Several different versions of the Leicameter have been produced since the introduction of the original Leicameter-M in 1955. The MR-4 was discontinued in 1988 with the

demise of the Leica M4-P, but it is still widely available and is the best of all the clip-on meters made for the M-series cameras. The MR-4 is also listed under M4-P system guides as the Leicameter MR (code 14 218) and should not be confused with the 1966 version (14 210) or earlier models. Leiameters MR and MR-4 are identical except for the finish, chrome or black.

This is a battery powered Cds meter which slips into the accessory shoe on the camera top plate and couples, via a spigot, to the camera

Fig. 122. Leicameter MR-4, code 14 218.

shutter speed dial. The measuring sensitivity extends from 0.5 to 32.000 cd/sq.m and its selective measuring area is equivalent to that covered by the 90mm Leica-M lens. To view the area when the meter is fitted, use the preselector lever to bring up the 90mm projected bright-line frame. Align the projected frame with the area to be metered and read off the aperture indicated. As the meter is linked to the set shutter speed, the photographer only needs to transfer the indicated f/-stop to the aperture setting ring of the lens in use.

The sophistication of this meter permits the reading to be stored. The on/off switch is of the sliding type and situated on top of the meter, conveniently placed for the left hand forefinger. The meter has a dual range metering scale for high and low light levels. The meter was sold with a protective leather case and, being very small, it can be conveniently carried in a pocket until needed. Photographers in a hurry and wearing more than one Leica-M will probably not want to leave the Leicameter MR-4 fitted. The risk of damage to the dial and glass cover is quite high when two bodies are bouncing together.

5.2. Leica Winder-M for M6, M4-P, M4-2 and MD-2.

The current product code is 14 403. Some photographers have to have it. The current type is a development of the first compact version (1976) to follow the electric Leicamotor developed for the M2 in 1967. Instead of a separate battery pack, which effectively tripled the height of the whole camera and motor unit, the new compact models used micro motors powered by four penlight 'AA' cells.

The first versions (code 14 214), designed for the M4-2 camera, could be used at all shutter speed settings and provided a maximum frame advance of 2 frames per second. The film transport rate was increased in subsequent models to 3 fps. The specification is the same for the current Leica Winder-M. Unlike the R-series motors and winders, the release on the Leica Winder-M is mechanically coupled to the shutter release of the camera. Depressing the shutter release once fires the camera, advances the film and re-tensions the shutter ready for the next frame. Keeping the shutter release

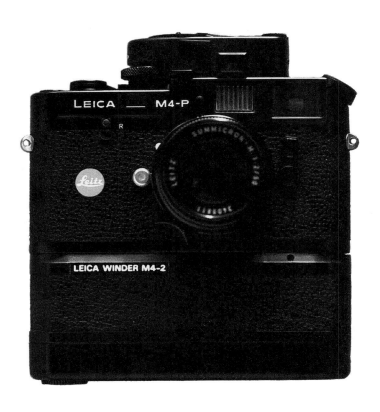

Fig. 123. Fully loaded Leica M4-P complete with Leicameter MR-4 and late serial No. M4-2 winder.

Figs. 124a, b & c. (below and opposite) Sports and wildlife are not the only subjects where the photographer might benefit from the use of an electric motor drive or mechanical rapid film advance accessory. Children are an especially active subject group, making serious demands on a photographer's ability to react to the moment.

depressed after the first frame has been exposed continues the process, if necessary through a complete roll of film at the frame speed already stated. The camera can still be used independently of the Winder in its normal mode with the Winder attached. An on/off switch on the Winder activates this facility.

The Leica Winder-M is ready to use immediately. The camera needs no modification. However, early versions of the M4-2 winder cannot be used on all M4-P's or M6. The table in Appendix II should be consulted before considering purchase of a second-hand winder.

5.3. Leicavit

The Leicavit fits on the base of the camera replacing the base plate. It is a lateral trigger operated mechanism for rapid film advance and shutter tensioning. The first Leicavit was introduced in 1951 and largely based on the pre-war trigger operated winder, SCNOO. Originally it was used on the Leica IIIf and IIIg models. The trigger could be folded into a recess in the base when not in use.

When the prototypes of the M3 were field tested, some were fitted with Leicavit bases as standard (see Chapter 1, MP models). Later they were made available for the M2, M1 and MD cameras, as well as being supplied ready fitted to the Leica MP of 1956. From 1960 to 1966, the trigger base was designated 'Leicavit MP'. It was, and still is much sought after by collectors and users alike. Mechanical winders for the Leica rangefinder first came into use as far back as 1934 when a New York company produced the 'Rapido', comprised of a sprung steel string housed in a replacement film wind-on knob. A year later, Leitz had perfected their own trigger base and this was the concept on which subsequent trigger mechanisms evolved.

There is no doubt in my mind that a mechanical winder of this type can be of great value to the busy press and sports photographer, as well as to the photojournalist. They have several important advantages over the electrical motor type; less bulk and no dependence on batteries. Light rain and moisture do not impair reliability. They are virtually silent in use.

The problem facing today's Leica rangefinder photographers is that the Leicavit MP is now beginning to

show its age. Those that rarely come on the used market are invariably expensive and well used. If you ever see one in a red box wrapped in greaseproof paper with a handwritten stock number on a label.......!

5.4. Abrahamsson Rapidwinder for M4-2, M4-P and M6

Fortunately for Leica-M users, Canadian industrial designer and photographer Tom B. Abrahamsson is one of the rare breed of ingenious and creative people who are never content with what exists. If there is a way to replace, modify or invent, he will find it.

Abrahamsson's RAPIDWINDER began life in the early 1980's when his favourite M2 with Leicavit MP ceased to function. Tom immediately began to design and build a prototype trigger-wind replacement. The case was made from brass in two parts and silver soldered. At first he had problems with the fit because the brass was too soft and had a tendency to warp. Another problem to

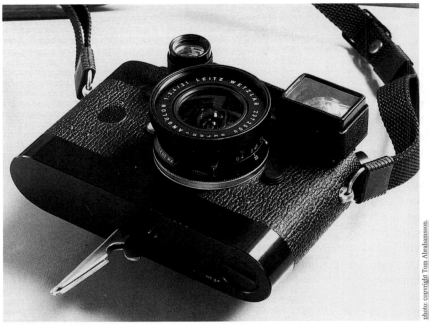

Fig. 126. The RAPIDWINDER fitted to a Leica M4-P, which also has mounted the Abrahamsson 21mm Super-Angulon f/3.4 with ocular. A clutch in the trigger wind mechanism of the rapidwinder allows multi-stroke operation.

which Tom readily admits was that he had no idea of what he was doing; 'Everything was done handbook in one hand, tools in the other'.

Originally, there were ten prototypes which bore fruit in the shape of 164 production models in black- or silver-chrome (24 of the latter). The fitment problem was overcome by the more careful casual-user customers by means of a file and several hours patience. The photojournalist on the other hand was inclined, says Tom, to part fit the winder to his M6 and, using the desk as an anvil, slam! Now it fits.

There was no doubt of the demand for the Abrahamsson Rapidwinder. To cater for it in a more professional manner, the designer set about having the cases machined from solid blocks of titanium/aluminium alloy on a CNC machine (Computer Numerically Controlled). It's the same process used by Leica themselves in machining the diecast bodies of the M6 (as well as some late examples of the M4-P). Interestingly, Abrahamsson says that the machine tolerances are so fine on these cases that a 'slop' factor had to be introduced to permit proper fitting to the

Fig. 125. The Abrahamsson RAPIDWINDER, which is made in Canada, showing the underside (top) with recess for foldaway lever and (bottom) the interior with film take-up spool engaging-wheel, and to the right of it the rapid film advance drive shaft claw.

M6 and M4-P, in which, contrary to Leica specifications, there are minute size differences.

The standard stock product is finished black anodized. It fits the M6, M4-P and M4-2 without modification to either winder or camera. M2, M3 and M4 cameras can be adapted at huge expense – the camera winding mechanism has to be modified.

The advantages of this winder, which is currently in production at the rate of some 150 – 200 per year (some 600 are now in use worldwide) have already been mentioned with regard to the Leicavit MP. The Abrahamsson Rapidwinder has additional features. It is only 14mm tall and weighs 120 grams. It centres the tripod bush. The clutch in the Rapidwinder permits multi-stroke advance (which the Leicavit MP did not) which is extremely useful when shooting in the portrait mode. It is quiet, simple and very rugged.

The cost at the time of going to press is US $500.00. You can order direct from the manufacturer, Tom Abrahamsson, whose address is at the back of this book. Delivery is approximately 6 to 8 weeks.

5.5. Leica Lens Carrier-M.

When this accessory, product code 14 404, was introduced in 1991, there were quite a few raised eyebrows, even among regular Leica-M users. It is probably not the sort of thing that a photojournalist on assignment would have much call for, especially if the Leica body in use is already fitted with a Leica Winder-M. For the casual, the travel and even the street photographer, however, this invention was a bright idea. Perhaps it's true that the simplest ideas are usually the best.

The Lens Carrier-M attaches to the base of any Leica-M camera and is secured by a large knurled screw into the tripod bush of the camera base plate. Models with 3/8" threads can be fitted with a standard 1/4" Whitworth threaded insert.

The idea is that one M-body can carry two lenses in a handy, compact shoulder slung arrangement. The carrier will accept any Leica-M bayonet-mount lens, and when so fitted provides an additional, comfortable grip for really shake-free pictures. A longer focal length lens can be used as a rigid camera support when its head is rested on a solid support, such as a table, making an effective, short monopod. I have used one of these lens carriers since it was first launched and have been glad of it on innumerable occasions. The only observation I would make is that unprotected lenses mounted on the carrier are at a higher risk of damage to the front element when there is a lot of action going on. It will pay to keep at least a lens hood in place when mounting the lens, just to reduce that risk.

I am surprised that Leica did not at the same time launch a companion gizmo to the lens carrier. The design and central position of the carrier mount would be ideal for a rapid-mounting ball and socket swivel head, which could then be attached to a monopod or tripod. A monopod is nearly always useful. With the special bayonet mount swivel head, perhaps Leica should take it one stage further and produce a unique, but secure and quick acting podhead. For those who do not want to risk carrying additional lenses in this fashion, a special M-type handgrip which can rapidly be bayoneted into the mount when required is another idea worth exploring..

5.6. Filters and lenshoods for Leica-M Lenses

A great variety of older and current filters and lens hoods are available. More than anything else perhaps, these are the essential

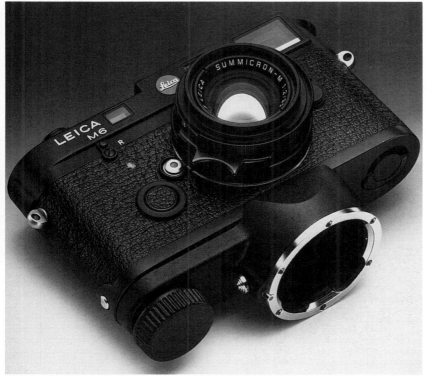

Fig. 127. The Leica Lens Carrier-M, a useful device which can also be used as a camera support.

Fig. 128. The cut-out sections in hood of this older 5cm Summarit f/1.5 type (left) and that of the newer 50mm Summicron f/2 permit unobstructed rangefinder viewing.

accessories that nearly always need replacing from time to time. Fortunately, Leica filters and the specially designed lens hoods are more robust than most other makes. The coatings of the optical flats used to make the filters are resilient to all but the worst kind of continuous punishment. The lens hood design ensures more or less guaranteed protection of the filter rim and the front part of the lens mount as far back as the aperture ring. No other manufacturer produces an accessory of this type suitable for use with Leica-M lenses.

Photographers specialising with black-and-white materials, who like to use a wide range of filters for different subjects, might baulk at the additional cost when purchasing a

Fig. 129. Leica-M lenses use special thin film coatings which absorb ultraviolet rays. Use of the protective UVa Leica-M filter is advised in environments like this to protect lens front elements from salt spray and sea mist.

Fig. 130. Wreck; late evening light. A light yellow filter helped maintain the correct balance of tones between sky and mud

Leica-M lens and filter selection. Just how much difference is there between the red filter of Leica and any other? Will there be any significant difference between a negative exposed through the filter manufactured to match the optical properties of the lens and one which is not? Nine times out of ten, I doubt whether many photographers could distinguish between one and the other. Leica technicians on the other hand will want to go to great lengths to explain the equally complex design computations, materials and methods used to produce perfection. Given the opportunity, I have no doubt that some other manufacturers would want to do the same. At the end of the day, the astute will realise that as good as the optical and engineering quality is, there is also a psy-

chological element at work which persuades most of us that the best is not the best until it is complete in every respect.

Colour specialists must, of necessity, take the broader view. While Leica certainly meet the basic requirements with regard to UV protection and polarised light, as well as a basic range of correction filters, the subtle nuances of colour change and colour cast demand a wider range of accessories. Wherever possible, I try to maintain the advantages offered by Leica-M lenses and their coatings to produce as neutral rendition of the scene as possible, relying only on the UVa filters as a means of protection for the lens. There are often occasions though, when colours and scenes can benefit from special treatment. For this I usually turn to the

Kodak Compensating Correction (CC) gelatin filters, or another proprietary brand known for its excellent quality and size range. The important thing to remember when opting for the latter is to ensure that the filter thread pitch is correct for the lens used.

Cheaper varieties should be avoided at all costs, and not just because of the optical quality of the glass or coatings employed; there is always a real chance of damaging the lens filter thread by mating it to a rim that has been incorrectly or badly machined.

Over the past 60-odd years, Leitz and Leica have produced a vast array of filters and lens hoods. They can frequently be found at camera fairs and occasionally on non-specialist dealers' shelves at sensible prices.

Fig. 131. A different requirement for a more moody picture at the same time of day as in Fig 130, required the use of an orange filter to enhance clouds and deepen sky tones.

They should be inspected closely for hairline scratching caused by improper cleaning as well as more obvious damage to threads and rims.

5.6. Compact electronic flashgun for the Leica-M

Leica lore can be a curious thing. The purists, of which there would seem to be many, have always advocated the rule of 'no flash with a Leica rangefinder'. The more rational minded will have no compunction. 'If you need it, use it'. Odd then, in a way, that Leica do not make an electronic flashgun of their own. Perhaps if they did, the M6 would be blessed with a slightly more sophisticated TTL meter. As it is, the photographer is obliged to use whatever comes to hand, and that is usually the flash gun purchased to accompany an SLR outfit.

In the world of professional photography, only two or three independent electronic companies manufacture the kind of units which stand up to the rigours of every day (and nigh!) use. Press photographers the world over demand a very high standard of reliability, longevity and sophistication. The one thing busy photographers don't have the time or inclination to think about is guide numbers and f/-stops. That equation may be instilled from an early photographic age but the fully automatic portable flash gun has done much to ease the headache in the last twenty years.

Now we are at the point where the microprocessor no longer permits mistakes of any kind. Couple it to a camera with sophisticated TTL off-the-film exposure metering and an equally sophisticated in-camera CPU, and even a small child will be

photo; Hove Collectors Books Arhive

Fig. 132a. In the early 1960's, the heyday of the M-cameras in technical applications before they were overtaken by the SLR, Leitz produced this filter turret for use with the Visoflex II.

Fig. 132. Not all marine subjects need or benefit from the use of filters. Detail in both shadow and highlight areas can easily be maintained with modern film emulsions using special development techniques.

able to make accurately exposed photographs. But wait! The M6 has neither flash TTL metering nor a CPU. It cannot take advantage of the revolution in flash photography which is afforded to most electronic SLR cameras of today.

That's true, but some of the functions offered by modern electronic flashguns can help the M6 user. As a standard piece of equipment – which could also be used by photographers operating a rangefinder Leica as second fiddle to their main SLR outfit – I have selected the Metz Mecablitz 40 MZ2 as the most suitable small portable machine to accompany the M6, M4-P, and M4-2. These three camera models are all fitted with a conventional flash hot-

shoe and standard 3mm co-axial PC sockets. Earlier models do not have the hotshoe facility and the connecting sockets require the use of special, now discontinued, Leitz connecting leads (product codes: COONS-lead connects M1, M2, not M3, & MICOO is a special M3 lead). The M4 uses a standard 3mm socket connection and can be used with the Metz 40MZ2 with standard or coiled off-camera extension lead (see Metz accessory list below).

The Metz 40MZ2 is one of the latest (1992) in a long line of electronic flash guns to come from the German company and has been designed to be compatible with most makes of camera using the Metz SRCA 3000 connecting system, which permits the electronic SLR to transfer essential data to the flashgun. Needless to say, it is designed to work with autofocus cameras too.

Photographers who are familiar with the earlier Metz SCA 300 system will be pleased to know that the 40MZ2 can be connected too, and will perform all SCA 300 functions. The flashgun features a power zoom reflector allowing full illumination for focal lengths of 24, 28, 35, 50, 70, 80mm, which can be manually set. The 40MZ2 has a wide range of partial light level outputs in addition to stroboscopic flash mode with selectable flash frequency. Of special interest to the occasional social photographer or paparazzo will be the 40MZ2's winder and motor drive mode, which permit operation and total flash recycling from 2 to 5 frames per second. With the Leica Winder-M fitted, the M6 is well covered by this flashgun. An easy to use LCD panel on the rear of the flashgun is blue back-lit at the press of a button so it can be read in the dark. It has a memory capacity for up to 9 different flash programmes which can be stored and retrieved and used automatically with the M6. There is a key lock setting which secures data already input so that it cannot be

Fig. 133. Modern electronic flashguns have many variable modes which allow the photographer plenty of room for creativity. Leica M6, 35mm Summicron f/2, Metz 36CT flash set to f/5.6, shutter at 1/8 second. Original on Kodachrome 64.

Fig. 134. The Metz 40MZ-2 electronic flashgun.

erased inadvertently. The power comes from standard alkaline batteries, rechargeable NiCad's or lithium cells. The unit is equipped with a standard SCA3000 adaptor suitable for use with the M6 hotshoe. A coiled extension cord of 1m is an optional accessory which permits use of the gun off-camera. A special SCA slave adapter allows cordless multi-flash operation. The main features of the flashgun are listed below. '#' indicates those features not usable with the M6 and other Leica-M models.

Fig. 135. Photographers working at the scene of accidents or other night-time events will find the rapid recycling rate of the Metz 40MZ-2 an advantage when working with the Leica-M.

Metz Mecablitz 40MZ2

Guide number 40 with ISO 100/21 film and zoom set at 50mm. (GN 46 at 85mm)

SCA 3000 adapter system, compatible with all SCA 300 system functions.

Power zoom reflector with 6 settings (24, 28, 35, 50, 70, 85mm).

Secondary reflector with clip-on light reduction filters. Can be attached to gun when not in use.

Tilt & swivel reflector – 13° to 90° vertical, 270° horizontal.

Integrated autofocus measuring beam. (#)

Liquid crystal display.

IGBT light output control.

Manual flash mode.

Telecomputer mode providing 12 auto apertures with ISO 100/21 film; may be combined with partial light output.

TTL flash mode; may be combined with partial output. (#)

Winder mode (2 fps).

Motor drive mode (5 fps).

Stroboscopic mode.

Cordless TTL flash control (#. N.B. remote flash control possible only using SCA slave adapter)

Partial light output with 25 levels from 1:1 to 1:256 in steps of 1/3rd aperture stops.

Programme function; memory for 9 user-input flash data.

Key function.

Audible buzzer warning.

Ready light.

OK. Correct exposure light emitting diode.

Battery warning.

Automatic power cut-out with manual override.

Power supply; rechargeable NiCad battery or standard alkaline or lithium.

Standard SCA base and 2 light reducing filters included in basic outfit.

Metz product code 0401200.

Metz Mecablitz 40MZ2 compatible accessory list/product code.

Battery charger B-28/ 0010028.

Connecting lead A17 for above/ 0000117.

Filter set 40 – 32/0004032.

Flash bracket 40 – 36/2/0004036.

Set of light reducing filters 40 – 76/0004076.

Mecalux 11/0000011.

Power Grip G15/0000015.

Power Grip G16/0000160.

Bounce diffuser 40 – 23/0004023.

Coiled sync cord 36 – 52/0003652.

Sync cord 1m, 36 – 51/0003651.

Sync extension lead, 1.25m, 60 – 53/0006053.

Sync extension lead, 5m, 60 – 54/0006054.

Case T35/0000635.

Case T46/0000646.

5.7. Other Leica-M Accessories

A comprehensive range of other useful accessories are available to complement the current M6 camera. Some of these items have been listed in the Leitz and Leica product catalogues for several years; one or two listed below are either no longer manufactured or are unlisted.

The large ball-and-socket head has been specially designed to be used as a hand-grip when screwed into the tripod socket on the base of the Leica-M. It provides a solid and stable support for any number of situations where a monopod or tripod is not absolutely necessary, but where some additional support is required for hand-held operation. It is one of those useful gadgets that can easily be stowed in a pocket when not screwed to the camera.

In Richard Whelan's biography, *Robert Capa*, (see Bibliography) there is a wonderful picture of two of the founder members of the famous *Magnum* agency, Capa and George

Rodger, engaged in conversation in Naples in 1943. They are both dressed in Army uniform. Hanging from Capa's neck is a Contax IIa and down Rodger's front is draped what appears to be a Leica IIIc with collapsible Elmar. He also has a twin-lens reflex slung over the right shoulder. All three cameras are hanging in ever-ready cases, the front flaps of which are flopped open, ready for action. More than a decade later, another picture shows Capa in Laos still wearing the same Contax in the same case.

In the hurly-burly of a faster moving world where film is used faster than water can flow from a tap, the ubiquitous ever-ready case could only be a hindrance. By the sixties, the new image adopted by photojournalists covering wars from the Belgian Congo, through Cyprus to Vietnam, a kind of laid back, blas– mixture of youthful machismo and arrogance, began to sweep the world of photography. E.R.C.'s were out; black enamelled brassy bodies were

Other Leica-M Accessory List	
Item	**Code**
Cable release, 500mm (20") with screw clamp	14 076
Cable release, 250mm (10") with screw clamp	14 067
Ball-and-socket head. (Large)	14 110
Ball-and-socket head. (Small)	14 119
Table-top tripod.	14 100
Spare flash socket plug.	15 526
Spare M6 body cap (Usable with all M-models)	14 195
Spare rear lens cover cap	14 269
M-type camera strap with shoulder pad.	14 253
Back-to-back locking lens cap for 2 lenses.	14 838
Eyesight ocular correction lenses + or – 0.5; 1; 1.5; 2 and 3 dioptres.	14 350 to 14 359
Black leather Ever Ready Case for M6 & 50/2.	14 505
Small Leica-M combination shoulder bag for M6, two lenses and accessories, no winder, in fawn coloured leather.	14 840
Large Leica-M combination bag in black leather. Takes M6, 5 lenses & accessories.	14 842
Holdall for Leica-M, black leather. Takes M6 up to 5 lenses and accessories.	14 827

Fig. 136. Ajax-M leather body pouch.

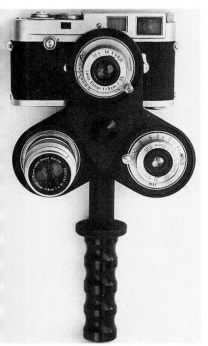

Fig 136a: One of the less practical, beautifully made, short-lived, and therefore rare Leica-M accessories – the lens turret, OROLF, for *screw-mount* lenses.

in. Newspaper photographers issued with new equipment would immediately attack the body with emery cloth, wire wool or the first blunt instrument that came to hand. The more wreckage that hung from a photographer's neck, the higher up the status ladder they went.

Over the years, Leica have researched and produced the best looking and toughest camera body coatings with the same vigour and enthusiasm used for all their products. They want the user to benefit from their efforts, and why not. With constant and reasonably respectful use, the Leica-M will acquire a patina of its own. In my book, as a freelance investing hard-earned funds in capital equipment, no points are given to owners adopting the couldn't-care-less attitude. A camera is only good for as long as it remains working. Mindful of the habits of professionals who tend to throw equipment into bags after use, I designed the Ajax-M soft pouch. Its purpose is to protect a Leica-M body during transportation, in or out of a bag, in a pocket or over the shoulder. The pouch does not impede the use of the camera strap, but it is not an ever-ready case for use with the lens. These pouches are hand-made from high quality leather and are ideal for the owner with two or three bodies. Address for more information at the end of the book.

Fig 137. Vigo, Spain. A more measured approach.

The Leica-M – Basic Handling Procedures

6.1. Getting started

As any skilled craftsman will tell you, how a particular tool is handled and used in shaping an artifact has a direct bearing on its final quality. A camera in this respect is no different from a saw, a chisel, or a paint brush. Some aspects of this subject have already been discussed (see Chapters 3.2, 4.3), but it will do no harm to emphasize the point that newcomers to the Leica-M rangefinder camera will find it very different to the ubiquitous single lens reflex. It is smaller, lighter and a different shape; although in skilled hands it can be wielded deftly in a fraction of second, at times hardly seeming even to be raised to eye level. On first acquiring the camera, it will pay long term dividends to spend time perfecting the basic handling techniques with regard to individual dexterity. It is a good idea to stand in front of a mirror when trying the various holding positions. In this way you can see just where the fingers that are not in use are resting, and which controls that are not continuously used, such as the frame preselector lever, are accessible.

Fig. 138. Paris Metro. Leica M4-P, 35mm Summicron f/2.

The M6 being the current production model, it is used here as the basis for discussion. Where necessary, any significant differences relating to older models will be compared. Each new M6 is packed with a comprehensive instruction manual which begins in the usual way by identifying the camera's various functions.

6.1.1. Fitting the strap

Unlike modern plastic bodied cameras, the diecast metal body of the M6 is fitted at each end with substantial stainless steel strap lugs to which the specially designed Leica strap is fitted. Many other proprietary brands of strap are available and the conventional steel or brass split ring permits easy fitting. The Leica strap, however, is designed to provide the most secure attachment to the camera body and it must be correctly fitted to gain the full advantage. The tough narrow nylon webbing strap is fitted with a non-slip shoulder pad. Over the years, I have used many different types of shoulder/neck strap, even to the extent of

designing and having my own heavyduty leather straps specially made. The latter have never lasted long, especially in a salt water environment. There are some very good, comfortable and tough webbing straps as alternatives to the Leica type, but the best ones are quite expensive and there are none to my knowledge which have Leica's unique lug-to-strap steel connector and locking device.

6.1.2. Mounting and removing the lens

Mounting and removing the lens is straightforward; simply align the raised red dot on the lens with the red marker of lens-release/lock catch on the camera body. Face the lens to the mount flange and twist sharply in a clockwise direction. An audible click can be heard as the locking spigot seats accurately into the milled recess of the lens. To remove the lens, the procedure is reversed; hold down the release catch and turn the lens anti-clockwise, then lift out; with practice both actions can be accomplished single-handed, even in the dark.

6.1.3. Loading the M6, M5, M4-P, M4-2, M4

The special Leica speed loading system of the M6 (as well as M4-P, M4-2 and M4) has already been discussed in an earlier chapter. A film loading diagram is conveniently located on the bottom of the shutter crate, visible when the camera base plate is removed. The essential idea is that film loading by the push-in method can be accomplished easily under a variety of weather conditions, even by the photographer with gloved hands. Provided the user follows the handling procedure more or less to the letter, faulty loading cannot occur. However, it is worth mentioning that not all film emulsions behave in the same way. Films that have been left lying around for months tend to stiffen and the protruding portion of the leader can take on a kink when pulled the extra few

Fig. 140. M6 film chamber. The open shutter curtains allow a view of the light-gathering meter lens in the roof of the camera. Note also the gold-plated contact pins on the hinged film back which transmit film speed data to the meter.

Fig 139. Leica heavy-duty webbing straps have special steel ring connectors. Fitting instructions should be followed carefully, taking care to fit the steel ring to the camera lug as shown here.

Fig. 141. Loading film into the M6. For security, film leader should be taken right through spool petals and a visual check of perforation engagement made before closing the hinged back.

centimetres required to reach from one side of the camera to the other. Always use fresh film, and always keep unused fresh film in the refrigerator.

First-time users should carefully remove the camera base plate by turning the locking key, then lift the plate off. Put this top to one side and, using a flat secure surface, place the camera top down with back of the camera facing you. Fold down the hinged camera back. Hold the camera in both hands and tilt it under a good light so that all the design details can be clearly seen. Note the position of the film winding sprockets, the film guide rails, the petal shaped take-up spool and so on. This is a familiarisation lesson. Refrain from touching the focal plane shutter curtains. They are tough, but inadvertent fingering can cause damage of an expensive kind.

Now take a cassette of fresh film and draw out enough leader to reach from the camera cassette chamber to the petal shaped take-up spool. You can measure this approximately before attempting to load the film. Insert the cassette partially into the camera film chamber and feed the leader along the body slot to the take-up spool. Tuck the film leader down between two of the petals of the take-up spool, simultaneously pushing the cassette further into the chamber with the fingers of the left hand.

Ensure the top edge of the film is not kinked or jammed under the top guide rail or between the body casting and the shutter curtains. There is always a risk that this will happen when loading film in a hurry. If the top edge is kinked and resting on the top edge of the focal plane shutter gate, the film will jam as soon as the base plate is secured. When this happens, there is a high risk of damage occurring to the shutter blinds. In practice, I have found that whatever Leica say about not being 'too fussy in loading your Leica M6', it pays to make sure the film is resting properly on the guide rails, the cassette is pushed right home, and the film perforations are properly engaged on top and bottom rows of the winding sprocket before the hinged back is closed and the base plate secured. Wind on and fire the camera once and then wind on again to bring the self-zeroing exposure counter to '0'. Again, some time spent practising the loading technique will benefit the user. An old cassette loaded with a short length of film can be used repeatedly until a degree of competence has been achieved.

It goes without saying of course that no matter which model Leica-M you are using, the early habit of checking whether film is already in the camera should be adopted. Casual users who may only expose a few frames at a time at intervals of days or weeks will do well to get into the habit of turning the rewind lever to check the camera's contents. The slack in a loaded film is always taken up rapidly so there can be no doubt when the camera is loaded.

6.1.4. Loading earlier M-cameras

Cameras such as the M3, M2 and M1 require the take-up spool to be removed from the camera and the end of the film leader inserted into the sprung clip on the spool before loading can take place. This is a fiddly operation, especially in cold weather, and virtually impossible to accomplish successfully with gloves on!

The novice should use a firm surface, such as a table top, onto which the camera can be placed upside down once the base plate has been removed. The front of the camera should face the user. Allow the hinged back to drop open. Hold the camera firmly with the left hand and with the right, grasp the protruding end of the take-up spool visible on the right hand side. Pull the spool out of the camera. A firm jerk may be required, especially if the camera has not been used for some time.

Take the unexposed film in the left hand and with the right, draw out a couple of inches (5cms) of film. Place a generous quarter inch (1cm) of the leader end under the spring clip of the take-up spool. Make sure the top edge of the film is hard up against the top (bottom as it is being held) edge of the spool. Now with cassette in the left hand and spool in the right, manoeuvre the film into the camera chamber so that the exposed length of film between cassette and spool neatly slides over the winding sprockets and rests comfortably on the guide rails. Pick the camera up and turn it right way up, holding the hinged back open with the left

thumb. Check that the film perforations are properly engaged with the winding sprocket, that there are no kinks in the film, and then close the back. Secure the base plate. Using the rapid film advance lever, wind on the film once, release the shutter and then wind again. The self-zeroing exposure counter of the M3 should now be at '0' ready to start. M2, M1 and MD users will need to reset the exposure counter dial manually. In order to ensure no light has leaked through the trap of the film cassette, especially when loading film in the tropics or anywhere in bright light, I always advance the film counter to 1, rather than 0. I may waste a frame but I can be certain that the first frame will be free of any fogging.

6.1.5. Checking film advance

Proper film advance on all M-models can be checked by observing the rewind lever while activating the wind-on lever. M3, M2, M1 and MD models all have the pull-up type of film rewind knob. The centre portion of this is marked variously with a single red dot, two red dots or a red line, all of which can easily be seen revolving as film is advanced. From M4 cameras onward, the whole rewind lever head revolves.

6.1.6. Setting film speed

Once you are satisfied that the film has been correctly loaded, set the film speed and type reminder dial located on the back of the camera. The M4-2 and M4-P models have write-on dials. Earlier Leica-M models have dials which can be set to the correct ASA/DIN and film type by pressing the dial centre and turning to the appropriate setting.

The M6 dial is different. On the M6 it is used to set the film speed in use (the setting can be changed at any time) and this data is transferred via twin gold plated contacts located on the back of the camera under the hinged flip-up back. The contacts are visible but recessed and are well protected under normal circumstances. The occasional light brush to remove any build-up of dust will do them no harm and ensure accurate data transmission.

To set the film speed required, push in the centre of the M6 dial and turn it so the marker arrows align with the required ISO and corresponding DIN speed indicated on the outer portion of the dial. The centre of the dial automatically springs back to the same level as the outer dial when pressure on its centre is removed. Film speeds from ISO 6 to 6400 and DIN 9 to 39° are marked together with white dots for intermediate settings. (see table section at end of the book.)

To set the film speeds on the M5, push in the serrated edged lock button on the top plate and adjust the film speed until the desired figures appear in the two windows either side of the dial. ASA speeds are visible in the right hand window looking down on the camera in the normal user position. DIN speeds are visible in the left hand window. The selector button returns to its slightly proud position on the top plate as soon as finger pressure is released.

6.1.7. Unloading

Once the film has been fully exposed, disengage the wind-on mechanism by turning the rewind clutch release lever located on the front left hand face of all M-cameras (looking at the camera from front), then, holding the camera in the left hand, open out the rewind crank lever (M6, M4-2, M4-P, M4, MDa, MD-2) and wind gently in a

Fig 144.
Film
speed
setting
dial of M6.

LEICA GMBH GERMANY

clockwise direction. You will feel tension on the cassette spool as the film is gradually wound back. A sudden freeing of tension indicates that the film leader is now free of the three-pronged take-up spool. One more complete turn of the rewind crank will get the leader to a position where, when the camera base is removed, the cassette should drop out freely. Some photographers prefer to wind the leader all the way into the cassette, either to ease the unloading process or to indicate the film has been fully exposed. The rewind clutch release lever on the M5 is in the same place as all other Leica-M models, but the rewinding crank is recessed in the base plate of the camera. Turn the camera over, lens toward the user to rewind.

Forcing the wind-on lever as tension on it increases sharply towards the end of a roll of film being exposed may tear the tape securing the film end to the cassette spool. If this happens, the only recourse is to remove the film in a photographic darkroom or to use a special photographic changing bag. If you are without one of these gadgets, a dark, thickly padded coat will do. Leaving the two arms outstretched. Button the coat and roll the top and bottom ends inside the body of the coat so that a double thickness is created. Insert the camera body through an arm to the coat centre. Carefully insert your hands and arms into the coat sleeves until you can feel the camera. Now begin the process of removing the film, taking care not to let the coat come apart.

6.1.8. M6 Power supply

The M6 is essentially a manually operated mechanical camera with a facility for through-the-lens metering. (see Chap. 1 for details). The meter is powered by two tiny silver oxide button cells or a single lithium battery cell. If the batteries become exhausted they should be removed and replaced as soon as possible to maintain the metering function of the camera. The power supply to the meter does not affect any other function of the camera. In other words, the camera will function normally, but without the metering facility, when battery power is exhausted or batteries are removed.

A set of fresh batteries will supply sufficient power for approximately 20 hours of continuous operation. Assuming a 15 second exposure measurement cycle, the batteries have sufficient energy for 4,800 exposures; about 133 rolls of 36-exposure film. In practice, the batteries last a lot longer than this because not every frame is metered.

The battery housing is located on the front of the M6, lower left looking at the camera from the front. A milled edged cap must be unscrewed to access the compartment. When the meter is functioning normally, the twin red LED arrows visible in the viewfinder are brightly lit. Their brightness diminishes as battery power is exhausted but the meter will continue to give accurate readings at this stage. When power is insufficient, the red LED's do not appear in the viewfinder.

Oxidation of the battery surfaces can cause a circuit malfunction. When this happens, the meter ceases to function or may only function intermittently. Remove the battery compartment cover and with a clean (not new) cloth, gently clean the surfaces of the batteries and the battery contacts. Replace the batteries, ensuring correct polarity. If the meter still doesn't work, your M6 should go to the nearest Leica specialist workshop for diagnosis and repair.

Since the camera was first introduced, a number of photographers have complained of problems with the battery compartment cover. Sometimes this is replaced in a hurry and over tightened. Several weeks or months hard use in inclement weather can cause the cover to jam. To undo it successfully, pliers have had to be used. This action, if it is not done carefully, can easily strip the

Fig. 145. Leica M6 clearly showing: (a) central white meter spot of shutter curtain; (b) Leica R-type battery housing cover with coin slot (left under lens lock release catch), and (c) top dead centre of lens mount ring, the tiny paste-filled hole which hides a top panel retaining screw.

milling off the edge of the cover, which makes it all the more difficult to remove on subsequent occasions. A simple and relatively inexpensive remedy, until Leica can devise a better cover plate, is to use the battery cover from a Leica R-type camera. This is of the flat, flush fitting pattern with coin slot. Unfortunately the slot pierces the cover plate, so the moisture resistance isn't as good as the correct M6 cover, but this too can be remedied by covering the compartment with heavy duty insulating tape.

6.2. Focus and viewing

When purchasing a Leica-M, one of the first tasks is to check that the viewfinder eyepiece lens is of the correct dioptre for your eyesight. All new Leica-M cameras are fitted with a standard '0' strength dioptre lens, but individual eyesight varies, often from one eye to the other. If you are in any doubt about the strength of your own eyes, pay a visit to your optician. Explain the purpose for an accurate measurement of any differential in your eyesight; the optician should be able to advise whether you need to change the viewfinder lens for one of a different dioptre value. (see Chapter 4 or end tables for the dioptre range covering Leica-M cameras.) If your eyesight is slightly off from the norm, what you will see

through the Leica-M viewfinder is an unsharp image over the whole field, assuming the camera to be in good condition (if not new). If your dealer is uncertain, ask for the viewing lens to be changed for a lens of known value.

With older used M-models, the process of fitting the new lens may have to be carried out by a Leica technician. The ring securing the lens in place needs a special tool to remove it, not a set of pliers, evidence of the use of which can sometimes be found on older cameras.

At one stage, Leitz discontinued the supply of eyesight correction lenses and instead supplied only the mount into which an optician could fit the lens. This policy was in effect from 1973 to 1977, after which the situation reverted to normal and lenses were again offered by Leitz. All of the lenses currently listed are

intended for spherical correction. Astigmatism can also be corrected, but the lens for this has to be supplied by an optician and fitted to a special mount obtained through your Leica dealer.

The Leica-M rangefinder system and its workings are discussed at some length in Chapters 3.1 and 3.2. With a little practice, the photographer new to the rangefinder focusing system will soon become adept. The principle of overlapping images converging into one comes naturally to most people, to the extent that once familiar with the method of obtaining a single image, the length of time spent adjusting focus is considerably reduced compared to that spent with a reflex camera. This partly has to do with the overall brightness of the rangefinder image, the level of which is so much higher than with the SLR

Figs. 147 & 148. Confidence in handling ability is one of the keys to successful picture making with a Leica-M. Practise seeing the picture about to happen, raising the camera and firing the first frame; follow through to...be ready for the second and subsequent frames.

Fig. 146. The ability to judge distance with a fair degree of accuracy can be a useful asset. In the street, pictures come out of nowhere; often there is no time to set the rangefinder. (see also Figs. 95 & 96).

that even a cat in a dark coal cellar can be focused very quickly.

There are other advantages. The Leica-M camera is so light and easy to manipulate, it encourages the photographer to look at objects in a slightly different way where focus is concerned. Whenever I am using a rangefinder camera, I frequently find myself subconsciously looking at things and estimating their distance. From time to time, the camera is quickly raised to eyelevel and the object in question focused. A quick glance at the lens barrel confirms the figures I had already arrived at. This is probably a throw-back to a time in another career when calculating distances was an essential part of daily life; or it may go back further than that to the time when I first started using a rangefinder camera. Either way it doesn't really matter, what I find useful is the ability to reckon the object-to-camera distance with a reasonable degree of accuracy.

I use this frequently when I am travelling, shooting the kind of pictures which often, because they appear fleetingly, leave little or no time to dither over the focus. The urgency to bag the picture first time round is overpowering at times. Using a reflex camera for this kind of work is out of the question, for several reasons, not least of which is the give-away sound it makes when the shutter is released. With a Leica, I need only think about what is before my eyes and how it needs to be framed. When time is available to make slight adjustments to focus, I will take advantage of that, but 90% of the time, as near accurate focus is arrived at using a combination of estimated distance and depth of field. Depending on the focal length of the lens used, there are considerable advantages to be had from the method of 'zone' focusing, whereby a specific distance is set on the lens barrel. Given say, a choice of two

effective working apertures, the zone of sharp focus can easily be calculated. This information is stored in the subconscious (yes, it takes a lot of practice and concentrated effort to think in this way) and is called upon instantly when a picture situation arises.

To make the task of focusing simpler, the lenses most frequently used for candid, off-the-cuff and spontaneous travel pictures, are specially marked around the focus ring at the most useful distances. The figures on the distance scale of most modern Leica lenses are picked out in white or light orange paint. The numbers are quite small and close together, so even if you wanted to read all of them, it takes a little time to focus the eye and separate the numerals. Some years ago, I adopted the procedure of repainting the distances I normally set the lens at with bright red enamel. It shows up better than light orange on a black ground and can be easily

Figs. 149, 150 (left), and 151 (overleaf) In documenting certain aspects of social life, the photographer may need to remain as unobtrusive as possible. Learning to handle the Leica-M with confidence makes the job of obtaining photographs easier. English car booting. Leica M4-P, M6, 35mm Summicron f/2.

picked out of the mass of figures when I'm in a hurry. In addition, some other lenses are specially marked with a white line on the focus ring which can be clearly seen in the viewfinder as an out of focus blob. When this comes into view, I know the lens is focused at a certain distance.

Many years ago when I had just begun to think seriously about photography, a piece of advice from one of the all time greats of photography, Andreas Feininger, stuck in my mind. To get the hang of how a picture should look or how it could be improved before shooting, he suggested cutting two L-shaped pieces of black card about 24" long. Held at arms length in the configuration of a rectangle or square, the two pieces of card are adjusted one against the other to exclude extraneous matter from a scene.

Some years later, when I acquired my first Leica M2, the configuration of the projected bright-line frames in the camera viewfinder reminded me of Feininger's advice. Even though the frames are white, the invariably darker image ground had a similar effect to his two card trick. The more I used the camera, the more permanently fixed in my mind's eye the frames became, to the point where now I cannot look at anything much without first seeing the white frame outline.

I am not suggesting that if one eventually acquires the habit through constant wielding of a pair of black card frames or, by retiring to bed with images of Leica projected bright line frames, that it will make one any more creative or photographically articulate. But it does help;

especially in how to see the image as you would like it to appear in the final photograph.

As I have already outlined in the introduction to this book, ownership of a great camera does not a great photographer make; but it helps to put one on the right track. If a tool has to be adjusted every five seconds to make it work efficiently, you might as well throw it away. The Leica-M needs no such attention and it is this freedom from worry over the technical aspects which helps to liberate the mind and the eye. What we are after here, after all, are great photographs. The Leica-M is the tool to get them, a simple box at arms length endowed with just enough mechanical sophistication for the purpose.

It can be used in any number of different ways in the hand-held mode. Bringing the camera to eye level lets the photographer see the image frame. Use this method when you want to take a more measured view of life, when there is time to focus, adjust exposure and time to consider the composition and lighting. Raising the camera only part way to the eye allows you to photograph instantly what is happening right now. Bang! Quickly wind on, another frame; bang! By the time the camera has reached eye level in its natural upward progression one of two things may have happened to the scene being photographed. The moment when the picture was there may have passed already, in which case you will have it on film; a new moment when things might happen to make another frame could be forming, in which case you will be ready for it and will have already captured the build up toward this new

moment. But the camera cannot see this, either before the moment, when it is about to happen, or afterwards, when the moment is gone. It cannot think for itself. Only the photographer can see these things, which is why it is important to practise camera manipulation so that handling and using it becomes as near second nature as possible.

In a crowd, in an area where it might be politically sensitive to use a camera or be seen with one, the Leica-M excels. The virtually silent shutter is just that. The photographer will be more aware of the noise of it through being familiar with the sound. Other people around the camera, even within arms length, are unlikely to hear, let alone recognize what it could be. It is a distinctive sound – to those who know it – but as nothing compared to the clatter of an SLR and its associated whining motor; a sound which can travel over great distances and to which a large portion of society is now accustomed to hearing and to which an equally large portion are averse.

The Leica-M can be hidden behind an open coat with only its lens protruding. It can be carried casually in the hand, the strap wound around the wrist, the thumb or index finger ready on the shutter release. It can be aimed and fired in all manner of ways which the unsuspecting subject will never see, hear or take a second glance. The key, when using the camera in this way, is to keep it level. This takes more practice to perfect than might at first be thought and is another instance where the wardrobe mirror will be useful.

Leica M6 and Leica-M Light Metering Systems

7.1 Leica M6

A brief description of the M6 metering system appears in the technical specification for this camera in Chapter 1.12.

Fig. 152. The sophisticated TTL metering of the Leica M6 brings a high degree of exposure accuracy to the rangefinder camera. But older clip-on light meters can be equally accurate. Leica M2, 5cm Summicron f/2, Kodachrome 25 original.

To recap, the M6 meter relies on a white spot painted on the front face of the first shutter blind. It can be clearly seen when the shutter is fully tensioned. Light reflected from the patch is collected by a tiny lens mounted in the top body of the camera in the 11 o'clock position. The light collected by this lens is measured by a highly sensitive silicon photodiode located immediately behind the lens. This can be clearly seen by holding the camera front towards the user with the taking lens removed. No attempt should ever be made to touch the white spot or clean it. The apparently uneven coating of white pigment is exactly that. A thicker coating would have affected the shutter curtain performance; its irregularity has no detrimental effect on the meter's ability to measure exposures accurately.

To activate the meter, the camera shutter must be in the fully tensioned position and the shutter speed dial set to any figure but 'B'. A light touch of the release button switches on the meter power and as long as your finger remains on the button, the power remains switched on. Looking through the viewfinder while keeping the release button slightly depressed, the user will see a pair of red triangular LED's, the brightness of which should be equal when the exposure settings, f/-stop and shutter speed, are set in the correct combination.

Even when the ambient light levels are very bright, as they would

be for example in parts of the world where snow is the dominant feature, the LED's are always visible. This is made possible by the narrow semi-silvered strip visible from the front of the camera on the main viewfinder window at the right. In very dark surroundings, the brightness level remains constant but is apparently brighter than when the camera is used in normal daylight conditions. When ambient light level reaches the lowest possible sensitivity capable of being recorded by the meter, the LED's may take longer than normal to appear in the viewfinder window. Once finger pressure is removed from the shutter release, the LED's remain active for approximately 10

seconds before the meter power is automatically switched off and the lights are extinguished. After the shutter is released, the meter is turned off and cannot be switched on again until the film has been wound on to the next frame.

Both LED's may not always light up simultaneously when the power is turned on. This does not mean that there is a meter malfunction. The user should check that the correct ISO (ASA/DIN) film speed has been set on the dial on the back flap of the camera. Select a usable shutter speed for the prevailing conditions and subject. Then, while viewing the subject through the viewfinder, activate the meter with

▶ Under-exposure of at least one f-stop.
 Turn lens aperture ring to the right.

▶◀ Under-exposure of ½ stop.
 Turn lens aperture ring to the right.

▶◀ Correct exposure.

▶◀ Over-exposure of ½ stop.
 Turn lens aperture ring to the left.

◀ Over-exposure of at least one f-stop.
 Turn lens aperture ring to the left.

Fig. 153. The simple exposure LED balancing system of the M6 TTL meter as seen through the range/viewfinder.

Fig. 154. The TTL metered field areas of the M6 relative to each of the projected bright-line viewing frames.

Figs. 156 & 157. Subjects with a high degree of contrast need special metering attention. In portraiture, bright highlights can cause underexposure of the important facial areas, but it is important to try and maintain correct tonal values. Circles indicate the areas metered in these two examples.

the index finger of the right hand and slowly adjust the aperture ring of the lens in use to the left or right until both LED's are visible and are at the same level of brightness. The correct exposure settings for the scene to be photographed will now be set.

The diagrams clearly show the relative areas of the image field the meter is able to measure. The area covered is equal to approximately 27% of the total field. This is considerably more than the area covered by a true spot meter, but only about half that of the normal centre-weighted averaging systems used on many SLR cameras. The diameter of the measuring field is equal to 2/3 of the short side of the bright-line frame in use.

This is a useful piece of information because in practice it means that the photographer can accurately measure very small areas of the object to be photographed using the preselector lever.

For example, when using wide-angle lenses, the measuring field of

Fig. 155. Plan of the M6 light measuring path.

Fig. 158. The brightness range identifiable by the human eye far exceeds that capable of differentiation by modern film emulsions. In this back-lit scene, the sun's rays penetrate the lens at about 40° at 10 o'clock. The photographer had the option of emphasizing a silhouette effect or retaining as much detail in the shadows as the film would allow. Metering was based on the development compensation technique (see section 7.2) in which the effective film exposure index is considerably reduced, thus effectively overexposing the whole scene. Subsequent reduced development retains printable highlight detail while maintaining near accurate mid- and deep-shadow tones.

the meter appears to get larger. When photographing scenes in which large areas of sky, sea or similarly toned landscape dominates the image area, a false exposure reading could be interpreted by the user. By flicking the preselector lever to bring up the 90mm bright-line frame, particular areas of the scene can be measured and interpolated. Even smaller areas can be picked out using the 135mm projected frame, in effect giving the photographer a selective metering facility.

Remember that each scene or object to be photographed is made up of many areas of light and dark. Not all of these will be important to your photograph. In other words, the desired emphasis may fall somewhere between the brightest and darkest areas of the field. The camera cannot know which of these areas are the key ones. It needs some help from the photographer. Given the data regarding the meter measuring field relative to each lens used, selective measurements of parts of the image field can be made that will accurately interpret the photographer's interest.

Other factors have a direct influence on the final photographic result. Not least of these concerns the type of film used to record the scene, whether colour transparency (reversal), colour negative, black-and-white negative, or black-and-white transparency. Each type of film has a different set of characteristics with regard to the brightness range it can record and these change from one make of film to another as well as from one effective film speed to another.

It is not the intention of this work to delve deeply into the subject of exposure, film characteristics, film processing and printing, all of which can have a direct effect on the technical quality of the final photographic image. However, there are some fairly simple general guidelines which can help.

To begin with, in normal daylight, objects and scenes to be photographed reflect a certain amount of light. If they didn't, if all the light falling onto the scene was absorbed, we wouldn't be able to see it. A surprisingly small amount of light is reflected back, about 18% on average. Obviously, black objects reflect a lot less than this, and bright white objects a great deal more, but usually in any scene there is only a relatively small portion of either. There are many other colours of differing tonal

Fig. 159. At sea, light levels are often disconcertingly higher than those on dry land, given similar weather conditions. If you want images with a full range of tones, take care when metering subjects not to underexpose the main areas of interest. In this picture, the sea at the lower right and the dark-toned coats were used as the basis for exposure.

Fig. 160. A classic case of 'where do I point the meter?' In this type of architectural illustration it is still important to retain as much subject detail as possible. The final reading for this shot was based on one taken from the upturned palm of my hand, allowance being made for a reduction in film development of up to 20%.

value and if we take an average of all of them, it is equal to the figure given. If you imagine the overall tone in black-and-white terms it would look grey. In the photographic world, a sheet of grey card with an 18% reflectance value is the commonly accepted basis upon which exposure meters are calibrated.

In reality, the brain can differentiate between many different tones and is easily able to accommodate a huge range of brightness values. This brightness range is effectively compressed into a much shorter range on photographic film and that in turn governs the effective tonal range any particular type of film can be made to record. The amount of exposure given to any film thus has a direct bearing on the final pictorial result.

The triangular red LED's of the M6 can be used effectively and accurately to determine the level of exposure given to any particular type of film. Obviously, from what has been said, the student will realise that the more that is known about a particular film's characteristics, the greater the degree of control over the final image using the M6 meter.

With colour reversal films, the general rule was always to expose for the highlights of the object and allow the shadows to look after themselves. The problem with this rule is that it came about in the days when colour reversal technology was in its infancy, at a time when the brightness range that could be accommodated was very small. Today's films are far more sophisticated and their exposure latitude is higher than it once was. In other words, it is possible to over- or underexpose some colour reversal films by as much as 2 or 3 stops and still produce a reasonably acceptable result.

Today's TTL meters are so accurate that virtually any part of the object or scene to be photographed can be selected as the primary target and accurately metered, thus providing the photographer with the

Fig. 162 right: An average of lightest and darkest areas is the normal method of assessing exposure using TTL metering. Just enough detail in highlights and deepest shadow was retained in this image by metering from the coat's darkest areas and reducing development by 5%

Fig. 161. A straight reproduction from an original drug store machine-made colour print. No attempt has been made to enhance or modify the technical quality of the print, which exhibits a full range of tones and detail, even in the little girl's white stockings. In using the coat as the basis for exposure, highlights in the surreal cone topped figure are overexposed by almost two full stops. This is of no consequence to the final image, showing yet again, that modern colour negative materials are the most forgiving of all emulsions available to photographers.

means to produce creative and effective images with the emphasis placed in exactly the right place.

In photographing scenes where the ambient brightness levels are very high, at sea or in the snow covered Alps, care should be taken not to underexpose the areas of main interest in a scene. For example, in photographing the actions of the crew of a racing yacht, it is not the white sails of the yacht which should be measured but a tone which more accurately reflects the level of brightness around the deck area, otherwise there is a high risk that the sails will be accurately exposed, but the crew and the rest of the boat will not. In the snow, light is reflected around into nooks and crannies which in the normal course of events would probably be ignored. Exposing for snow, unless that is the deliberate intention, will have the effect of underexposing those other parts of the scene which are more important photographically.

Use the meter of the M6 selectively, to pick out the exact areas to be measured. In backlit scenes, where the light is essentially the dominant feature behind the object, person or scene, don't be afraid to move in close with the camera and meter those areas of the subject you want to record accurately. The M6 meter can be used at much closer distances than the minimum focusing distance marked on the lens scale, in just the same way as an independent handheld meter. Point the lens at the object area to be metered, don't attempt to focus the lens, adjust the exposure settings and then retreat to the photographic position, focus, compose and shoot. The backlight will be overexposed, possibly even washed out and devoid of all detail. This doesn't matter. What is important is that all the main features of the person, object or scene are accurately recorded.

With colour negative film, exposure latitude is much greater than that of colour reversal film. The photographer can err on the side of up to 4 or 5 stops of over exposure and still obtain a print. It has a greater capacity in this direction than towards underexposure, but even here it can be surprisingly accommodating. Expose for the mid-tones of the subject; those that would match the 18% grey scale already mentioned. You will find that more than 90% of what you expose will produce perfectly acceptable prints when the film is normally developed by a commercial processing laboratory or in a high street mini-lab.

The quality of the final print is largely dependent on the skills applied by the photographer from the outset. Exposure, processing and printing techniques, the type of film used and the chemicals and paper employed and the way in which they are used, all have a direct bearing on the final result. The high level of competence applied by many photographers in their own darkrooms is obviously not available from the high street processor, but surprisingly good quality small prints and enlargements are possible. Many press photographers in a hurry use mini-labs for colour negative film processing and print making and the results of their endeavours frequently appear in newspapers and magazines around the world. The very high standard of colour newsprint reproduction has been made possible in recent years by the introduction of sophisticated electronic processes used to scan the original photograph. The image can be cleaned up by changing colour, increasing or decreasing the contrast in the whole or parts of the image. What the reader sees in print is invariably a far cry from what the photographer saw at the time of shooting the original.

Working in black-and-white requires a great deal more attention to exposure detail than that given to colour negative. Very few photographers use the medium these days as a means of simply making a record of an event or object, but when they do, a fairly straightforward exposure and processing technique is used to produce prints which depict as full a range of tones from pure black through to base white as possible. As a general rule, exposing for the shadow areas of any object or scene and processing for the brighter highlight areas will provide acceptable negatives which can be printed efficiently on normal grades of paper.

The more creative photographer will want to go further; but producing a negative with exactly the right qualities is more complex. Again, as with colour reversal materials, the wide range of different film emulsions available plays a huge part in arriving at a desired result. The student will need to experiment with many different materials and chemicals before arriving at the one best suited to his or her needs. The key always, however, begins with exposure of the film and is linked directly to the processing technique formulated to produce a particular type of negative. Once you know what this is, the TTL metering facility offered by the M6 can go a long way towards helping you to produce consistently high quality work.

7.2. The Zone Exposure system

One of the most accurate methods of controlling exposure, development and print making in black-and-white photography was initiated by the American photographer Ansel Adams (1902 – 1984), in conjunctions with a colleague, Fred Archer. The pair were both members of the F64 Group which had been founded in California in the 1930's.

The F64 Group became known throughout the photographic world, and subsequently in the art world, not only for their interpretations of the wonders of nature, but for the clarity, tonal range and presentation

values of their prints. Today, an original Ansel Adams print will command an exceptional price in the photographic auction rooms of London and New York.

Adams spent years developing the Zone System and wrote several books devoted to the explanation of light in photographic terms and the first, Exposure Record (1945) is essentially a description of the zone system of exposure which he and Fred Archer developed from the results of tests conducted by the Western Electric Instrument Company a few years earlier.

According to the normally accepted precepts of black-and-white photography, a particular contrast grade of paper is selected to match a particular negative which has been produced almost arbitrarily through averaging exposure techniques and normal development. The Zone System, on the other hand, allows the photographer to visualize the final print, to accurately select a particular contrast and to visualize the gradation of tonal values of a subject from 0 – 10, where 0 is the richest area of black in the final print in which no detail is visible, and 10 is the purest white, equivalent to paper base. In between are eight zones of varying shades of grey of which one, No.5, is equivalent to the tone of an 18% Kodak grey card (see above). By measuring the brightness range of the parts of the subject to be photographed, it is possible, by shifting exposure one full stop in either direction, to render tones exactly as required, and then, by development compensation, to produce a negative in which the contrast exactly matches a pre-selected grade of paper.

Adams' techniques were particularly applied to the use of one-shot cameras. i.e. the large-format type capable of exposing single sheets of film. Other than using impracticably short lengths of film, this approach to black-and-white photography is

extremely difficult to exploit using a miniature camera such as the Leica-M. When a roll of film has been exposed in the Leica there may be as many as 36 differently exposed negatives, all with different contrast and tonal ranges. That is why the principle of adapting the paper contrast to the negative forms is the most convenient and cost effective for the small format user.

But it would be much easier at the outset to be able to visualize, as Adams and his colleagues did, how the scene to be photographed would best be rendered and on what grade of paper. Exposure for the gradation of tones and development for contrast is the key. But here again, it would hardly be practical to cut and process 36 tiny frames individually.

The normal procedure when using a TTL meter is to assess exposure based on the measurement indicated for the brightest and darkest areas of the scene – the average of the two being taken as the mean for the whole scene. The drawback with this method is that the resulting print invariably lacks detail in both the highlight and the shadow areas when exposure measurements are taken in bright, contrasty light. In even, diffused light, the same method produces lacklustre negatives which print on normal grades of paper as a series of muddy grey tones.

To overcome this deficiency, many photographers use a system of bracketing exposures a half- to one-stop either side of the mean, in the hope that one or more negatives will have the required detail AND contrast to produce an acceptable print without having to resort to devious shading and dodging techniques. I have never liked this system. It is bug ridden; a hit-and-miss approach which may or may not achieve a required result.

In a studio, where lighting can be controlled and access to processing facilities for testing ensures a greater degree of accuracy, the problem

hardly exists. In the outside world, both the amateur and the professional photographer need a system which guarantees the same degree of consistency irrespective of the subject matter and the conditions it was shot under.

Using a system of basic TTL averaging exposure and development compensation, I developed a percentage development table some years ago which seems to meet all the normal requirements of film exposed under the following conditions.

1) Bright, contrasty, deep shadow, little cloud.
2) Bright, haze, sun and cloud.
3) Bright, diffuse light.
4) Overcast or dull conditions.
5) Available light, i.e. indoors using restricted daylight or artificial light such as tungsten or fluorescent.
6) Electronic flash light.

Over- and underexposure systems geared to percentage increase/reduction developing techniques allow the photographer more control at the print stage. Normal metered readings are used in most instances where light is even or diffused, except where more or less emphasis is desired at the main point of interest. In bright and very contrasty situations which would normally render shadow areas in the 0 – II zone of blackness, and lighter areas as zones equivalent to VII, IX or X, some further adjustment may be necessary to control the extent of the brightness range. In this case, pick out the zones which are of most importance and work on the assumption that only 7 zones, including deep black and brilliant white, are available. Most medium and slow speed emulsions can cope with these situations easily. With high speed film it is necessary to increase the contrast range. This can be done by lowering film speed and decreasing development.

This processing technique was developed specifically to cater for

Fig. 163. Compensating development techniques can be used for most subjects. Lighting is provided here by a mass of fluorescent light, permitting exposure of 1/60th sec. at f/4 with ISO 400 film rated at EI 320.

the wide variety of subjects my own news agency deals with on a daily basis. The system is not a 'zone' system as such, but it takes the principle from that system that by controlling exposure, effective film speed and subsequent development, negative density and contrast can be controlled fairly consistently to produce high quality prints with a satisfactory range of tones and detail. The following table should be used as a basis for individual formulation to arrive at the best possible compromise of effective exposure index and development.

Kodak's HC110 is a general purpose developer supplied in highly concentrated liquid form. It must first be diluted to a working stock solution before use. The table was originally devised for use with Ilford's HP5, which has a different base composition and grain structure to HP5 Plus. Using Kodak film will require some adjustment to the times shown. For example, Kodak T-Max rated at 400 ISO developed in a 1:31 solution of HC110 needs 7 minutes for normal development. Percentage increase/decrease in times can be found easily using a pocket calculator, but individual prefer-ences should be calculated through practical processing tests.

7.3. Using the Leicameter MR-4.

The meter is described in chapter 5.1. It slides into the accessory shoe on the camera top plate and an interlock device couples it to the rotating shutter speed dial of the camera. The meter cannot be fitted to the M6 because there is no slot in the shutter speed dial for connecting the spigot on the underside of the meter dial.

The Leicameter MR-4 is designed to be used on earlier M-models such as the M4, M4-2 and M4-P. It can also be used on the M3, M2, and M1 and was the last in a line of similar clip-on selenium or Cds meters which came into being first in 1955. The MR-4 version was the most sophisticated of the range, having the narrower acceptance angle of its predecessor, the MR, and an on-off sliding switch on top of the housing where it would not be in the way when using the canted rewind of the M4 models.

When the meter is fitted the axis of the light collecting lens is con-vergent with the lens axis. The MR-4 sensitivity range is considerably less than that of the TTL meter of the M6, measuring from 0.5 to 32.000 cd/sq.m., but the measuring field area is somewhat more than that of the M6 and is identical to the area of the image field covered by the 90mm lens. By activating the preselector lever and bringing up that frame in the viewfinder, the user can see exactly the area and position of the meter coverage irrespective of the lens in use.

This facility will be found useful when photographing scenes with a wide-angle lens such as the 21mm, 28mm and 35mm focal lengths. In cameras which are fitted with all six projected bright-line frames, the user will see immediately the area covered by the meter when a 28mm lens is used because the 90mm frame is paired with it. When the 35mm lens is in use, the central frame visible in the viewfinder is the one for the 135mm lens. The area covered by this frame is only slightly smaller than that covered by the 90mm.

The meter is activated by pushing the sliding switch on top of the meter. As soon as the finger is removed, the reading just taken is stored as the meter needle comes to rest in its last activated position. The dial on top of the meter now indicates both the shutter speed already set and the new metered aperture. This can be transferred immediately to the lens or noted for future use.

Measurements of certain objects may also be made at a closer distance to that of the closest focusing distance of the lens in use. Simply hold the camera facing the object to be photographed at the distance required to obtain a shadow-free reading. Switch the meter on and allow the needle to settle. Note the aperture indicated on the meter dial. Several readings of the same object may be made in this way and integrated to give the optimum exposure setting for the camera.

Exposure Development Compensation Table

Times are given for a working solution temperature of 68°F (20°C).
Film: Ilford HP5 Plus, rated at 400 ISO.
Stock developer, Kodak HC110, 1 part stock: 9 parts water.

Exposure	\	Development time in minutes increase/decrease development %						
	0%	10%	15%	20%	25%	30%	35%	
-3 stops							9.78	I
-2 1/2 stops						9.4		N
-2 stops					9.06			C
-1 1/2 stops				8.9				R
-1 stop			8.34					E
-1/2 stop		7.97						A
								S
Normal	7.25							E
+1/2 stop		6.5						D
+1 stop			6.16					E
+1 1/2 stops				5.8				C
+2 stops					5.4			R
+2 1/2 stops						5.08		E
+3 stops							4.7	A
								S
								E

Fig. 164. The Leicameter MR type is one of the most finely tuned accessory meters and can be relied upon under a wide variety of conditions to provide accurate exposure information.

Fig. 165. Situations like this demand a high performance camera and meter combination which can be quickly removed from protective clothing for rapid use. Leica M2, 5cm Summicron f/2, Leicameter MR, 1/500th sec. at f/4.

The measuring cell of the Leicameter MR-4 is a cadmium sulphide type. Its response time is noticeably slower than that of the silicon photodiode type of the M6, but this does not make it any less accurate. The only significant difference is in the sensitivity range of the two meters. When the MR-4 meter is used under conditions approaching its lower threshold in the normal light position, another switch on the meter top plate can beturned to a 'low light' measuring position. The switch effectively widens the normally narrow bandwidth, having the apparent effect of increasing the response time when readings are taken under low light conditions.

The MR-4 meter is a useful pocketable accessory, which can be relied upon to give accurate service under a wide range of lighting conditions. Although designed primarily to be used on the camera where it operates effectively in the 'aperture priority'

mode, the MR-4 and all earlier meters of this type can be hand held and used to take measurements in the same way as any other hand-held meter.

A white arrow at the right-hand end of the meter is the index against which the set shutter speed is indicated on the main dial. Normally, with the meter in place on the camera, the thumb wheel under the meter, which locks into the shutter speed dial, is used to change the shutter speeds. The thumbwheel becomes an extension of the camera shutter speed dial, so the resistance normally felt when changing shutter speeds is also present when the meter is in use. Once the meter is off the camera, this resistance disappears and there is no click-stop between the shutter speeds which can now be freely set on the dial.

To use the meter in the hand-held mode, carefully point the lens collecting window in the direction of the object or scene to be measured.

Push the on/off switch to the 'on' position and allow the needle to settle for a few seconds before releasing the switch. The needle will now remain in this position. Having previously set the ISO (ASA/DIN) speed of the film in use, carefully turn the thumbwheel so that the shutter speed required falls against the white (black on chrome meters) index arrow. The aperture measured may now be read off the dial opposite the meter needle segment.

Measuring the reflectance of a scene in this way requires some care, in part because the MR-4 is hardly the right shape for hand-held use. Because there is no resistance on the thumbwheel when it is off the camera, it is also easy to let the dial against the shutter speed index slip, which may result in the wrong f/-stop being selected for use.

The MR-4 meter has been discontinued from Leica production catalogues for some years now, but these and examples of the older versions

Fig. 166. TTL metering, such as that found in earlier Leica M5 and Leica CL cameras, has a slower response time to that of the silicon diode powered M6, but will still respond to low light levels.

regularly appear from time to time on the secondhand shelves. When checking the meter it is best to fit it to a Leica-M body. Cover the light collecting lens window and turn the meter on. Ensure that the meter needle remains in the zero position. If it begins to move when there is no light to activate the measuring cell, move on to the next one, negotiate a realistic price as a non-working example or see if your dealer is prepared to send it to an authorised Leica repair centre. The same advice would apply, if, after having fitted the meter with a new battery, it could

not be activated in the normally accepted manner.

Meters that have obvious signs of hard wear are best avoided. A surprisingly high proportion, however, come to the market in fine condition; a good indicator that they have been cherished by their owners or not used at all.

7.4. Metering with the Leica M5 & CL.

The mechanical details of the M5 meter are dealt with in Chapter 1. Apart from the differences in types of measuring cell used for the M5 and M6, Cds and silicon, resulting in a slightly slower response time for the former, the M5 metering facility and that of the CL are both true selective TTL types and can be used in much

the same way as the meter in the M6. Both camera viewfinder displays lack the red LED's of the M6. The sensitivity range of the meter in the Cl is ranged in 16 EV steps from 0.5 to 32,000 cd/sq.m with fully adjustable film speeds from ISO 25 to 1600 (DIN 15-33). With the Leica M5, the sensitivity range of the meter is in 20 EV steps from ISO 6 to 3200 (DIN 9-36). The meter is only active in both cameras when the shutter is fully tensioned. Combinations of both shutter and aperture can be matched against the viewfinder needle, but the ergonomic emphasis was designed to favour rapid meter balance using the shutter speed dial of both cameras. Problems associated with the M5 shutter speed setting dial have already been described in chapter 1.

Seeing With The Camera

8.1. Format

Format means shape and size. Shape is the key factor controlling the way in which we see things photographically. Size dictates the area of the negative, the extent to which it can be successfully enlarged as well as a number of other important factors concerning contrast, resolution, apparent sharpness, grain and how it might be cropped; this brings us back full circle to shape.

Before Oskar Barnack and Leitz produced the first Leica prototype, a number of other cameras using 35mm film were already on the market employing the standard movie format of 24mm x 18mm. One or two manufacturers adopted the square shape measuring 24mm x 24mm, one imagines more for reasons of film economy than for any artistic value.

These cameras had all developed out of the need at the time to find convenient ways to improve the quality of movie film exposure and this is one of the reasons why Oskar Barnack developed the Ur-Leica (prototype) in 1913. The fact that a standard frame size already existed was convenient. Manufacturers who recognized that there might be a wider market for their 35mm 'still' cameras, doubled the frame size in an effort to improve the final print quality. It was a sales ploy rather than one which had been carefully thought out with regard to quality of composition. Even Barnack's concerns were centred squarely on the technical quality of the print, if we are to believe what Leica historians have so far committed to print.

By doubling the size of the negative to 24 x 36mm, some provision was inadvertently made for the possibility of cropping the negative. Ironically, Japanese designers endeavoured to engineer a more artistically useful shape in the 1947 Nikon S by reducing the long side of the frame to 32mm. The camera initially fell foul of General McArthur's disapproval on the grounds that it wouldn't be acceptable in the U.S. because Eastman Kodak had already standardized the size of card mounts for Kodachrome film. In fact, all early versions of the Nikon rangefinder

Fig. 168. How the photographer sees a picture building to a climax is governed largely by pre-visualisation, a multitude of prior graphic experiences and emotions of the moment, hopefully controlled by an element of objectivity. The 35mm format allows a useful degree of cropping in the darkroom. Compare with Fig 168(a) below.

were plagued by an irregular negative size and the camera was not accepted for export until the company bowed to commercial processing pressure and adopted the Leica standard.

From a purely artistic point of view, and disregarding the advantages of the miniature camera for a moment, it has always been my contention that the 24mm x 36mm format is totally unsuitable as a basis for making great pictures. The proportions might be suitable for a movie screen, but it is hardly ideal for the printed page where reproduction proportion has historically always favoured the whole, half and quarter plate sizes of the previous century. Still, no good complaining about the goose that's cooked. It's been around too long to revive.

When it comes to choosing equipment, the overriding consideration for the vast majority of photographers is usually cost. In many cases, format gets no consideration at all. The emphasis is invariably always on hardware and how much of it the allocated budget will purchase. Size for size, budget for budget, 35mm equipment is more cost effective and has a potential for greater versatility. I make no distinction here between amateur and professional photographer because those in each camp who put other considerations first are in the minority.

Leica enthusiasts form part of that minority. Leica-M users form an even smaller segment, probably less than 0.001% of the photographic fraternity. We can break this figure down still further into collectors, amateur users and professional users. When you add up the total of Leica-M production in the last 40 years, you begin to get a fairly good picture of the spread of equipment and, perhaps, a little understanding of the uniqueness which drives some to ownership and use.

The photographer who chooses to work with a Leica-M does so in the

Fig. 169. Arles, France. Creating order in composition out of chaos with the miniature, especially when the camera is being used to snatch images on the hoof, is a practised art requiring single minded concentration.

knowledge that, like most tools designed for a particular purpose, the camera and its associated lenses have limitations. Most likely, the choice to use one (or more) is governed by purpose; a special tool for special work. Within that boundary the limitations of format are perfectly acceptable and are therefore, like cost, of little consideration.

'What' asks the student 'has any of this got to do with seeing with a camera?'

How the photographer sees the final printed image in the mind's eye – and that state of mind exists for many photographers immediately before, during and after a scene is recorded on film – is governed by format. Photographers who are con-

cerned about their work, are concerned with making images which they can live with for years afterwards, that have some lasting appeal for the casual or interested viewer, that communicate information in an impressive visual manner, and which may, under certain circumstances, provide endless pleasure to the viewer.

These concerns are interpreted by using a particular format in the same way that an artist uses a canvas. The shape of the canvas dictates the basic composition of the picture, the placement of objects or scenes, the tones of colour and gradations of light and shade. The negative format is the photographer's canvas and within it, he must bring together all the ele-

ments which, when perfectly placed, make the photograph a picture and not simply a record of an object or place.

The Leica format – for long the universal format for 35mm photography – is not easy to work with. Being unsymmetrical it has none of the advantages of a square, for example, which can be used as a device to create order out of chaos. In order to create the perfect composition with 35mm, the photographer is frequently required to compromise the framework by cutting pieces out of the photograph at the darkroom stage; the photojournalist and the press photographer's work is often further hacked about by editors, newspaper and magazine layout

artists, who because of the pressure of space and commitment to advertisers, are often forced to publish photographs in such a manner that they resemble little of what the photographer originally intended. At these times, and they are often, the photographer has no control over how his or her work will finally appear in print.

In this respect, the amateur photographer has greater control over presentation but that is where the differences between the pro and amateur stop. No matter the end purpose, the photographer must still see the picture and press the shutter release at exactly the right moment. Seeing the picture form within the imaginary format boundary is a practised art. As ordinary mortals, we are not blessed from birth with square eyes; in the case of the photographer, they have to be developed over time to the

Fig. 170. So long as the photographer's position remains unchanged relative to the subject, perspective remains the same – even when lenses of a different focal length are employed. What does change is the apparent scale of the rendered image. In fig.170 a 35mm focal length was employed; Figs 170(a) & 170(b) show the sections obtainable with the 90mm objective. Fig 170(c) uses the 135mm focal length to isolate human interest.

stage where seeing the scene, the object, the person to be photographed within a frame, comes as naturally as normal vision with its objective and peripheral field of view.

Those of us blessed with an 'artistic' bent from an early age will probably have less difficulty in visualising how a particular scene could be photographed than those who come to the hobby or profession later in life. However, the fact that some of us can 'see' may not necessarily be of any great advantage, especially if the way in which we see is constrained by all the conventional traditionalism of 'art'. In some instances, this conventional concept of artistic values may be more a hindrance than a blessing because it binds us too rigidly to particular values. In photography, one needs the freedom to see more than just a frame and the form of objects contained within it. All the influences of normal life should be allowed to play a part in this business of 'seeing' and I know of no better illustration than the observation made many years ago by the great French photographer, Jean-Philippe Charbonnier, who said, 'Using a camera is very much like putting on a tie, or

another tie or another pair of shoes, according to God knows why. There are days on assignment when I will shoot only with a 200mm lens. I put my 200 vision in my head and shoot away. I don't see anything else. When I'm fed up with it, I either stop shooting or switch lenses.'

8.2. Leica-M lenses in use

Having the facility to change the focal length of lenses used within a given format, increases the photog-

rapher's visual scope. The expert knows instinctively, because he or she has committed many hours to learning, the lens to use which will best portray the pre-visualized scene. Returning to the 'L' shaped pair of card frames, the student can see at a glance how a change in focal length alters image concept.

Pick a scene or an object in a room which can be easily seen. Holding the 'L' frames in a similar format to the 35mm proportions at arms length, view the scene. Maintaining the same angle of view and position, shunt the pair of frames together to half the size. By eliminating the objects in the periphery of the first frame, the main object viewed becomes more isolated and apparently larger relative to the second frame size. This is exactly the same effect achieved when changing say, the standard 50mm focal length lens to a 90mm lens.

To see the effect this has on the negative, the preselector lever on the Leica-M camera can be used to determine which is the best lens for the scene to be photographed. Discard the 'L' plates for the moment and, standing in the same spot, view the scene through the camera viewfinder while flicking the preselector lever from centre to left, back to centre, and then to the right. The bright-line frames actually indicate a frame size that is 1mm less than the negative size. This allows for the slight image overlap all round the frame incurred when reversal materials are card mounted. In particular, the viewfinder frame shows exactly the area visible on Kodachrome film after mounting.

An additional advantage offered by the Leica-M is gained over the majority of SLR cameras in the short to medium telephoto lens range. With the exception of the 28mm focal length, a clear margin outside the image field of the remaining five bright-line frames allows the photographer to see what is happening

just outside the extreme edges of the frame. Right-eyed photographers will find this facility particularly useful when a rapidly developing situation can be monitored, partially with the left eye, without removing the camera from the viewing position. This means of course, that the natural habit of closing the left eye when viewing with the right must be resisted.

8.3. Choosing the right focal length

From the outset, the Leica has always been a 'system' camera. Long before the advent of the ubiquitous and versatile SLR, Leica users could pack a camera and several lenses to cover almost all eventualities. The standard 50mm lens formed the backbone of the system and the vast majority of events, places, people and things were photographed with it.

The 50mm focal length has long been said to be the one that more closely matches the human angle of vision and the one producing the most accurate rendition of scale in a 10 x 8 print when seen from the normal viewing distance. Nowadays, 50mm is a length marked on a zoom lens covering a range of focal lengths from 28 to 100mm or more. For the majority of first time camera buyers, outside of the Leica circle, the short zoom has taken the place of the standard 50mm lens.

Leica do not produce a zoom lens for the rangefinder camera. Indeed, it would be difficult to see how they could overcome the problem of viewing without increasing the dimensions of the camera body. What the company continues to offer is not one, but three 50mm lenses, (see Chapter 2.) in the belief that the length with its 45° angle of view is still the one best suited to the faculties of the human eye.

The faith in amassing a great armoury of lenses in the belief that all eventualities can be covered, is

belief in a myth. After all, you can only use one at a time. What is more, the large majority of subjects for which the Leica-M will be used can be covered with a single focal length; only occasionally does a scene present itself which cannot adequately be photographed without resorting to a different focal length. Where cost is a factor to be considered in the initial purchase of Leica-M equipment, the 50mm lens would undoubtedly be my first choice.

8.4. Scale and perspective

Landscape, and cityscape photography are two of the most popular subjects for photography, and nowhere has more confusion reigned where the topics of scale and perspective are concerned.

To deal with the last first, we can say that photographic perspective has to do with the relationship between the size and form of objects and the position from which they are viewed. Thus, it is not the use of different focal length lenses which changes the viewer's perspective of an object or scene, but the position from which the object or scene was photographed.

The photographic delineation of the relative scale of objects is a more complex affair. It is directly related to the photographer's distance from an object and the focal length of lens used to record the image. We have already seen the effect of this using the L-shaped cards and in using the preselector lever of the Leica-M to switch from one focal length to another. A more lasting impression of the effect which focal length can have on scale and proportion is demonstrated in the practical experiment as follows.

Find a location where you can photograph a general scene of your town or city from a distance of about 1 mile (1.5kms). Alternatively, choose a landscape in which a large object, such as a tree or group of trees

Fig. 171. St.Tropez. In this scene using the 35mm focal length, the scale of the clock tower and the way in which it tends to dominate the town is diminished by the all encompassing angle of view.

Fig. 172. From the same position using a 400mm lens, the proportions of the tower relative to other buildings is restored.

is clearly visible and which will fit into the central portion of the frame. The camera-to-subject distance should be the same as that indicated above.

A bright, clear day, free of atmospheric haze and other forms of pollution, will give the best results. Use a slow to medium speed black-and-white or equivalent colour print film. Colour reversal materials are not suitable unless you are able to make reasonable quality prints direct from the transparencies. Use a tripod or some other support which will keep

the camera in a fixed position. Now expose two or three frames of the scene in front of the camera using a 50mm lens. Select an area within the 50mm image field which you can now shoot using the longest focal length lens available. The result will be more dramatic with a 135mm, but a shorter lens will do nevertheless.

Once the film has been developed, make a 10 x 8 inch print from the best negative of the whole scene shot with the 50mm lens. Make a similarly sized print from the best longer focal length negative. Dry the two prints and lay them on a flat surface under a good light. On the print shot with the 50mm lens, mark the image area on the print, using a chinagraph pencil or biro, which corresponds exactly to that of the image area covered by the longer lens. Return to the darkroom and enlarge the marked section of the 50mm negative to make a print which is identical in size to the print from the longer lens.

To register a more or less exact duplicate, put the enlarged telephoto print on the enlarger easel and use it to obtain the correct magnification from the 50mm lens negative. Now make a properly exposed and developed print, dry and return all three to the viewing area.

The perspective in all three prints will be identical. In selecting a portion of the 50mm lens negative for enlargement, the scale of objects within the frame is more accurately proportioned relative to the viewer's position. Using a longer focal length lens does not distort the perspective because that is not changed. The photographic position remained the same. The angle of view is diminished but the objects within the frame are in correct proportion to the surroundings. Another advantage of using the longer lens is that it permits prints to be made in which detail is more finely resolved and free of the grain associated with big

Fig. 173. In this example made with a 35mm lens, the apparent height of the building is partially maintained due to the shape of the building, the eyepoint, the inclusion of diagonal lines of the road and roof line leading to vanishing point as well as pedestrians who help to maintain the impression of correct scale.

Fig. 174. Using a slightly longer focal length (50mm), many of the geometric elements which make the previous picture (Fig 173) successful, are lost because of the foreshortening effect. This is one instance where the use of a longer focal length provides no benefit to the photographer.

enlargements of small portions of a negative.

Wide-angle lenses have the effect of foreshortening vertical proportion; an effect which may reduce the apparent overall size or height of an object, such as a tall building. The result is that any impression of grandeur or sheer bulk which the viewer may have had in reality, is diminished in the final print. Nowhere is this more apparent than in the use of wide-angle lenses used to make a photographic record of impressive landscapes, mountain-scapes or seascapes. The real scene confronting the viewer may be impressive for a variety of reasons; light, shade, scale, expanse, mood, the effect of aerial perspective and depth, all play an important part in affecting the way we think about cer-

tain scenes. But the camera records objectively. It cannot think or feel. Using a wide-angle lens to cram as much of the scene into the frame as possible minimizes all of the out-standing features and all but elimi-nates the least important aspects. When the result of this optical reduc-tion is presented in the form of a two-dimensional print a mere frac-tion the size of the original scene, all of the original drama is lost.

8.4. Candid applications – Street photography

An element of voyeurism exists in the make-up of most photographers. Observing how other people are in ordinary everyday life can produce compelling pictures. Facial expres-

sions and body language which reflect the spontaneity of the moment are the visual signs a photographer responds to.

These actions alone, however, may not always result in the picture we want, or the one that simply just 'happens'. Photographers must look for other signs which can add a moment of drama, humour, incon-gruity. To describe in words every aspect of this input is almost impos-sible because essentially it boils down to one thing, 'feel'. A feel for the environment and the people in it; a feeling for what is about to happen, a feeling for the juxtaposi-tion of light and shade, of form and content. What we want from a pic-ture is the frozen moment which combines all of these elements into a kind of explosive symmetry, even

Fig. 176. The great department stores of the world can provide a wealth of material for the candid photographer; most, if not all, have rules which discourage casual photography. I would not advocate that it's necessary to obtain permission to shoot first; on the other hand, if you plan several visits. a permit could be useful.

Fig. 175. Waterloo Station, London. The incongruities of life abound. In a matter of seconds this situation dissolved with the photographer being assailed by the figure to the right of the picture and several companions who were momentarily out of frame.

though in its final form there may be many aspects which are not conventionally symmetrical. What we don't want is the kind of vacuous banality that leaves the viewer unmoved, the cliché that has been done to death a thousand times before.

That this happens all the time is evident from the thousands of photographs which end up in print year in year out and in a way, I suppose it is inevitable, no matter how hard the discerning photographer tries to avoid the possibility. In this respect there is an analogy to be drawn between photographers and the sporting fraternity. Both draw on the exploits and achievements of heroes. But the similarity stops there. In

sport, the aim is always to do better, to improve on a world record, to be the best of the best. In photography, the modern practitioner looks to the hero for ideas that will make his or her photographs as good as, but not necessarily better than, what went before.

Ideas, styles, even composition and content are frequently copied, sometimes unwittingly at the moment of exposure. Only afterwards is a comparison drawn. This also is inevitable, because there are times when the photographer who is thoroughly cognisant with what has gone before absorbs some of that pictorial greatness. It hangs around in the subconscious as a kind of target to aim for. Often, there is no desire

to emulate, but the target remains all the same as a driving force, pushing photographers to always be ready for the 'now'. Admire what has gone before, be proud of what great photographers have done, but beware of imitation, plagiarism and the need to be better than; it can only lead to mediocrity.

The reader may feel I have cheated a little here. Little of the foregoing tells the Leica user how to approach the subject in a purely physical sense. This is a difficult

Figs. 178 & 179. The Leica-M's virtually silent shutter and rapid focusing gives the voyeuristic photographer a distinct advantage in being able to work from close quarters, affording a more natural viewpoint.

area, for in my book there are no hard and fast rules by which the photographer can operate. There are also other considerations, and perhaps the most important of these is to recognize that in an ever faster moving world with an ever growing population more cognisant of the continuing and growing public debate concerning privacy, the photographer's endeavour will not be made any easier.

The old adage that people willing to be seen in a public place are fair game for the voyeuristic photographer, is no longer valid. In my experience in different parts of the world, there are definite signs that some people see themselves more as victims than subjects of what is

intended to be a perfectly harmless endeavour. A few short years ago, this was not a problem that photographers often had to face. And I am not talking about areas or specific countries where people have always been traditionally sensitive to photography because of an underlying culture. In the so-called western civilised world, ordinary folk frequently see the camera as an intrusive device because of the seemingly endless way in which it is used to criticize.

How the camera is manipulated in front of the subject will depend largely on the character of the photographer wielding it. Street photography, as enjoyable and rewarding as it may be for some, is not for the

faint hearted. Elements of brashness, bravado and deviousness all have their part to play, and it is largely the situation to hand which will dictate how the photographer reacts.

I suppose deviousness is implicit in the nature of candid photography. The voyeur – a peeping Tom – is compelled frequently to hide behind a screen. The argument for this has always traditionally been that subjects, once they are aware of a camera's presence, stop doing what the photographer found interesting and do something else which is not. The Leica-M user has a significant advantage in these situations; the whisper silent shutter and the speed with which subjects can be focused. There is no need to distance yourself

Fig. 177. Ordinary street scenes are transformed in a instant by continuous comings and goings. Watching such scenes is akin to watching an uncut and unedited movie film in which every frame is an unexpected surprise. The still photographer takes many elements from many frames and co-ordinates them into one.

from the subject with a telephoto lens, which in any case invariably attracts the wrong kind of attention. The 50mm or 35mm focal length is perfectly adequate for the majority of subjects. Prefocused to permit the greatest zone of sharpness for a given f/-stop, in combination with the highest practicable shutter speed, the photographer should have no difficulty obtaining an intimacy with the subject.

Zones of sharpness are extended when using lenses with an even wider angle of view, such as the 28mm or 21mm. Now you have to approach the subject closer than before in order to overcome the diminishing effect of scale referred to earlier in this chapter.

At organised events such as carnivals, street parties and sports which take place on the public high-

way, photographers become a natural part of the scene and for the most part are tolerated by the public at large, even when they, the spectators, become the photographer's material. Under these circumstances, the photographer will find it easier to work, but perhaps less satisfying in terms of picture content.

Street performers, busking musicians, market traders and people performing a public duty are all subjects which can be approached openly without resort to more surreptitious methods. In some countries however, a permit to photograph on the streets may be required, and if you are planning to travel abroad, enquiries concerning this aspect should always be made in advance.

Wherever and whenever I am working the streets, I prefer to carry a minimum amount of equipment.

Two Leica-M bodies, one for black-and-white and one for colour, a 35mm Summicron f/2 fitted with protective UVa filter and lens hood on one body, a 50mm Summicron f/2 on the other, and in my pockets a 90mm, a 21mm with viewfinder and the 50mm Summarit f/1.5 which is used a lot for colour work. In addi-

Fig. 180. Top Right: The reader may detect that the eyepoint in this picture is somewhat higher than might normally be expected from someone pavement bound. I made the picture from the open back of a bus which had halted momentarily.

Fig. 181. Right: Photographers who hope to practise their craft on the street should avoid travelling by car. Public transport affords a vastly more interesting view of the world. London's burgeoning docklands.

tion, I use a Gossen or Weston hand-held light meter and carry heaps of film and cleaning cloths in a rucksack.

On longer assignments, I carry a spare third body in case of disasters, a Visoflex II mirror box housing, a Novoflex 400mm f/5.6 lens and Rapid Follow Focus grip which is fitted with the correct Viso adaptor and two Nikon lenses, a 55mm f/1.2 and 28mm f/3.5 for occasional use with the LEINIK-M adapter. There are at least two small electronic flash-guns with short connecting coaxial leads, spare batteries, filter pack and jeweller's screwdriver kit for emergencies. Neither the electric Leica Winder-M, nor its predecessors, are considered necessary for the bulk of work shot on these assignments. One item which is very useful however, is the voice activated Olympus Pearl-corder. This is a tiny extra burden to carry and can be secreted away in the top breast pocket of my jacket. It is ideal for recording caption details, messages and telephone numbers, which I find invariably get lost when they are committed to paper.

Photojournalism

9.1. What is it?

Times and fashion change. As I write, the term 'photojournalist' is socially acceptable. To the lay person, it means someone who makes words with pictures.

Fig. 182. From a story on tattooists.

To the photographic reporter its connotations have as much to do with fashion, glamour and adventure as with the real task of informing the uninformed. To the student of photography it may help to understand some of the background.

It is really only in the last three decades that the description photojournalist has gained its popularity, born out of an age when youth stampeded against the values most admired in post-war society. At that time, in the late fifties and early sixties, the press photographer was generally seen as some kind of low life. Of unkempt, shabby appearance whose trade mark was invariably a grubby trench coat and trilby hat that had seen better days. The explosion of newspaper magazine supplements in glorious colour, the dramatic change in styles of fashion photography in England and Europe, news-

Figs. 183 & 184. More frames from the tattoo series. The mistake made by many inexperienced photographers is to assume that magazine editors are only interested in stories which take place half-way round the other side of the globe; more ordinary subjects closer to home can provide interesting material for the freelance photojournalist.

Fig. 185. QE2. The more unusual angle of a familiar object stands a better chance of publication. Hardy perennials – subjects which have some longevity of interest for a broad range of readers – are the life blood of freelance photojournalism.

paper demands to obtain ever more intimate pictures of the day's action, were spurred on by youthful energy, stamina, determination to be somebody without having to spend years grafting in education.

Youngsters were filling their gadget bags with film and getting to the action any way they could. The pictures they brought back were different from those of even a few years earlier when the plate camera, the Rolleiflex and a pocketful of flashbulbs were king. The mass availability of sophisticated miniature-format cameras suddenly made the logistics of photographic expeditions into the jungles of Papua New Guinea or some other equally inaccessible place a very real possibility. One person could carry all that was needed to comprehensively shoot a war, a climb to the peak of the world's highest mountain or a voyage down (or up) the world's longest river. These people were no longer press photographers in the commonly accepted sense. Now they were photo-reporters, journalists with a camera. Eight, ten, twelve pages in a Sunday colour supplement devoted to their exploits was not uncommon. By-lines began to carry the title 'photo-journalist' instead of 'photographer' or 'photo-reporter'. Photojournalist rolled off the tongue easier. It was a title, like lawyer, doctor, accountant; it had connotations of respectability woven into a fabric that was actually all about the search for a glamorous way of life, a way of life that was different from the normally accepted ways, the apparent drudgery of work which prevailed.

All of this happened in a surprisingly short time, in keeping perhaps with other changes that were taking place in society. Photographically, the change continued, carried on the crest of the Vietnam War and pop culture waves. Somehow it has managed to survive, but its pedestal is fragile. Whenever the concrete around the edges begins to crumble, there is a sudden rush by the trade media to support it, but how long new generations of photographers will seek its mantle is another matter.

Strictly speaking, the photographer who also writes words to support pictures, is a photojournalist, but I much prefer the lay definition outlined at the beginning of this chapter. The idea that a photograph can be worth a thousand words, is still as relevant today as it was in years past. In that sense, the idea that one has to produce several pictures to make a story is rubbish. Where one will do the job, the other five become nothing more than padding. Less is often more.

The other side of the coin is that there are stories which cannot be told in less than two pictures; but the danger is that without the supporting words of diligent and accurate reporting, some of the real essence of a story can get lost, superficially washed over in a few picture spreads published more for their graphic form than for any objective and factual content. Photographers, I am told, are invariably their own worst editors when it comes to making portfolio selections. My view is that this is a theory perpetrated by editors who have never been photographers. Many writers before me have endeavoured to define the position and purpose of the photojournalist; they may well have done a better job of it. However, my feeling is that the nature of photography is too personal a thing to be so specific and the notion that the photojournalistic approach is something relatively new in editorial photography is frankly, rubbish.

Long before the Beatles or Vietnam, pop culture and the rest of the 60's social revolution was dreamt about, Henry Luce had founded *Life* magazine. It was to become a vehicle for some of the world's greatest photographs, picture stories and photo-journalism by some of the world's greatest photographic practitioners of the 1930's.

For many photographers, *Life* magazine more than any other perhaps, remains a monument to great photographic reporting; no publication before or since has been held in such high esteem, and when you are aware of the greatness that has already been achieved, settling for anything less is something of a compromise. Margaret Bourke-White, Andreas Feininger, W.Eugene Smith, Robert Capa, Henri Cartier-Bresson, Edward Weston and Dorothea Lange are just a handful of the many who pushed forward the boundaries of photographic reporting to a standard that in my view only a few modern photographers have been able to equal. I think they were able to do that by not losing sight of the fact that they were simply photographers above all else.

9.2. Practical considerations

Television has increasingly eaten into the market that photographers once relied upon to provide the space for extensive news picture stories. Compared with the choice that was available only ten years ago, today's market is a shadow of its former self. That said however, there is still a burgeoning outlet for photographs of all kinds in trade newspapers, the specialist press and books. Whatever advances television may make it will not, certainly in the foreseeable future, replace the printed image.

The photographer who wishes to see his/her work in print must first research the market. This requires a serious commitment to scanning the type of material published. Single photographs are invariably used to support text, to illustrate the salient points of an article or to head them up. A great many are supplied by stock agencies who keep hundreds of thousands, sometimes millions, of photographs of all kinds of subjects on file. Picture researchers are

commissioned by publishers to track down selections of photographs on particular themes and specific subjects such as events, people, inventions and so on. Specialist agencies and picture libraries exist side by side with the more general collections to cater for these needs.

Then there are the individual photographers who do not work through agencies, who prefer instead to work on a casual freelance basis directly with a specific publication or a number of similar magazines and book publishers around the world. To give some indication of the size of the market, in England alone, some 50-60,000 new book titles are published each year. This includes a large proportion of non-illustrated

Fig. 186. Gdansk, Poland. 21mm Elmarit-M. Often during the course of longer assignments, the opportunities for single pictures will present themselves to the observant photographer.

works of fiction, but even these cannot be sold unless they have an illustration on the cover.

It is a highly competitive world, but the rewards are commensurate with quality and in this respect the Leica-M user has no excuse for not being able to produce the finest quality possible in relation to the format.

Ironically, it is often the expense of feeding a camera which undermines the quality of material produced. I always found it slightly illogical that a person who could afford the world's best camera would make prints from it using an enlarger fitted with the cheapest and poorest quality lens. A similar philosophy applies to the photographer's basic raw material; film. It makes no sense at all to use anything but the highest quality available, even if the cost may be several times more than that of someone's own brand. Nowhere is

this more important than in the shooting of colour reversal images.

Over the years, I have used just about every type of colour reversal material available. There is only one type which is any good in my view, and not only for its colour rendition and acute sharpness. Kodachrome images, when they are properly stored, outlast anything else on the market. They rarely fade and there is no deterioration in colour quality or sharpness, such as is caused by structural breakdowns in the colour substrates of other types.

It could be argued of course that this may be true of yesterday's emulsions. Present-day colour films of the E-6 variety are vastly improved and there are many photographers who would be willing to debate their superiority even over Kodachrome. My feeling is that good though the modern E-6 emulsions may be, not enough time has elapsed yet to be

photo: copyright Adam Eastland

Fig. 187. Increasing use is being made of colour negative materials for reproduction purposes. C-41 type film stock has all the advantages of exposure latitude associated with b/w, and colour prints can be easily scanned to b/w repro without the loss of tonal quality often experienced with reversal materials.

Fig. 188. A Leaf 35mm electronic picture transmitter in use. Photographs can be sent to a receiver within minutes of film being developed.

able to judge the long-term considerations. Kodachrome on the other hand has been around for almost 60 years and there is plenty of evidence to prove its stability, longevity and excellent resolving ability.

Frequently, these advantages will have to be weighed against the distinct disadvantage of lengthy processing turn-round times for Kodachrome as against an hour or so with E-6 types. Where a breaking news story needs to be moved quickly to the market, E-6 reversal materials and increasingly, C-41 negative types are the staple diet of sports and press photographers.

In recent years, film manufacturers have dramatically improved the quality of colour print film. There is virtually no comparison to be made today between the quality of say Fuji 400 of five or six years ago and today's equivalent. It is just streets ahead in all respects. C-41 technology has improved of necessity to meet the growing demands of professional photographers, but especially to satisfy press photographers. It has great exposure latitude and can be processed in just about any high street minilab anywhere in the world in a few minutes. Globe trot-

ting photographers armed with laptop electronic picture transmission facilities no longer need prints or the associated mess of a temporary darkroom tent. Soon, the amateur too will be able to plug in to a relatively inexpensive electronic darkroom based around a personal computer incorporating a CD-based rapid print facility, which uses no messy chemicals.

Mark my words, it will come much sooner than you think.

Once you have decided on the type of subject or story you want to work on there are two ways to go about marketing it. The usual method is to approach the publisher you hope will take your work and outline your ideas for the story. A lot hangs on the story idea and the angle you intend to pursue. It will help,

Fig. 189. But first exposed film has to be safely returned to the press office. Here film for *The Associated Press* is collected from a photo-launch during an America's Cup Race. The cassettes are in the airborne bottle – which will float if dropped!

when visiting the photo editor or art director responsible, to go armed with a portfolio of work that shows your capability in dealing with similar subjects. Better still if you have already had some work published prominently. But don't despair if you haven't; editors are usually fairly open-minded even if, after you have explained in minute detail your hopes and aspirations, they turn round and suggest that another publisher might be more suitable. I'm afraid there is no easy way to get into print and whether you do or not will depend almost as much on individual determination as on the quality of work produced.

Some photographers will only undertake work when it is commissioned. Frankly, I think if you have a strong enough belief in your own ability, it is easier and quicker to take the bull by the horns and go out

on a limb. If your aim is to make a career out of editorial photography, risks will have to be taken most days of your working life. It doesn't seem like that after a few years of success, but initially one is cognisant of the fact that a great deal of capital must inevitably be tied up in self assignments. The risks that you won't get everything back that you put in are very real, but you must weigh this against instinct for the story and confidence in your ability to cover it well. If in doubt, leave it out.

The first requirement of any good story is that it should have wide readership appeal. Stories about interesting people, humour and sport can invariably guarantee publication. Features about social concerns are also popular, but you have to be careful not to criticize or take a political stand. The photojournalist's position

should always be objective, the neutral observer.

Planning a feature or photo-story is not difficult, but it does take time to set up well and may take even longer to shoot and put together as finished work. One-photo stories should be given the same meticulous treatment, but these too can take days, sometimes weeks to arrange, even if they are over in 1/250th of a second. The logistics of planning will initially involve perhaps dozens of telephone calls to editors, people who are already intimately involved with the story you wish to cover, as well as a good deal of letter writing to obtain permits and facilities. Dealing with this aspect in one's own country is a big enough headache; dealing with it in a foreign country is even more tedious, time consuming and frustrating when all you want to do is get on with the shoot. But do

Fig. 190. South Korea. Stories about different countries and cultures can prove a worthwhile investment for freelance photographers aiming to work in travel related fields.

it you must. It is no good turning up on the doorstep ten thousand miles from home and hoping that official blessing will automatically be granted. You may well find to your chagrin that your presence is suddenly an embarrassment and the only facility being offered is a seat on the next flight out of country.

Before planning a visit to a foreign country in any capacity other than tourist, the photojournalist will be well advised to obtain an official view of the current political situation. The British Foreign Office, the equivalent foreign affairs ministries of other European countries and America's Office of Foreign Affairs are usually very helpful in this respect. In countries where the political situation is known to be unstable or volatile, where entry visas are required for all visitors, be prepared for official obstruction and a long wait. Professional photographers in the employ of large news gathering organisations or high-circulation glossy magazines are in the enviable position of not only having their expenditure refunded, but also in having the assistance of numerous persons whose task in life is to ease the pain of travelling.

The struggling freelance determined to explore new ground, and the dedicated amateur photographer interested in broadening photographic horizons, are invariably loners. At best, there may be a girl/boyfriend or a wife/husband upon whom they can call for assistance when the going gets rough in planning an overseas trip. The time consumed in making preparations can often be halved with a little help and forethought.

Once the nature of the assignment has been established, the photographer will be able to select and pack equipment. This could end up being one bagfull or several aluminium cases full of expensive gear. Either way, you will need to think about whether or not there will be a need for a customs carnet for the equipment to facilitate its temporary export, and eventual re-importation, without having any of it impounded and being subjected to hefty fines. Customs regulations in certain countries often forbid the importation of more than a few rolls of film and one camera with two lenses. As a professional with the description 'photojournalist' clearly marked in my passport, I have experienced few problems in carting heaps of stuff to different destinations around the world. If I am on a travel assignment, I try to make sure I have a letter of accreditation from the tourist authority of the country I am visiting, but this, while it may satisfy the curiosity of a passing policeman, is rarely enough to calm an excited customs official.

Fig. 191. Photographers on long distance assignments should ensure they carry correct documentation; provenance information requirements with regard to equipment, and customs controls, vary from one country to another.

What you need is a carnet. This is an official looking document that is really nothing more than a manifest; an official list of equipment carried by yourself and recognized (because you provided the sales receipts) as having all duties and taxes paid in the country of origin. In the U.K. the nearest Chamber of Commerce can introduce you to the carnet voucher system which is operated by a number of countries. For a hefty fee the COC will list all of your equipment and its serial numbers in a booklet containing sufficient vouchers for you to pass freely from one country to another with the minimum of customs aggravation. The carnet is valid for a year. As you pass from one country to another, customs officials take your voucher and match it with another. Having passed through enough countries, one is eventually left with a booklet of stubs which must be handed back to the local COC. I say must, because in order to join in this game, the equipment owner is required to provide guarantee funds in the event of a claim being made for duty on the COC. They receive the bill – but you pay!

Fortunately for residents of the EU, border controls of most of the member countries no longer exist and one is usually able to pass without let or hindrance. Residents of the British Isles however, can still be subject to H.M.Customs and Excise controls. Photographers packing large consignments of expensive equipment will benefit from carrying the right documentation in the event of being stopped and questioned on re-entry to the country.

At the very least, the freelance photographer carrying one or two bodies and handful of lenses will do well to travel with copies of original purchase receipts of more recently acquired equipment, and if these are not available, a simple list naming type and serial number of each piece, together with a short statement which explains that the equipment was used for personal purposes only on temporary export from the country of origin.

9.3. Travel accessories

In chapter 8.4 I have described some of the essential equipment I would normally choose to work with. The problem when travelling a long distance to remote and out-of-the-way places is that the luggage problem grows. Many items of equipment have to be doubled up as insurance against damage and loss. In addition, there is a whole host of extra smaller items which may not be required all of the time, but surely will at some stage. Notebooks, writing materials, maps, guidebooks, heaps of spare tapes for the recorder as well as batteries, motor drives if any, electronic flash guns and a torch. One is a must, but two are better.

Over the years, I have tried to keep kit to an absolute minimum, but it is just about impossible if you aim to be prepared for most eventualities. Another factor worth considering is that while it is cheaper now than it ever was to travel long distance, if the budget is coming out of the photographer's pocket, it doesn't pay to leave a special lens at home, even if you think you'll never need it. The chances are that you will.

With the Leica rangefinder, I can at least keep the weight to a minimum and the bulk down to a sensible level. But it still has to be carried. The conventional shoulder bag has

Fig. 193. Billingham's 'Stowaway' pouches can be shoulder slung or clipped to a belt. Useful for carrying accessories, film and additional Leica-M lenses on casual assignments.

photo: Billingham Co. Ltd.

Fig. 192. Billingham of England manufacture high quality camera bags. This version of the 'Hadley' was a special edition for Leica-M enthusiasts, available through Leica Fotografie International magazine. (see address list for U.S. distributor)

photo: Pathfinder-Fox Ltd.

Fig 194. Underwater Kinetics Inc., manufacture this tough range of watertight and dustproof ABS moulded cases. They are available in different colours with padded dividers or pluck-foam interiors. Smaller models fit under aircraft seats. (see address list for U.K. distributor)

never been my idea of fun and no matter how much lighter the Leica-M may be compared to an SLR and lenses, by the time everything else is crammed into the bag, all the weight hangs in the wrong place. Constant use for long periods of time over a number of months can soon cause the kind of back injuries that are likely to stay with one for life.

The photographer's jacket, a kind of waistcoat with many lined and padded pockets, is probably one of the most useful accessories. Occasional travellers to the Far East will know where to get them tailor-made at reasonable cost. For the rest, several proprietary brands are available through distributors in the U.S. and Europe, including Tamrac and Billingham. The great thing about these jackets is that the equipment load can be spread so that it no longer becomes a burden. The Leica-M and most of its lenses can be easily ported in this way. A small shoulder bag may still be required to carry things like the Visoflex housing and a longer lens if you have one, a few spares, film stock, notebooks and the other paraphernalia some of us seem to accumulate in our travels.

Inevitably, there will be times when the quantity of photographic equipment which must be taken on assignment exceeds the limits of normal human endeavour. On occa-

sions when lengthy flights are necessary to reach far off destinations, all of my equipment is packed carefully into customized aluminium boxes and consigned to the aircraft baggage hold. Once past the check-in desk, equipment disappears down a conveyor belt tunnel and somehow, miraculously reappears on a similar belt (you hope at the same airport that you are) thousands of miles from where you last saw it.

I must confess, that even after many years and many thousands of miles travelling in this fashion, I still have to take a large gulp of faith when my bags trundle on their merry way. A miniscule element of comfort is gained from the fact that the cases are specially strengthened with additional plywood panels, glass fibre bound into the top, bottom and side panels. Ordinary proprietary brand aluminium cases can be used for lightweight equipment and accessories, but they should still be stripped on acquisition and rebuilt from the inside out. Fibreglass kits can be purchased from most auto spares suppliers. Alternatively, use West Epoxy (in the U.S.) or SP Systems Epoxy glues (U.K) to fit the additional stiffening. Once the g.r.p. resin or epoxy has cured, foam inserts can be glued back in place using contact adhesive.

Afterword

There are many practical aspects of photography in general which are well beyond the scope of this work. I have tried to consider the applications which the Leica-M will be most used for in the areas in which it excels, and one has to be realistic. In this day and age, a wealth of other types of equipment exist which are better suited to performing certain tasks. Take copying for example. While it is perfectly feasible, given the right equipment, Leica GmbH no longer manufacture the great range of technical apparatus they once did. It can be found on the secondhand market, but by the time you have spent months or even years amassing all the correct pieces, the job could have been done quicker and more efficiently another way.

Fig. 195. Leica M4-3-2, ser. nr. 1531841. This camera is unique. It is a black chrome M4-2 which has been stripped and rechromed silver. It has M3 projected bright-line frames fitted. The work was carried out by Reinhold Mueller in Toronto for Tom Abrahamsson.

The Leica-M is a very special instrument and it has a special place in the hearts of many photographers, but it is not an end in itself. It has advantages over the SLR and it has disadvantages. One of these is in the area of big telephoto and long focus lenses. Using the Telyt or Novoflex outfits as I have already described is a way out of the dilemma for the purist who has no need of the SLR. However, the majority of professional photographers would no more contemplate using a Leica-M fitted with Visoflex to cover a football match, than a chef catering for a banquet would consider peeling the tons of potatoes required by hand.

In the areas of photo reportage the Leica-M excels, but even here it may be necessary to resort to other types of camera to record specific images. The TTL meter of the M6, as useful as it is for 99% of work, lacks the sophisticated TTL flash facility of a Leica R7, which in macro or microphotography is a definite advantage to the user.

The real gains to the user of the rangefinder are in any area of photography where speed, silence and unobtrusiveness are the important and overriding factors. Where this type of camera is a necessary adjunct to an existing Leica SLR system, the advantage of being able to use an optical system which matches that of the SLR in every respect will be appreciated, not only by the user but in the publishing world when images from both systems are used in a layout.

In the long history of Leica rangefinder camera use, dozens of publications have appeared over the years. In order to obtain a real feeling for what is photographically possible, I would refer the reader to the Bibliography at the end of this book. In addition, there are some excellent illustrated works and biographies by different photographers in which the Leica rangefinder features prominently, and none more so perhaps than those by the late J.Allan Cash, an English photographer who made it his business to travel the world with a Leica.

A great deal of what Cash produced with his Leica is still widely published today in newspapers and magazines world-wide. It seems that the man had a phenomenal capacity

Fig. 196. Wily Ronis, who documented French life and culture over many decades with a Leica.

for getting into and out of places and countries that lesser men would have skirted around. Cash's photographs have a charm that harks back to Victorian artistic values; they are not the kind of stark soot and whitewash reportage we see so often today. Some might even consider them stereotyped, a little banal perhaps, but they are nonetheless a fine instruction in the essential art of photographic composition.

Other photographers, notably Henri Cartier-Bresson, Wily Ronis, Jacques Henri Lartique, David Douglas Duncan, Ernst Haas, Bert Hardy, Werner Bischof, Alfred Eisenstaedt have all been ardent practitioners of the Leica rangefinder and many

superb publications of their works are available.

I have touched lightly on the subject of collecting. It is not really within the scope of the work to be more specific. However, it has to be said that I have yet to meet a photographer who owns a Leica-M who can resist the topic. It simply shows that even the most blasé, hard-headed cynic who is forever proclaiming that it's the person behind the camera and not the hardware that counts, can be moved by the Leica!

As I began to write this work, an old pal who is now responsible for covering a large section of South-East Asia for one of the major news photo agencies dropped by on his annual leave. Somewhere along the

route he had acquired a virtually mint example of an early black enamelled Leica IIIa. On it was screwed a fairly late example of a 50mm Elmar f/2.8. I made the suggestion that considering the camera's condition it really ought to have been treated with some deference. He would have none of it, insisting that it was such a joy to use he had seriously considered selling his M6, using the funds to finance a few more screw thread lenses!

The fact is that there are a great many screw thread models available at reasonable prices in perfect working order. A Leica IIIg or IIIf is a real delight to use; different from the M-series in lots of ways, but still a practical camera for many subjects.

Fig. 197. Tim Page got so close to the action in Vietnam, it freaked other people. He goes back regularly with his Leicas to document the country and its people.

Figs. 198. The late Larry Burrows at work in Vietnam with Leica M3 and N/F 5cm Summicron f/2. Burrows worked for *Life* magazine. Some of his outstanding photographs can be seen in the book *Best of Life*. (see Bibliography.)

Fig 199.
Sowada San
(left) and
Pullitzer prize
winning
photographer
Horst Faas
armed with
Leica M3's in
Vietnam.

Screw threaded lenses made for these models are also relatively easy to find; by using the special screw/bayonet ring adapters, (see end tables) they can also be used on the M-series cameras. Older lenses may be slightly less contrasty than later models, but otherwise there is no difference in the optical quality or design of lenses with screw and bayonet mounts manufactured simultaneously. As Leica GmbH approaches the 21st century, the M6 may be modified and updated in minor ways. We may also see the introduction of a new focal length in the lens line up; a 24mm has been talked about for several years. The growing tendency to produce specially engraved models marking Lord knows what anniversary is beneficial to Leica; the worrying aspect is that these models have also acquired a specially inflated price that may not genuinely reflect their worth. Only time will tell.

The stated aim of Burkard Kiesel who is head of R & D at Leica Camera Group headquarters in Solms is to devote time and effort into improving the existing line up of equipment. This has been Leica's philosophy throughout the company's history. Subtle changes, even some major ones, often pass by without ceremony. In recent years, we have seen the process of bending to photographers wishes acted on a little more rapidly perhaps than in years past; it's an encouraging sign. But don't expect too many changes to the rangefinder. As Kiesel has said, 'What is there to change? Market research has confirmed that the product is absolutely correct.'

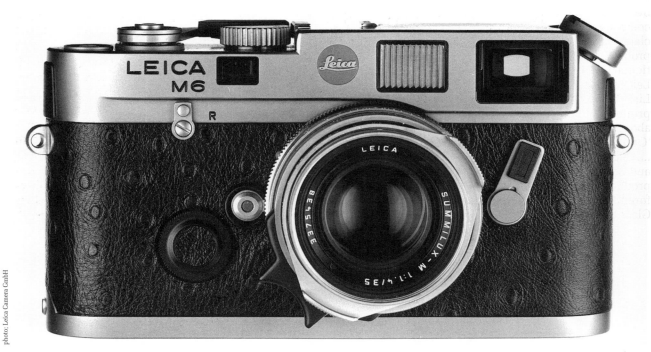

photo: Leica Camera GmbH

Fig. 200: Leica M6 Titanium, identical technically to standard M6, but with a scratch resistant titanium finish and leather body covering. Here with matching 35mm Summilux f/1.4.

The Leitz Glass Research Laboratory

There has been much confusion as to whether Leitz made their own optical glass for their production lenses. In a letter from Leica GmbH to the author, dated 27 April 1993, a company executive stated that neither Leica or Leitz ever smelt its own glass from raw materials for production purposes. The letter acknowledges the existence of the 'scientific laboratory' for the exploration of new optical glasses, and details the fact that 'some of the very special optical glasses were smelt there'.

This information was supplied after persistent requests by the author over a period of two years for the company to clarify certain aspects of claims made in advertising literature produced by the company. In particular, of the document entitled Leica Lenses for Optical Excellence, List Nr. 110-190 published and printed IV/85. On page 14 of this above document the text states, 'Optical glass of the highest quality,is the principle raw material, and some ten tonnes per year are produced in our own factory, from formulations originated by the Leitz Glass Research Laboratory.'

Similar statements are made in other documents published by the company and in virtually all literature produced by the company which deals with lens products, the intimation is the same; that glass blanks are derived from raw glass blocks and sheets produced on the premises. Logistically, the production requirements, even for Leica's relatively small output (compared to Japanese manufacturers) would require extensive smelting facilities which Leica GmbH do not have and Leitz before never had.

The work of the Leitz Glass Research Laboratory has, however, been very significant. Over 40,000 smelts (a figure consistent with the total of ten tonnes a year mentioned above) have been recorded in this laboratory before it was disposed of, and from this vast array of research, Leitz scientists have been able to establish the exact optical glass compositions required for the company's purposes. But as they had done from the beginning, Leitz procured their glass for production, in block and blank form, from outside suppliers who were able to smelt to Leitz's highly specialized requirements.

Charts and Tables

The following charts and tables have been included for your information and are, we believe, up to date.

Leica Rangefinder cameras since 1925

MODEL	YEAR OF LAUNCH	FIRST SERIAL No.:	LENS MOUNT
Leica I	1925	N/A	Fixed
Leica I (Compur)	1926	5701	Fixed
Leica I	1930		Screw
Leica II	1932	71500	Screw
Leica (Standard)	1932	100000	Screw
Leica III	1933	109000	Screw
Leica IIIa	1935	156201	Screw
Leica IIIb	1938	240001	Screw
Leica 250	1937	130001	Screw
Leica 1c	1949	455000	Screw
Leica If(B/D)	1952	562000	Screw
Leica IIc	1948	440000	Screw
Leica IIf(B/D)	1951	451000	Screw
Leica IIf(R/D)	1952	574401	Screw
Leica IIIc	1940	360000	Screw
Leica IIIf(B/D)	1950	525000	Screw
Leica IIIf(R/D)	1952	615000	Screw
Leica IIIf(S/T)	1954	685000	Screw
Leica IIIg	1957	825001	Screw
Leica Ig	1957	887001	Screw
Leica M3	1954	700001	Bayonet
Leica MP	1956	MP1-MP500 (402)	Bayonet
Leica M2	1958	926001	Bayonet
Leica M1	1959	950001	Bayonet
Leica MD	1965	1102501	Bayonet
Leica M4	1966	1175001	Bayonet
Leica MDa	1966	1159001	Bayonet
Leica M5	1971	1287001	Bayonet
Leica CL	1973	1300001	Bayonet
Leica M4-2	1978	1480001	Bayonet
Leica MD-2	1980	1545361	Bayonet
Leica M4-P	1981	1543351	Bayonet
Leica M6	1984	1657251	Bayonet

B/D = Black dial
R/D = Red dial
S/T = Self-timer

Current Leica-M Lenses

LENS	Speed/ focal length mm	Angle of view	Lens elements/ groups	Smallest Aperture	Focusing range in mm	Smallest object field in mm	Rec. Filter size	Length in mm	Largest ø in mm	Weight in g	Order No.
Elmarit-M*	f/2,8/21	92°	8/6	16	∞–0,7	705x1058	E 60	46,5	62	290	11 134
Elmarit-M	f/2,8/28	76°	8/6	22	∞–0,7	533x800	E 49	48	53	240	11 804
Summilux-M	f/1,4/35	64°	7/5	16	∞–1,0	630x950	Serie 7	28	53	195	11 870
Summilux-M titanium	f/1,4/35	64°	7/5	16	∞–1,0	630x950	Serie 7	28	53	195	11 860
Summilux-M** aspherical	f/1,4/35	64°	9/5	16	∞–0,7	420x630	E 46	44,5	53	300	11 873
Summicron-M	f/2/35	64°	7/5	16	∞–0,7	430x640	E 39	26	52	160	11 310
Noctilux-M	f/1/50	45°	7/6	16	∞–1,0	410x620	E 60	62	69	630	11 821
Summilux-M	f/1,4/50	45°	7/5	16	∞–1,0	410x620	E 43	46	53	320	11 114
Summicron-M	f/2/50	45°	6/4	16	∞–0,7	277x416	E 39	42	52	225	11 819
Summilux-M	f/1,4/75	31°	7/5	16	∞–0,75	192x288	E 60	80	68	600	11 815
Summicron-M	f/2/90	27°	5/4	16	∞–1,0	220x330	E 55	77	62,5	475	11 136
Elmarit-M	f/2,8/90	27°	4/4	22	∞–1,0	220x330	E 46	76	56,5	410	11 807
Elmarit-M	f/2,8/135	18°	5/4	32	∞–1,5	220x330	E 55	114	66	780	11 829
Tele-Elmar-M	f/4/135	18°	5/3	22	∞–1,5	220x330	E 39	105	59	535	11 851

*Additional 21mm viewfinder necessary ** Limited Special Edition

Quick guide lens fitting table

FOCAL LENGTH/NAME	M6	M4-P	M4-2	CAN BE USED WITH M5	M4	M1	M2	M3*
21mm Super-Angulon f4	no†	yes	yes	no	yes	yes	yes	yes
21mm Super-Angulon f3.4	no†	yes	yes	no*	yes	yes	yes	yes
21mm Elmarit f2.8	yes	yes	yes	yes	yes	yes	yes	yes
28mm Elmarit f2.8 (*) (£)	yes	yes	y/n	nbl	nbl	nbl	nbl	nbl
35mm Summilux f1.4	yes	yes	yes	yes	yes	yes	yes	yes
35mm Summicron f2	yes	yes	yes	yes	yes	yes	yes	yes
50mm Noctilux f1 (£)	yes	yes	yes	yes	yes	yes	yes	yes
50mm Summilux f1.4	yes	yes	yes	yes	yes	yes	yes	yes
50mm Summicron f2	yes	yes	yes	yes	yes	yes	yes	yes
75mm Summilux f1.4	yes	yes	y/n	nbl	nbl	nbl	nbl	nbl
90mm TeleElmarit f2.8	yes	yes	yes	yes	yes	nbl	yes	yes
90mm Elmarit f2.8	yes	yes	yes	yes	yes	nbl	yes	yes
135mm Tele-Elmar f4	yes	yes	yes	yes	yes	nbl	yes	yes
135mm Elmarit f2.8	yes	yes	yes	yes	yes	nbl	yes	yes

KEY:

no: rear element back projection cuts off meter cell.
no†: rear element back projection cuts off meter lens. Lens can be fitted.
no*: lenses above serial number 2473251 only can be fitted.
nbl: can be fitted, but no integral bright line viewer frame. Use of separate viewer in hot shoe possible.

y/n: a few late M4-2's factory fitted with 28mm and 75mm frames, but see below.
(*): only lenses above serial number 2411001 bring up 28mm viewer.
(£): lenses below serial number 2314921 cut off meter lens. Can be fitted.
M3*: only 35mm lenses with ocular attached, otherwise use separate viewfinder.

RESTRICTIONS WITH CERTAIN LENSES ON THE LEICA M5 AND LEICA CL

All lenses with LEICA bayonet mount, and, with a suitable bayonet adapter, the earlier, screw-thread versions of LEICA lenses can be used on the LEICA M5, and CL.

With minor exceptions or restrictions they can also be fully utilized for selective light metering through the lens.

EXCEPTIONS

1. When a lens is collapsible, collapsibility must be limited to the permissible amount by means of a protective tape. **The lens need not be returned to the factory.** The protective tape is available in various widths internationally from Messrs DYMO.

 The tape should surround the lens mount leaving a gap of 1mm. To obtain the right length, a paper pattern should first be cut.

Collapsible lens			Required width of tape
ELMAR®	f/3.5	50mm	
ELMAR	f/2.8	50mm	
SUMMAR	f/2	50mm	9.5
SUMMITAR	f/2	50mm	
SUMMICRON®	f/2	50mm	
ELMAR	f/4	90mm	
HEKTOR	f/2.5	50mm	12.7mm

2. **Lenses to be returned to a Leica National Agency or authorized workshop for adaptation:**
 Readers will need to check that this service is still available.

 a) 21mm and 28mm wide-angle lenses, parts of whose mounts protrude too deeply into the camera body.

 A recess in the lens bayonet prevents the swinging-in of the photo resistor. The lenses can be subsequently attached – but exposure measurement through the lens is not possible.

SUPER ANGULON	f/4	21mm	with screw thread.
			Only the **bayonet adapter** (Code No. 14 097) has to be changed.
			Please state: for 21mm
SUPER ANGULON	f/4	21mm	with bayonet mount
SUPER ANGULON	f/3.4	21mm	with bayonet mount (below Serial No. 2 473 251)
ELMARIT	f/2.8	28mm	with bayonet mount (below Serial No. 2 314 921)

 b) lenses whose detachable viewfinder attachments foul the cover plate of the LEICA M5.
 Lens bayonet and viewfinder attachment must be re-machined.

| SUMMARON | f/3.5 | 35mm | with **detachable** viewfinder attachment |
| SUMMICRON | f/2 | 50mm | with **near-focusing** range |

In addition the VISOFLEX I and III and the universal focusing bellows can be used with the LEICA M5. With these accessories, selective light metering is also possible with photography from a tripod. The measured value is read from the measuring viewfinder of the camera when the mirror is swung out.

The VISOFLEX II cannot be used.

Please use only the top plate supplied with the M5.

CASSETTES

In the LEICA M5 only films in cassettes with standardized spools (to din 4535 or ISO standards 1057) can be used. These spools have drive lugs on both ends.
The rewind key of the LEICA M5 (see illustration)
engages in the drive lugs facing the camera baseplate.

Eyesight correction lenses

DIOPTRE STRENGTH	PRODUCT CODE FOR M-CAMERAS 1977-1987	PRODUCT CODE FOR M-CAMERAS 1987 ONWARDS	M-CAMERAS PRE-1977
+0.5	14 361	14 350	
+1	14 362	14 352	
+1.5	14 363	14 352	
+2	14 364	14 353	
+3	14 365	14 354	
−0.5	14 366	15 355	
−1	14 367	15 356	
−1.5	14 368	15 357	
−2	14 369	15 358	
−3	14 370	15 359	
Near or long sight			Ortox (to 1951) then: 14 061
Astigmatism			ORLEO (to 1956) then: 14 062

M6 meter setting scale

METER DIAL SHOWS	ACTUAL SPEED SET ISO(ASA/DIN)
6/9'	6/9'
–	8/10
–	10/11'
12/12'	12/12'
–	16/13'
–	20/14'
25/12'	12/12'
–	25/15'
–	32/16'
50/18'	50/18'
–	64/19'
–	80/20'
100/21'	100/21'
–	125/22'
–	160/23'
200/24'	200/24'
–	250/25'
–	320/26'
400/27'	400/27'
–	500/28'
–	640/29'
800/30'	800/30'
–	1000/31'
–	1250/32'
1600/33'	1600/33'
–	2000/34'
–	2500/35'
3200/36'	3200/36'
–	4000/37'
–	5000/38'
6400/39'	6400/39'

Filter colour/grade size product codes

Filter Colour/Grade	Size	Product Code
Yellow/v.light/No.0	E39	13 081
	E41	13 155
	E43	YBEOO
Yellow/light/No.1	E39	13 086
	E41	13 160
/medium/No.2	E41	XOORU
	E43	13 161
	E55	13 236
	Ser7	13 006
	Ser8	13 019
Green/No.1	E39	13 096
	E41	13 170
Yellow-green	E55	13 391
	E60	13 392
	Ser7	13 007
Orange/	E39	13 101
	E41	13 175
	E43	13 176
	E55	13 312
	E60	13 383
	Ser7	13 011
	Ser8	13 008
Red:infrared/No.1,3	E39	13 116/13 126
No.1,3	E41	13 190/13 200
No.1,3.	E43	13 191/13 196
Blue	E39	13 098
	E41	13 172
	E43	13 173
UVa	E39	13 131
	E41	13 205
	E43	13 206
	E46	13 004
	E49	13 328
	E55	13 373
	E60	13 381
	Ser7	13 012
	Ser8	13 009
Polarising Filter	A42	13 352*

* supplied as a rotatable filter in special lens hood for M-lenses 50mm, f/2; 90mm, f/2.8; 135mm, f/4.

Battery types suitable for M6 meter

NAME	PRODUCT CODE	TYPE
Ever Ready	S 76 E	Silver Oxide
Mallory	MS 76 H – 10 L 14	Silver Oxide
Maxell	SR 44 F	Silver Oxide
National	G 13	Silver Oxide
Ray-O-Vac	RS 76G	Silver Oxide
Ucar	EPX 76 – S 76 E – 357	Silver Oxide
Varta	V 76 PX – V 76 HS – 541	Silver Oxide
Varta	CR 1/3 N	Lithium
Duracell	DL 1/3 N	Lithium

Lenshoods, fittings & product codes

Lens	Type of hood	Code
21mm Super-Angulon f/3.4	clip-on rectangular	12 501
21mm Elmarit f/2.8	clip-on rectangular	12 537
28mm Elmarit f/2.8	clip-on rectangular	12 536
35mm Summilux f/1.4	clip-on	12522
	below ser.no.2166701	
	above	12 504
35mm *Simmicron f/2	clip-on,	12 585 H,12 524,12 524*
35mm Summilux- Aspherical f/1.4	clip-on	12 504
50mm Elmar f/2.8	clip-on	12 580
50mm Summarit f/1.5	clamp type	XOONS/12 520
50mm Noctilux f/1	clip-on	12 538, 12 519
50mm Summilux f/1.4	clip-on	12 586*
50mm Summicron f/2	clip-on	12 538, 12 585*
75mm Summilux f/1.4	built-in telescopic	
90mm Elmarit f/2.8	built-in telescopic	
90mm Elmarit f/2.8	clip-on	12 575*
90mm Summicron f/2	built-in telescopic	
135mm Tele-Elmar f/4	built-in telescopic	
135mm Elmarit f/2.8	built-in telescopic	

* includes non-current versions.

Filters for current Leica-M lenses

Lens	Filter size	Internal Thread x Pitch
21mm Elmarit f/2.8	E 60	M60 x 0.75mm
28mm Elmarit f/2.8	E46	M46 x 0.75mm
35mm Summilux f/1.4	Series 7	M36 x 0.5mm
35mm Summicron f/2	E39	M39 x 0.5mm
35mm Summilux- Aspherical f/1.4	E43	M43 x 0.5mm
50mm Noctilux f/1	E60	M60 x 0.75mm
50mm Summilux f/1.4	E43	M43 x 0.5mm
50mm Summicron f/2	E39	M39 x 0.5mm
75mm Summilux f/1.4	E60	M60 x 0.75mm
90mm Elmarit f/2.8	E46	M46 x 0.75mm
90mm Summicron f/2	E55	M55 x 0.75mm
135mm Tele-Elmar f/4	E46	M46 x 0.75mm
135mm Elmarit f/2.8	E55	M55 x 0.75mm

Filter sizes for older Leica-M lenses

Lens	Filter size	Internal Thread x Pitch
21mm Super-Angulon f/3.4	E48/Series VII	M48 x 0.75mm
28mm Elmarit f/2.8	E48/Series VII	[1st series only] M48 x 0.75mm
28mm Elmarit f/2.8	E49/Series VII	[over Nr.2977550]
35mm Summaron f/2.8	E39	M39 x 0.5mm
35mm Summicron f/2	E39	M39 x 0.5mm
50mm Elmar f/3.5	A36, E39	M39 x 0.5mm
50mm Elmar f/2.8	E39	M39 x 0.5mm
50mm Summicron f/2	E39	M39 x 0.5mm
50mm Summarit f/1.5	E41	M41 x 0.5mm
50mm Summilux f/1.4	E43	M43 x 0.5mm
50mm Noctilux f/1.2	E48/Series 8	M48 x 0.75mm
90mm Elmarit f/2.8	E39	M39 x 0.5mm
135mm Elmar f/4	E39	M39 x 0.5mm
135mm Elmarit f/2.8	Series VI	M55 x 0.75mm*

* product code for M55 x 0.75 adaptor to Series VII = 14 225.

Leica-M Winders

Leica-M Winder type	FPS	Usable with M6.	M4-P	M4-2.	MD-2.	Override switch	Product code
M4-2. (ser.nr 10349 and under)	2(s)	no.	yes*	yes	yes	no.	14 214
M4-2. (ser.nr 10350 and over)	3	yes	yes	yes	yes	yes	14 400
M4-P	3	yes	yes	yes	yes	yes	14 400
Winder-M	3	yes	yes	yes	yes	yes	14 403
Replacement Battery Housing for M4-2							14 227
Remote Supply Power Cable							14 229
Hand Strap							14 228
Replacement Battery Housing for Winder-M							14 402

* Leica Winder M4-2 with serial numbers below 10349 cannot be used with the Leica M4-P camera with serial numbers between 1552500 and 1552884, or 1563000 and 1588536. (s) Approximate rate of frames per second. Winder was not capable of continuous firing until after serial number 10350.

Bayonet Adapter Rings

For Leitz lenses with screw mount: adapters to fit the same to 'M' bayonet cameras.

For the Leica M3:

FOCAL LENGTH OF LENS	PRODUCT CODE
21-50mm focal length	14 097
90mm focal length	14 098
135mm focal length	14 099
21, 28 & 50mm focal length	14 097
90mm focal length	14 098
35 & 135mm focal length	14 099

Screw threaded Visoflex II used on M camera*: Use any of the above adapter rings.

*Release lever needs modifying for M type cameras.

Visoflex III System

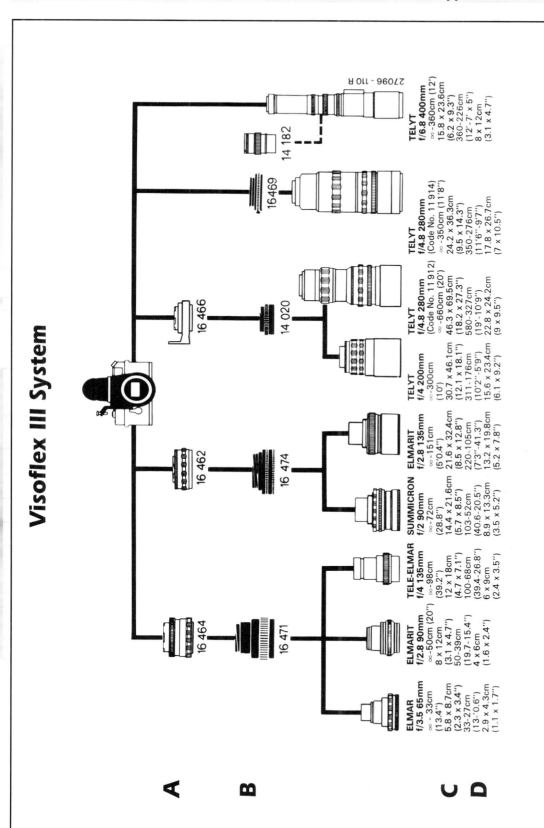

A 16 464

**ELMAR
f/3.5 65mm**
∞ – 33cm
(13.4")
5.8 x 8.7cm
(2.3 x 3.4")
33-27cm
(13"-0.6")
2.9 x 4.3cm
(1.1 x 1.7")

16 471

**ELMARIT
f/2.8 90mm**
∞-50cm (20")
8 x 12cm
(3.1 x 4.7")
50-39cm
(19.7-15.4")
4 x 6cm
(1.6 x 2.4")

**TELE-ELMAR
f/4 135mm**
∞-98cm
(39.2")
12 x 18cm
(4.7 x 7.1")
100-68cm
(39.4-26.8")
6 x 9cm
(2.4 x 3.5")

B 16 462

16 474

**SUMMICRON
f/2 90mm**
∞-72cm
(28.8")
14.4 x 21.6cm
(5.7 x 8.5")
103-52cm
(40.6-20.5")
8.9 x 13.3cm
(3.5 x 5.2")

**ELMARIT
f/2.8 135mm**
∞-151cm
(5'0.4")
21.6 x 32.4cm
(8.5 x 12.8")
220-105cm
(7'3"-41.3")
13.2 x 19.8cm
(5.2 x 7.8")

16 466

14 020

**TELYT
f/4 200mm**
∞-300cm
(10')
30.7 x 46.1cm
(12.1 x 18.1")
311-176cm
(10'2"-5'9")
15.6 x 23.4cm
(6.1 x 9.2")

**TELYT
f/4.8 280mm**
(Code No. 11 912)
∞-660cm (20')
46.3 x 69.5cm
(18.2 x 27.3")
580-327cm
(19'-10'9")
22.8 x 24.2cm
(9 x 9.5")

16469

**TELYT
f/4.8 280mm**
(Code No. 11 914)
∞-350cm (11'8")
24.2 x 36.3cm
(9.5 x 14.3")
350-276cm
(11'6"-9'7")
17.8 x 26.7cm
(7 x 10.5")

14 182

27096 - 110 R

**TELYT
f/6.8 400mm**
∞-360cm (12')
15.8 x 23.6cm
(6.2 x 9.3")
360-226cm
(12'-7' x 5")
8 x 12cm
(3.1 x 4.7")

C
D

A = adapter rings for normal focusing range
B = additional adapter rings necessary for the close-up and macro ranges
C = object field dimensions at minimum focusing distance
D = Format with additional adapter ring

Visoflex II System

The technical data beneath the lenses are as follows:

Focusing range (subject/film distance) **Scale of reproduction**
Subject covered at closest focusing limit **(EF) Exposure increase factor**

The lower two rows of data refer to the close-up or macro range obtained by the use of
the adapting rings 16469 Y, 16471 J, 16474 M or 16468 X

16469 Y **A**

16466 M **B**

35 mm Lenses*	**50 mm Lenses***	**HEKTOR f/2.5 125 mm**	**135 mm Lenses** in short mount	**TELYT f/4 200 mm**
5 1/2'' 1.1 : 1	8 3/8'' 1 : 1.3	∞ − 3′ 11 1/4'' 1 : 8	∞ − 4′ 11 1/16'' 1 : 9	∞ − 9′ 10 1/8'' 1 : 12.8
7/8'' x 15/16'' EF = 4.5 x	1 1/4'' x 1 7/8'' EF = 3 x	7 9/16'' x 11 5/16'' EF = 1.3 x	8 1/2'' x 12 3/4'' EF = 1.2 x	12 1/16'' x 18 1/8'' EF = 1.2 x
5 11/16'' 1.4 : 1	8 3/16'' 1 : 1	5′ 6 9/16'' − 32 11/16'' 1 : 5	6′ 11 1/16'' − 3′ 4 9/16'' 1 : 5.5	14′ 5 1/4'' − 6′ 6 3/4'' 1 : 8
11/16'' x 1'' EF = 6 x	15/16'' x 17/16'' EF = 4 x	4 1/2'' x 6 13/16'' EF = 1.5 x	5 3/16'' x 7 13/16'' EF = 1.4 x	7 3/8'' x 11 1/16'' EF = 1.3 x

*Lenses with screw attachment require bayonet adapting ring 14 097 D (or 14 098 N, 14 099 P)

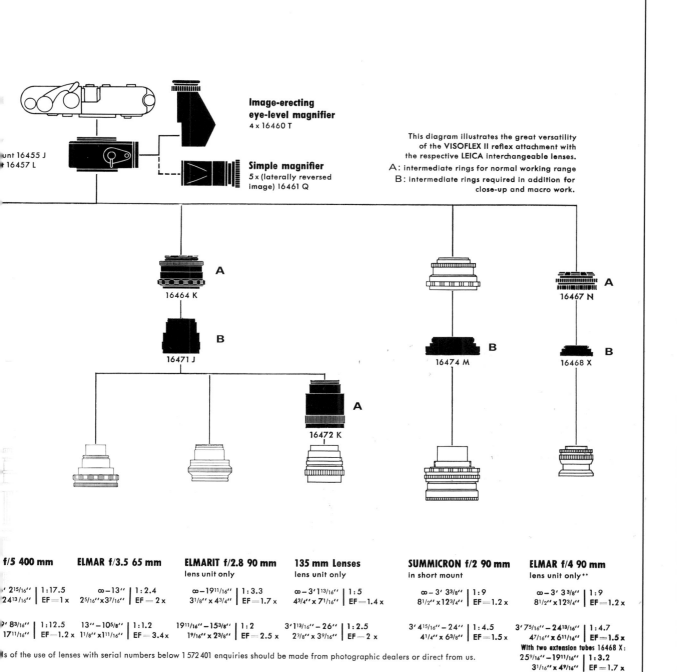

Image-erecting eye-level magnifier
4 x 16460 T

Simple magnifier
5 x (laterally reversed image) 16461 Q

unt 16455 J
16457 L

This diagram illustrates the great versatility of the VISOFLEX II reflex attachment with the respective LEICA interchangeable lenses.
A: intermediate rings for normal working range
B: intermediate rings required in addition for close-up and macro work.

16464 K — A

16471 J — B

16472 K — A

16467 N — A

16474 M — B

16468 X — B

f/5 400 mm		ELMAR f/3.5 65 mm		ELMARIT f/2.8 90 mm lens unit only		135 mm Lenses lens unit only		SUMMICRON f/2 90 mm in short mount		ELMAR f/4 90 mm lens unit only **	
2¹⁵/₁₆″	1:17.5	∞–13″	1:2.4	∞–19¹¹/₁₆″	1:3.3	∞–3′1¹³/₁₆″	1:5	∞–3′3³/₈″	1:9	∞–3′3³/₈″	1:9
24¹³/₁₆″	EF=1x	2⁵/₁₆″x3⁷/₁₆″	EF=2x	3¹/₈″ x 4³/₄″	EF=1.7x	4³/₄″ x 7¹/₁₆″	EF=1.4x	8¹/₂″x12³/₄″	EF=1.2x	8¹/₂″x12³/₄″	EF=1.2x
8³/₁₆″	1:12.5	13″–10⁵/₈″	1:1.2	19¹¹/₁₆″–15³/₈″	1:2	3′1¹³/₁₆″–26″	1:2.5	3′4¹⁵/₁₆″–24″	1:4.5	3′7⁵/₁₆″–24¹³/₁₆″	1:4.7
17¹¹/₁₆″	EF=1.2x	1¹/₈″x1¹¹/₁₆″	EF=3.4x	1⁹/₁₆″ x 2³/₈″	EF=2.5x	2³/₈″ x 3⁹/₁₆″	EF=2x	4¹/₄″ x 6³/₈″	EF=1.5x	47¹/₁₆″ x 6¹¹/₁₆″	EF=1.5x

With two extension tubes 16468 X:
25⁹/₁₆″–19¹¹/₁₆″ | 1:3.2
3¹/₁₆″ x 4⁹/₁₆″ | EF=1.7 x

ls of the use of lenses with serial numbers below 1 572 401 enquiries should be made from photographic dealers or direct from us.

Rare and unusual Leica-M cameras

Since the launch of the Leica M3 in 1954, excluding special MP, MD and CL models, only nine different basic models of the Leica rangefinder camera have been produced. Occssionally, Leitz and Leica have made special versions of these cameras, some of which are discussed in the text. These models have been those produced to special order, for example for military use, and special limited anniversary issues for authorised dealers, Leica Historical Societies and those issued by Leitz and Leica to commemorate "Leica anniversaries."

Other rarities have evolved during production runs of basic cameras. The M4-2, for example, features several different types of top plate engraving. A few special silver-chrome models, with lenses to match, were made when ordered by customers. The exact quantities of black enamel M3's are unknown. Two types of paint were used for these. One wears well, the other does not. Several suspect black M3's have been sighted in recent years. These were thought to have originally been silver-chrome, but have been stripped and painted. Throughout Leica history, many 'different' examples have been seen.

The following table lists factory issues numbering more than 10 units.

M-TYPE	YEAR	INDENTIFICATION MARKINGS/COLOUR	Approx. No. of units
M3	1954	Ser. Nrs. 700,000 on (obtuse angled top plate)	450
M3	1959-66	black lacquer/enamel	3010*
M3	1957	Olive Green. Ser. Nrs. 910501-910600	100**
MP	1956-58	MP1-12 chrome MP13-150 black enamel MP151-402 chrome	388
M2	1958-65	black enamel	1851
M2-R	1969-70	"M2-R" on top plate	2000***
M1	1960	Olive Green lacquer	50
M4	1968-71	Black enamel paint	4888****
M4	1970	Olive Green lacquer	31
M4	1971	Zeiss 'Fundus' M4-M and white circle. Ser. Nrs. 1274001-1274100	100
M4	1972	engraved on top plate "camera still picture KE-7A"	505 (1)
M4	1975	engraved on top plate "50 Jahre" with oak leaf cluster	1750 (2)
M5	1975	engraved on front top plate "50 Jahre" with oak leaf cluster	1750
CL	1975	engraved as above on front	1750
M4-2	1977-80	Carried red "Leitz" logo disc on front of camera	91-105

M4-2	1979-80	24ct. gold plate 'Oskar Barnack' signature engraved with anniversary dates on back	1000 (3)
M4-P	1982	Special edition engraved with triangular Mt. Everest logo in white	200
M4-P	1983	Ur-Leica anniversary edition. Engraved "1913-1983," with special lot Nr. preceded by one letter of name 'LEICA.' Silver-chrome	2500
M6	1988	engraved with logo of Leica Historical Society of America	200
M6	1989	Limited edition. Platinum plated, to celebrate 75 years of Leica photography. Engraved "75 Jahre Leica Photography" and "150 Jahre Photography" between special film symbol.	1250
M6G	1989	Special Swiss Photo Center dealer order. Red Leitz logo replaced by gold logo. Schematic of Elmar lens engraved on top plate. Each one numbered on base of shutter crate.	100
M6	1992	"Columbus" special Italian dealer edition. Engraved on top plate and body cap with dates and symbol.	200 (4)
M6	1993	'Rooster' Special edition for official Taiwan Leica dealership. Engraved with Chinese year of the Cock symbol and Chinese lettering	300 (5)
M6	1993	Fach-Foto Royal 25 years. Special edition for Foto-Royal, Salzburg. Silver and black. Embossed red leather. Engraved on top and back plate.	102
M6	1994	Engraved "M6J." Special Leica GmbH edition to mark 40th anniversary of the introduction of the M3.	1600

KEY:

* Nakamura (Leica Collection) quotes more than 6000 black Leica M3's being produced. Serial number records show small batches, mainly 200's, the largest 2000 and smallest. 10. P. H. Van Hasbroek quotes 'a few small batches were finished in black paint.'

** produced for German Army contract.

*** U.S. Army contract order cancelled, cameras sold to public.

**** This figure is calculated from serial number records. From 1974 onwards, Black M4's were finished in the special Leitz anodised black chrome.

(1) Contract for U.S. Army. Manufactured in two lots. First comprises five units only. Overrun without engraved U.S. Army contract Nr. released for public sales.

(2) 1400 manufactured at Leitz, Wetzlar; 350 by E. Leitz, Midland, Canada. Each camera carries a special lot number preceded by one letter of name L.E.I.C.A. in addition to standard serial Nr.

(3) Produced in two lots of 500 units each between 1979 and 80.

(4) Each camera additionally identified with lot number 1-40 using one letter of name I.T.A.L.Y.

(5) In fact, only 267 cameras were produced. Certain No's were dropped because of their connotations with bad luck in the Far East.

Depth of Field Tables

The following depth of field tables have been included for your information and are reproduced by courtesy of Leica Camera GmbH

Depth-of-field table for 21mm lenses

Distance Setting, m		0.2	0.25	0.30	0.35	0.4	0.45	0.5	0.6	0.7	0.8	1	1.2	1.5	2	3	5	∞
f/stop	2,8	0,196	0,243	0,29	0,33	0,38	0,41	0,46	0,54	0,62	0,70	0,84	0,98	1,16	1,43	1,87	2,46	4,74
		0,204	0,258	0,31	0,37	0,43	0,49	0,55	0,67	0,80	0,94	1,24	1,57	2,14	3,36	7,91	∞	∞
	3,4	0,20	0,24	0,29	0,33	0,37	0,42	0,46	0,54	0,61	0,69	0,82	0,95	1,13	1,38	1,78	2,31	4,24
		0,21	0,26	0,32	0,37	0,43	0,49	0,55	0,68	0,82	0,96	1,28	1,63	2,26	3,69	10,00	∞	∞
	4	0,19	0,24	0,28	0,33	0,37	0,41	0,45	0,53	0,60	0,67	0,80	0,92	1,08	1,31	1,66	2,12	3,61
		0,21	0,26	0,32	0,38	0,44	0,50	0,56	0,70	0,84	1,00	1,34	1,75	2,49	4,35	17,20	∞	∞
	5,6	0,19	0,24	0,28	0,32	0,36	0,40	0,43	0,50	0,57	0,63	0,74	0,84	0,97	1,15	1,41	1,72	2,60
		0,21	0,27	0,33	0,39	0,45	0,52	0,59	0,75	0,92	1,11	1,56	2,14	3,41	8,34	∞	∞	∞
	8	0,19	0,23	0,27	0,31	0,34	0,38	0,41	0,47	0,53	0,58	0,67	0,75	0,85	0,98	1,16	1,35	1,84
		0,21	0,27	0,34	0,41	0,48	0,56	0,65	0,84	1,07	1,34	2,07	3,26	7,70	∞	∞	∞	∞
	11	0,19	0,22	0,26	0,29	0,33	0,36	0,38	0,44	0,48	0,52	0,60	0,66	0,73	0,82	0,94	1,07	1,35
		0,22	0,28	0,36	0,44	0,53	0,62	0,73	1,00	1,34	1,81	3,53	9,74	∞	∞	∞	∞	∞
	16	0,18	0,21	0,25	0,28	0,30	0,33	0,35	0,39	0,43	0,46	0,51	0,55	0,60	0,66	0,73	0,80	0,95
		0,23	0,30	0,39	0,50	0,62	0,76	0,94	1,45	2,36	4,49	∞	∞	∞	∞	∞	∞	∞
	22	0,17	0,20	0,23	0,26	0,28	0,30	0,32	0,35	0,37	0,40	0,43	0,46	0,49	0,53	0,57	0,61	0,71
		0,24	0,33	0,45	0,59	0,79	1,05	1,45	3,33	45,90	∞	∞	∞	∞	∞	∞	∞	∞

Depth-of-field table for 28mm lenses

Distance Setting, m		0,3	0,35	0,4	0,45	0,5	0,6	0,7	0,8	0,9	1	1,2	1,5	2	3	5	10	∞
f/stop	2,8	0,29	0,34	0,39	0,43	0,48	0,57	0,65	0,74	0,82	0,90	1,06	1,30	1,60	2,20	3,20	4,60	8.40
		0,31	0,36	0,41	0,47	0,52	0,64	0,76	0,88	1,00	1,12	1,38	1,80	2,60	4,60	12,10	∞	∞
	4	0,29	0,34	0,38	0,43	0,47	0,56	0,63	0,71	0,79	0,87	1,01	1,20	1,50	2,00	2,70	3,70	5,90
		0,31	0,37	0,42	0,48	0,53	0,65	0,78	0,91	1,05	1,19	1,48	2,00	3,00	6,00	31,30	∞	∞
	5,6	0,29	0,33	0,38	0,42	0,46	0,54	0,61	0,68	0,75	0,82	0,95	1,10	1,40	1,80	2,30	3,00	4,20
		0,31	0,37	0,43	0,49	0,55	0,68	0,82	0,97	1,12	1,28	1,64	2,30	3,70	10,00	∞	∞	∞
	8	0,28	0,33	0,37	0,41	0,44	0,52	0,58	0,64	0,71	0,76	0,87	1,00	1,20	1,50	1,90	2,30	3.00
		0,32	0,38	0,44	0,51	0,58	0,72	0,89	1,06	1,25	1,46	1,95	2,90	5,80	∞	∞	5	∞
	11	0,28	0,32	0,35	0,39	0,43	0,49	0,54	0,60	0,65	0,70	0,79	0,91	1,06	1,30	1,50	1,80	2,20
		0,33	0,39	0,46	0,53	0,61	0,78	0,99	1,21	1,47	1,77	2,50	4,60	21,70	∞	∞	∞	∞
	16	0,27	0,30	0,34	0,379	0,40	0,46	0,50	0,54	0,58	0,62	0,69	0,77	0,88	1,02	1,17	1,30	1,50
		0,34	0,42	0,50	0,595	0,68	0,90	1,22	1,59	2,08	2,74	5,30	83,00	∞	∞	∞	∞	∞
	22	0,26	0,29	0,32	0,35	0,37	0,42	0,45	0,48	0,52	0,54	0,59	0,65	0,73	0,82	0,91	1,00	1,10
		0,37	0,45	0,55	0,66	0,79	1,12	1,72	2,57	4,17	8,34	∞	∞	∞	∞	∞	∞	∞

Depth-of-field table for 35mm lenses

Distance Setting, m	0,3	0,35	0,4	0,45	0,5	0,6	0,7	0,8	0,9	1	1,2	1,5	2	3	5	10	∞
1,4	0,298	0,347	0,396	0,444	0,493	0,59	0,68	0,78	0,87	0,97	1,15	1,42	1,87	2,70	4,20	7,30	26,30
	0,302	0,353	0,405	0,456	0,508	0,61	0,72	0,82	0,93	1,04	1,25	1,58	2,16	3,37	6,10	16,00	∞
2	0,297	0,345	0,394	0,442	0,489	0,58	0,68	0,77	0,86	0,95	1,13	1,39	1,81	2,60	3,90	6,50	18,40
	0,303	0,355	0,407	0,459	0,511	0,62	0,72	0,83	0,94	1,05	1,28	1,62	2,23	3,60	6,80	21,70	∞
2,8	0,295	0,343	0,391	0,438	0,485	0,58	0,67	0,76	0,85	0,94	1,11	1,36	1,75	2,50	3,60	5,70	13,20
	0,305	0,357	0,409	0,462	0,516	0,62	0,73	0,84	0,96	1,07	1,31	1,68	2,34	3,90	8,00	41,00	∞
4	0,294	0,34	0,39	0,43	0,48	0,57	0,66	0,74	0,83	0,91	1,07	1,30	1,66	2,30	3,30	4,80	9,20
	0,307	0,36	0,41	0,47	0,52	0,64	0,75	0,87	0,99	1,11	1,36	1,77	2,52	4,40	10,70	∞	∞
5,6	0,29	0,34	0,38	0,43	0,47	0,56	0,64	0,72	0,80	0,88	1,03	1,24	1,55	2,10	2,90	4,00	6,60
	0,31	0,36	0,42	0,48	0,53	0,65	0,77	0,90	1,03	1,16	1,44	1,91	2,82	5,40	20,00	∞	∞
8	0,29	0,33	0,38	0,42	0,46	0,54	0,62	0,70	0,77	0,84	0,97	1,15	1,42	1,80	2,40	3,20	4,60
	0,31	0,37	0,43	0,49	0,55	0,67	0,81	0,94	1,09	1,25	1,58	2,16	3,42	8,20	∞	∞	∞
11	0,28	0,33	0,37	0,41	0,45	0,52	0,59	0,66	0,73	0,79	0,91	1,06	1,28	1,60	2,00	2,50	3,40
	0,32	0,38	0,44	0,50	0,57	0,71	0,85	1,01	1,19	1,37	1,80	2,60	4,70	24,10	∞	∞	5
16	0,28	0,32	0,35	0,39	0,43	0,49	0,56	0,62	0,67	0,72	0,82	0,94	1,10	1,30	1,60	1,90	2,30
	0,33	0,39	0,46	0,53	0,61	0,77	0,95	1,16	1,39	1,66	2,33	3,90	12,30	∞	∞	∞	∞
22	0,27	0,31	0,34	0,37	0,41	0,46	0,52	0,57	0,61	0,65	0,73	0,82	0,95	1,10	1,30	1,50	1,70
	0,34	0,41	0,49	0,57	0,66	0,86	1,10	1,39	1,75	2,21	3,60	10,20	∞	∞	∞	∞	∞

f/stop (left axis)

Depth-of-field table for 50mm lenses

Distance Setting, m	0,5	0,6	0,7	0,8	0,9	1	1,2	1,5	2	3	5	10	∞
1	0,498	0,597	0,695	0,794	0,892	0,99	1,18	1,48	1,96	2,90	4,72	8,92	81,17
	0,502	0,603	0,705	0,807	0,908	1,01	1,22	1,53	2,05	3,11	5,32	11,38	∞
1,2	0,497	0,596	0,694	0,79	0,89	0,99	1,18	1,47	1,95	2,88	4,67	8,70	67.70
	0,503	0,604	0,706	0,81	0,91	1,01	1,22	1,53	2,06	3,13	5,39	11,70	∞
1,4	0,497	0,595	0,69	0,79	0,89	0,99	1,18	1,47	1,94	2,86	4,61	8,50	58,00
	0,503	0,605	0,71	0,81	0,91	1,01	1,22	1,54	2,07	3,16	5,46	12,00	∞
2	0,496	0,593	0,69	0,79	0,88	0,98	1,17	1,45	1,91	2,80	4,47	8.00	40,60
	0,504	0,607	0,71	0,81	0,92	1,02	1,23	1,55	2,10	3,23	5,68	13,20	∞
2,8	0,494	0,591	0,69	0,78	0,88	0,97	1,16	1,43	1,88	2,70	4,30	7,50	29.00
	0,506	0,610	0,71	0,82	0,92	1,03	1,25	1,57	2,14	3,30	6,00	15,20	∞
4	0,491	0,587	0,68	0,78	0,87	0,96	1,14	1,41	1,83	2,60	4,00	6,70	20,30
	0,509	0,614	0,72	0,83	0,93	1,06	1,27	1,61	2,20	3,50	6,60	19,50	∞
5,6	0,488	0,582	0,67	0,77	0,86	0,94	1,12	1,37	1,80	2,50	3,80	6,00	14,50
	0,513	0,619	0,73	0,84	0,95	1,04	1,29	1,65	2,30	3,70	7,50	31,40	∞
8	0,483	0,574	0,66	0,75	0,84	0,92	1,09	1,32	1,70	2,30	3,40	5,10	10,10
	0,518	0,628	0,74	0,86	0,97	1,09	1,34	1,73	2,40	4,20	9,60	∞	∞
11	0,477	0,566	0,65	0,74	0,82	0,90	1,05	1,27	1,60	2,20	3,00	4,30	7,40
	0,525	0,640	0.76	0,88	1,00	1,13	1,40	1,84	2,70	4,90	14,80	∞	∞
16	0,468	0,551	0,63	0,71	0,78	0,86	1,00	1,19	1,50	1,90	2,60	3,40	5,10
	0,538	0,659	0,79	0,92	1,06	1,20	1,52	2,05	3,20	6,90	144,00	∞	∞
22	0,457	0,535	0,61	0,68	0,75	0,81	0,94	1,10	1,30	1,70	2,20	2,80	3,70
	0,554	0,685	0,82	0,97	1,13	1,30	1,69	2,38	4,10	13,80	∞	∞	∞

f/stop (left axis)

Depth-of-field table for 75mm lenses

Distance Setting, m	1	1,1	1,2	1,3	1,5	1,7	2	2,5	3	4	5	7	10	20	∞
1,4	0,993	1,092	1,190	1,288	1,48	1,68	1,97	2,45	2,93	3,88	4,80	6,62	9,24	17,15	119,23
	1,006	0,108	1,210	1,312	1,52	1,72	2,03	2,55	3,07	4,13	5,21	7,42	10,90	23,99	∞
2	0,990	1,088	1,186	1,283	1,47	1,67	1,96	2,43	2,90	3,83	4,73	6,48	8,96	16,20	84,32
	1,010	1,112	1,214	1,317	1,52	1,73	2,04	2,57	3,10	4,19	5,30	7,62	11,32	26,16	∞
2,8	0,987	1,084	1,180	1,276	1,47	1,66	1,94	2,41	2,87	3,76	4,63	6,28	8,59	15,01	59,64
	1,014	1,117	1,221	1,325	1,53	1,74	2,06	2,60	3,15	4,27	5,44	7,90	11,97	29,97	∞
4	0,981	1,077	1,172	1,267	1,46	1,64	1,92	2,37	2,81	3,67	4,49	6,03	8,11	13,61	42,19
	1,019	1,124	1,229	1,335	1,76	1,76	2,09	2,64	3,21	4,40	5,64	8,35	13,04	37,79	∞
5,6	0,974	1,068	1,161	1,254	1,44	1,62	1,89	2,32	2,74	3,55	4,31	5,70	7,53	12,02	29,85
	1,028	1,134	1,242	1,350	1,57	1,79	2,13	2,71	3,31	4,59	5,96	9,08	14,92	59,90	∞
8	0,964	1,055	1,146	1,236	1,41	1,59	1,84	2,25	2,65	3,39	4,07	5,29	6,83	10,32	21,13
	1,040	1,149	1,260	1,372	1,60	1,83	2,19	2,81	3,46	4,88	6,48	10,35	18,75	349,60	∞
11	0,949	1,038	1,125	1,211	1,38	1,54	1,78	2,17	2,53	3,19	3,78	4,81	6,04	8,61	15,32
	1,057	1,171	1,287	1,404	1,64	1,89	2,28	2,96	3,70	5,38	7,39	12,93	29,48	∞	∞
16	0,930	1,014	1,096	1,178	1,34	1,49	1,71	2,05	2,37	2,94	3,44	4,26	5,19	6,97	10,59
	1,083	1,204	1,327	1,453	1,71	1,98	2,42	3,20	4,10	6,28	9,24	19,98	156,53	∞	∞
22	0,904	0,982	1,059	1,134	1,28	1,42	1,61	1,91	2,18	2,66	3,05	3,67	4,34	5,50	7,51
	1,121	1,253	1,388	1,528	1,82	2,13	2,65	3,63	4,83	8,24	14,29	88,51	∞	∞	∞

(f/stop values in left margin: 1,4 / 2 / 2,8 / 4 / 5,6 / 8 / 11 / 16 / 22)

Depth-of-field table for 90mm lenses

Distance Setting, m	0,7	0,8	0,9	1	1,1	1,2	1,3	1,5	1,7	2	2,5	3	4	5	7	10	20	∞
2	0,698	0,797	0,895	0,99	1,09	1,19	1,29	1,48	1,68	1,97	2,45	2,93	3,88	4,81	6,63	9,30	17,20	121,60
	0,703	0,804	0,905	1,01	1,11	1,21	1,31	1,52	1,72	2,03	2,55	3,07	4,13	5,20	7,41	10,90	23,90	∞
2,8	0,697	0,795	0,894	0,99	1,09	1,19	1,28	1,48	1,67	1,96	2,44	2,91	3,84	4,74	6,50	9,00	16,30	86,90
	0,704	0,805	0,907	1,01	1,11	1,21	1,32	1,52	1,73	2,04	2,57	3,10	4,18	5,29	7,59	11,30	25,90	∞
4	0,695	0,793	0,89	0,99	1,08	1,18	1,28	1,47	1,66	1,94	2,41	2,87	3,77	4,64	6,30	8,60	15,10	60,80
	0,705	0,807	0,91	1,01	1,12	1,22	1,32	1,53	1,74	2,06	2,60	3,14	4,26	5,42	7,90	11,90	29,60	∞
5,6	0,69	0,79	0,89	0,98	1,08	1,17	1,27	1,46	1,65	1,92	2,38	2,82	3,68	4,51	6,10	8,20	13,80	43,40
	0,71	0,81	0,91	1,02	1,12	1,23	1,33	1,54	1,76	2,08	2,64	3,20	4,38	5,61	8,30	12,90	36,70	∞
8	0,69	0,79	0,88	0,98	1,07	1,16	1,26	1,44	1,62	1,89	2,33	2,75	3,56	4,33	5,70	7,60	12,10	30,40
	0,71	0,81	0,92	1,03	1,13	1,29	1,35	1,56	1,78	2,12	2,70	3,30	4,56	5,93	9,00	14,70	57,40	∞
11	0,69	0,78	0,87	0,97	1,06	1,15	1,24	1,42	1,60	1,85	2,27	2,67	3,42	4,10	5,40	7,00	10,60	22,10
	0,71	0,82	0,93	1,04	1,14	1,25	1,36	1,59	1,82	2,17	2,78	3,43	4,82	6,40	10,10	17,90	194,00	∞
16	0,68	0,77	0,86	0,95	1,04	1,13	1,22	1,39	1,55	1,80	2,18	2,54	3,21	3,80	4,90	6,10	8,70	15,20
	0,72	0,83	0,94	1,05	1,17	1,28	1,40	1,63	1,88	2,26	2,93	3,66	5,31	7,30	12,60	28,10	∞	∞
22	0,67	0,76	0,85	0,94	1,02	1,11	1,19	1,35	1,51	1,73	2,08	2,40	3,00	3,50	4,40	5,30	7,20	11,00
	0,73	0,84	0,96	1,07	1,19	1,31	1,44	1,69	1,96	2,38	3,14	4,00	6,10	8,80	18,20	89,40	∞	∞
32	0,66	0,75	0,83	0,91	0,99	1,07	1,14	1,29	1,43	1,63	1,94	2,20	2,70	3,10	3,70	4,40	5,60	7,70
	0,74	0,86	0,98	1,11	1,24	1,37	1,51	1,80	2,10	2,60	3,56	4,70	8,00	13,50	67,90	∞	∞	∞

(f/stop values in left margin: 2 / 2,8 / 4 / 5,6 / 8 / 11 / 16 / 22 / 32)

Depth-of-field table for 135mm lenses

Distance Setting, m	1,5	1,7	2	2,5	3	4	5	7	10	20	50	∞
2,8	1,49	1,69	1,98	2,47	2,96	3,93	4,88	6,77	9,50	18,20	39,90	195,40
	1,51	1,71	2,02	2,53	3,04	4,08	5,12	7,25	10,50	22,20	67,00	∞
4	1,49	1,68	1,98	2,46	2,94	3,90	4,84	6,70	9,30	17,50	36,70	136,80
	1,51	1,72	2,02	2,54	3,06	4,11	5,17	7,40	10,80	23,40	78,50	∞
5,6	1,48	1,68	1,97	2,45	2,92	3,86	4,78	6,60	9,10	16,70	33,20	97,60
	1,52	1,72	2,03	2,56	3,08	4,15	5,25	7,50	11,10	25,00	101,80	∞
8	1,48	1,67	1,95	2,43	2,89	3,80	4,69	6,40	8,80	15,50	29,00	68,30
	1,53	1,73	2,05	2,58	3,12	4,22	5,36	7,70	11,60	28,10	183,20	∞
11	1,47	1,66	1,94	2,40	2,85	3,73	4,60	6,20	8,40	14,40	25,10	49,70
	1,53	1,75	2,07	2,61	3,17	4,31	5,50	8,10	12,40	33,10	∞	∞
16	1,45	1,64	1,91	2,36	2,79	3,60	4,40	5,90	7,80	12,70	20,40	34,20
	1,55	1,77	2,10	2,67	3,25	4,50	5,80	8,70	13,90	47,10	∞	∞
22	1,44	1,61	1,88	2,31	2,70	3,50	4,20	5,50	7,20	11,20	16,80	24,90
	1,57	1,80	2,14	2,73	3,40	4,70	6,10	9,50	16,30	96,50	∞	∞
32	1,41	1,58	1,83	2,23	2,60	3,30	3,90	5,10	6,40	9,40	12,90	17,20
	1,61	1,84	2,21	2,86	3,50	5,10	6,90	11,50	23,00	∞	∞	∞

f/stop (row label, left vertical)

The upper figures indicate the object-to-film distance engraved on the relevant lens. The associated depth-of-field range is indicated in the groups.

Example: Distance = 3m

At f/4 Depth-of-field between 2,60
3,50

The tables have been calculated with a circle-of-confusion of ⅟₃₀mm, and the figures rounded off.

Bibliography

Bower, Brian; *Leica Reflex Photography*; David & Charles, Newton Abbot, 1991.

Daval, Jean-Luc; *Photography, History of an Art*; Editions d'Art Albert Skira S.A., Geneva, 1982.

Dmitri, Ivan; *How to Use Your Miniature Camera*; The Studio Limited, approx 1950.

Duncan, David Douglas; *Nomad, A Photographic Odyssey*; Paul Hamlyn Ltd, London, 1966.

Duncan, David Douglas; *War Without Heroes*; Thames and Hudson Limited, London 1971. `I depended on two Leicas (custom-built M3D's). One Leica was fitted with a Leitz 50mm, f/1.4 Summilux, and the other with a Nikkor 28mm, f/2.8 lens; both lenses with medium yellow filters.'

Eastland, Jonathan; *Cityscape Photography*; B.T.Batsford, London, 1985.

Ehrlich, Richard; *Tony Ray-Jones*; Cornerhouse Publications, Manchester, England, 1990.

Eisenstaedt, Alfred; *Witness To Our Time*; The Viking Press Inc., New York, 1966, 1967.

Frank, Robert; *The Americans*; Cornerhouse Publications, Manchester, England, 1993. Original edition, *Les Americains*; Robert Delpire, Paris, 1958.

Gernsheim, Helmut and Alison; *A Concise History of Photography*; Thames and Hudson, London 1965, 1971.

Hasbroeck, van, Paul-Henry; *Leica - A History Illustrating Every Model and Accessory*; Revised edition. Sotheby Publications, London, 1993.

Karfeld, Kurt Peter; *My Leica and I - Leica Amateurs Show Their Pictures*; Photokino-Verlag Hellmut Elsnert K.-G., Berlin, 1937.

Kingslake, R; *A History of the Photographic Lens*; Academic Press, London, 1989.

Laney, Dennis; *Leica Collectors Guide*; Hove Collectors Books, Hove, 1992.

Laney, Dennis; *Leica Lens Practice – Choosing and Using Leica Lenses*, 2nd Edition; Hove Books, Hove, 1993.

Morgan. Willard D. Lester, Henry M.; *Leica Manual* and *Leica Manual and Data Book*; 15 editions; Morgan & Morgan Inc., New York, 1935 to 1973.

Nakamura, Shin-ichi; *Leica Collection*; Asahi Sonorama Co. Ltd., 1991.

Osterloh, G; *Leica M – The Advanced School of Photography*; Umschau Verlag, Germany. 1987.

Pfaender, Heinz G.; *Schott Guide to Glass*; Schott Glaswerke, Mainz, Germany.

Rogliatti, Gianni; *Leica – The First Sixty Years*; Hove Collectors Books, Hove, reprinted 1993.

Rotolini, Robert; *Nikon Rangefinder Camera*, Second edition; Hove Collectors Books, Hove, reprinted 1983.

Whelan, Richard; *Robert Capa, A Biography*; Alfred A. Knopf Inc., New York, 1985, also Random House, Canada; Faber and Faber Ltd, London 1985.

The Best of Life; Time Inc., 1973.

MAGAZINES

Leica Fotografie International; various issues; Umschau Verlag, Germany.

Leica Photographic Bulletin; Published by Leica UK Ltd., various issues.

Modern Photography; December 1975 issue. ABC Leisure Magazines, New York. (M5 meter details.)

Address File

Abrahamsson Rapidwinder and 21 Super Angulon Viewer
Tom B.Abrahamsson
Industrial Designer, Photographer
#203-1512 Yew Street
Vancouver B.C.
Canada V6K 3E4

Ajax M-Pouch
contact the author at;
Ajax News & Feature Service
Box 1, Riverside Boatyard,
Blundell Lane,
Bursledon,
Southampton S03 8BA, UK

Novoflex Fotogeratebau
Karl Muller
Donaustrasse 78
D-8040 Memmingen
Germany

Leica Camera GmbH
Oskar-Barnack-Strasse 11,
D-6336 Solms
Germany
Tel: + 49 0 64 42 208 0.
Fax: + 49 0 64 42 208 333
Telex 4 82 610 LEICA D.

Leica Camera Ltd.
Davy Avenue
Knowhill
Milton Keynes MK5 8LB
Tel: 44 908 666663. Fax: 44 908 671316.

Leica Camera Inc.
156 Ludlow Avenue
Northvale
New Jersey NJ 07647 USA
TEL: + 201 767 7500

Leica Fotografie International
(8 issues per year published in English,
German and French)
Umschau Verlag
Stuttgarter Strasse 18 – 24
6000 Frankfurt/Main
Germany

Index

Page numbers in italics refer to illustrations

Volcanoes of the Earth, Moon and Mars

Volcanoes of the Earth, Moon and Mars

Edited by G. Fielder and L. Wilson

St. Martin's Press New York

First published in 1975 by
Paul Elek (Scientific Books) Ltd.,
All rights reserved. For information, write:
St. Martin's Press, Inc., 175 Fifth Avenue, New York, N.Y. 10010
Library of Congress Catalog Card Number: 74-19887
First published in the United States of America in 1975.

Printed in Great Britain

Contents

Editors' Prologue

The last ten years have seen an unprecedented expansion in the exploration of the Moon and inner planets. Probes have now visited the Moon, Mars, Jupiter, Venus and Mercury; and a score of men have visited the Moon. Two essential features of this expansion have been the development of space probes, especially artificial satellites capable of orbiting planets for long periods, and the production of entirely automatic experimental packages that require little or no control from an Earth base, but continue to relay data on their surroundings as long as their power supplies last.

It has been possible to develop this sophisticated technology as a result of the great advances in electronics that have been forged during the last decade. The introduction of miniaturised solid state components, complete 'integrated' circuits built in single, encapsulated packages, and fast, computer-controlled data-recording and analysis have not only allowed scientists and engineers to guide artificial satellites and probes to explore the planets; they have also effected an enormous expansion of geophysical and geological exploration of the Earth. Scientists in all fields now think of the Earth simply as another planet, albeit the most important one to mankind, and the Earth can be explored by virtually all of the techniques employed for the other inner planets.

In this book, designed for those having sixth form science, recent space results relating to volcanism on the planets Earth, Moon and Mars have been assembled and interpreted in conjunction with complementary field work relating to the Earth, and with recent theoretical analyses.

Support

The Lunar and Planetary Unit is one of the largest interdisciplinary teams in the world concentrating on research on the Moon and planets. The L.P.U. was established in the Department of Environmental Sciences of the University of Lancaster in 1970. L.P.U. personnel are supported by the Natural Environment Research Council and by the University of Lancaster which has also put workshops, laboratories and general facilities at the disposal of the Unit. Space photographs and support data are supplied to the L.P.U. by the National Aeronautics and Space Administration of the U.S.A., principally through the World Data Center A for Rockets and Satellites.

Editors

Dr G. Fielder is Head of the Lunar and Planetary Unit and Reader in Environmental Sciences. He graduated with honours in Mathematics and Physics in 1954 (London University) and then specialised in lunar astronomy and geology at Manchester University, where he initiated astrophotographic work, sponsored by the United States Air Force, on the preparation of lunar relief maps. In 1965 he worked as Consultant at the Lunar and Planetary Laboratory of the University of Arizona to assist the late Dr G.P. Kuiper with the interpretation of Ranger close-up photographs of the Moon and, from 1966 to 1970, Dr Fielder was Lecturer in Astronomy in London University and head of its

Lunar Laboratory. During this time, he spent a year as Visiting Associate Professor in the University of Arizona and as Consultant to the Boeing Aircraft Corporation (Seattle) interpreting Lunar Orbiter photographs. In 1969, NASA elected him as Co-Investigator in the Lunar Apollo Programme. He is the author or editor of five previous books.

Dr L. Wilson is in charge of the L.P.U. Research Laboratories and Lecturer in Environmental Sciences. He graduated with honours in Physics (University of Birmingham) in 1965 and then specialised in lunar and planetary photometry at the Lunar Laboratory of the University of London. He was admitted as a Graduate of the Institute of Physics in 1965. He has worked as Visiting Observer at the Royal Greenwich Observatory on the photometry of the planet Mercury, at Meudon Observatory (Paris) on lunar photometry, and as Consultant at the Lunar and Planetary Laboratory of the University of Arizona on lunar crater formation. Dr Wilson is advisor to the Meteor Section of the British Astronomical Association and is currently working on volcanic cratering and impact cratering.

Authors

Chapter 1 was prepared by Dr Fielder.

Chapter 2 was written by Mr H. Pinkerton, L.P.U. Research Fellow and senior geologist of the team. Mr Pinkerton gained an honours degree in Engineering Geology (University of Strathclyde) in 1970 and has since built advanced equipment for measuring the viscosities of liquid lavas and has led numerous field expeditions to European volcanic districts. In 1973 he investigated the active volcano Heimaey, illustrated in this book.

Chapter 3 was compiled by Mr Pinkerton (opening part), Miss R. Todhunter (lunar flows) and Dr G. Hulme (theory). Miss Todhunter is a L.P.U. Research Student with an honours degree in Geology (University College of Swansea). She specialises in the interpretation of lunar lava flows and has conducted related field work in Iceland. Dr Hulme is L.P.U. Research Associate and senior geophysicist of the team. He graduated with honours in Physics in 1966 (University of Newcastle-upon-Tyne) and then specialised in geophysical fluid dynamics. Thereafter, Dr Hulme was Scientific Officer at the National Gas Turbine Establishment (Pyestock) before joining L.P.U., in 1971. Since then, his research has covered the rheology and thermodynamics of lavas and lunar gravitational problems.

Chapter 4 was also written jointly, by Dr Wilson and Dr S. Self, who graduated with honours in Geology at the University of Leeds in 1970. Since then, he specialised in tephrochronology in the Department of Geology of the Imperial College of Science and Technology, London, and has worked on two active volcanoes (Etna, 1971 and Heimaey, 1973). Dr Self, currently in New Zealand, is the sole extra-mural collaborator in the preparation of this book and contributed the latter part of the chapter.

Chapter 5 was composed by Dr Wilson and Mr A. Hawkins, L.P.U. Research Assistant with an honours degree (1970) in Molecular Sciences (University of Warwick). Mr Hawkins has been measuring the thermal conductivity of lunar rocks returned by the Apollo missions; and he is now working on the effect of the solar wind on the chemical alteration of rocks.

Chapters 6 and 7 were prepared by Mr J.L. Whitford-Stark, L.P.U. Research Assistant and an honours graduate in Geology and Geography (University of Keele, 1971). Mr Whitford-Stark is working on lunar tectonic mapping and the petrology of the rocks from the various landing sites on the Moon. He also acts as curator of the L.P.U. collection of lunar and planetary photographs.

Chapter 8 was assembled by Dr R.J. Fryer, L.P.U. Research Associate, who graduated with honours in Physics (University College London) in 1966 and then gained a diploma in Space Science from the same Department. His specialities include lunar crater statistical analyses, the cataloguing of terrestrial crateriform structures, and computerised

planetary mapping techniques. Dr Fryer joined the staff of the Lunar Laboratory of the University of London in 1967 but has worked at the Meudon and Pic-du-Midi Observatories (France) and, for parts of 1967 and 1968, as Research Associate at the Lunar and Planetary Laboratory of the University of Arizona. While in Arizona he was responsible, with Dr Fielder, for developing new methods to segregate lunar volcanic and impact craters. Dr Fryer has co-edited Parts 1 and 2 of the ESRO Catalogue of Terrestrial Crateriform Structures and is currently working on martian tectonic mapping.

Chapter 9 was written by Dr Hulme and is based on his most recent work on lava rheology (*vide supra*).

Acknowledgements

The research on which this book was based was sponsored by the University of Lancaster and by the Natural Environment Research Council (London). The Editors would like to express their sincere thanks to Mrs Maureen Shuttleworth, L.P.U. Secretary, for her supreme efforts in connection with the preparation of the book; and to record their appreciation of the willing co-operation provided by all L.P.U. staff at all times during the planning of the work and the writing of the manuscript. The Ranger 9, Lunar Orbiter 2, 4 and 5, Apollo 8, 15 and 17, and Mariner 9 photography was provided by the National Space Science Data Center through the World Data Center A for Rockets and Satellites. We are greatly indebted to Dr James I. Vette, Director of the World Data Center A for Rockets and Satellites for his continuing courtesy.

GF and LW, 1974

1 Volcanic Environments

Introduction

Space missions have opened up a new perspective on the planets (Figure 1.1). Physical processes well known to our special planet, the Earth, have been found to operate elsewhere. Volcanoes and lava flows have suddenly assumed great significance. Some scientists are beginning to see them as general planetary phenomena of fundamental importance. On Earth, volcanism has provided us with the lands on which we live and find sustenance; volcanic exhalations have provided the basis of the air which we breathe; volcanoes may even have helped to bring life to the Earth by creating conditions of the right sort for the spontaneous generation of organisms from inanimate matter. Other planets, such as Venus and Mars, may also have derived their atmospheric blankets from volcanic gases.

Volcanic rocks are erupted on a planet when hot rocks at depth find access to the surface. The way out will always be that which offers the least resistance. A fracture, a set of parallel fractures, or, again, intersecting fractures in the crusts of the Earth, Moon and Mars (Figure 1.2) are common routes of access of volcanic lavas. Hydrostatic pressure of the surrounding, solid rocks on the underlying, liquid magmas squeezes them upwards.

At what depths in a planet do volcanoes have their origin? How are the rocks at depth heated? Why does one volcano assume the form of a steep-sided cone whilst another has a profile like that of a gently curved shield? Why are some eruptions violent, flinging out hot ash, and others quiescent, exuding vast volumes of black lava? Answers to these questions are to be found among the pages of this book. First, it is appropriate to enquire about the broad environment of volcanoes by discussing the nature and genesis of the planets themselves.

Origin of the Planets

The planet Earth is one of the many objects in the Solar System (Figure 1.1) that accumulated from the gas and dust of the Sun's nebula some 4.6 thousand million years ago. The Earth underwent a process of evolution that was unique among the Sun's succession of planets. For, although it may be argued that the Earth is comparable in size (Table 1.1) to Venus — and that, therefore, the two planets may have followed parallel evolutionary tracks — these planets are subject to different environmental conditions; and the environment of a planet at any given time is an important factor governing its evolution. Planets in their early stages of growth would be particularly sensitive to the physical conditions — such as the nature and type of the radiation from the Sun, the temperature and the magnetic field — around them in the partly ionised gas and solid grains of the solar cloud. Little is known with certainty about these early conditions; but it is clear that they must have influenced the chemical composition of planets and, in particular, that they must have introduced compositional differences between planets at different distances from the Sun. Lists of the presently observed abundances of elements would indicate that hydrogen, helium, carbon, nitrogen and oxygen, and their compounds were prelevent in the solar nebula. A glance at the mean densities of the planets and satellites listed in Table 1.1 illustrates that, broadly speaking, the terrestrial planets (those closest to the Sun) are composed of Earth-like materials whereas, by contrast, the more remote group of major or jovian planets (the biggest ones) have lower mean densities not very different from that of the Sun itself.

Some of the satellites of the major planets also have estimated densities that are not dissimilar to those of rocks or to those of the Earth as a whole. It is known that the observed temperatures (Table 1.1) of Jupiter and Saturn are significantly higher than they would be were the planets in question heated by the Sun alone: these planets, like the Earth and Moon, must have their own sources of internal heat. Because Jupiter and Saturn are (like Venus)

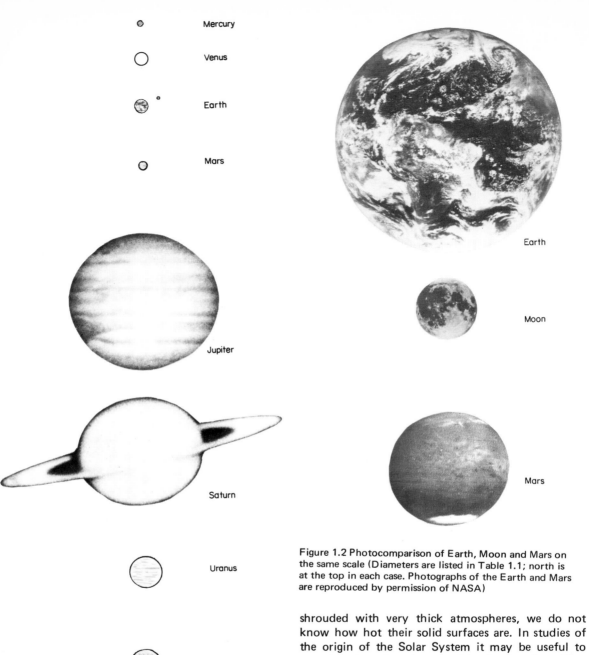

Mercury

Venus

Earth

Mars

Jupiter

Saturn

Uranus

Neptune

Pluto

Figure 1.1 Comparative sizes of the planets of the Solar System (Diameters are listed in Table 1.1)

Earth

Moon

Mars

Figure 1.2 Photocomparison of Earth, Moon and Mars on the same scale (Diameters are listed in Table 1.1; north is at the top in each case. Photographs of the Earth and Mars are reproduced by permission of NASA)

shrouded with very thick atmospheres, we do not know how hot their solid surfaces are. In studies of the origin of the Solar System it may be useful to regard each major planet and its family of satellites as a solar system in miniature, with the Sun replaced by a central, warm planet, and, in the case of Jupiter at least, by a planet with its own magnetic field as well.

Whereas interplanetary magnetic fields and temperatures in the early solar nebula had important influence on the birth of a planet, other sources of energy became increasingly viable with the passage

2

Table 1.1 Solar System planets and their satellites compared with the Sun

	Equatorial diameter (km)	Mean density (10^3 kg/m^3)	Escape velocity (km/s)	Distance from Sun (10^6 km)	Approx. daytime surface temperature (K)
Sun	1 392 000	1.4	615	0	6 000
INNER PLANETS					
Mercury	4 860	5.5	4.2	57.9	600
Venus	12 100	5.2	10.1	108.3	800
Earth	12 756	5.5	11.2	149.6	300
Moon	3 476	3.3	2.4		380
Mars	6 800	3.9	5.0	227.9	270
Phobos	19	3.0	0.01		
Diemos	13	3.0	0.01		
OUTER PLANETS					
Jupiter	141 900	1.3	60	778.3	140 (cloud)
Amalthea	170	2.0	0.1		
Io	3 500	3.5	2.4		
Europa	3 100	3.1	2.0		
Ganymede	5 600	1.9	2.9		
Callisto	5 000	1.6	2.3		
VI	130	2.0	0.1		130
VII	40	2.0	0.02		
X	13	2.0	0.01		
XII	12	2.0	0.01		
XI	18	2.0	0.01		
VIII	12	2.0	0.01		
IX	14	2.0	0.01		
Saturn	120 000	0.7	37	1 427	100 (cloud)
Janus	370	1	0.1		
Mimas	900	1	0.3		
Enceladus	600	1	0.2		
Tethys	1 200	1	0.4		
Dione	800	3	0.5		80
Rhea	1 300	2	0.7		
Titan	4 900	2	2.6		
Hyperion	350	3	0.2		
Iapetus	1 300	3	0.8		
Phoebe	200	1	0.1		
Uranus	50 000	1.6	22	2 870	100 (cloud)
Miranda	500	5	0.4		
Ariel	1 500	5	1.3		50
Umbriel	1 000	4	0.7		
Titania	1 800	6	1.6		
Oberon	1 600	5	1.3		
Neptune	50 000	2.2	25	4 497	100 (cloud)
Triton	5 700	5	4.8		40
Nereid	500	5	0.4		
Pluto	6 000	6	5	5 900	40

Note: Many of the values given in this table are merely order of magnitude estimates. Satellites of a given set (indented) are listed in order of increasing distance from their planet.

of time. The nucleus of a planet could attract surrounding material gravitationally, and the kinetic energy released as shock waves in a mutual collision would be converted into thermal energy. Appreciable heat could be retained if enough of these collisions occurred in a short time: over a longer time-span the planet might, through conduction and infra-red radiation to the surrounding cloud, lose much of its newly imparted heat. With the growth of a planet, the superincumbent load would increasingly compress the underlying rocks adiabatically and heat them.

Thermal radiation from the protoplanet would tend to dissipate the lighter gases by imparting more kinetic energy to them. Whether or not a particle at a given height above the surface of a planet of a particular mass and radius escapes depends only upon the velocity of the particle (assuming it is not on a collision course with the planet or with another particle). The approximate velocity of escape from the surface of each planet is listed in Table 1.1. Larger, cooler planets would tend to attract larger proportions of lighter materials — always assuming that such materials were available to be swept up and accumulated.

Using elementary (and grossly simplified) arguments such as these, it is easy to understand, in principle, why the massive, major planets, the more remote from the Sun and therefore the cooler initially, are observed to have low mean densities whilst the smaller terrestrial planets, in the warmer region of the solar cloud, have comparatively high mean densities.

Tidal Heating of the Moon
Another sort of heating — that introduced in a two- or multi-body system by tidal flexing of the solid bodies of planets — plays its part in certain of the planets. It is common knowledge that water tides are raised on the Earth by the gravitational attractions of the Sun and, more importantly, the Moon. The same forces cause the solid body of our planet to rise and fall in like fashion, although with a much smaller amplitude. The Earth is 81.3 times as massive as the Moon, and the Moon's body undergoes even stronger tidal distortions as a result of the Earth's gravitational pull on it. It is true that the Moon rotates once on its axis every time it completes one orbit of the Earth — that is, in a period of 27.32 days — and that, as a consequence, the Moon is not rotating freely relative to the Earth. But the Moon's orbit around the Earth is elliptical, with the Earth at one focus of the ellipse, and there is a periodic variation in the distance between the Earth and

Moon. When the Moon is closest, the force which raises tides on it is greatest; as the Moon recedes from the Earth, the distortion of the Moon's body decreases. In fact, the tide-raising force is proportional to the inverse cube of the distance between two bodies.

Scientific experimental stations established at various points on the Moon's surface by the successive teams of NASA* Apollo astronauts included sensitive seismometers to detect meteoric impacts and internal disturbances in the Moon. The records, transmitted from these seismometers, showed that moonquakes occurred most frequently at the times of maximum change of tidal stressing. Some of the lunar seismic energy derives from deep faults where rocks shift relative to one another along the planes of contact. The tidal flexing (and, in principle, fault movements) impart thermal energy to the Moon. Regular patterns of faults can be produced on the surface of a planet as a consequence of tidal flexing. Alternatively, broad-scale tectonic (fracture) patterns can develop as a result of deep-seated convective motions — so called solid-state creep — in the solid parts of a cooling planet. Again, crustal fractures can develop as a result of the expansion of the inner parts of a planet. However fractures are formed, they can provide the routes of easiest escape of volcanic materials.

Although the tidal heating of the Moon is trivial at the present epoch, there are convincing arguments that the Moon was once much closer to the Earth. Early in its history, therefore, the Moon may well have suffered strong tidal distortions, with a correspondingly high rate of heat generation.

Chemical and Radioactive Heating of the Planets
Sources of early planetary heating would also include any exothermic chemical reactions in the body of a planet. All these sources of heat would have contributed to the setting of an 'initial' temperature to the planet; yet so little is known about the conditions in the Solar System earlier than four thousand million years ago that estimates of 'initial' temperatures — required in complete theories of planetary evolution — vary over wide limits.

Radioactivity provides one important source of the heating of planets; it is currently in operation; and the mechanism of heat generation by the natural, radioactive decay of certain isotopes of elements, such as potassium, thorium and uranium, which occur in rocks, is understood in terms of well-established physical laws.

* National Aeronautics and Space Administration (U.S.A.)

Measuring probes placed on and beneath the surfaces of the Earth and Moon have shown that heat is being generated today in the interiors of both planets. This thermal energy is passing out through the surfaces of the Earth and the Moon at a rate which exceeds the net rate of input of solar energy across their respective surfaces. Of the major planets, Jupiter at least is delivering more heat to its atmosphere than the atmosphere is receiving by way of solar radiation. (By contrast, the Earth's atmosphere receives $\sim 10^4$ times as much heat from the Sun as from the interior of the Earth.) In the case of the Moon, accurate sets of measurements are available at only two localities on the surface, close to the landing sites of the Apollo lunar modules 15 and 17, respectively. Both experiments showed a rate of release of thermal energy equal to about one half of the mean heat flow from the interior of the Earth, estimated from observations to be about 0.05 W/m^2. Over the mid-oceanic ridges, described in more detail in Chapter 2 (Figures 2.5 and 2.6), however, the flow of heat may reach ten times the average for the Earth as a whole. The longitudinal fractures in these ridges define the loci of numerous submarine volcanoes fed with dense, basaltic lavas from the underlying mantle (Figure 2.5) of the Earth in regions where slow, convective motions carry mantle rocks upwards.

Analyses of rock samples have shown that the granites of the terrestrial continents are more radioactive than the basalts of the ocean floors. It is known that the core (Figure 9.1) of the Earth is hot — probably at a temperature of around 3000 K — but whether or not the core itself generates much, if any, radioactive heat is unknown. Vehicles in orbit around the Moon have shown that the darker areas (termed *maria* or *mare* areas) have a higher concentration of radioactive elements than have other parts of the Moon. When rocks melt they tend to become differentiated into dense and less dense fractions; and the radioactive elements tend to concentrate in the less dense rocks because the bulk of isotopes in question can more readily fit the gaps existing in the atomic lattices of these rocks. Hence, peculiarities in the observed distribution of radioactive elements across the surface rocks of a planet provide an indicator of past igneous activity.

Collisions in the Solar System

In spite of the fact that at least large fractions of the present surfaces of the Earth, Moon and Mars have been built by volcanism, stray bodies in the Solar System have certainly contributed to the bulk of planets through collisional processes. Parts of the planet Mercury (Figure 1.3), recently photographed by the NASA probe Mariner 10, are, like parts of the Moon and Mars, densely cratered; and it may be argued that a large proportion of these craters mark the effects of a terminal phase of planetary accretion. The dating of returned lunar samples proves that the Moon's face offers a fossil record of events that occurred mostly between 3 and 4 thousand million years ago; and, from lunar cratering studies, it is generally considered that there was a much higher probability of major collisions between stray bodies and the planets early in their history than in the last few thousand million years. However, as it is known today, the Earth's surface was formed precisely in this last few thousand million years. An abundance of probable impact craters has been discovered, in recent decades, in old continental shields of the Earth. The famous Meteor Crater in Arizona is over 1 km in diameter and 200 m (originally 250 m) deep. Yet, taken together, all these craters — and there could be hundreds identifiable — and their associated deposits contribute little to the actual structure and composition of the terrestrial land masses and ocean floors. By contrast, volcanic deposits account for an appreciable fraction of the Earth's surface.

Other Planets and Volcanism

With volcanism ranking so important — as prime builder of the crustal rocks of the Earth and of large portions of the Moon's surface — it was no surprise when volcanoes were discovered, through Mariner 9 photographs, on Mars: the surprise was that the martian volcanoes were of unprecedented size. Mars is intermediate, in terms of both size and density, between the Earth and Moon.

Are other planets that are composed of Earth-like rocks likely to show signs of having been shaped by volcanic forces? Mercury, Venus and possibly Pluto come between the Moon and Earth as regards size and mean density (Table 1.1). Of the satellites of the major planets, Io and Triton — and possibly Europa, and Titan — seem to be candidates for volcanism on the basis of the same criteria. Much of the surface of Callisto and the darkest parts of Ganymede are known to be as dark as lavas; but Pioneer 10 indicated that both satellites consist, largely, of water-ice. Of course, volcanism could occur on these bodies only if at least parts of their interiors were sufficiently warm; for rocks about to erupt have to melt, and this can happen when the confining pressure upon

Figure 1.3 Mercury, presenting a crescent phase, showing craters mostly less than 200 km in diameter. The craters are illuminated under evening conditions (Mariner 10, NASA)

them is reduced to a certain threshold value. This may occur when the crust of a planet fractures, for example.

In the case of Mercury, release of tidal energy from the Sun may not have been insignificant: the present distance between the two bodies varies from 4.6×10^7 km to 7.0×10^7 km. The amount of heat produced by radioactivity is unknown. Yet the pictures of Mercury obtained from Mariner 10 have already revealed positive evidence of volcanic features (Figure 1.4). Scientists had expected the Moon to be cold and lower in radioactive elements than typical terrestrial rocks; but spaceflight research proved that the Moon had a warm interior and that samples from its surface layers had a higher concentration of heat-producing radioactive elements than Earth rocks.

Venus is less susceptible to tidal heating than is Mercury, since the orbital radius vector of Venus changes from a minimum of 1.075×10^8 km to a maximum of 1.089×10^8 km. Again, little is known about the quantity of radioactivity that may be contained by the planet.

It is quite reasonable to consider other planets and satellites as volcano-bearers. However, the smaller a sphere the larger its surface-to-volume ratio; and, since planetary heat is generated in a volume of material but is lost from that volume through its surface, it follows that, below a critical size, planets would never retain enough heat to lead to volcanism. This is certainly true of the satellites of Mars which, for their particular composition, are not big enough, and have never been hot enough, to become truly spherical.* The NASA Mariner 9 probe showed that the minor and major axes of Phobos measured 17 km and 21 km and, of Deimos, 12 km and 13 km, respectively.

Other planetary satellites, with specific gravities of around 1 or 2, are likely to be composed of water ice or admixtures of solid particles and ices; and it is hard to imagine that any sort of volcanic process could occur on them.

Volcanism and the Origin of Planetary Atmospheres

Why does the atmosphere of the Earth contain 78 per cent by volume of nitrogen, whereas the atmos-

* Strictly, to generate equipotential figures.

Figure 1.4 A detail of the planet Mercury showing volcanic features: **A**, possible lava flow front; **B**, chains of endogenic craters; **C**, volcanic domes; **D**, possible volcanic craters. Tectonic lineaments other than the crater chains, **B**, may also be seen (Mariner 10, NASA)

pheres of both Venus and Mars contain over 90 per cent by volume of carbon dioxide? And why is the Moon, which displays many signs of past volcanism on its face, devoid of an atmosphere? The answers to these questions are complex. For the Moon, however, the answer has been given earlier in this discussion. The last major episode in lunar volcanism abated three thousand million years ago. With the Moon's small mass, and with the high daytime temperatures of the rocks, the lighter gases escaped from the Moon in a comparatively very short time. Only the very heaviest gases — molecules of argon and xenon — could persist in cold parts of the lunar surface to the present day.

In the case of the other planets in question, more subtle effects have to be considered in addition to the effects of their masses, radii and temperatures: for example, its atmospheric composition can influence the temperature of a planet. Solar radiation passing through an atmosphere heats the gases and the soil and they emit infra-red radiation. But the water, especially in the form of clouds, in the Earth's atmosphere is opaque to infra-red radiation. Likewise, infra-red radiation is absorbed by the carbon dioxide in the atmospheres of Venus and Mars. The net effect is that the surfaces of these planets are much warmer than they would be in the absence of their respective atmospheres. Because of the analogy with the situation in a greenhouse, the effect is known as the 'greenhouse effect'.

To further complicate the problem, it is the temperature at the level of the exosphere — the region where gases enter and leave the planet's upper atmosphere — that is of interest in calculations of the net movement of gases. The effect of solar radiation — particularly solar ultraviolet light — on an exospheric gas is important, and the magnitude of this effect varies between the planets. In the high atmosphere of the Earth, water dissociates under the action of ultraviolet radiation and produces oxygen (which, after it has diffused downwards, contributes to the oxygen we breathe) and hydrogen. Hydrogen is a very light gas, attains high velocities in the atmospheres of Earth, Venus and Mars and, thus, escapes. Other gases, such as helium, are continually acquired (some fractions are later lost) by the Earth from the solar wind — a rain of neutral and charged particles which sweeps, from the Sun, through space.

Questions relating to the effects of the surfaces of planets on their atmospheres may also be relevant. Do the soils or exposed rocks of a planet interact chemically with its atmosphere? Do vegetation and other forms of terrestrial life have other than a negligible effect as determinants of the Earth's atmosphere? On the Earth, rocks can consume oxygen in the production of oxides; and vegetation uses carbon dioxide (CO_2), photosynthesises oxygen and decays to yield such atmospheric constituents as methane and nitrous oxide. Industry produces traces of poisonous gases (such as carbon monoxide) and other pollutants; but, locally, volcanoes exhale some of these gases in more significant quantities.

Over the ages, water, CO_2, carbon monoxide, hydrogen and nitrogen have poured out, with other gases, from terrestrial volcanoes. The CO_2 and water of Venus and Mars may also be volcanic in origin. Chemical activity at the Earth's surface could have removed the bulk of our CO_2 in the production (with the aid of water) of carbonates. In spite of the high pressures, liquid water cannot exist on the surface of Venus because of the high temperatures prevailing there. On Mars, conditions are such that fluid water has to assume the form of atmospheric vapour and, even in the atmosphere, water is in short supply. The argon of the Earth's atmosphere is principally the isotope of mass 40 times that of a hydrogen atom, and is formulated Ar^{40}. It is produced in the process involving the radioactive decay of potassium. In the Earth's atmosphere, natural argon, Ar^{36}, is rare by standards set in astronomy; the ratio of Ar^{40}/Ar^{36} measures about 300 for the Earth's atmosphere and only about 0.1 for the average solar wind; and this fact supports the theory that the Earth lost most of its natural atmosphere while it was in a primitive state and that the present atmosphere is of secondary origin. Xenon is another heavy, inert gas which is in extremely short supply in the atmosphere in comparison with cosmic standards: it seems, again, that the atmosphere we breathe is the end product of a chain of complicated events that occurred — and continue to occur — during the outgassing of the Earth.

Volcanoes are sometimes the sources of disaster where fiery clouds of gases, hot, red and black rains of ash and cinders, and steadily advancing walls of hot rock (lava flows) obliterate peoples and their cities; but they are also one of the very reasons for our existence.

Suggestions for Further Reading
Cook, A.H., 1973 *The Physical Study of the Earth and Planets,* John Wiley and Sons, New York.
Dollfus, A. (Ed.) 1970 *Surfaces and Interiors of Planets and Satellites,* Academic Press, New York.

Elvius, A. (Ed.) 1972 *From Plasma to Planet*, John Wiley and Sons, New York.

Fairbridge, R.W. (Ed.) 1967 *Encyclopedia of Atmospheric Sciences and Astrogeology,* Reinhold Publishing Corporation, New York.

Goody, R.M. and Walker, J.C.G., 1971 *Atmospheres,* Prentice Hall, Englewood Cliffs, New Jersey.

Kuiper, G.P. and Middlehurst, B.M. (Eds.) 1961 *The Solar System, Vol. 3: Planets and Satellites,* University of Chicago Press, Chicago.

Runcorn, S.K. (Ed.) 1967 *Mantles of the Earth and Terrestrial Planets,* John Wiley and Sons, London.

2 Volcanic types and their distribution

Introduction

A wide variety of types of volcano and of volcanic activity are encountered on the Earth and, it now seems, on the Moon and Mars. In order to discuss planetary volcanism in a systematic way it will first be necessary to define some of the fundamental terms used in volcanology and, also, to discuss, briefly, the chemistry of the more common volcanic rocks, since their chemistry is a major factor governing the nature of the activity exhibited by volcanoes.

What is a Volcano?

The popular conception of a volcano is of a 'smoking mountain' like Stromboli (Italy), the 'Lighthouse of the Mediterranean'. This idea, however, is misleading, not only because only six of the 517 active terrestrial volcanoes — apart from Stromboli — are presently the sites of continuous emission of 'smoke' from their summits but also because the 'smoke' emerging from these volcanoes is really a mixture of steam, gas and volcanic ash.

The presently accepted definition of a volcano is a multiple one. A volcano is both the place and opening from which molten rock, solid rock or gas issues from a planetary interior and also the mountain or hill built up around the opening at the surface by an accumulation of the ejected materials.

Products of Volcanism and their Sources

A source of molten rock below the surface of a planet is called a magma reservoir, magma being the general term given to molten or semi-molten rock below ground level*. The magma travels up to the surface from the magma chamber through conduits, which may have circular or elongate horizontal sections, and emerges at the surface through volcanic vents. If the eruption is relatively explosive, the

* Some authorities also describe molten rock above ground level as magma.

magma is ejected from the vent principally as a dense cloud containing volcanic ash, bombs and other forms of pyroclastic rocks. The names given to pyroclastic rocks depend on the size of individual fragments and Table 2.1 shows an acceptable classification system. The term tephra, first used by Aristotle, is sometimes used to replace the more cumbersome terms pyroclastic rocks and pyroclastic materials. If the eruption is non-explosive the activity is said to be effusive, and the magma issues from the volcano as lava.

Table 2.1 Pyroclastic rocks

Name	Size range
Dust	<0.35 mm
Fine ash	0.35-1 mm
Coarse ash	1-4 mm
Lapilli	4-32 mm
Blocks and bombs	>32 mm

Most eruptions result in the formation of both lava and pyroclastic rocks: they are termed mixed eruptions and generate composite volcanoes (Figure 2.1). The magma emerging from a magma chamber may travel upwards through fissures (elongate conduits) and solidify, as a result of cooling, before reaching the surface. The resulting features are called dykes. On other occasions, the magma rises through a conduit, and, instead of issuing at the surface as a lava flow, the magma is intruded between layers of tephra or lava. The resulting sub-surface equivalent of a lava flow is called a sill.

Where conduits are circular or elliptical in transverse section, they are known as pipes and if, after volcanic activity ceases, they are exposed by erosion they are called volcanic necks. The hills or mountains which result from single or repeated eruptions from

Figure 2.1 Cross section of a composite volcano

\vdash1cm\dashv

Figure 2.2 Lava sample from the Thjorsa flow (Iceland) showing vesicles, phenocrysts (light-toned plagioclase crystals) and dark groundmass which derived from the liquid phase (photo, J. Thompson)

a vent are known as cones and shields and, most commonly, they are truncated and indented with circular depressions called craters.

Volcanic Rocks

All rocks formed as a result of volcanic activity are designated volcanic rocks. They are one variety of igneous rocks: the other variety is termed plutonic. Plutonic rocks are deep-seated, igneous rocks formed either during volcanism or orogenies (mountain building episodes). Volcanic rocks which solidify below ground level are described as intrusive rocks, whereas those emerging from the volcano in the form of lava or tephra are termed extrusive rocks.

Magma consists of molten or semi-molten rock plus volatiles (mainly H_2O and CO_2) either in solution or as gas bubbles. Normally, the volatiles remain in solution at relatively large depths (> 2 km in Hawaii), although they nucleate (begin to come out of solution) and grow, as bubbles, as the magma approaches the surface. On reaching the surface, most of the gas normally escapes, and the remaining gas accumulates in gas cavities known as vesicles. Rock emerging from volcanic vents normally consists of three separate phases: (i) liquid — molten silicates and oxides; (ii) solid — either crystals which formed as a result of cooling in the magma chamber, or xenoliths, which are rock fragments derived either from the wall of the magma chamber or from deeper in the mantle and transported upwards with the melt; (iii) gaseous — volatiles coming out of solution. Lavas may consist of either one or both of the other phases in addition to the liquid phase: this is illustrated in Figure 2.2.

Solidification of magma takes place in response to a loss of volatiles or a decrease in temperature, or both. If magma cools slowly in a volatile-rich environment, the resulting rock is coarsely crystalline. If it cools rapidly in a volatile-poor environment, the rock produced contains either very small crystals or is glassy. As a magma cools, certain minerals reach their saturation point and start to crystallise. The chemistry of the melt changes as the relevant oxides and silicates involved in the growth of the nucleating crystals migrate towards their crystal faces. In response to the change in magmatic chemistry or decrease in temperature, the melt becomes saturated with other minerals and these, too, start to crystallise. This process continues either until crystallisation is complete or until molecular migration ceases on account of the diminishing molecular mobility at lower temperatures. Thus modified, lava consists of crystals of rock-forming minerals together with lesser amounts of glass and vesicles. The common igneous rock-forming minerals are listed in Table 2.2.

The chemistry and mineralogy of volcanic rocks is so varied that it is necessary to classify them. There are numerous methods of classification, most of which are based on the percentages of minerals present in a rock. Figure 2.3 shows one method of classifying volcanic rocks based on the normative percentage of silica (Q, mainly quartz), feldspathoids (F), alkali feldspar (A), and plagioclase feldspar (P). Rocks occurring between the lines AP and BC are said to be saturated with respect to silica whereas those occurring below the line AP are undersaturated. Those rocks which appear above the line BC are

Table 2.2 List of common igneous rock-forming minerals

Quartz	SiO_2
Orthoclase Feldspar	$K\,Al\,Si_3\,O_8$
Plagioclase Feldspar	$\begin{cases} \text{Albite } Na\,Al\,Si_3\,O_8 \\ \text{Anorthite } Ca\,Al_2\,Si_2\,O_8 \end{cases}$
Mica	$\begin{cases} \text{Biotite } K(Mg,Fe)_3\,[(AlSi_3)O_{10}]\,(OH)_2 \\ \text{Muscovite } K\,Al_2\,[(AlSi_3)O_{10}]\,(OH)_2 \end{cases}$
Pyroxenes	$\begin{cases} \text{Ortho-pyroxenes e.g. Hypersthene } (Mg,Fe)\,SiO_3 \\ \text{Clino-pyroxenes e.g. Augite } (Ca,Mg,Fe,Al)_2\,(Si,Al)_2\,O_6 \end{cases}$
Amphiboles	e.g. Hornblende $(Ca,Mg,Fe,Na,Al)_{7\text{-}8}\,[(Al,Si)_4O_{11}]_2\,(OH)_2$
Feldspathoids	$\begin{cases} \text{Leucite } K\,Al\,Si_2\,O_6 \\ \text{Nepheline } Na\,Al\,SiO_4 \end{cases}$
Olivine	$(Mg,Fe)_2\,SiO_4$

said to be oversaturated (acidic). Finally, rocks which fall in the vicinity of the line AP are termed basic rocks. The chemical analyses of a few volcanic rocks are presented in Table 2.3.

The chemical composition of a volcanic rock is determined by numerous factors, the most important being the tectonic setting, the depth at which the primary magma is formed, the rate of movement of the magma from its chamber to the surface, and the type and percentage of volatiles which are present in the magma. The primary magmatic composition can be altered by various processes, the most important being sinking or floating of crystals in the melt and assimilation (melting and incorporation) of crust surrounding the magma chamber or conduit.

Apart from igneous rocks, there are two other types of rock found on Earth: sedimentary (formed by the lithification of rock detritus and animal remains) and metamorphic (sedimentary or igneous rocks which have been subjected to intense heat or pressure resulting in re-crystallisation of the primary rock). The lunar regolith (soil) is an example of an unconsolidated sedimentary rock. The main erosional process which produced the lunar regolith was probably meteoric impact. When a meteoroid is travelling at a sufficiently high relative velocity some of the rock fragments at the point of impact are subjected to large increases in pressure and temperature which weld them into the special variety of metamorphic rocks called impact breccias. Similar rock types exist locally on Mars and on the Earth, in and near impact craters.

Viscosity of Volcanic Rocks

The chemical composition of a rock affects the most important physical parameter of the magma from a volcanological point of view, the viscosity. The viscosity of a rock melt is a measure of how easily it can flow under any given applied forces. The high viscosity of molten rocks (more than 10^4 times that of water) is primarily the result of the chains and networks (polymers) of silica tetrahedra (atoms of silicon, each with 4 oxygen atoms attached in a tetrahedral pattern) which develop in the melt. If the silica content of the rock melt is high, an extensive polymer network develops and the resulting melt has a high viscosity as a result of the impedance which this network offers to the flow. If a large number of metallic ions or volatiles are present these silicon chains are readily broken and, as a consequence, the viscosity is reduced. The viscosity of a melt affects numerous factors, among which is the rate of crystal growth. In a viscous melt — for example, that of rhyolite — atomic migration is more difficult than it is in a basaltic melt. Under the same physical conditions of cooling, therefore, basalts are coarser grained than rhyolites.

The viscosity of a magma controls the type of volcanic activity with which it is associated by influencing the ease with which gas can emerge from the melt. Gently effusive activity is commonly associated with volcanoes which produce basaltic rocks, whereas explosive activity normally occurs at volcanoes in which the silica content of the melt in the underlying magma chamber is high. The gas

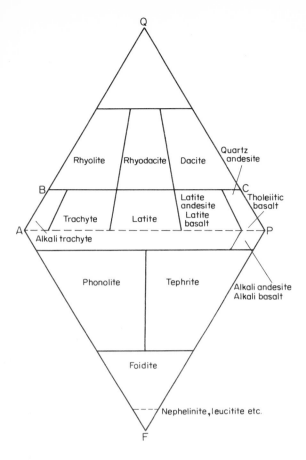

Figure 2.3 Classification of volcanic rocks, based on A.L. Streckeisen. The diagram refers to those rocks containing less than 90 per cent of mafic minerals (dark coloured minerals such as olivine, pyroxene, amphiboles and magnetite). Rocks containing more than 90 per cent mafic minerals include melilites and picrites

the type of activity associated with past and present volcanic eruptions is so diverse, or that there is such a wide morphological variation in the resulting volcanic cones. Because of these variations, it is necessary to adopt some system of classifying both eruptions and the resulting volcanoes.

Three schemes are in common use. They are based on (i) the morphology of volcanic cones, (ii) the comparison of volcanic activity with that of a small number of 'type' volcanoes and (iii) the tectonic setting of volcanoes.

Classification of Volcanoes based on Morphology

The shape of volcanoes is influenced mainly by rock composition, geometry of the vent, volume rate of extrusion of the magma and the explosivity of the eruption. Explosivity, as already mentioned, is primarily a function of the viscosity of the melt in the underlying magma chamber. There are two basic shapes of conduit through which magma is transferred to the surface. They can either be central vents, where the vent is circular or ellipsoidal in cross section, or fissures, where the ratio of length to width of the vent is large. Fissures can be either linear or arcuate.

Central vent volcanic activity is normally explosive: the ratio of pyroclasts to lava is high when the explosivity is high, an extreme example being diatremes. Diatremes which tap magma chambers situated at depths of 200 to 300 km are called kimberlite pipes. In addition to the high pressure mineral assemblage derived from the magma, kimberlites consist of numerous fragments of the wall rock through which the gas stream has passed. Hence, kimberlites provide information of the type of rocks between the surface and a depth of ~ 200 km.

When the explosive index is lower, the resulting volcanic cone consists of intercalated lavas and pyroclasts. The resulting cone is fairly steep-sided, normally with a concave surface, and is called a composite cone (also referred to as a strato-volcano).

In cases in which both the explosive index and viscosity are very low it is found that the ascending magma normally issues from linear fissures. If the volume and rate of extrusion are high, lava may flow from the entire length of a fissure many kilometres long; the lavas may then form extensive lava plains or plateaux. Because of the absence of pyroclastic activity during this type of fissure eruption, little or no surface eminence will be left to mark the vent and, if the area were subsequently flooded by another

forming in a low viscosity, basaltic melt readily escapes as a separate phase at the vent, leaving lava which is relatively deficient in gas to flow out from the volcano. In the case of viscous eruptions, escape of gas from the melt is difficult and, as a consequence, the gas pressure rises and eventually tears apart the enclosing magma to form pyroclastic materials.

Other factors affecting the type of volcanic activity in any region are the temperature of the melt — which may vary from 700°C for rhyolitic rocks to 1300°C for basalts — the percentage of volatiles, the size and type of the volcanic conduit, and the rate at which magma is extruded from the vent. Since, in practice, there is a wide variation in all of the above parameters it is not surprising that

Table 2.3 Chemical compositions of some terrestrial and lunar volcanic rocks

	Average chemical composition of terrestrial volcanic rocks (Weight per cent)							Chemical composition of some lunar basalts (Weight per cent)		
	Rhyolite	Dacite	Andesite	Tholeiitic basalt	Alkali basalt	Perido-tite		Apollo 11*	Apollo 12†	Apollo 15††
SiO_2	73.6	63.6	54.2	50.8	45.8	43.5	SiO_2	39.60	46.41	48.80
TiO_2	0.2	0.6	1.3	2.0	2.6	0.8	TiO_2	11.10	4.14	1.46
Al_2O_3	13.4	16.7	17.2	14.1	14.6	4.0	Al_2O_3	9.51	10.50	9.30
Fe_2O_3	1.2	2.2	3.5	2.9	3.2	2.5				
FeO	0.8	3.0	5.5	9.1	8.7	9.8	FeO	19.17	19.95	18.62
MgO	0.3	2.1	4.4	6.3	9.4	34.0	MgO	8.10	6.38	9.46
MnO	0.3	0.1	0.1	0.2	0.2	0.2	MnO	0.28	0.27	0.27
CaO	1.1	5.5	7.9	10.4	10.7	3.5	CaO	11.07	11.71	10.82
Na_2O	3.0	4.0	3.7	2.2	2.6	0.6	Na_2O	0.36	0.30	0.26
K_2O	5.4	1.4	1.1	0.8	1.0	0.2	K_2O	0.05	0.07	0.03
H_2O^+	0.8	0.6	0.9	0.9	0.8	0.8	Cr_2O_3	0.47	0.38	0.03
H_2O^-	0.1	0.2	0.3	0.2	0.4	0.1				
Total	100.1	100.0	100.1	99.9	100.0	100.0		99.71	100.11	99.05

Note: As can be seen by comparing the above analyses, the lunar basalts are enriched in Fe, Mg and Cr, and depleted in alkalis and water, compared with terrestrial basalts.

* 10045 Agrell et al. (1970), Geochim. et Cosmochim. Acta. Suppl. 1, **1**, 93-128.
† 12064 Scoon (1971), Proc. Second Lunar Sci. Conf., **2**, 1259-1260.
†† 15076 LSPET (1972), Science, **175**, 363-375.

flow of plateau or flood lavas, the source of the underlying lavas would no longer be visible.

Another type of fissure eruption is that in which the fissures are arcuate and commonly associated with calderas — collapse craters normally greater than 2 km in diameter. On the Earth, such eruptions have resulted in extensive areas of ignimbrites, described in Chapter 4.

Whereas the lavas resulting from central eruptions are normally of limited areal extent, individual eruptions of flood basalts, phonolites (Figure 2.3) or ignimbrites cover areas in excess of 10^4 km^2.

In cases in which the rate of extrusion of lava from a fissure is low, activity tends to be confined to one or more parts of the fissure and the resulting volcano — a shield volcano — tends to be circular in plan and to have convex sides which normally slope at angles of less than $20°$ to the horizontal. When the viscosity of the lava is high, and the rate of extrusion is low, steep-sided lava domes are produced. The occurrence of linear chains of these volcanic domes indicates that they probably derived from fissures.

Classification of Volcanoes based on Eruptive Character

The traditional method of classifying volcanic eruptions depends on a comparison of the activity of the volcano under study with that of other, well-documented volcanoes or eruptions. The classification is given in Table 2.4. The type-volcanoes used are: Mauna Loa and Kilauea in Hawaii; Surtsey, off

Table 2.4 Classification of volcanic eruptions (based on G.A. Macdonald)

Eruption type	Physical nature of the magma	Character of explosive activity	Nature of effusive activity	Structure built around vent
Basaltic flood	Fluid	Very weak ejection of very fluid blebs; lava fountains.	Voluminous wide-spreading flows of very fluid lava.	Spatter cones and ramparts; very broad flat lava cones; broad lava plain.
Hawaiian	Fluid	Weak ejection of very fluid blebs; lava fountains.	Thin, often extensive flows of fluid lava.	Spatter cones and ramparts; very broad flat lava cones.
Strombolian	Moderately fluid	Weak to violent ejection of pasty fluid blebs.	Thicker, less extensive flows of moderately viscous lava; flows may be absent.	Cinder cones.
Surtseyan	Moderately fluid	Weak to violent ejection of highly fragmented lava.	Very fine dust produced by interaction of water and magma.	Tuff rings.
Vulcanian	Viscous	Moderate to violent ejection of solid, very viscous hot fragments of new lava.	Flows commonly absent; when present they are thick and stubby; ash flows rare.	Ash cones, block cones, block-and-ash cones.
Pelean	Viscous	Like vulcanian, commonly with glowing avalanches.	Domes and/or short very thick flows; may be absent.	Ash and pumice cones; domes.
Plinian	Viscous	Paroxysmal ejection of large volumes of ash, with accompanying caldera collapse.	Ash flows, small to very voluminous; may be absent.	Widespread pumice lapilli and ash beds; generally no cone building.
Ignimbritic flood	Viscous	Relatively small amounts of ash projected upward into the atmosphere.	Voluminous wide-spreading ash flows; single flows may have volume of tens of km^3.	Flat plain, or broad flat shield, often with caldera.
Gaseous	No magma	Continuous or rhythmic gas release at vent.	None	None
Fumarolic	No magma	Essentially non-explosive weak to moderately strong long-continued gas discharge.	None	Generally none; rarely very small ash cones.

Iceland; Vulcano and Stromboli, both in the Mediterranean, and Mt Pelée in Martinique. In addition, plinian eruptions are named after Pliny the Elder, a famous Roman naturalist who lost his life while observing the earliest recorded eruption of that type. Other types of eruption listed in Table 2.4 are those of basaltic and ignimbritic flood eruptions, and gas eruptions, and fumarolic activity.

Classification of Volcanoes based on Tectonic Setting

The chemistry, eruptive violence and resulting morphology of volcanic cones is related to the tectonic setting of volcanoes. The Earth's active volcanoes can be placed in the following classes: (a) oceanic; (b) continental-orogenic, and (c) continental-non-orogenic. In order to appreciate fully the reasons for this classification, it is first necessary to examine the distribution of active volcanoes on the Earth.

Distribution of Terrestrial Volcanoes

When a map showing the distribution of active terrestrial volcanoes is studied it is obvious that volcanic activity is confined to well-defined belts crossing the Earth's surface. Seventy-five per cent of the active terrestrial volcanoes are situated in the Pacific 'ring of fire', 14 per cent of them being confined to Indonesia. Other volcanicity occurs in East Africa, the Mediterranean, and at various islands in the Atlantic and Pacific Oceans (Figure 2.4). When maps showing the distribution of active volcanoes and the epicentres of recent earthquakes are compared, a close correlation is observed.

The 517 active volcanoes which can be seen on the Earth represent only a very small fraction of the total number of active volcanoes. About 29 000 volcanoes more than 1 km in height have been found in ocean basins, and it is normally only when such volcanoes erupt in shallow seas (as Surtsey did in 1963) that observers note an eruption. A high proportion of these submarine volcanoes occur on or near mid-ocean ridges — submarine mountain ranges that dissect the oceans.

On land, volcanoes are rapidly eroded by physical processes, whereas erosion proceeds much more slowly in a submarine environment. It was thought, therefore, that these submarine volcanoes would include some of the oldest known terrestrial volcanoes. But when rocks dredged from these volcanoes were dated, it was discovered that none of the volcanic rocks was older than 1.5×10^8 years. The comparative youth of these rocks may be judged against the geological time scale illustrated in Table 2.5.

Another startling fact established by oceano-

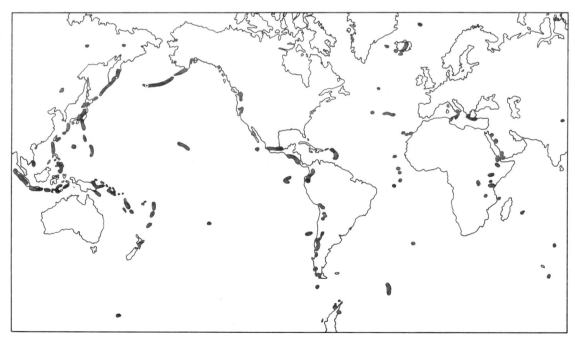

Figure 2.4 Distribution of active volcanoes on the Earth

Table 2.5 Geological time scale for Earth

Approx. time (10^6 years)	System
0	
	Quarternary
1.5	
	Tertiary
64.5	
	Cretaceous
136	
	Jurassic
190	
	Triassic
225	
	Permian
280	
	Carboniferous
345	
	Devonian
395	
	Silurian
430	
	Ordovician
500	
	Cambrian
570	
	Pre-Cambrian
4600	Age of Earth

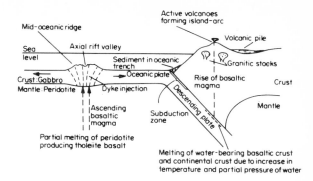

Figure 2.5 Idealised section through Earth's lithosphere showing ocean floor spreading and active continental margin

graphers is that the oldest sediments yet found in the ocean basins are from the Jurassic era; they are about 1.8×10^8 years old. What has been happening in the ocean basins? Where are the older volcanoes and sediments?

This problem was solved in 1962 when it was discovered that magma was emerging, at mid-ocean ridges, to form new ocean floors; and that, while some continents were moving apart, others were moving closer together. It was argued that some of the new ocean floor disappears down oceanic trenches (Figure 2.5). Plots of earthquake epicentres in these regions helped to show that slabs of oceanic crust were descending along well-defined zones called subduction zones. Volcanic activity along the Pacific ring of fire (Figure 2.4) is clearly associated with these zones.

Another major advance was made in 1968 when it was proposed that the Earth consisted of seven major 'plates', and that these were in relative motion. Since then, numerous other plates have been

postulated. The major plates are shown in Figure 2.6. Plate margins are of different types. Where one plate slips sideways past another the common margin is described as a transform fault. Alternatively, plate margins can be one of the following types: (i) divergent — oceanic ridge crests (for example, the mid-Atlantic ridge) and (ii) convergent — (a) oceanic-oceanic (Western Pacific), (b) oceanic-continental (Andes) and (c) continental-continental (Himalayas, Urals). Volcanism occurs at each of these plate margins except at the continental-continental margin. Importantly, the volcanic activity associated with different types of plate margin differs both chemically and volcanologically.

However, not all volcanoes are associated with plate boundaries. Volcanoes such as those in East Africa occur in continental interiors and there is apparently no direct relation to any plate margin. Numerous oceanic volcanic islands are likewise unrelated to any divergent or convergent plate margins. Again, these volcanoes are apparently unrelated to plate tectonics. Since there is a difference between the character of oceanic and continental volcanoes they will be considered separately.

Oceanic Volcanism

It has been estimated that up to 100 km³ of magma is being produced annually along the crests of mid-oceanic ridges. Whilst most of this activity is intrusive, magma is occasionally extruded and the resulting volcanoes may emerge above sea level. Iceland, which sits astride the mid-Atlantic ridge, provides a prime example. According to some geologists, the island is growing outward from the mid-Atlantic ridge at a rate of 2 to 3 cm per year, dykes being formed by the successive intrusion of magmas into fissures which develop along the ridge. In addition to the intrusive

Figure 2.6 Distribution of major tectonic plates, mid-oceanic ridges and flood lavas on the Earth

activity, there are frequent eruptions on or around Iceland. In fact, some 24 per cent of the total volume of lava extruded on the Earth's surface since the year A.D. 1500 is from Icelandic volcanoes.

Most, though not all, lavas extruded from ridge crests are tholeiites, whereas the volcanoes situated further from the ridges have a higher alkali and lower silica content. More specifically, the $(Na_2O + K_2O)/SiO_2$ ratio increases with increasing distance of the volcano from the ridge crest. Experimental studies have shown that this ratio is a function of the pressures at which partial melting of the source (mantle) material takes place. High pressure at greater depth favours the formation of alkali basalts, whereas lower pressures result in the formation of tholeiites. Hence, the increase in alkalinity with distance from the ridge crest indicates an increase in the depth to the parent magma. This, in turn, may be related to a thickening of the oceanic crust.

Whilst a number of oceanic volcanoes are found close to the ridge crests, others are found near transform faults; and the remainder are unrelated to any physical signs of sea-floor spreading. These active volcanoes occur at one end of long, aseismic ridges built of volcanic rocks and, until recently, the existence of these volcanoes was an embarrassment to the proponents of plate tectonics. Numerous geologists now accept the theory that the aseismic

volcanic ridges develop when plates move over fixed hot-spots marking the position of mantle plumes — vertical columns of upwelling, hot, mantle material. Where hot-spots develop along mid-oceanic ridge crests, the resulting volcanic activity gradually migrates outwards from the principal, seismic ridge to form two accessory aseismic ridges. The youngest volcano is on the seismic ridge, as in the case of Tristan da Cunha. Where mantle plumes develop in the centre of oceanic plates, long, aseismic volcanic ridges are built up, and the youngest volcano, or volcanic island, tends to be at one end of the ridge. Hawaii is an example.

Continental Volcanism — Orogenic
Volcanic activity in continental orogenic regions is more varied than in oceanic basins and is related to subduction zones, where plates return to the mantle (Figure 2.5). Such activity is normally associated with island arcs. In areas where a continental plate margin is being underthrust by oceanic crust, the composition of the resulting volcanic rocks varies with distance from the plate margin. Either andesitic volcanoes are found, the potassium content increasing inland, or tholeiites are produced at the margin, the volcanic rocks further from the margin being basalts which are high in alumina or alkalis. At the junction

of oceanic plates, the magma is normally andesitic, and the tendency is for composite cones to be produced. By contrast, tholeiitic volcanism normally gives rise to shield volcanoes.

Continental Volcanism — Non-orogenic
The rocks of these volcanoes are normally very high in alkalis; the volcanoes are apparently unrelated to plate movement; and they are found either in, or adjacent to, rift valleys. These volcanoes will be considered more fully in Chapter 8.

Lunar Volcanism — Type and Distribution
It is now well established that volcanism has played a major role in the formation of the Moon's surface, and examples of numerous volcanic types have been found on the Moon. It is now accepted that the dark, mare regions visible in Figure 1.2 have resulted from the flooding of low-lying regions by lava. One of these regions, Mare Imbrium (discussed in Chapter 3) is covered by numerous, readily identifiable, major flows and their subsidiary flow units. In addition to these flood basalts, dome-shaped (possibly shield) volcanoes, \sim 10 km in basal diameter, and other volcanoes with bases \sim 1 km in diameter (and larger) have been found; and it can now be demonstrated that numerous lunar craters have resulted from volcanic activity. Ring structures \sim 100 km in diameter, sinuous rilles (tortuous, lava valleys) and mare ridges, up to 200 m high, provide other manifestations of volcanism on the Moon's surface.

The distribution of lunar volcanoes and other volcanic features is illustrated in Figure 2.7. It will be noted that essentially all the maria, and nearly all of the other signs of lunar volcanism, are situated on the near side of the Moon.

The distribution of individual types of volcanoes, and their characteristics, are studied in more detail in the ensuing chapters. The most important generalisation to be made here is that lunar volcanic activity, unlike that on the Earth, is apparently unrelated to major crustal movements: no fold mountain belts, subduction zones or other indications of continental-type migration have been established on the Moon. On the other hand, oceanic-type ridges might be present on the Moon.

Distribution and Types of Volcanoes on Mars
The recently returned Mariner 9 photographs have revealed that the surface of Mars, like that of the Earth and Moon, has supported substantial volcanic activity. The distribution of the major, martian shield volcanoes can be seen in Figure 2.8. A property common to both Mars and the Moon is that volcanic activity appears to be confined almost exclusively to one half of the planet. This may suggest that large-scale planetary convection resulted in a thinner crust in one hemisphere compared with a thicker crust in the other. Volcanoes would then probably form preferentially in one hemisphere. Another possible similarity between Mars and the Moon is found in the fact that crustal migration has not been established on either planet.

The principal volcanic activity on Mars is related to topographic highs and to visible tectonic features. Some of the large shield volcanoes — for example, Ascraeus Mons, Pavonis Mons and Arsia Mons (informally named North Spot, Middle Spot and South Spot, respectively, Figure 2.8) — lie on a great circle and the amount of weathering of the volcanoes suggests a decrease in age towards the north east. Could these volcanoes be caused by migrating mantle plumes like those recently postulated in the Earth? The most striking difference between the volcanoes of Mars and those of the Earth and Moon is the difference in size of the shield volcanoes. Whereas, on the Earth, the basal diameter of shield volcanoes is normally less than \sim 100 km, and on the Moon shield volcanoes are less than \sim 50 km in diameter, the largest martian shield volcano, Olympus Mons, has a basal diameter* of the order of 2000 km and a height* of \sim 20 km.

Comparative Planetary Volcanism
The pattern set by terrestrial volcanoes is determined by the movement of lithospheric plates which, in turn, is probably connected with the convective creep of solid rocks in the mantle. On the Earth, volcanoes occur along linear ridges or at point sources of mantle upwelling, or they are related to subduction zones. The disposition of martian volcanoes seems to be controlled by underlying fractures; and some lunar volcanoes are controlled by faults whilst others are aligned along deep fractures.

The respective types of volcano on all three planets are similar in many ways. One important difference is the comparative lack of large cone volcanoes on both the Moon and Mars. A search for the reasons for these differences must be preceded by

* These estimates are not to be confused with the well-exposed upper portion of the shield, which has a diameter of about 550 km and a height of about 8 km.

Figure 2.7 Distribution of (a) lunar domes; (b) possible lunar ring structures (after J.E. Guest and G. Fielder); (c) lunar sinuous rilles (after J.B. Murray)

Figure 2.8 Distribution of martian volcanoes. Some of the dark spots seen telescopically were ascribed the name *lacus* (lake); but the term *mons* (mountain) would be more appropriate and is used in the text. Nix Olympica has been officially renamed Olympus Mons, and Nodus Gordii has become Arsia Mons.

detailed examination of some of the aspects of planetary volcanism mentioned in this chapter. Accordingly, lava flows will be examined, first, in the following chapter.

Suggestions for Further Reading

Bullard, F.M., 1962 *Volcanoes: in History, in Theory, in Eruption,* University of Texas Press, Austin.

Fielder, G., 1965 *Lunar Geology,* Lutterworth Press, London.

Gass, I.G., Smith, P.J. and Wilson, R.C.L. (Eds.) 1972 *Understanding the Earth,* Artemis Press, Sussex.

Holmes, A., 1965 *Principles of Physical Geology,* Nelson, Edinburgh

Macdonald, G.A., 1972 *Volcanoes,* Prentice Hall, Englewood Cliffs, New Jersey.

McBirney, A.R., 1970 'Some current aspects of volcanology', *Earth Science Reviews,* **6,** 337—352.

3 Lava Flows and Flood Lavas

Introduction

Each year 60 to 100 km^3 of new volcanic material is added to the Earth's crust. This magma is generated under mid-ocean ridges and, whereas most of it is intruded in the form of dykes (Figure 2.5), a small proportion of the magma is extruded, either on the ocean floor or on volcanic islands sitting astride the mid-oceanic ridges. In addition to the mid-oceanic ridge volcanism, about 3 km^3 of lava and pyroclasts are erupted each year in other crustal regions.

The resulting lava flows exhibit wide variations in their thickness, areal extent, internal structure, and surface morphology. The four main factors which influence the shapes of lava flows are the environment into which the lava is erupted, the physical properties of the erupting magma, the total volume and rate of effusion of the lava, and the shape of the ground over which the lava flows. An attempt to account for these variations will now be made, following descriptions of lava flows on the Earth, Moon and Mars.

Eruptive Environments

Terrestrial lava flows are commonly erupted into ice, water or air: the resulting eruptions are termed subglacial, submarine, and subaerial, respectively.

Subglacial eruptions have been, and are presently, very important in Iceland. The volcano Katla lies under the Myrdalsjokull Glacier in Southern Iceland and the eruptions of this volcano result in large-scale melting of the surrounding ice which, in turn, causes extensive flooding of the land in front of the glacial margin. The rock formed in this type of eruption is normally fragmented and glassy: both these properties derive from the rapid cooling rate of the lava in contact with water (see Chapter 2). The resulting flow is known as a hyaloclastite flow, though the glassy fragments are commonly altered, by oxidation and absorption of water, to yellow-brown palagonite. As far as extra-terrestrial subglacial volcanic activity is concerned, there is no evidence of even localised glaciation at any time in the Moon's history. Mars, however, does house two polar caps which are found to contain both solid carbon dioxide and ice. These polar caps have probably persisted for long periods throughout the history of Mars, and there is a considerable seasonal variation in their areal extent. It would therefore be logical to suggest that any volcano located in the winter polar cap regions would, at some time during its history, have erupted subglacially. All of the martian volcanoes which have been located, however, lie outside the areas covered by the present icecaps. It is therefore unlikely that subglacial volcanic activity has been important on either the Moon or Mars.

On the Earth, submarine flows are more important, volumetrically, than subglacial flows. Most of the ocean basins are covered with submarine lava deposits, capped by sediments. Whereas difficulties of observation of submarine flows have prevented detailed studies of them, dredged samples of the lavas have revealed that some are similar to the subglacial hyaloclastites. Where old ocean basins have been raised above sea level by plate collision, the lavas are seen to be built up of a series of bulbous pods of lava with hyaloclastite margins. These lavas are called pillow lavas.

Although the large, dark areas of the Moon are termed 'maria' water can never have existed on the Moon's surface in a liquid state. Unlike the Moon, Mars would be capable of retaining water on its surface if there were a slight increase in the present atmospheric pressure. There is some evidence that liquid water was once present on the martian surface. With our present knowledge of the planet, however, any suggestion that there has been submarine volcanism on Mars would be highly speculative.

All of the lava flows which have been located on the Moon and Mars are presently considered to have been erupted into a waterless and ice-free environment. The remainder of this discussion will, therefore, centre on subaerial lava flows.

(a)

(b)

Figure 3.1 (a) Pahoehoe lava, Hawaii (Photo, G.Fielder)
 (b) Pahoehoe ropes, Iceland (Photo, R.J.Fryer)

Types of Subaerial Lava Flow

There are numerous types of subaerial lava flow, some of which travel quickly and cover vast areas, whilst others spread out slowly from the vent and are of limited areal extent. The extensive type of lava flows are known as flood lavas whereas, at the other end of the scale, the slowly erupted lavas are said to form exogenous volcanic domes. Flows with a greater areal coverage than domes are known as coulées. Most of the subaerial lava flows presently being erupted on Earth are intermediate between floods and coulées. In addition to the classification based on the areal extent of flows, subaerial lava flows are also classified according to the morphology of their surfaces though, as will be seen later, a strong correlation exists between morphology and areal extent.

Classed according to their surface characteristics, there are three main types of lava flow on the Earth and they are known as pahoehoe, aa and block lava. Photographs of each type are shown in Figures 3.1, 3.2 and 3.3. The type of lava erupted from any particular volcano depends on the physical properties of the erupted magma (see Figure 3.4).

Figure 3.3 Block lava, Mauna Kea, Hawaii (Photo, G. Fielder)

Figure 3.2 Active aa lava flow front, Heimaey, 1973 (Photo, H. Pinkerton)

Pahoehoe has a smooth crust which, however, contains small ridges and hollows (Figure 3.1a). Commonly, the surface is twisted into small folds, called ropes (Figure 3.1b), which result from the dragging of the thin, plastic crustal layer by the underlying molten lava. The ropes tend to be curved and the convex side of a rope points in the direction of movement of the flow. Thus, in specific cases it is possible to locate the source regions of old lavas by plotting flow directions at different points in the flow.

Aa lava has an exceedingly rough, clinkery surface of jagged fragments. The fragmentation of the original surface layer is the result of the disruption of the once viscous crust by movement of the underlying molten lava.

Block lava is similar to aa in that its surface layer consists of numerous angular fragments of lava. The main difference between the two types is that the fragments of block lava have relatively smooth faces and, in general, they lack the characteristic spininess of aa.

As with most classification systems in geology there is no rigid boundary between groups; in this case there are gradations in structure between pahoehoe, aa and block lava; but, in general, subaerial flows can be assigned to one of the above types.

The lava flows on the Moon vary from very viscous-looking flows to extensive flows flooring the mare basins. It can be seen, by referring to Table 3.1, that there are numerous terrestrial flows which have travelled distances comparable to those covered by three of the more extensive lunar flows. It can also be shown that there are no problems in constructing a valid mathematical model for lunar flows which proves that it is possible for such materials to flow distances in excess of 1000 km.

The study of extensive lunar flows can reveal a great deal about past volcanic activity on the Moon, especially when these flows are compared with terrestrial flows called flood lavas.

Physical properties	Lava type Pahoehoe	Lava type Aa	Lava type Block
Main rock groups	basalt	basalt to andesite	andesite to rhyolite
Viscosity on eruption (poise)	$>2 \times 10^3$	$>10^4$ to 10^{10}	$>10^5$
Typical flow thickness (m)	$\ll 15$	~ 10	10 to 300
Type of associated structure	shields and fissures	shields, fissures and cones	cones and domes
Presence of tubes or channels	tubes (rarely channels)	channels (rarely tubes)	neither
Typical cross-section			

	Lava type Pahoehoe	Lava type Aa	Lava type Block
Typical rates of advance	few metres/minute	few metres/hour	few metres/day

Figure 3.4 Physical properties of pahoehoe, aa and block lavas

Table 3.1 Flood lavas

Details of some terrestrial flood lavas

Name	Country	Age	Volume (km³)	Area (km²)
Siberia	U.S.S.R.	Upper Permian to Mesozoic	2.5×10^5	1.5×10^6
Parana or Serra Geral	Brazil	Cretaceous	2×10^5	10^6
Deccan	N.W. India	Upper Cretaceous to Oligocene	7×10^4 to 10^5	5.1×10^5
Columbia River basalt	W. U.S.A.	Miocene	10^3	10^4
North Atlantic Province	N. Ireland	Tertiary	800	3.8×10^3
	Scotland	Lower Miocene	2×10^3	2×10^3
	Iceland	Tertiary to present	5.5×10^4	10^5

Details of some individual flows

Flood name	Name of flow	Flow length (km)	Flow thickness (m)	Total area covered (km²)	Total volume (km³)
Individual Terrestrial Flows					
Keweenawan	–	60	100 to 460	4×10^3	820
Iceland	Laki	150	4 to 13.5	565	12 to 15
	Thjorsa	125	17 to 24	700	13
Columbia River basalts	Yakima	300	~13.5	5×10^4	~800
	Roza	320	30 to 50	5×10^4	2.4×10^3
Individual Lunar Flows					
Mare Imbrium	Unit C (Fig. 3.7)	1 200	30 to 40	~10^5	~10^4
		600	10 to 60		
		400	10 to 60		

For comparison with other flows, the longest historic Hawaiian flow is ~50 km long, covers an area of 90 km² and has a total volume of 0.45 km³.

Flood Lavas

The term 'flood lava' is used in preference to 'flood basalt' so as to incorporate some of the most extensive East African lava flows, some of which are trachytic or phonolitic in composition. A map showing the distribution of some terrestrial flood lavas, and their ages, is given in Figure 2.6; and Table 3.1 gives the total volumes of, and areas covered by, some of these flood lavas, together with lengths and areas of some of their most extensive lava flows. The ensuing discussion will deal with some of the less obvious differences between flood lavas and those of shield or composite-volcanoes.

There is a remarkable chemical similarity between most of the lava samples drawn from a flood lava pile, whereas there is normally a widespread variation in the composition of lavas erupted during the history of most composite and shield volcanoes. Flood lavas are, in common with spreading oceanic ridges, predominantly tholeiitic, though alkali-basalts are widespread in, for example, the Tertiary Thulean Province. As already mentioned, most of the extensive fissure-fed lavas in East Africa are either phonolitic or trachytic.

In general, flood lavas have different vertical cross sections from those of composite cones or shield volcanoes. Flood lava flows characteristically lack the basal, brecciated layer which is found in most flows. The surface of flood lavas commonly consists of fragmented pahoehoe crust. In addition, tubes and channels, characteristic features of pahoehoe and aa flows respectively, are both missing in typical flood lavas.

Where they have flowed down constant slopes, flood lavas are remarkably uniform in thickness: less extensive lava flows tend to thicken in their flow direction. The flood lava piles themselves, however, are not uncommonly found to be thicker in the source regions than in areas farther from the source. This is, of course, to be expected, since some of the lavas have flowed only a relatively short distance. Because of their high density relative to the surrounding crustal regions, the source areas tend to 'sink' more than the remainder of the lava pile. Consequently, the net slopes created by successive eruptions of flood lavas remain essentially constant (normally $1°$ to $2°$).

Where there are variable inclinations of the palaeoslopes — for example, where the lavas flow over depressed areas — 'ponding' of the lavas is common. Ponding has occurred in some of the Columbia River basalt flows, whilst others have been channelled down existing valleys. There is evidence (discussed later) for 'ponding' and 'channelling' of lavas on the Moon.

Another difference between most terrestrial lava flows and flood lavas is that, whereas the former are distributed in various parts of oceanic basins and continental crustal regions, the latter are confined, essentially, to continental margins and rift valleys (Chapter 8).

Again, whereas the period of quiescence between the eruptions of most active volcanoes varies between 0 and 1000 years, the period between extensive eruptions of the Columbia River basalts was about 50 000 years.

Sources of Terrestrial Flood Lavas

Until recently it was assumed that flood lavas emanated from fissures. The source of the Columbia River basalts is thought by some to lie in fissures in the Grande Ronde area in the south-east of the Columbia River Plateau, the numerous source fissures being infilled by dykes. Similarly, the source of the Deccan flood basalts has recently been postulated to be an area of fissures now forming a dyke swarm off the west coast of northern India. However, recent detailed mapping of the Tertiary flood basalts in the Faeroes has revealed that at least this part of the Thulean Plateau is a series of gently sloping coalescing shield volcanoes — although at depth these shield volcanoes are obviously fissure-controlled. Similar mapping of the Snake Plain basalts has revealed that they also are composed of coalescing shields; although some of the flows are fairly extensive, one having travelled 80 km. Fissure control at depth is again evident. One point which is generally accepted concerning the source of flood lavas is that they occur in regions of tension, regardless of how that tension was produced. In the case of a number of flood basalts — for example, the Thulean flood lavas — this tension appears to have resulted from continental breakup, whereas the tension which gave rise to the extensive Columbia River basalts in western America resulted from the deformation of the northwestern U.S.A.

It is of great interest, now, to ask the related question as to whether, on the Moon, closed or open fissures are the sources of extensive mare lavas. Or, are the lavas there merely a series of gently-sloping shield volcanoes?

The Lunar Flood Lavas in Mare Imbrium

After its eruption on the Moon, the magma forming a flow would develop a porous crust as a result of the violent liberation of gas into the vacuum of space. The lower lunar gravity would permit a thicker porous

layer to form than on Earth and this layer would act as a thermal insulator for the remaining, fluid lava beneath it; and, as a consequence, the lava would cool slowly. Crystallisation, rather than the formation of glass, occurs in a cooling flow which has a low viscosity; and an almost totally crystalline rock is formed on solidification. The returned lunar samples that are similar to terrestrial basalts show this texture.

In south-western Mare Imbrium extensive flood lavas (Figure 3.5) have been erupted from source areas around the crater Euler and have flowed northwards to the vicinity of Le Verrier, covering a distance of about 450 km. The flows have lobate tongues with minor, marginal irregularities caused by the outwelling of small flow units along the feet of major flow fronts. The lavas have moved up slopes and over pre-existing ridges by ponding in front of high terrain until sufficient head has been reached to allow the lavas to pass over the obstruction. These lavas are between 25 and 30 m thick and together cover approximately 50 000 km^2. Small volcanic domes and cones are visible in the source areas but these were erupted after the flood lavas.

The source areas are situated within a region which shows a high thermal anomaly. These anomalies are thought to be caused by a higher than average proportion of solid (as opposed to fragmental) rock close to the surface. The thermal anomalies could be produced by young volcanic rocks with a thinner covering of accumulated rock fragments than their surroundings. A moonquake epicentre has also been identified in the source area — immediately to the south-west of Euler — from signals received by the Apollo seismic network. Lunar transient phenomena have been noted in the south-western part of the crater Lambert and, also, at the Mons La Hire, which is probably a volcano. Together with the photo-geological evidence for extensive volcanism in the area, these observations indicate a tectonically and volcanically important area that may still be active.

The following stratigraphical units* have been identified in south-west Mare Imbrium (Figure 3.6). The mare surface, the older unit, is situated to the north and west of the younger flows and also occurs as an inlier near Mons La Hire between the craters Lambert and Euler. The old mare surface presents only minor undulations which lack prominent flow

Figure 3.5 Location of lava flows in Mare Imbrium. (Areas covered by Figures 3.6 and 3.8 are indicated). Mare Imbrium is the largest, dark, circular area at the top, left of the Moon in Figure 1.2

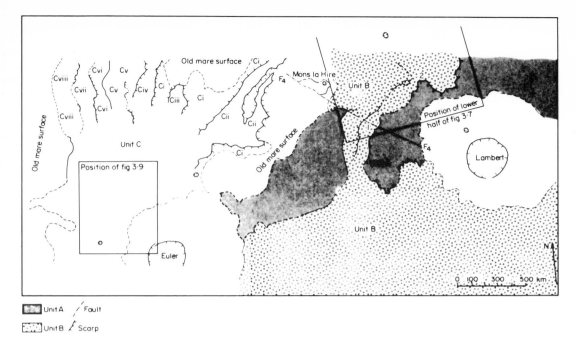

Figure 3.6. Detail of Figure 3.5 showing individual flow boundaries. (Areas covered by Figures 3.7 and 3.9 are shown)

scarps. Meteoric erosion has destroyed the original topography of these old lavas and a layer of regolith has blanketed them.

The younger mare flows are distinguished by their prominent and almost continuous flow margin scarps, their comparatively smooth flow surfaces, and the presence of lava channels, some with levées. Unit **A** in Figure 3.6 is the oldest unit in the mare flow series and is situated to the north-east of Euler and to the west and north of Lambert; it lies directly upon the old mare surface. The flow scarps are irregular, discontinuous, and show signs of denudation, whilst the surface of the unit, although smoother than the old mare surface, is hummocky. Ancient impacts might have produced these hummocks.

Unit **B**, occurring between Lambert and Euler, lies immediately above unit **A** and transgresses it, to cover the old mare surface to the northwest. One distinct flow extends northwards across several mare ridges to unite with material from unit **C**. The surface is smooth with well-formed channels and levées indicating an age close to, if not contemporaneous with, the flows of unit **C**. In the north the flow boundaries

are easier to identify: here, the lavas probably thicken with distance from their source to the south. Parts of this flow are obliterated by secondary craters associated with Copernicus.

The prominent lava flows, lobes and sheets of unit **C** occur north of Euler and extend north-eastwards past the crater Carlini towards the centre of Mare Imbrium. The majority of these flows do not lie directly on unit **B** but are assumed to be younger because of their sharper outlines. To the north and west they lie directly on the old mare surface. The individual flows of this unit overlap each other and become younger towards the west, flow **i** being the oldest and **viii** the youngest. These flows must have been extruded simultaneously since, in places, they can be seen to interdigitate.

A separate lava flow follows the course **1, 2, 3** (Figure 3.7). The flow is between 10 and 15 km wide and possesses a central channel varying in width from 700 to 1500 m. Where the flow crosses a fault-controlled monocline at **1**, there are three superimposed levées. The three separate lava floods probably derived from the draining of the small lava pond that built up behind the monocline. As the lava travelled down the monocline its velocity increased and a narrow flow was produced. The lava spread out on the flatter surface between the monocline and the mare ridge. The central channel grades into the flow. The mare ridge blocked northward movement

* The use of the word unit in the stratigraphical sense is not to be confused with the special term 'flow unit' which is used by volcanologists to describe subsidiary tongues of lava which issue from the front or flanks of a principal lava flow

Figure 3.7 Flows, channels and mare ridges (Apollo 15, NASA)

have flooded the area, partly submerging hills and infilling craters.

The majority of the small hills and mounts have craters or depressions at their summits or along their crests — a fact which lends support to their volcanic nature. Some hills and mounds grade gently into the flood lavas, and these particular eminences were probably produced towards the close of the eruption episode by lavas that were more viscous than those of the floods. A sharp break of slope occurs at the base of some of the other volcanic hills, however, and indicates that floods of lava occurred either contemporaneously with, or after, the formation of the hills.

Rilles and lava channels occur between the volcanic hills. Rille **5** (Figure 3.8) had its origin at a circular, narrow-rimmed crater unlike a terrestrial volcano but similar in appearance to an impact crater. The sources of three lava courses, **6, 7** and **8** and one possible collapsed lava tube roof, **9**, are found close together in the centre of the region. The source of the lavas that cut rille **7** is a circular crater at the summit of a cone. The channels **6** and **8** derive from a series of irregular, rimless, collapse craters which coalesce in places and grade into the channels. These channels have prominent marginal scarps where the lava has eroded the pre-existing material. The collapsed lava tube **9** begins adjacent to the volcanic hill **10** and can be traced, through a series of collapse depressions, to the west of the volcanic hill **11** where it unites with channel **6**. All these lava courses flow from south-west to north-east, whereas rille **12** (which issues from a shallow crater off the photograph) flows southwestwards until it is intercepted by the hills **13** which have formed at a later date.

A dark, smooth area with a low crater density marks a flood lava plain containing rille **5**. This lava has flooded over parts of the Euler rim unit which can be distinguished on both sides of the dark area. Nearer the source of rille **5**, this flood has lapped against the group of volcanic hills **13**. The younger craters on the flood plain at point **14** are probably secondary impact craters associated with the formation of Copernicus. Older, flooded craters occur at **15**; two are still comparatively intact with infilled, flat floors, whilst others are almost obliterated.

A second source area containing numerous channels, volcanic craters, cones and fissures is found in a down-faulted area of approximately 5900 km^2 to the north-west of Euler (Figure 3.9). Prominent lava flows appear to have originated from this source area, since their long axes converge on it. The edges of the flows become lower, and eventually disappear, as the source area is approached. The

and a head of lava built up behind the ridge until an outlet was found at **2**, where flowing lava cut a deep channel through the ridge. This led to the partial draining of the lava pond. Once across the ridge the lava fanned out to form a delta-shaped lobe. This delta emptied, in turn, through a broad channel, **3**, in the north-west and flowed across another mare ridge to unite with the flows of unit **C**. Arcuate ridges, marked **4** in Figure 3.7, occur on the surface of the lava delta. They are to be found on either side of the central channel and converge on the points where lava entered and left the delta. They may represent covered distributory lava channels (lava tubes) which for some reason have been resistant to erosion and have remained as positive features on the lava surface.

Source Areas of Mare Imbrium Flows

A source area situated between Euler and the Montes Carpatus (Figure 3.5) has been identified using Lunar Orbiter and Apollo 17 photographs and covers approximately 5500 km^2. It is a major volcanic region (Figure 3.8) as shown by the great number of domes, cones, crater chains, rilles and lava channels. Lavas

Figure 3.8 Lava source areas south of the lunar crater Euler (Apollo 17, NASA)

reason is not hard to find: near its source, low viscosity lava would form thin flows whereas, further from the source, where temperatures would be lower and the lava viscosity higher, thicker flows would be deposited.

Channels formed by lavas are best developed in this region between the parallel faults **F1F1, F2F2, F3F3**. Local topography has influenced the direction of flow so that some lavas have flowed away from the centre of Mare Imbrium, rather than towards it as might have been expected. All the major lava flows, however, have lobes indicating flow towards the mare centre, irrespective of local topography; these two facts together suggest that these particular channels are likely to have been formed at a later date than the lava lobes.

A channel originated from a crater at **16** (Figure 3.9) and its lava travelled southwards. It was joined by the tributary channel which had carried lavas from a series of fault controlled craters at **17**. The post-confluence channel is wider than its tributaries and

its lavas cut into the existing surface material. Braided channels and abandoned channel courses are to be noted further downstream; similar features occur when a terrestrial river discharges across a wide, almost flat surface. Well-defined levées are absent on this lunar channel, although the darker material on either side of the channel is probably lava that has spilled laterally to form indistinct levées. The channel becomes shallower and appears to have emptied southwards.

The lavas of channel **18** issued near the fault **F2F2**. A line of collapse craters marks the position of a lava tube which appears to commence at the same fault. Channel **18** carried lavas towards the NNE. After some 8 to 9 km it developed levées and further downstream widened and gradually graded into the lava sheets. Similarly, the wide channel at **19** has well-developed levées and gave rise to the lava sheet **Cv** (Figure 3.6).

Two circular, rimless depressions **20** (Figure 3.9) form the sources of a small channel that carried

Figure 3.9 Lava source areas to the north-west of Euler. (Areas covered by Figures 3.10 and 3.11 are shown) (Apollo 15, NASA)

lavas north-eastwards towards lobe **Cvii**. Several elongated ridges occur to the south of these depressions and terminate at the junction with two linear depressions which suggest the opening of lava tubes; the ridges are the sources of two south-flowing channels. It is probable that the ridges were formed above buried lava tubes that were fairly resistant to erosion. A series of ridges, cones and breached craters

occurs within the area of the flooded rim deposits of Euler, and to the south of the fault-controlled channel source at **17**. At **21** a small cone (Figure 3.10) of basal diameter 62 m, topped by a summit crater, is encompassed by the breached wall of an older cone. Several domes, **d**, and ridges, **r**, with craters on their crests, occur to the south of this cone. The breached craters and ridges with summit craters around the

linear depression shown in Figure 3.10 together provide evidence for a volcanic complex. It is possible that lava flowed north-eastwards from the open end of the depression but there are apparently no flow scarps to establish this point.

Figure 3.10 Volcanic complex identified in Figure 3.9 (Apollo 15,NASA)

There is very little evidence for fissure eruptions in the part of Mare Imbrium discussed here. One small fissure, about 9 km long, occurs at **22** (Figure 3.9). It trends NW-SE – almost at right angles to the main faults but parallel to the Mare margin. Two narrow lava flows, 400 to 500 m wide, issued from the northern part of the fissure and flowed north-eastwards where they merged with lava which must have issued from the channels **23a, b**. These small flows have prominent marginal scarps and terminate a short distance from the fissure. They are not connected to the major flows. This suggests that these small flows formed after the principal flood lavas – probably during the final stages of eruption when the viscosity of the erupting lava had increased and the volume rate of eruption had decreased.

Other linear depressions, such as **24** and **25**, although lacking associated flows, could also be fissures, as they trend in the same direction as both the fissures discussed above and in the same direction as some small faults in the area. The depressions are bordered by linear ridges with craters in their crests.

To the north of Euler, there is a linear crater group (Figure 3.11) approximately 18 km long and with a maximum width of 6 km. The craters have diameters of 1 to 1·5 km and are associated with elongate depressions. A lobate feature **f** – possibly a lava flow – seems to have originated from one of these depressions. Two ridges **26a, b**, having small craters **c** on their crests, dissect this group of features. All the features in the western part of the group seem to be of volcanic, rather than impact, origin. The linear crater concentration extending eastwards defines an asymmetrical ridge, its crest lying along its northern margin. Small volcanic cones **v** and smooth areas, probably blanketed by ash expelled from the cones, occur along the ridge crest. These various features obliterate some flow margins and are therefore younger than the main lava sheet in the area. The presence of cones and craters indicates a magma of higher viscosity than that which formed the flood lavas.

The major fault (Figures 3.6 and 3.12) between Lambert and Mons La Hire has been utilised by rising magma, and various volcanic features have been produced along its trace. The fault **F4F4** (Figure 3.6) is subparallel to the mare ridge **2** (Figure 3.7) and both features are concentric with Mare Imbrium. Immediately to the west of Lambert the fault has been covered by lavas which have reduced the fault scarp to a monocline. The line of the fault can be traced from this monocline to the source of rille **27** (Figure 3.12) and the volcanic crater **32** which has lobes of lava associated with it. The fault scarp is plainly visible between crater **32** and Mons La Hire and the fault can also be traced across the flow **Cii** to Mons La Hire α at **33**. Mons La Hire is a mountain with smooth sides and a prominent summit crater and is surrounded by hummocky ground which displays numerous flow scarps. Mons La Hire α at **33**, also on the fault, possesses a summit crater and appears to be the source of a small flow marked **s**. It therefore seems that this major fault has led to the construction of a volcanic complex.

The main volcanic source area of south-west Mare Imbrium is delineated by three parallel, normal faults situated to the north-west of Euler (Figure 3.9). These faults contain a trough which is 95 km in length and radial to Mare Imbrium. The faults **F2F2,F3F3** on the southern margin of the source area are staggered and, as a result, the north-eastern end of the trough narrows to a width of approximately 25 km, whilst the south-western end is as wide as 40 km. The ridge **30** is truncated by the northern fault, yet no sign of the ridge can be found within the fault-bounded trough: this proves that

Figure 3.11 Probable volcanic craters and cones in the area identified in Figure 3.9 (Apollo 15, NASA)

the trough has been infilled by volcanic material since the faulting. In that case the original throws of the faults would have been greater than the present, apparent, vertical displacements.

A rille which originated north of the northern fault at **31** was formed by lavas which flowed across the fault scarp. This situation labels the rille as being younger than the fault; but the rille has been partly destroyed on the scarp, possibly by later movement along the fault. The pronounced flow scarps of the lava sheets to the north of the trough terminate abruptly against the northern faults: the sheets, therefore, were certainly formed before the faults. Channels and flow margins cross the southern faults unhindered, indicating that here, too, the faults are older than the last stages of volcanism. The channel which originates on the fault line at **17** shows that the fault plain was used by ascending magma.

This evidence proves that the down-faulted trough was produced after the main eruptive episode and

before the smaller volcanic features that have been identified in the source area. Doubtless the mare surface subsided, along the faults, in response to the removal of the vast amount of material that was erupted to form the lava deposits.

Development of the Lunar Mare Ridges
Although flows cross the mare ridges in several places, no evidence has been found (at least, from the area shown in Figure 3.12) that would indicate that the ridges themselves were sources of lava flows. The stages in the development of the ridges can be deduced, however, by studying the morphology of the lavas that have flowed across them (Figure 3.7).

The lava flow of unit **B** has been blocked by a mare ridge at **2**, forcing the lava to pond until it crossed the ridge and flowed northwards. After the formation of the channel which carried the last lavas across the mare ridge, viscous material was

34

Figure 3.12 Volcanoes on a fault paralleled by mare ridges and crossed by lava flows (Apollo 15, NASA)

extruded along the crest of the ridge and interrupted the channel.

The course of rille **27** (Figure 3.12) across the mare ridge has been distorted so that it is no longer continuous. Stretching of the surface, and extrusion of viscous material, has evidently occurred since the formation of the rille. This suggests that the steep gradients of the mare ridge were probably formed

after, rather than before, the rille. The original surface must have been a gentle upwarp, rather than a steep-sided ridge.

The flows **Ci** and **Cii** have crossed the same mare ridge at **28** and **29**, respectively. Even though later, viscous extrusions have occurred the flow scarps can still be traced on either side of the ridge. At the time of formation of these flows

the ridge must have been quite low; for these flows have not widened a great deal before passing over the ridge.

It seems, therefore, that, in the early stages of development of the mare ridge, the mare surface was domed to form a gentle anticline. Any deposits from extrusions at this stage would have been covered by the later flood lavas. The prominent lava flows passed over the ridge almost unhindered in the west but ponded and cut a channel in the east. The viscous extrusions from the fissure presumed to underly the mare ridge occurred in the final stages of its development. These extrusives are similar in appearance to terrestrial acidic tholoids. Although some craters occur on the more angular (and hence more acid) ridges, there are no specifically volcanic features such as cones or flows associated with them and so the craters may be of impact origin.

Lava Flows on Mars

Extensive flows (Figure 3.13) on Mars resemble the flood lavas of the Earth and Moon. On the other hand, long, narrow tongues of lava (arrowed in Figure 3.14a) derive from vents on the flanks of the martian volcano Olympus Mons (Figure 3.14b). One flow of lava has produced a channel along the crest of a constructional ridge, clearly visible in Figure 3.14a.

Yet other martian lava flows (Figure 3.15) are intermediate in shape between the broad and the narrow flows. What are the factors that determine the final shape of a particular lava deposit? Why do some flows contain well defined channels with levées? In order to answer these questions, it is necessary to describe, first, elements of the physics of the flow of lavas.

Figure 3.14 (a) Details of lava flows on the flanks of the martian shield volcano Olympus Mons. Three tongues of lava each over 20 km long — are arrowed. One lava channel (30 km long) is conspicuous, other channels less so

(b) Outline shows area enlarged in (a). The diameter of the biggest caldera shown here is 70 km (Mariner 9, NASA)

Figure 3.13 Extensive sheets of lava in the Amazonis region of Mars (Mariner 9, NASA)

The Shapes of Lava Flows and Their Rheology

Rheology is the study of the flow of materials. A material which flows is said to be a fluid and is distinct from a solid, which does not flow. If a force, or stress, is applied to one side of a solid block as in Figure 3.16, the solid changes shape or suffers a strain. Most solids obey a simple law: *stress is pro-*

Figure 3.15 Successive flows of differing shape from the vicinity of a martian crater some 9 km in diameter. The white bar should be ignored (Mariner 9, NASA)

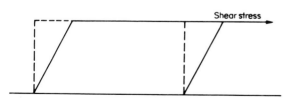

Figure 3.16 Deformation of a block (solid or liquid) by a shear stress resulting in internal strain

portional to strain. When the force is removed the solid returns to its original shape as predicted by the law.

Most liquids, on the other hand, obey a slightly different — but still simple — law: *stress is proportional to rate of strain.* If the block shown in Figure 3.16 were an unconfined layer of liquid, a shear force would again cause a change of shape or strain which, in this case, would correspond to some flow in the liquid. A constant force would result in a constant rate of strain; whereas increasing the stress would cause the strain to grow faster. This behaviour would be quite uncharacteristic of a solid. Moreover, removing the stress from the liquid would not lead the liquid to return to its original position: it would simply cause the change of shape to cease.

This law of liquid behaviour, discovered by Newton, is followed by so called Newtonian liquids. Written in the form: *stress = viscosity x rate of strain,* it is apparent that the law serves to define the viscosity of a liquid*. At a given temperature, the viscosity is different for each liquid and indicates the stress required to produce a given rate of strain. Thus, water has a lower viscosity than that of oil. The behaviour of liquids may be plotted on a graph of stress versus rate of strain (Figure 3.17). Newtonian liquids show the behaviour represented by a straight line through the origin. The gradient of this line is the viscosity of the liquid.

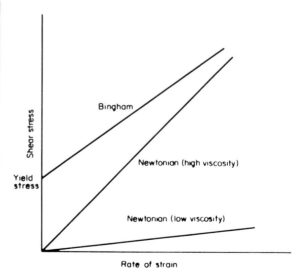

Figure 3.17 Shear stress as a function of rate of strain for Newtonian and Bingham liquids

* Gases are also Newtonian fluids.

Lava does not come into the class of Newtonian liquids. It is observed that, on eruption, most lavas are at a temperature near or below their liquidus — that is, the temperature at which they become fully molten. Below its liquidus, lava contains crystals. In addition, most lavas contain many small gas bubbles and these, like crystals, affect the viscosity. It is well known that liquids which contain a high proportion of solid particles or small bubbles do not behave like Newtonian liquids. Their most significant property is that, for stresses below a certain value — the yield stress — the strain rate is zero and the liquid does not flow. This behaviour is also shown in Figure 3.16. Examples of such liquids are mud, table sauce and foams.

If a vehicle drives through a patch of mud, the mud splashes and flows like a liquid of low viscosity but afterwards tyre tracks may well be seen in it. This is not the behaviour of a Newtonian liquid, which could not sustain sharp surface indentations even for a short time. Even a liquid of fairly high viscosity, like syrup, would not preserve such indentations for very long. The mud which behaves like a liquid of low viscosity under high stress, behaves like a liquid of very high viscosity under weak stress. Its viscosity thus depends on the shearing stress. This may be seen from the graph of its behaviour in Figure 3.18. The apparent viscosity of the mud is the gradient of the line joining the working point to the origin. This is always greater than its true viscosity but, at stresses which are high in comparison with its yield stress, the two lines — and hence the two viscosities — become indistinguishable. At low stresses, however, the apparent viscosity becomes very high; and it becomes infinite when the applied stress is equal to the yield stress. It should now be clear why table sauce may flow slowly if the bottle is simply tipped, but astonishingly quickly if the shear stress is increased by shaking the bottle. Both mud and sauce are concentrated suspensions of fine particles. Foam is a concentrated suspension of small bubbles but behaves similarly.

The Thickness and Width of a Lava Flow

It may now be seen how the thickness of a lava flow is determined. Lava flows downhill under the action of gravity. The shear stress in the lava is zero at its surface and increases in proportion to the depth below the surface. The greatest shear stress thus occurs at the base of the flow and, if it is smaller than the yield stress of the lava, no flow will occur. If the lava is slightly deeper the stress at the base becomes greater than the yield stress and the whole flow will

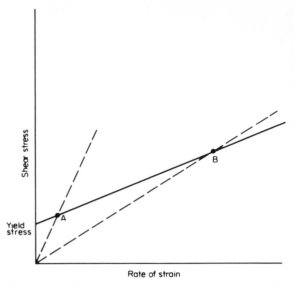

Figure 3.18 Change in the apparent viscosity of a Bingham liquid. The apparent viscosity at any point A (or B) on the continuous curve is given by the slope of the straight line joining A (or B) to the origin.

move downhill. It can be seen that a small increment in flow thickness may lead to a large increase in flow rate. Under steady conditions the flow rate must equal that at the vent and, in most cases, a flow need be only slightly deeper than the critical depth d_c for this to be the case. The critical depth is given by the formula:

$$d_c \approx S_y / g \rho \alpha$$

where S_y is the yield stress, ρ the density of the lava, g the acceleration due to gravity and α the slope of the ground. This shows that lavas with lower yield stresses give thinner flows and, for a given lava, flows are thinner on steeper slopes.

Lava spreads sideways because of the greater depth of lava in the central parts of a flow: the driving force for lateral movement is provided by the excess of hydrostatic pressure at the centre. A situation develops in which the force causing lateral spreading is balanced by the yield stress of the lava and, then, no further spreading occurs unless there is an increase in the eruption rate. A Newtonian liquid constantly supplied to a uniform slope would continue to spread; but a lava flow would be expected to maintain a uniform width after spreading a little. This is, in fact, commonly the case.

The ratio of flow thickness to flow width may be called the aspect ratio. It is a very useful parameter for describing the shapes of flows. By combining

the conditions which determine both thickness and width it can be shown that aspect ratio depends mainly on yield stress and slope. An increase in either of these parameters causes an increase in the aspect ratio. It is also weakly dependent on gravity — decreasing as gravity increases.

It is now possible to discuss the effect on flows of the variation of some of the more important constraining parameters. If the yield stress of lava were to be increased, the aspect ratio would increase. If a given flow were to encounter a decrease in slope, the aspect ratio would decrease. At the same time a smaller slope would have the effect of increasing the thickness of the flow according to the formula for critical thickness; and, therefore, its width would have to become very much greater. This is in accord with the observed behaviour of flows. If any terrestrial flow were transferred to the Moon so that it flowed in a weaker gravitational field the theory predicts that the aspect ratio of the flow would double, approximately.

Channels and Levées

When a liquid with a yield stress flows down a flat slope with nothing to contain its sideways spreading it automatically forms a bank of stationary liquid along both sides of the flow. This is thought to be the origin of channels and levées which are commonly seen on lava flows. It is easy to see how these features may develop. The thickness of the flow varies across the flow and is greatest at the centre. At some point between edge and centre the thickness is equal to d_c, the critical thickness. Between this point and the centre, the lava is deep enough to flow quickly but, outwards from this point, the lava is not deep enough to flow at all in the downhill direction. Thus both edges of a flow remain stationary to form latent levées. The central part of a flow is contained by these levées and, when the eruption ceases or slackens, the level of lava between the levées falls, thereby creating channels. The heights of levées can be augmented by later surges of lava spilling over the sides of the channel and freezing.

Cooling of Lava

The distance to which lava will flow is very difficult to predict. One factor which may limit the length of a flow is the rate at which lava cools. Lava loses heat to its surroundings in several ways. Heat is conducted into the ground and into any surrounding atmosphere. Conduction is a slow process, because of the low thermal conductivities of rocks, but con-

duction into the atmosphere generates atmospheric convection which increases the heat transfer rate. Far more effective than conduction is the radiation of heat from the exposed surface. If the surface is at a temperature appreciably above that of its surroundings radiation is so copious that the surface temperature falls rapidly. As a consequence, the surface temperature of a flow is essentially the same as the temperature of the surroundings. The lava acquires a cool skin which slowly thickens as heat is gradually lost from the interior.

At the base of a flow, heat loss is principally by conduction; the temperature at the base of a fresh flow is about halfway between that of the hot interior and that of the cool ground. These conditions favour the formation of a layer of solid lava next to the ground; although the crust of a flow tends to crack and warp the active front of the flow, and this broken crust also forms part of the base of the flow. Eventually, the solid boundaries of the flow extend to the centre but this takes a long time.

Some idea of the quantities involved in the rate of cooling of a lava flow may be gained from the following approximations. The relative amount of heat remaining in the lava may be expressed by the quantity G, where G = (amount of heat supplied at vent)/(amount of heat lost by cooling). Clearly G must decrease as the lava travels further:

$$G = \frac{F}{\kappa x} . A$$

where F is the volumetric flow rate of lava, A the aspect ratio of the flow, x the distance from the vent, and κ is the thermal diffusivity of the lava and is linked to the rate at which heat spreads throughout the lava.

Near the vent, G is large and the temperature of the lava is uniform across the central part of the flow and essentially equal to its eruption temperature. There are very thin regions of cool lava at all boundaries. Further along the flow, G is smaller and the cool regions are thicker but the central temperature remains equal to the eruption temperature. As the cool margins grow inwards, towards the centre, the central temperature falls. It falls by 1 per cent of the difference between the eruption temperature and the external temperature when G falls to about 30. The distance needed for this to happen may be calculated from the equation for G if certain properties of the flow are known. Some typical examples are given in Table 3.2. The value of κ has been taken as 3×10^{-7} m^2/s.

The table shows that, typically, flows cease to flow long before they solidify. There are other cooling processes, such as convection within the flow and the loss of volatiles, which may shorten the distance travelled by a flow. These processes may be significant in some cases. Cooling by radiation will be essentially the same on both Earth and Moon but the more rapid and effective loss of volatiles from lunar lavas may cause them to cool more quickly. However, if the rapid loss of volatiles were to create a very porous structure in the upper parts of a lunar flow, the excellent thermal insulation properties of the underdense layers would have the effect of reducing the cooling rate.

Table 3.2 Typical parameters of lava flows on the Earth and Moon

	Moon	Earth	
Flow type	Flood basalt in Mare Imbrium	Typical basalt	Typical acid lava
Flow rate (m^3/s)	2.5×10^5	50	3
Aspect ratio	1/300	1/100	1/8
Distance (km) for $G = 30$	8000	50	38
Observed flow length (km)	1200	10	3

The Length of a Flow

The general picture is that the length of a flow is limited mainly by the total amount of lava erupted in a single flow rather than by the cooling rate. It has been found that the greater the eruption rate, the further the lava flows. This means that the amount of lava which is erupted is related to how quickly it is erupted. The explanation of this relationship must lie in the processes inside a volcano.

Little is known of the interior of volcanoes. Generally there is a magma chamber at a shallow depth beneath the vent. Between eruptions the chamber fills with magma from much deeper sources in the Earth. The siting and shape of chambers is detected seismically and by electrical resistivity, gravity and magnetic survey methods. It is also possible to measure geodetically the change in height of the surface as the chamber fills. On eruption the chamber empties rapidly through a conduit to the surface. By relating flow rates, volumes and the rheology of lavas, more may be learned of the fluid processes in chambers and conduits.

Lava Tubes and Sinuous Rilles

As a flow cools it forms a solid skin at the surface and it is common for fluid lava to drain out from beneath this solid roof and leave a lava tube or cave. The roof may collapse as a whole or in parts, later, to leave either a complete channel on the ground or simply a line of collapse pits.

It has been argued that the sinuous rilles (one example is numbered **5** in Figure 3.8) on the Moon are such collapsed lava tubes. Whereas certain rilles on the Moon do seem to be of this nature, it seems unlikely that sinuous rilles originated in this manner, because they are much larger than terrestrial lava tubes and are also more regular in form. An alternative explanation is that sinuous rilles are the product of turbulent lava flow. Usually the rate of flow of lava is such that laminar flow occurs. Each particle moves in a line parallel to other particles and to the ground. If the flow rate becomes large enough, however, laminar flow may break down and then each particle travels along a very tortuous path. This is known as turbulent flow and it enables heat to travel more quickly from the interior to the sides of the lava. It becomes possible for the base of the flow to remain above its solidus temperature and, in this situation, the ground itself can be melted. In this way a flat-bottomed, winding channel could be carved out by the flow. Sinuous rilles are observed to become progressively shallower downstream and this may be explained by the fact that, as the lava cools its cutting ability becomes weaker.

Flow Regimes

The reason why sinuous rilles are seen on the Moon and not on the Earth may therefore be that some lunar lava is less viscous and has a lower yield stress than any terrestrial lava. In this way, turbulent flow conditions may be achieved more readily on the Moon. When the same lunar lavas flow in a laminar fashion they form very wide flows because of their low yield stress. The flows in south-west Mare Imbrium are of this type. Their great width also implies a high rate of eruption, which is usually associated with a large erupted volume. The large flow rate would also mean that the flows could travel great distances before solidifying (Table 3.2).

From observations of terrestrial flows it appears that the yield stress and apparent viscosity of a

lava are closely linked. Lavas of low viscosity have low yield stresses, and vice versa. Terrestrial basalts are similar to lunar basalts except that they have larger yield stresses and viscosities. Terrestrial flows, therefore, tend to be thicker and to have larger aspect ratios. More acidic terrestrial lavas have still higher yield stresses and, hence, produce even thicker flows with yet higher aspect ratios on similar slopes. Thus, the theory outlined here accords with what has been known qualitatively for a long time.

The shape of one of the flows (number **1** in Figure 3.7 and 3.12) in Mare Imbrium was analysed using the foregoing theory and it was found that the lava must have had a low yield stress in comparison with terrestrial basalts. This is consistent with the low viscosity implied by analysis of samples returned from the Moon. The flow rate of this single flow was estimated to have been 8×10^4 m^3/s, which is similar to estimated eruption rates of the Columbia River basalts. The velocity of the flow front would have been about 1.4 km/h and the velocity in the channel (also visible at **1** in Figure 3.12) about four times greater. The emplacement of the flow would have taken about one week.

The next aspect of planetary volcanism to be described is distinct from the relatively quiescent volcanism discussed in this chapter, and is characterised by the more acid rocks which commonly erupt violently.

Suggestions for Further Reading

Fielder, G. (Ed.) 1971 *Geology and Physics of the Moon,* Elsevier Publishing Co., Amsterdam.

Macdonald, G. A., 1972 *Volcanoes,* Prentice Hall, Englewood Cliffs, New Jersey.

Walker, G. P. L., 1973 'Lengths of lava flows', *Phil. Trans. Roy. Soc. London,* **A274,** 107-118.

4 Explosive Eruptions and Pyroclastic Flows

Introduction

The word explosion usually calls to mind an event of considerable violence lasting a very short time. All explosions are the result of a quantity of gas at high pressure escaping from a contained region very quickly. In the case of volcanic explosions the gas responsible is usually released at some depth below the surface; its rapid expansion and escape above the surface generate the force that produces readily visible effects such as the ejection of solid or liquid rock.

All rock fragments thrown out of a vent by an explosion are termed ejecta and collections of such fragments are called pyroclastic rocks, the word pyroclastic meaning 'broken by fire'. It often happens that a stream of gas will rush continuously from a vent for a long time — even many hours — carrying ejecta with it. The term explosion is also used to refer to this kind of event, since it differs from a more conventional explosion only in that, in the former, the source of high pressure gas is not consumed in a fraction of a second.

In most explosions ejecta are thrown to considerable heights before they fall back to the surface. But in some circumstances an explosion can release large quantities of solid particles which never rise far from the surface and are carried along, mixed with hot gas, to form a pyroclastic flow.

There are two possible sources for the gas involved in an explosive eruption. It may be released from the magma rising in the vent, in which case it is called magmatic gas and is said to cause a magmatic explosion, or it may be derived from water in the rocks immediately surrounding the pipe or vent. All explosions involving water may be called hydro-explosions, but the usual case is that only water very near, or at, the surface is involved and the explosions are then said to be phreatic.

Unless an eruption takes place near the sea or in a lake, the supply of water to cause phreatic explosions is normally very limited: the free water in rocks near the vent is soon boiled away. No water has yet been found on the Moon, and there is good

reason to think that none was ever present as rivers or lakes. Also, there are at present no expanses of water on Mars, although water may have been more plentiful there in the past. For these reasons, together with the fact that underwater explosions are in any case not well studied on the Earth, the present discussion will be concerned, mostly, with magmatic explosions.

Explosive activity takes place at some stage in almost all eruptions, but the most extensive and violent events are usually associated with the more acidic (silica-rich) magmas. The causes of this association are not hard to understand. First, there is reason to believe that acidic magmas contain a rather larger proportion of dissolved gas than basic (basaltic) ones: this question is discussed again in Chapter 5. Second, the ease with which gas can escape from a magma depends on the viscosity of the magma; and the viscosity, in turn, depends on the composition and temperature. Acidic magmas always have a higher viscosity than basaltic ones at any given temperature; also the viscosity of any magma increases as its temperature falls, and acidic magmas are generally erupted at lower temperatures than are basaltic magmas. These facts combine to ensure that gas bubbles forming in an acid magma, as it rises towards the surface, find it hard to escape. This allows the pressure in the bubbles to rise higher than it might otherwise rise. When the gas does eventually force its way out it does so suddenly, tearing the magma into small pieces and imparting high speeds to the pieces, which form the ejecta.

Types of Explosion

It is found, in practice, that only a small number of types of explosive activity are to be found in terrestrial volcanoes. The types are usually called, approximately in order of increasing violence, hawaiian, strombolian, surtseyan, vulcanian, strong strombolian or ultravulcanian, pelean and plinian (Table 2.4).

Hawaiian explosive activity consists of the production, usually from fissures, of vertical jets or fountains

of liquid, basaltic lava which shoot up to heights of a few hundred metres. The lava is still hot (usually molten) when it falls back to the ground. Commonly, the lava splashes and freezes to form irregular lumps of 'spatter'; occasionally the still molten material coalesces to form a lava flow. When gases find easy escape from the lava, pumice is rarely formed. A fissure can produce a row of fountains, several hundred metres long, which play for ten to twenty days, the liquid lava jets pulsating as the speed and volume of material change every few seconds or minutes.

Strombolian activity (Figure 4.1) seems to represent the intermediate stage between basaltic and acidic magma. Irregular lumps of glowing, cindery material and larger 'bombs' are thrown a few hundred metres into the air, rhythmically, every few seconds. A succession of explosions may continue for months or even years. Frequently, the ejecta are so hot that larger pieces can become rounded, by surface tension forces, as they pass through the air. If any liquid lava leaves the vent it is always viscous and flows only a short distance. Recent evidence shows that it may be necessary to introduce a new term — strong strombolian — to describe a type of enhanced strombolian activity in which an ash that is finer-grained than usual is produced. The cause of this activity may lie in the presence of an unusually viscous magma, the repeated clogging of the vent, or the presence of groundwater in the vent. Whatever the cause, fragments ejected are usually fairly cool — certainly not hot enough for rough surfaces to become rounded during flight. This kind of ejection of cool material from a vent may occur before or after some other phase of an explosive eruption, and has been referred to as 'ultravulcanian activity'.

Surtseyan activity is the result of a basaltic eruption in the sea or in a lake. The main features are a high degree of fragmentation of the pyroclastic particles (the result of the explosive boiling of water in contact with the hot magma) and a greater degree of dispersal of the resulting ash than in the case of strombolian eruptions: the column of ash and gas can extend to a height of several kilometres if the eruption occurs in shallow water (Figure 4.2). A common product of surtseyan eruptions is an ash-ring, built up by ejecta which land at intermediate distances from the vent, causing neither a cone nor a widely dispersed ash sheet. Another common feature of surtseyan activity is the presence of lightning discharges in the eruption cloud, caused by the build-up of static electricity.

Explosive activity involving truly acidic magma is first met in the case of vulcanian eruptions. Explosions take place at intervals of a few minutes to a few hours and the activity may last for up to several months. Viscous lava is present in the vent and, indeed, the surface of the lava may freeze in the intervals of time between explosions. Fragments of lava, glowing as they leave the vent — but solid rather than liquid or plastic — are thrown up to heights of as

Figure 4.1 Strombolian activity exhibited during the 1973 eruption of the volcano Heimaey (Iceland) (Photo, H. Pinkerton)

Figure 4.2 Surtsey erupting in 1963 (Copyright, Solarfilma, Reykjavik, Iceland)

much as 10 km. In the most extreme case recorded the cloud of ejecta and gas reached a height of 40 km. The eruption cloud of a vulcanian eruption, like that of a surtseyan event, commonly displays lightning discharges.

The events which have usually been called pelean eruptions are characterised by the explosive formation of one or more pyroclastic flows. These flows are important events in their own right and will be discussed in greater detail later in this chapter.

Finally, plinian eruptions are to be regarded as the most extreme examples of vulcanian activity. Over the course of several hours, as much as a cubic kilometre of magma may be driven, by a continuous gas blast in a narrow column, to heights of up to 25 km. Gas expansion within lumps of magma converts them to fine particles or pumice, and fragments of rock (lithic fragments) are torn from the walls of the vent and mixed with the true pyroclasts. Near the top of the narrow eruption column, where upward motion of the gas is very slight, a cloud forms and spreads, especially downwind if an appreciable wind is blowing. From this cloud, ash, pumice and lithic fragments fall to the ground; but the smallest particles are carried the greatest distances by the wind. In protracted eruptions the composition of the magma changes slowly as the molten rock in the reservoir is consumed; and there may also be compositional changes as a result of the incorporation into the magma of rocks originally forming the walls of the magma chamber.

From the descriptions given above it will be seen that the various kinds of terrestrial explosive eruptions differ from one another in the amounts of ejecta produced, in the intervals between explosions, and in the heights and distances to which ejecta are thrown. Certainly, plinian events produce pyroclastic deposits covering a larger area, for a given vent, than any other type of explosive eruption, and this is one of the reasons why plinian eruptions will be examined in more detail.

Many parts of the Earth's surface can be visited to examine the results of eruptions. In difficult terrain, or in regions remote from civilisation, it is convenient to examine aerial or satellite photographs to discover the positions of volcanoes and the extent of flows or pyroclastic deposits associated with them. With regard to the Moon and Mars, the bulk of the data derives from photographs taken from orbiting space probes: the lunar regions visited by the Apollo astronauts and soft-landing Surveyor spacecraft represent only a tiny fraction of the total surface area, and the Russian probes landing on the surface of Mars have not produced pictures. Nor, indeed, are there plans to send large numbers of landing missions to the Moon or Mars in the forseeable future. Thus, information locked in photographs taken from orbit will remain the prime source of survey data for many years to come. This being the case it is necessary to consider what sorts of feature can be most easily detected on such pictures and, clearly, the extensive pyroclastic deposits produced by plinian events — assuming they occur at all — will be more readily picked out on photographs than the products of any other kind of explosive eruption.

There are two other good reasons for studying plinian explosions in more detail. First, plinian eruptions release gas steadily, and it happens that this is an easier process to analyse theoretically than a sudden explosion. Second, although the theory describing plinian events is still by no means complete, it does appear likely that the details of such an eruption depend strongly on the gas content of the erupting magma. Since the gas content is an important clue to the composition of the magma and to conditions inside the planet on which it is produced, the analysis of plinian eruptions offers some prospect of obtaining information about the interiors of other planets — as well as about the Earth — without the need to land on them and collect rock samples.

A Model of Plinian Events

Recent calculations have shown that it is possible to follow the release of gas from a magma which is moving towards the surface of a planet from a magma chamber at great depth, working out the pressure in the gas and its velocity of ascent at all points on the way. The factors that control the speed of the gas and its density as it leaves the vent are, as one might expect, the depth and temperature of the magma chamber, the proportion of gas in the rocks melted to form the magma, the acceleration due to gravity and the diameter of the vent. Figure 4.3 shows a typical situation in which gas is escaping from a vent. As a result of the calculation of models of many magma chambers and vents it has been shown that, within reasonable limits, the effects of depth and temperature of the magma chamber on the speed of gas release are relatively small. It is the proportion of gas in the rock and the gravity that are most important in determining those physical parameters, at the instant of release, which define the nature of the eruptions. In fact, the upward velocity of pyroclasts increases with increasing gas content of the magma and decreases with increasing gravity.

Taking the maximum water content of terrestrial magmas at around 5 per cent, the greatest steady speed

Figure 4.3 Steady flow through an open conduit. The mixture of gas, liquid rock and solid inclusions is treated as a single fluid in most calculations

at which one would expect gas to leave a vent is found to be 600 to 700 m/s. Now the approximate height, h, that can be reached by material launched upward at a given speed, v, is found by equating the initial kinetic energy per unit mass, $\frac{1}{2}v^2$, to the potential energy per unit mass, gh, at that height, where g is the acceleration due to gravity. This calculation neglects non-gravitational forces acting on the released gas; these are likely to be small in most cases. With $g = 981$ cm/s^2 for the Earth and $v = 600$ m/s the result is $h = 18.4$ km; with $v = 700$ m/s, $h = 25.0$ km. The best estimates of the heights of eruption columns range from 15 to 25 km, in good agreement with the calculation. The record height of 40 km, mentioned above, does not conflict with this conclusion since it was the result of a sudden vulcanian explosion rather than of a steady plinian blast. One would expect the build-up of pressure prior to a sudden explosion to give rise occasionally to speeds in excess of 700 m/s.

Let us consider, first, a plinian eruption on the Earth. The eruption column rising from a vent consists of a mixture of gas and pyroclastic particles. In order to understand what happens to the solid particles, which are the only post-eruption results seen on the surface, the motion of the gas must be considered. As the gas rises from the vent its velocity falls, in essentially the same way as the velocity of a stone thrown vertically upwards also decreases as it rises. At the base of the column the gas is passing into the atmosphere through a progressively widening vent, and so the gas and particles acquire a significant horizontal component of velocity. This initial, lateral expansion will take place very quickly. A further sideways expansion also occurs, for, as the gas rises and its velocity falls, it must spread out horizontally to prevent gas accumulating at any level. The extreme case is met near to the top of the column, where the gas must flow mainly sideways since it cannot rise further.

Gravity is constantly acting to cause the pyroclastic particles in an eruption column to fall to-

wards the surface. But the gas rushing upwards exerts a drag on the particles. The drag force depends on the size and the density of the particles and on their velocity relative to the gas. In the central part of the rising eruption column the total mass of particles is much greater than the mass of gas, and the drag forces constrain the gas to follow the average particle motions. As rock fragments cease to rise, and their horizontal velocity carries them further from the central column, their motion becomes dominated by the now much larger mass of the atmospheric gas through which they are moving, and the final part of the trajectory of small pyroclasts is significantly affected by atmospheric drag. Figure 4.4 shows what happens at the various levels in an eruption column and cloud.

Figure 4.4 Structure of a plinian eruption column. The cloud carries small particles in all directions unless an appreciable wind is blowing, in which case the cloud spreads only downwind.

On Mars the atmospheric pressure at ground level is only about 0.006 of that at sea level on Earth, so that the initial expansion of a given eruption column leaving a vent will be greater on Mars than on Earth. Since martian gravity is only about one third of the terrestrial value, the eruption column will proceed to a maximum height about three times greater than that reached by one on Earth with the same gas velocity in the vent. The motion of the central part of the eruption column will be similar on both planets, but the subsequent motion of particles will be different due to both the differing atmospheric pressures at the surface and the differing variations of pressure with height. In particular, the low overall martian atmospheric gas density will lead to reduced drag on particles in the late part of near-ballistic trajectories,

and the final ash deposit on Mars is expected to be rather more widespread, though thinner, than on Earth. Figure 4.5 shows the variation with distance from the vent of maximum diameter of particles deposited in typical cases computed for the Earth, Moon and Mars.

Figure 4.5 The diameter of the largest particle likely to be found at a given distance from a vent for very high energy plinian eruptions on the Earth, Moon and Mars

For the Moon, the upward motion of an eruption column will proceed in the same way as for the Earth and Mars, the only difference being that even greater heights will be reached by the column on the Moon due to the very low gravity — about one sixth that of the Earth. However, the fact that the Moon possesses virtually no atmosphere means that the lateral expansion of the erupting gas will continue indefinitely. Calculations show that the horizontal velocities imparted to solid fragments caught up in the gas are very important in determining the form of the deposit and, together with the reduced lunar gravity, lead to a much wider dispersal of the final pyroclastic deposit than on Earth. As with Mars, however, this means that the thickness of a deposit from an eruption which is similar to a terrestrial eruption will be small. It should be noted, incidentally, that the actual thickness of a pyroclastic deposit on any planet will depend on the total volume of ejecta, as well as on the mechanism of dispersal of the ash.

How well do the theoretical models agree with the observed terrestrial plinian deposits? And can examples of plinian eruptions be identified, by applying this theory, on the Moon and Mars? The maximum distances from the vent at which lithic (dense) particles of a given diameter were found in the ash deposits from two Azores ·eruptions are shown as

circled points in Figure 4.6. The associated curves define the predicted distances for stated values of the upward speed of the gas at the vent and the radius of the column just after the initial expansion. It should be noted that only one pair of values of speed and radius can lead to a good fit with the observations since the two are related to one another as well as to the actual ranges. The values found for both these eruptions seem entirely reasonable.

Figure 4.6 The points represent maximum particle diameters measured by G. P. L. Walker and R. Croasdale at various distances from the vent of the volcano Fogo on Sao Miguel in the Azores. Two eruptions are shown, designated A and E. Curves are theoretical fits, giving the following values for speed of gas in vent and radius of base of eruption column: Fogo A, gas speed 600 m/s, column radius 90 m; Fogo E, gas speed 220 m/s, column radius 50 m

Plinian Events on the Moon and Mars

Even the best martian photographs (from the recent probe Mariner 9), are of such a quality that it is quite easy to confuse any ash fields deposited by eruptions with the sand and dust eroded and deposited by the martian winds. Conversely, the smaller particles deposited from an eruption cloud can be picked up by a strong wind after the eruption and can be dispersed completely. Clearly one would expect to find the larger pyroclastic particles near the vent and, since individual rocks even as large as a few metres in diameter cannot be resolved in the Mariner pictures, these ash fields could be recognised only as roughly circular regions differing in tone and texture·from the surrounding surface material. The deposits might be lighter or darker than the surrounding country rocks. The texture of the deposits might well differ from both the rough texture of fresh lava flows and from the patchy, irregular outlines of regions of wind-blown dust.

A possible identification of a pyroclastic deposit

is shown in Figure 4.7 where a roughly circular deposit of diameter 17 km occupies part of the flank of a large volcanic crater in the region called Elysium. Had the deposit been formed by a very violent plinian explosion, the largest particles near the edge of the deposit would have diameters near 0.5 cm (from Figure 4.5), which would be much larger than the sizes of particles normally transported by the martian wind. But the sizes would be consistent with the ash field's still being visible despite the fact that it must, presumably, be contaminated by wind-blown dust. It should be possible to elucidate this kind of problem following receipt of further series of pictures of Mars from orbiting spacecraft — for example, from the Viking mission of 1976 — since a suspected pyroclastic field could be observed before and after a major dust storm in its area. If such a field vanishes after a storm (or at least changes shape radically) it is presumably only a patch of wind-blown sand left after an earlier storm. But if the field remains and preserves its shape then possibly it consists of coarser particles and, therefore, could be that part of a pyroclastic deposit which is nearest to a vent.

Figure 4.7 Possible pyroclastic field (arrowed) in Elysium (Mars) (Mariner 9, NASA)

On the Moon the problems of identifying plinian pyroclastic fields are, if anything, greater than on Mars, despite the excellent photographic coverage by the Ranger, Orbiter and Apollo probes. The reason seems to be that, on a small scale, the lunar surface, unprotected by any atmosphere, is constantly disturbed by the impact of small meteoroids which excavate craters and throw the fragmental material produced for some distances across the landscape. Naturally a large, fast-moving meteoroid produces

a larger crater, and distributes debris more widely than does a small, slow-moving meteoroid. Some doubt has been cast on the exact efficiency of this process, mainly as a result of the analysis of core samples taken on the Apollo missions, but it is clear that what has been termed the 'gardening' process must operate, on the Moon, to some extent. Imagine a lunar ash field exposed to this bombardment for a very long time (perhaps half the age of the Moon). Large meteoroids penetrate the deposit and blast out bits of the pre-existing surface, scattering them across the ash. Beyond the edges of the field, even quite small impacts throw pieces of the old, ash-free surface into the main ash field, again contaminating it. Once a part of the ash field has been diluted, small impacts in it will now disturb both ash and contaminant, spreading the latter even further. In this way the pyroclastic deposit (or indeed any deposit) becomes harder to recognise.

Add to these considerations the fact that the low lunar gravity causes the ash from any one event to be well dispersed and, hence, to form a thin deposit, then it is evident that large lunar pyroclastic deposits will be identified readily only if they are recent or if they were the result of a lengthy eruption in which a large volume of debris was produced.

There is, it seems, a type of lunar crater that may fit the requirements. All these craters have diameters of about 20 to 40 km and roughly circular, but rather crenellated, outlines and interiors that seem to have been greatly affected by volcanic forces. Perhaps the best example is Kopff (Figure 4.8).

The crater Kopff, 38 km in diameter, is surrounded by a blanket of material extending to about 19 km from the rim. Circular craters with diameters of up to 0.9 km are found on this blanket. Many of them must be primary craters produced by meteoric impact, but comparison of the numbers of craters per unit area on the blanket with corresponding numbers on the surrounding terrain shows an excess of craters on the blanket which must, apparently, be associated with Kopff itself. Furthermore, in order to have acquired their circular outlines these craters must have been formed by blocks of rock falling at fairly steep angles to the horizontal. It is possible, making reasonable assumptions about the nature of the blanket material — which, for the moment, is assumed to be a pyroclastic deposit — to compute the size of the impacting blocks, given their velocity. In this way it is found that, although the pyroclastic blanket could easily be generated by a lunar plinian eruption such as that described in Figure 4.5, the larger blocks are rather too large to be ejected in a steady gas blast. Perhaps they represent parts of the vent wall which, towards the end of an extended eruption, fell into the vent

47

Figure 4.8 The lunar crater Kopff in Mare Orientale (Lunar Orbiter 4, NASA)

and caused a temporary blockage. The gas pressure would rise below them and eventually hurl them out at ever greater speeds than usual in a vulcanian blast. The main crater of Kopff could be the result of the collapse of the lunar surface layers into the now empty chamber from which the ash could have been derived.

Other Explosive Events

On Earth, the very high-energy explosive eruptions described as plinian events are exceeded, in frequency of occurrence, by low energy eruptions of the strombolian and vulcanian types. How will these latter events leave their marks on the Moon and Mars?

For vulcanian eruptions, in which the lava freezes in the vent between explosions, a simple answer can be provided. In these cases, it is only the strength of the lava plug which determines the maximum pressure built up beneath it. Assuming that the strengths of rocks on all three planets are similar, the launch velocities of solid particles and gases would also be similar.

The situation is much less clear for strombolian explosions, however, since the factors controlling the launch speeds of gas and ejecta from these events are not known. Nonetheless, it is clear that since the gas is not being supplied from below in a steady stream, it dissipates rapidly (even on Earth) and effects little change in the velocity of the ejecta. For large lumps of debris which are not slowed down much by the resistance of the surrounding atmosphere on the Earth and Mars the ranges on the three planets will depend only on the gravity (assuming similar launch velocities), and blocks on the Moon and Mars will be thrown further than on the Earth, by factors of about six and three, respectively. Small

particles, however, are greatly decelerated by the drag of atmospheric gases, the effect depending on the atmospheric density. On the Moon, very small particles will travel as far as large ones with the same initial velocity and direction, since there is no atmosphere. On Mars the atmosphere is thin, so a particle of any given size will be slowed less on Mars than on Earth; but on both planets there will be a tendency for small particles to accumulate preferentially near to the vent and thus to form pyroclastic cones. The result of these considerations is that one expects martian cinder cones to be wider, lower and have more gently sloping sides than terrestrial ones, and lunar examples to be even flatter. Certainly the small 'dark halo' craters present on the Moon — normally associated with rilles — surrounded by thin, dark deposits a few kilometres in diameter, could be explained as being the results of strombolian explosions. These craters of collapse are illustrated in Chapter 8 (Figure 8.9). No small, pyroclastic cones have been found, yet, on Mars: they may be present, but the resolution of the Mariner 9 pictures is generally insufficient to show them unambiguously.

There are also many instances, on the Moon, of dark (and sometimes light) material thinly covering large areas (Figure 4.9) of both mare and highland terrain. These deposits are generally disassociated

Figure 4.9 A possible dark pyroclastic field covering hills near the 26 km diameter lunar crater Triesnecker (lower left). Compare dark hills (upper right) with neighbouring hills of normal brightness (Photo, G. Fielder, Pic-du-Midi Observatory)

with large impact craters, and may be pyroclasts even though the vents cannot be recognised. Taking the greatest launch velocity to be expected on the Moon as about 500 m/s (from the theoretical work mentioned earlier), the maximum range to which ejecta would be thrown ballistically is about 150 km — a result quite close to the maximum size of lunar plinian deposits shown in Figure 4.5. So lunar pyroclastic fields should not have diameters much greater than 300 km; and this is consistent with the deposits noted so far.

Pyroclastic Flows

The other principal results of explosive events on Earth are the production, in what have usually been called pelean eruptions, of pyroclastic flows (as distinct from pyroclastic falls) and their resulting deposits, called ignimbrites. Ignimbrites have been referred to by many names in the past and, indeed, have commonly been mistakenly interpreted as other rock types. A simple rule is to use the term pyroclastic flow to describe the actively moving body of hot, pyroclastic material and gas (other synonymous terms used previously are ash flow, pumice flow and nuée ardente) and the term ignimbrite (from the latin *ignis* — a fire, *nimbus* — a cloud) to describe the rock body resulting from such an eruption.

One term, nuée ardente, was used by Lacroix, an early scientific observer of volcanoes, to describe the flowing cloud of pyroclastic debris and gas that rushed down the slopes of Mt. Pelée, Martinique, in 1902 and devastated the town of St Pierre, killing every one of its 28 000 inhabitants. Perret*, who observed the eruption, estimated that the cloud travelled three kilometres in three minutes and described it as 'an avalanche of an exceedingly dense mass of hot, highly gas-charged and constantly gas-emitting fragmental lava, much of it finely divided, extraordinarily mobile, and practically frictionless, because each particle is separated from its neighbors by a cushion of compressed gas'. As the eruption is one of the very few involving pyroclastic flows which scientists have witnessed, it has become the 'type example' of a pyroclastic flow. Since the term ignimbrite was introduced in the late 1930s, it has been presumed that this mode of eruption produced ignimbrites. Though this may be correct in general, a recent investigation by G.P.L. Walker on the island of Martinique revealed that no pumice-rich ignimbrite existed on the island. The 1902 eruption was, in fact, rather exceptional —

* Perret, F. A. (1935). 'The Eruption of Mt. Pelee, 1929-1932, *Carnegie Inst. Wash., Publication* 458, page 22.

Figure 4.10 Sketch of a pyroclastic flow. Note the dark, dense base near the ground where most material is carried and the billowing cloud of dust and gas, above the base (Sketch by L. Self)

as will be described later — but, despite this, it can be argued that pyroclastic flows resemble the Mt Pelée eruption (Figure 4.10).

Pyroclastic flows form large beds of pumice, usually mixed with smaller proportions of lithic fragments (denser than pumice) and loose crystals. The main differences between ignimbrites and plinian deposits are, firstly, that plinian deposits are well sorted — that is, most fragments comprising the deposit at one place are similar in size — whereas ignimbrites are internally chaotic and poorly sorted, commonly having large pumice blocks in a surrounding matrix of dust and smaller blocks; and, secondly, that plinian deposits mantle the ground surface on which they fall whereas ignimbrites tend to 'pool' in the lowest areas (Figure 4.11). Also, ignimbrites are

commonly welded, especially in the middle third of the thickness of a flow, due to heat retained in the material; plinian deposits are rarely welded.

Samples which can be sieved to determine the weight of each size class of fragments are particularly useful in deciding whether isolated or new exposures of pumice-rich pyroclastic deposits in the field are the result of air-falls or ash flows. The difference between well sorted plinian material and poorly sorted ignimbrites may become apparent when simple histograms are plotted (Figure 4.12). Plinian deposits generate an essentially unimodal distribution of size against number whereas ignimbrites tend to yield a bimodal distribution.

Certain uniform characteristics of layering in ignimbrites can be detected in volcanic regions

Figure 4.11 Bedding displayed by a pyroclastic fall deposit (A) and an ignimbrite on the same topography (B). Note that in (A), due, principally, to slip on steep slopes, the deposit is thinner on the gradients and thicker at the base

Figure 4.12 A histogram showing the percentage of grains in a range of particle size classes for a pyroclastic-fall deposit (A) and an ignimbrite (B). Maximum diameter of a set of fragments is expressed in millimetres

throughout the world. Most have a thick middle layer (2b in Figure 4.13) which is very poorly sorted and commonly welded. Below this, there is a finer-grained basal layer (2a). Figure 4.13 also depicts flow units, which commonly form part of the structure of major ignimbritic flows. Each flow unit, however small, will be produced by a different pyroclastic flow as part of one eruptive sequence. Flow unit boundaries may be determined uniquely in an ignimbrite because of the presence of a basal layer.

A pyroclastic flow may be initiated in several ways (although only one has been described accurately) but it must always be assumed that, when ejecta leave the vent to form a flow, they are travelling more slowly than in the case of plinian eruptions. The cloud of pumice and gas may only just spill over the lip of the crater in which case it begins to move down the slopes as a density flow. Alternatively an eruption cloud rises but, owing to lack of momentum and the huge load of pyroclastic ejecta, it collapses and forms a pyroclastic flow. A third possibility is that ejecta from a low-powered plinian or vulcanian eruption may build up on the upper flanks of the volcano until they become unstable and collapse downslope. The last two processes described are obviously interconnected, the only proviso put upon the latter being that collapse takes place during the eruption and not well after it.

It is probable that the first type of eruption mentioned above gives rise to welded ignimbrites, since a great deal of heat can be retained in the quite coherent mass of ejecta and gas. The other flows described provide time for the ejecta to cool before settling to produce non-welded ignimbrites. J.G. Moore and W. G. Melson witnessed an eruption in the Philippines (in 1967) where the outer, slower moving parts of an andesitic, sub-plinian eruption column collapsed and formed pyroclastic flows.

After the eruption, nonwelded ignimbrite was found filling some small valleys, and areas of forest had been flattened and singed.

Ignimbrites have higher solid-to-gas ratios than plinian eruption products and are, therefore, denser. The pyroclastic flows can rush downslope and

Figure 4.13 Schematic section through an ignimbrite. 1: the underlying ground surge deposit; 2a: the basal layer; 2b: main body of ignimbrite; 3: fine ash on top. P, large pumice block concentration; L, large lithic block concentration (black diamonds) (After R. S. J. Sparks)

follow the lowest ground as a result of the combination of gravity and a process called fluidisation. In this process the volcanic gases accompanying the pumiceous ejecta, together with trapped air and extra gas coming out of the pumice as it vesiculates, effectively clothe each particle with an envelope of gas. Each particle is isolated from mechanical contact with its neighbours and the whole mass behaves like a liquid with low viscosity. This explains why pyroclastic flows can travel great distances (up to hundreds of kilometres) down average slopes of only two or three degrees. They can even travel uphill over seemingly impassible topographic obstacles, probably because of the great momentum involved.

Density and movement of pyroclastic flows can be understood from a close study of the arrangement of layers in ignimbrites. Many ignimbrite flow units show a reverse grading of large pumice blocks (that is, the blocks decrease in size downwards) and a normal grading of large lithic clasts (Figure 4.13). This is best accounted for by the respective processes of floating and sinking, both of which must depend on the presence of a fluid medium. The large pumice clasts (density 0.8 to $1.2 \times 10^3 \text{kg/m}^3$) are lighter than the fluidised matrix of the pyroclastic flow and literally float to the top. The heavier rock clasts (density 2.3 to $3.0 \times 10^3 \text{ kg/m}^3$) descend. Therefore the density of pyroclastic flows in motion is about 1.2 to $1.8 \times 10^3 \text{ kg/m}^3$. Ignimbrite rock densities are often quite low, approximately $2.0 \times 10^3 \text{ kg/m}^3$, indicating that the matrix was only slightly expanded during flow and implying that a pyroclastic flow is a dense, fluid phase.

The basal layer, nearest to the ground in the pyroclastic flow, differs fundamentally from the layer above only because of the absence of large fragments. Evidence suggests that large fragments are expelled from this bottom layer by frictional forces, again implying a dense, fluid phase.

As a result of their flow-like nature, ignimbrites are commonly absent from the upper flanks of their source volcano: rather they tend to be found a long way from the source. Pyroclastic flows head down valleys to open land and, until they slow down, little ignimbritic material may be left on the ground. This behaviour has led to uncertainty of the exact location of sources of ignimbrites in many areas.

Welded ignimbrite is quite a distinctive rock commonly having black, glassy lenses aligned sub-parallel to the bedding. Colour changes are sometimes found between zones of varying intensity of welding. In a non-eroded ignimbrite welding rarely persists throughout the whole thickness, the base and top being non-welded.

Pyroclastic flows may result, theoretically, during the explosive eruption of any composition of magma. However, the majority described so far are rhyolitic, dacitic, trachytic or phonolitic: rocks of these compositions all derive from the more volatile and gas-rich magmas. Andesitic pyroclastic flows are undoubtedly common during plinian and other airfall eruptions, as described by Moore and Melson, but the volume of material is minor compared with that produced by the main phase activity. Basaltic ignimbrites have been recorded on the Earth and have been suggested for the Moon; but pyroclastic flows of this composition have never been witnessed.

Therefore pyroclastic flows are usually restricted to the more differentiated magmas. They are also infrequent, especially large ones, as they rely on long periods of time (as do many other types of eruption) for differentiation and build up of gas content. Long time periods can allow vast quantities of magma to develop and ignimbrites of extremely large volume result. Some of the largest known, prehistoric and recent eruptions on Earth are ignimbritic and they are important on a world-wide scale. Large areas of the Western U.S.A., Alaska, Central America and Western S. America, New Zealand, Japan and Kamchatka are covered by ignimbrites. Young ignimbrite is also found on several oceanic islands, for example, Iceland, the Canaries and the Azores, as well as in Africa, Italy and Turkey. Ancient examples of ignimbrites occur in the United Kingdom in North Wales and the Lake District.

There have been few historic eruptions where pyroclastic flows have been witnessed by man, other than the 1902 Mt Pelée paroxysm. In 1912, Mt Katmai in Alaska erupted and an expedition was immediately mounted to investigate the results. Investigators found substantial alterations to the volcano, a new cone 'Novarupta' and a large, glacial-cut valley filled with hot, smoking pyroclastic debris. This valley, known as the 'Valley of Ten Thousand Smokes' was filled with ignimbrite in an eruption about ten times larger than the Mt Pelée event. In the A.D. 79 eruption of Vesuvius, the towns of Pompeii and Herculaneum suffered, at first, from a plinian-type air fall deposit, through which most of the population lived. But the people were subsequently wiped out by a pyroclastic flow; the ignimbrite from this phase of the eruption was, until recently, incorrectly interpreted as a mud flow.

Prehistoric examples of vast ignimbrite deposits include the Bishop Tuff (California), which extends over 200 km from its source, the Taupo Pumice deposit (New Zealand) and the Campanian Tuff in the Naples area (Italy). This latter ignimbrite covers more than 5000 km^2 and may include 40 km^3 of pyro-

clastic debris. Some authorities attribute such voluminous ignimbritic deposits to fissure-type eruptions, the fissures commonly being formed in association with the collapse of large calderas (Chapter 8).

A large proportion of fine-grained material in ignimbrites comes mostly from the initial explosion. Much less dust is lost, initially, into the atmosphere than in the case of plinian eruptions, as the ignimbritic eruption cloud remains comparatively coherent. Some dust must be produced by attrition within the flow but attrition is reduced by the fluidisation of the cloud. The support of fine particles by fluidisation cannot last indefinitely, for gas is continuously lost from the top of the flow, and only partly replaced even while vesiculation and degassing of the solids is still in progress. Eventually, no more gas is released from the solid particles, and all the gas remaining in the flow escapes upwards. In the later stages of gas-escape, the flow ceases to be fluidised and stops moving as a liquid.

Recently, S. I. Pai, T. Hseieh and J. A. O'Keefe have developed a theory of the vertical movements of gas and solids in a pyroclastic flow and they have shown that, mainly as a result of the differences in gravity, pyroclastic flows on the Earth and Moon are likely to differ in two ways. First, the gas pressure in a typical terrestrial flow falls off much more rapidly with height than in a lunar example. Second, the majority of ash particles are confined to the lower part of a terrestrial flow, but are carried up to greater heights on the Moon. Thus if a flow on Earth had most of its solid material carried in the lower ten metres, a similar flow on the Moon would have appreciable quantities of ash at a height of 200 m — though in both cases the proportion of solid material would fall off rapidly with height. Any martian pyroclastic flows of the same composition would lie between the extremes for the Earth and Moon.

In the terrestrial case, at least, the top of the lower layer containing most of the solids is coincident with the level above which the upward velocity of gas increases sharply. For this reason large numbers of glass shards, crystal fragments and dust particles are lost from the top of the flow and account for the billowing, dark clouds seen in Figure 4.10. These particles fall to the ground, later, as a fine-grained deposit (layer 3 in Figure 4.13) covering the ignimbrite and the surrounding topography. On the Moon, the small particles would settle through the escaping gas even more gently, at the end of a pyroclastic flow event, and would help to contribute to the Moon's unusual light-scattering properties through the open, porous structures they would form on the microscopic scale.

Finally, there seems to be a third class of explosive eruption on Earth, leading to the production of pyroclastic surges superficially similar to pyroclastic flows but having distinctive deposits. Although not important for their volume, these deposits are unusual and interesting. Only in recent years have they been properly interpreted and it is becoming increasingly apparent that they take on widely varying forms. There is an approximate division to be made between base surges and ground surges.

Base surges were first recognised, strangely enough, during the early nuclear test explosions such as Bikini in 1946 and Sedan in 1962. In these events a horizontal blast capable of transporting material accompanied the vertical development of the familiar 'mushroom' cloud. Study of the results of such base surges led to the recognition of their distinctive residual features. Volcanic base surges are found on flat ground and result mainly from phreatic basaltic activity. The German name *Maar* is commonly used to describe basaltic volcanoes resulting from phreatic activity where the bulk of the deposits are of the base surge type. Whilst a lot of material must be carried upwards in a phreatic eruption, horizontal surges carry low density loads outwards from the eruptive centre, depositing them much as a river deposits its load. This comparison can be taken further since base surge beds show many structures similar to those of river deposits — for example, thin bedding, cross bedding (Figure 4.14), dome-shaped beds and plastering of deposits against vertical obstructions. These terrestrial volcanic deposits are essentially local, extending only a few kilometres from the vent. However, some authors regard the characteristically sculptured terrain extending for ~1500 km from the centre of the lunar Mare Orientale to be the result of a base surge of unprecedented magnitude.

Ground surges have only recently been described in the literature, probably owing to their close association with other pyroclastic deposits, particularly ignimbrites. They may be composed of juvenile magma (vesiculated, as for pumice, or non-vesiculated) and of lithic fragments and crystals in any combination or proportion: there is little compositional restriction. They may be thought of as base surges from central-crater type volcanoes, where gravity as well as explosive forces assist their motion. In density of flow, deposition mechanism, and resulting deposits (Figure 4.15), ground surges are similar to base surges. They leave deposits that are rarely thicker than 10 m; and they are much more restricted in extent than are ignimbrites.

Ground surge eruptions form part of many eruptive sequences, for example, as a precursor to a pyroclastic

Figure 4.14 Base surge deposit on the island of Terceira in the Azores. Note the cross-bedding and lenticular beds. This deposit is near to a basaltic tuff ring which emptied several thousand years ago about 0.5 km offshore (Photo, S. Self)

flow of larger volume or in the waning parts of a plinian eruption. It is in this former capacity that ground surges have been described as the actual mechanism for the formation of ignimbrite (that is, as a pyroclastic flow). Probably, pyroclastic flows and ground surges would be indistinguishable to an observer, except that the former would be much larger. The so called nuée ardente of Mt Pelée was a ground surge and its deposit shows good cross-bedding. Perhaps the best description of a ground surge is that of the 1951 eruption on Mt Lamington in New Guinea. G. A. Taylor witnessed an 'ash hurricane' travelling at speeds in excess of 150 km/h, preceding a larger, slower pyroclastic flow. On Mt Lamington, as well as Mt Pelée, the surges were hot enough to incinerate objects in their path. Ground surges are to be found, as at 1 in Figure 4.13, underlying many ignimbrites.

In some of the places visited on the Moon by the Apollo astronauts, quite distinct layers are found in

Figure 4.15 Ground surge deposit on the island of Graciosa in the Azores. This example is not associated with an ignimbrite. The thin- and cross-bedded nature can be seen clearly (Photo, S. Self)

the regolith (the fragmental lunar surface material) which have led J. A. O'Keefe to suggest that fluidised flow mechanisms have been responsible for forming — or at least re-distributing — the regolith. The layers found are quite thin, commonly only a few centimetres thick, and so surges are a more likely source than normal pyroclastic flow. These surges could be volcanic in nature, or could be associated with large, nearby impact events. In the latter case, the explosion resulting from compression of near-surface materials by the impacting meteoroid should closely resemble the result of detonation of a shallowly buried nuclear bomb, and base surges like the ones seen at Bikini and Sedan could possibly develop.

Except for some peculiar, welded air-fall deposits found near craters of a very few volcanoes on Earth there is little that can be confused with welded ignimbrite. However, three types of terrestrial volcanic deposit may resemble the non-welded type in the field — mudflows, debris flows and rock avalanches.

Mudflows and debris flows are often indistinguishable from non-welded ignimbrites in the field and are commonly closely associated with them. Except for the exchange of water for gas in mudflows, the mechanisms involved are similar. Mudflows are badly sorted and commonly have finer, basal regions. Large particles may move upwards through them, though not so readily as in pyro-

clastic flows. Mud flows, called lahars, may arise as a result of fluidisation of pumice deposits by water. Pyroclastic materials can move as mudflows with less than 10 per cent water content. At lower water contents they merge into debris flows — gravity controlled movements of high concentration, high density material which may be fluidised slightly by trapped air. Often mud and debris flows are initiated by earthquake and volcanic tremors.

Some lavas, especially the very viscous, acidic ones, are essentially solid when erupted and are internally fractured and broken up; they crumble easily and do not flow well. If the lava has a moderate gas content, patchy vesiculation can occur. Lavas extruded on the upper slopes of volcanoes can generate unstable flows which break up and collapse downslope. When this happens soon after extrusion, avalanches of hot rock occur, and, if vesiculated lava is present, the resulting deposit can resemble a non-welded ignimbrite, fine-grained material being produced by attrition. For both these types of deposit the overall geometry of the situation is probably the best way of distinguishing them from pyroclastic flows; for the similarities can be great.

A Sequence for Explosive Eruptions

It has now been established that a sequence exists within explosive eruptions from many terrestrial volcanoes of andesitic and more acidic type. This in-

Figure 4.16 Two sketch maps illustrating the sequence in explosive eruptions. The 1783 eruption of Mt. Asama, in Japan, consisted of 1: a plinian phase; 3: a pyroclastic-flow phase; 4: an effusive lava phase; and 4a: mudflows and rock avalanches. The 1951 Mt Lamington eruption consisted of 2: 'ash hurricane' (ground surges phase); 3: pyroclastic phase; 4: effusive lava phase (After S. Aramaki and G. A. Taylor)

volves (a) a highly explosive, often plinian, phase producing a pumice air-fall deposit; (b) a pelean phase, with ground surges and pyroclastic flows; (c) an effusive phase producing lava flows or domes.

The simplest explanation of this sequence is that it is due to falling gas pressure and gas content in each phase of an eruption as it taps lava of increasingly deep origin. In the case of volcanoes such as Hekla in Iceland, eruptions become increasingly basic as they pass from a more explosive phase to a less explosive one. This also suggests a tapping of deeper levels in the magma chamber. Two examples of this sequence, numbered historically 1 to 4, are given in Figure 4.16. Such a sequence always appears to keep the same order within an eruption, but not every phase need be present.

This close correlation of type of explosive activity with gas content and composition of magma is of great importance and convenience in the development mathematical models of eruption processes, for it enables the theoretician to make a better initial guess at the factors controlling any one type of activity and, thus, to adapt theories of terrestrial explosive volcanic processes to Mars and the Moon.

Suggestions for Further Reading

Booth, B., 1973 'Pyroclastic paroxysms', *New Scientist,* **59,** 697-700.

Sparks, R. S. J., 1973 'Dusts of destruction', *New Scientist,* **59,** 134-136.

Tazieff, H., 1970 'Mechanism of ignimbrite eruption', in Newall, G. and Rast, N. (Eds.), *Mechanism of Igneous Intrusion,* Gallery Press, Liverpool.

5 Volcanic Gases

Introduction

In Chapter 4, it was explained how the pressure of the gases released from magma provides the force that drives all types of volcanic explosion; and the ways in which the viscosities of lavas are controlled by their gas contents were discussed in Chapters 2 and 3. Even more important is the fact that the very presence and composition of the atmospheres (Chapter 1) of the Earth, Mars and Venus are closely related to the kinds of gases available for release, probably by volcanic processes, from the interiors of these planets. Clearly, it is desirable to know as much as possible about volcanic gases.

Yet much less is known of the composition of these gases than of the composition of liquid magma. For, when accurate measurements of gas composition are to be made, samples must be taken at the surface of liquid magma, preferably within a vent, so that there is a minimum of contamination by atmospheric gases. And the person obtaining the samples will be working in the immediate vicinity of liquid lavas at temperatures normally well above 700°C, standing on a surface frequently shaken by explosions or earthquakes, rained on by bombs or ash and surrounded by a largely poisonous mixture of hot gases. It is not surprising that samples which can be guaranteed free from atmospheric contamination have never been taken.

Other methods of measuring gas composition and temperature do exist: most are based on the spectra of the light emitted by, or passing through, the gas. The fact that so few results of these methods have been reported can be attributed partially to the difficulty of mounting suitable spectroscopic equipment close to a vent.

A survey of published analyses of volcanic gases shows that the major possible constituents are water H_2O), carbon dioxide (CO_2), carbon monoxide (CO), hydrogen (H_2), nitrogen (N_2), argon (Ar), sulphur S_2), sulphur dioxide (SO_2), sulphur trioxide (SO_3), hydrogen sulphide (H_2S), and chlorine (Cl_2), though not all of these gases are detected in every sample. The main uncertainty is in the relative amounts of these gases released from a given magma and, perhaps most important, the origin of the water vapour detected. Water is very easily introduced into volcanic magmas from surface and sub-surface rocks, and estimates of the water content of uncontaminated gases at depth range from less than one per cent to over 99 per cent depending on the exact site on the volcano from which the gas sample was obtained.

An important part of the study of volcanic gases is the determination, in the laboratory, of the solubility of these gases in magmas of various compositions as a function of pressure and temperature. As the temperature of a melt rises, its ability to dissolve gases decreases; but, at any given temperature, the solubility of gases increases as the pressure to which they are subjected increases. Since the pressure on a magma decreases rapidly as it nears the surface whereas, under the same circumstances, the temperature changes only slowly, it is easy to understand why most lavas release excess gases in the form of bubbles as they are erupted. Unfortunately, these studies only show how much gas could be dissolved in a given magma at depth; there is never any guarantee that a magma is saturated with a particular gas at any given depth. As a result, it is essential to obtain field samples of volcanic gases.

Sources of Volcanic Gas Samples

The possible positions at which gas samples can be drawn from a terrestrial volcano are shown in Figure 5.1. Primary, high temperature gases are released from the hot magma and may be found in the main vents. Secondary gases are released from fumaroles on the flanks of a volcano and are called solfatara gases when they contain a large proportion of sulphurous compounds; the gases issuing from fumaroles may leave deposits of solid material, called sublimates, on the surrounding, cool rocks. These deposits may

Figure 5.1 Possible sites for gas collection around a volcano

contain the chlorides and sulphates of sodium, potassium, calcium, magnesium, aluminium and iron, and, also, free sulphur, iron oxide and ammonium chloride. The fact that many of these compounds are not found in appreciable amounts in what are taken to be primary gas samples suggests that the gases released in fumaroles are at least partially the result of reactions between primary gases and surrounding, cooler rocks. Finally, ground water at various depths may be heated during an eruption (or between eruptions) to produce hot springs and geysers.

Results of Terrestrial Gas Analyses

Prior to about 1930, the only way to analyse volcanic gases was to collect samples in some form of container and then take them back to a fully equipped chemical laboratory for more detailed analysis. This is acceptable for low temperature fumarolic gases, and hot spring emanations, but very unsatisfactory for high temperature, primary gases.

The pioneering work on volcanic gases was carried out in 1856 by Charles St. Claire Deville, who identified the main gases present in many samples and found water to be the dominant component in the majority of cases. Deville believed that the different sample compositions that were found all represented altered examples of a single magmatic gas.

In the early 1920s, a series of careful collections and analyses was performed at the geophysical laboratory on Hawaii, samples being collected from the two volcanoes Mauna Loa and Kilauea by J. A. Jaggar and E. S. Shepherd. Jaggar's[*] own words provide a vivid account of the collection conditions at a boiling lava lake: 'A brimming pit 1400 feet (427 metres) in diameter was easily accessible, with ponds of molten basalt vesiculating with rising gas bubbles. The melt partially congealed on the surface and heavy skins of silvery slag migrated with the currents impelled by convection. Clustered big gas bubbles burst out in so called "fountains". Flames played through cracks in the crust, through spatter cones at

local flow sources, through domes built up at border grottoes, through cracks in stiff lava covers, over molten lakes. At all these places, changing from day to day, the collectors stood on crusted living magma shorelines and plied their trade by thrusting vacuum-tube tips behind flames, seeing the tubes rupture, hiss and become cloudy, and then trying to seal the intake hole of the glass bulb effectively. To the leeward was the smell of sulphur dioxide. The trioxide is sometimes generated and is irrespirable. So cracked and porous are the lavas that carbon dioxide, though present in considerable amount, never troubles the visitor, because it flows down into pores.'

Jaggar and Shepherd took 26 samples and graded them according to where and how they were taken as very poor, poor, fair, good or excellent. They analysed the samples by volume and found that the average of the ten best sample compositions was 52 per cent water, 21.4 per cent carbon dioxide, 11.5 per cent sulphur dioxide, 10.1 per cent nitrogen and rare gases, 1.8 per cent sulphur trioxide and less than one per cent of all other components. When the percentage of each gas found was plotted against the 'quality of collection' some clear trends were seen: as sampling techniques improved, the proportions of CO_2, SO_2, CO and H_2 increased, and the percentage of H_2O, SO_3 and Cl_2 decreased. Other gases showed no consistent behaviour. Jaggar took this to mean that perfect collection technique would reveal a gas consisting of mainly CO_2, SO_2 and H_2. He assumed that water, SO_3 and Cl_2 were contaminants, or the results of reactions of the primary magmatic gases with air, and in 1947 he published the following estimated composition for the primary gas: 44 per cent CO_2, 24 per cent N_2, 20 per cent SO_2, 4 per cent S_2, 3.8 per cent H_2, 3.5 per cent CO and 0.7 per cent Ar.

This mixture is very interesting in that it contains, in almost the right proportions, the elements necessary for the formation of proteins. It has often been suggested that the best conditions for the formation of the biologically active molecules must have occurred in warm pools near volcanoes. Certainly the presence of all the necessary elements fulfills one necessary prerequisite of the process.

A considerable improvement in collection method was introduced in 1963 by E. F. Heald, J. J. Naughton and I. L. Barnes who used a tube containing silica gel to absorb the component gases as they were collected. When gases are exsolved from a

[*] Jaggar, J. A., 1940 'Magmatic gases', *Amer. J. Sci.*, 238, 313-353.

magma they are in dynamic equilibrium with one another. The following equations express this equilibrium, the relative concentrations of the component gases being related to the temperature and ambient pressure:

$$H_2 + CO_2 \gtreqless CO + H_2O,$$

$$4H_2 + 2SO \gtreqless S_2 + 4H_2O,$$

$$N_2 + 3H_2 \gtreqless 2NH_3,$$

$$2H_2 + S_2 \gtreqless 2H_2S,$$

$$CO_2 + 4H_2 \gtreqless CH_4 + 2H_2O.$$

The proportions of gases found after cooling will be very different, in general, from the proportions released from the magma in the first instance. The collecting tube used by Heald, Naughton and Barnes partly overcame this problem in that it separated many of the gases from one another at the moment of collection. It is well established that when a mixture of gases diffuses down a tube containing adsorbent material, such as silica gel, denser gases travel more slowly than the lighter ones and so are adsorbed nearer the open end of the tube. Heald *et al.* designed their collector, shown in Figure 5.2, on this principle.

The tube was pushed into a source of gas and a sample was admitted by fracturing the break-off tip, A, which was protected during transportation by the thimble, B. After gas collection the tube was re-sealed at the constriction, C. The adsorbent particles of silica gel, E, were held in the tube by plugs of glass wool, D. Depending on the amount of non-adsorbed gas expected, various sizes of tubing were used to make the free volume, F. The silica gel was activated (freed from previously adsorbed gases), prior to use, by heating *in vacuo* for at least two hours.

The collected gases were returned to a laboratory and analysed using gas chromatography. This analytical method involves separating gases along a diffusion column according to some physical property (for example, density) which is different for each one. The estimated accuracy of the analyses was about 5 per cent, a great improvement on earlier work; but the samples collected were mainly from fumaroles rather than from main vents. Nonetheless, Heald *et al.* assumed that their samples were representative of volcanic gases generally and used the equilibrium equations, given above, in a computer

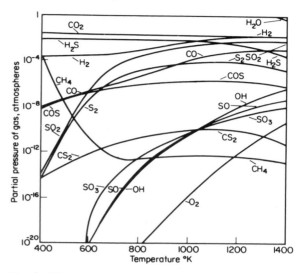

Figure 5.2 An adsorption tube used for gas collection by E. F. Heald, J. J. Naughton and I. L. Barnes. The various features are described in the text.

Figure 5.3 The change in equilibrium composition of a volcanic gas mixture with change in temperature at one atmosphere total pressure (After J. J. Naughton, E. F. Heald and I. L. Barnes)

programme to calculate the composition (Figure 5.3) of the collected gas as a function of temperature, total gas pressure, partial pressure of oxygen and partial pressure of water. Water constituted over 90 per cent of some of the samples collected but, after a discussion of the possibility of contamination, a likely initial proportion of between 10 and 50 per cent was suggested.

Samples were collected during the 1960s by many scientists, especially in Russia, Japan and Europe. The French scientist H. Tazieff, working on Mt Etna in Sicily, was presented with an excellent opportunity to collect primary magmatic gas samples when, in 1968, a chasm opened on the volcano's flanks, well away from the main crater. Previously, gas sampling at the main crater on Etna had been difficult. The new chasm, called the Bocca Nuova (Figure 5.4), appeared to be connected directly to the main vent and produced frequent bursts of hot gas at temperatures of up to 900°C. The gas speed was estimated and found to reach 165 m/s. Tazieff concluded that the gases he collected, between gas blasts, from the incandescent vent were heavily

Figure 5.4 The Bocca Nuova, a gas-emitting crater which opened in Etna in 1968 (Photo, Alison P. Brown)

contaminated with air, but that samples taken during phases of rapid gas release were much more reliable. He detected short term variations in gas composition and found that, between blasts, water comprised less than 40 per cent of the total volume, and that carbon dioxide was the next most abundant gas. During gas blasts, however, the water content fell to less than 10 per cent while the proportion of carbon dioxide rose to between 40 per cent and 60 per cent. Tazieff concluded that carbon dioxide, not water, was the main constituent of uncontaminated magmatic gas and cited other recent evidence in support of his conclusion. Thus M. Chaigneau, H. Tazieff and R. Fabre found, in 1960, that gases released from Niragongo volcano (West Africa) contained only about 43 per cent water and that carbon dioxide comprised 41 per cent of the total volume. Yet later findings were in direct conflict with these results: in 1969 a spectroscopic analysis, by Naughton, of the gas content of a Hawaiian lava fountain yielded 95 per cent water, 4 per cent carbon dioxide and one per cent sulphur dioxide.

Few other satisfactory spectroscopic analyses have been made. The earliest reported experiment was that of J. Verhoogen who photographed the spectrum of a volcanic flame during the 1938-1940 eruption of Nyamurigira (West Africa). Verhoogen identified sodium and potassium as being present in the flame and suspected several other elements and compounds. In 1959 A. Delsemme obtained a spectrum of a flame from the volcano Niragongo (West Africa) and, in analysing this spectrum, also re-discussed Verhoogen's analysis. Delsemme confirmed the presence of sodium and potassium in both spectra, corrected some other identifications by Verhoogen, and added copper and chlorine to the list of elements detected. An important point made by Delsemme was that temperatures in volcanic flames, although of the order of 1000°C, are not high enough to cause many atoms and molecules to generate their characteristic emission spectra. This fact automatically limits the usefulness of emission spectroscopy in volcanic gas analysis.

Using more conventional techniques, Russian scientists have drawn attention to the fact that the composition of the gas emitted by a volcano varies with time: they have detected significant, systematic changes in the ratios of various gases released just prior to major activity at a particular vent. It is clearly important to consider the possibility that eruptions might be predicted as a result of the monitoring of the composition of released gases.

A number of authors have reported the results of analyses of gases found trapped in vesicles in solid lavas after eruption. These analyses usually show 60 to 90 per cent water, 10 to 25 per cent carbon dioxide and less than 5 per cent of all other gases combined though, in rare samples, larger proportions of nitrogen are found.

It is appropriate at this point to try to summarise the results of these various collections and analyses of volcanic gases. Most experimenters find water to be the main gas collected, but as improvements in sampling techniques have been made it has usually been estimated that much of this water is the result of near-surface contamination. The most recent results of Tazieff suggest that the primary gas may contain up to 60 per cent carbon dioxide and as little as 5 per cent water vapour. All investigators agree that carbon dioxide, sulphur dioxide and hydrogen are important components at high temperatures; in addition, carbon monoxide, free sulphur and nitrogen are normally found. The detection of variations with time in the composition of the gas released from a given magma, and the fact that samples from different magmas never seem to have identical — or even similar — compositions, both suggest what one

TABLE 5.1 Compositions of volcanic gases and planetary atmospheres

Gas	*Volcanic gas samples, Jaggar (1940).	*Volcanic gas at 1200°C, based on Naughton et al. (1963)	*Bocca Nuova, Tazieff (1970).	†Estimated total gases released into Earth's crust, oceans and atmosphere	†Present composition of atmosphere of:		
					Earth	Mars	Venus
Water	52.7	30	<10	~80	0.5	~0.01	~0.1
Carbon dioxide	21.4	25	~50	~20	0.05	>98	>96
Sulphur dioxide	11.5	10					
Nitrogen	10.1			~0.5	75.5	<2	<4
Sulphur hydrogen		25					
Carbon monoxide		3					
Argon					1.3		
Hydrogen sulphide		7					
Oxygen					23.2	~0.01	~0.01

* Values are volume percentages

† Values are weight percentages

61

might reasonably have expected on theoretical grounds: that the gases released by magmas depend in a complex way on the composition, temperature and circumstances of eruption.

For this reason, and because so few reliable analyses are available, it is necessary to look for indirect information about the gases released by terrestrial volcanoes. This indirect information comes from a study of the present atmosphere of the Earth; for clearly the fate of all volcanic gases that do not condense, on cooling, to form solids or liquids is to collect in, and possibly react with, the pre-existing atmospheric gases. Indeed, the indications are that, on any theory of the origin and evolution of the Earth, the present atmosphere is derived almost entirely from within the Earth. In order to understand the way in which this conclusion is reached, the probable origin of the Earth and its present atmosphere must be considered in some detail.

Origin of the Earth's Present Atmosphere

It is now generally assumed that the Earth, like all of the planets in the Solar System, was formed as a result of the accretion of large numbers of small solid particles within a gaseous cloud surrounding the early Sun. As a result of many considerations it can be concluded that the original cloud broke up into smaller clouds of gas and solids, each of which formed one planet. The solid particles would have ranged in size from individual molecules up to objects a few kilometres in diameter, but would have constituted less than one per cent of the total mass of the protoplanetary cloud. The best estimates of the size of the Earth's cloud give it a mass of about 600 present Earth masses and a radius about 1500 times larger than the present value. Solar heating caused the evaporation of almost the entire cloud over the course of, perhaps, one hundred million years, to leave the present, solid Earth and a thin, residual atmosphere. A similar process is assumed to have operated for all of the other inner planets — Mercury, Venus, Mars and the Moon. The present atmospheres of the inner planets resulted from the degassing of their interiors during their subsequent, geological evolution.

The presence of traces of the so called rare gases — neon, argon, krypton and xenon — in the present atmosphere of the Earth provides a means of estimating how efficiently the Earth lost its first atmosphere.* The rare gases do not combine with other elements to form compounds (at least, not in appreciable quantities) and are found in only small proportions trapped in rocks. It is easy to estimate the proportions of these gases in the Earth (in the solid part, the hydrosphere and the atmosphere) relative to any other common element, say silicon. These proportions may be compared with those found in the Sun. (There are reasons for regarding the observed solar composition as being representative of the initial mixture in the protoplanetary cloud.) It is found that the rare gases have been depleted in the Earth by factors of between 10^6 and 10^9, depending on the molecular weight. Since compounds like oxygen, nitrogen, water and carbon dioxide — the present constituents of the Earth's atmosphere — would also have been gases at the time the protoplanetary cloud was being evaporated, it follows that they, too, should have been lost in similar amounts. Yet the amounts of these gases present in the oceans and atmosphere today are greater than those calculated, in the above way, by factors of between 300 and 10^7. All of these compounds must, therefore, have been combined chemically in the solid Earth and released after the loss of the primitive atmosphere.

Apart from the possibility that the Earth was hotter in the past than at present, it is arguable that the proportions of gases released by volcanoes have not changed greatly over geological time. These proportions, discussed earlier in this chapter, are compared with the present proportions of released gases in the solid Earth, atmosphere and oceans, in Table 5.1. This table also includes the latest estimates of the compositions of the atmospheres of Mars and Venus.

The differences between the composition of the Earth's present atmosphere and volcanic gases, especially in respect of the oxygen content, are the result of a number of processes that affect the equilibrium of atmospheric gases. Since these processes also take place, at least in principle, in the atmosphere of all planets, it will be useful to look at them briefly, in turn, in relation to the Earth, and then to see what can be deduced about the origins of the atmospheres of the other inner planets.

Retention and Evolution of Atmospheres

It is no trivial fact that the Earth, Mars and Venus are able to retain gaseous atmospheres. The molecules of

*The present argument is additional to that given in Chapter 1.

a gas all move at high velocities, the average velocity depending on the molecular weight of the gas and its temperature. Individual velocities are distributed on either side of the average and if the velocity of a given molecule is sufficiently large — and provided it does not collide with any other particle — that molecule can escape completely from the atmosphere. The temperature of a planet's atmosphere depends in a complicated way on the proportions of the gases composing it and, since these proportions may vary with height, so may the rate of escape of any particular gas. Any variation in gas concentration produced in this way will, in turn, lead to diffusion and redistribution of the components of the atmosphere. It will be seen that the composition of an atmosphere is controlled by a delicate balance of several forces.

The first main result of these considerations is that the Earth, Venus and Mars should be capable of retaining all gases except hydrogen and helium for times comparable with, or greater than, the age of the Solar System (about 4.6×10^9 years), and that the Moon and Mercury cannot retain light gases for any appreciable time. The Moon can retain gases heavier than argon for long periods and Mercury should be rather more efficient than the Moon in this respect. The calculations are not very accurate, but at least these results are in fairly good agreement with the observations that Earth, Venus and Mars do have atmospheres, the Moon has essentially none, and Mercury's atmosphere is extremely thin.

The second important result is that the Earth can lose hydrogen relatively easily. This gives a possible mechanism for producing the excessive quantity of oxygen which is present in the atmosphere but which is not released from volcanoes. Water vapour rises in small quantities to great heights and the action of sunlight breaks up the molecules into their constituents, hydrogen and oxygen. The hydrogen escapes much faster than the oxygen and the latter accumulates to provide the amounts measured today. Recently, many objections to this process have been raised. First, it is not clear that it can generate a sufficiently large quantity of oxygen over geological time, particularly when conditions in the atmosphere just after the loss of the primitive gases are taken into account. Although the formation of oxygen in the present atmosphere is quite rapid by this process, calculations by L. V. Berkner and L. C. Marshall suggest that, in the early stages of the formation of the present atmosphere, the oxygen content could have been only about one thousandth of its current value. This amount is the result of a balance whereby the oxygen formed from water by the action of sunlight absorbed energy at just those wavelengths responsible for its formation, thus reducing the sunlight supply to water vapour at lower levels and, therefore, reducing the rate of formation of more oxygen. This process could be acting now in the atmosphere of Mars, where the oxygen content is very low. Berkner and Marshall explain the present oxygen content of the Earth's atmosphere as being almost entirely the result of oxygen formation from carbon dioxide by photosynthesis in living organisms. With this hypothesis the absence of appreciable quantities of oxygen in the atmosphere of Venus and Mars would imply the absence of plant-like organisms on those planets.

Next, the carbon dioxide content of the Earth's atmosphere — especially the depletion of carbon dioxide relative to water — can be considered. This seems to be related to the combination of gaseous carbon dioxide with solid silicates through the reactions

$$MgSiO_3 + CO_2 \quad \gtreqless \quad MgCO_3 + SiO_2$$

and $\quad CaSiO_3 + CO_2 \quad \gtreqless \quad CaCO_3 + SiO_2.$

These reactions take place rapidly in the presence of liquid water, and slowly in contact with water vapour. The present carbon dioxide content of the Earth's atmosphere apparently represents an equilibrium condition for this reaction: but if the production of oxygen from carbon dioxide by living organisms were as important as was suggested earlier, then changes in the atmospheric carbon dioxide content would be controlled by both processes (operating at different rates), leading to a much more complicated balance.

Finally, the large quantities of nitrogen, relative to carbon dioxide and water, in the Earth's atmosphere need consideration. Assuming that the rate of release of gases by volcanic action has remained constant over geological time, then the total quantity of nitrogen which is presently observed is quite compatible with the amounts released by present day eruptions. The atmosphere of the Earth is depleted in water vapour — which has formed the oceans — and in carbon dioxide, which is mainly combined chemically with crustal rocks.

The Atmospheres of Mars and Venus
Table 5.1 shows the latest estimates of the

compositions of the atmospheres of Mars and Venus, together with a summary of the total quantities of common volatiles released from terrestrial volcanoes. On the basis of all the factors mentioned so far, and of our current state of knowledge of Mars, it is tempting to speculate that the planet is still accumulating its secondary volcanic atmosphere. Since the temperature and pressure just below the martian surface are normally such that any water would be frozen, the water vapour produced in martian eruptions would tend to condense and be trapped in these sub-surface layers. Some of the surface features seen in the Mariner 9 pictures have been interpreted as showing evidence of the presence of sub-surface ice. With this hypothesis, carbon dioxide and nitrogen would then accumulate in the atmosphere. It is true that nitrogen has not yet been found, but this gas is difficult to detect by any of the methods used to date. Also, since there is a little water vapour in the martian atmosphere, it may be that a little of the carbon dioxide that would otherwise be present in the atmosphere has combined with solid silicates of the surface. Only after probes have passed through the martian atmosphere and investigated the detailed composition of both that and the sub-surface layers will this interpretation be checked, however.

It is interesting to notice, in passing, that the atmosphere of Venus, composed largely of carbon dioxide and with a high surface pressure, may also represent an entirely volcanic secondary atmosphere. There is again the problem of nitrogen, which has not been detected on Venus; but, as with Mars, a suitably instrumented atmospheric probe could settle the matter. It is also necessary to explain the near-absence of water vapour from Venus's atmosphere — certainly from the upper layers which have been examined so far. The high temperatures on Venus make it likely that water will dissociate easily under the action of sunlight at the top of the atmosphere and that the resulting hydrogen will be lost rapidly into space. The oxygen is not observed as a gas; but it could have been absorbed into the crust. Analysis of the surface layers of Venus is needed to solve this particular problem.

Lunar Gases

The fact that the Moon cannot retain other than very heavy gases for appreciable periods of time means that, although many examples of volcanism can be seen on the Moon and although some vesicular rocks have been found, no traces remain of the gases which must once have been present in the rocks. Of particular importance in this context is the discovery, mainly as a result of the chemical analyses of lunar rock samples returned by the Apollo missions, that the lunar igneous rocks contain no, or almost no, water in any form. Although any free water might easily have leaked away into the vacuum of interplanetary space over long periods (all the lunar lava flows so far sampled appear to be more than 3×10^9 years old), there is no sign of chemically bound water, either, implying that lunar magma was deficient in water even at depth in the Moon. This peculiarity may reflect the initial composition of the Moon immediately after accumulation from its pre-planetary cloud; or it may just possibly be associated with the early differentiation and out-gassing of the Moon's interior following the loss of any primitive atmosphere. If Tazieff's conclusion — that carbon dioxide is the main constituent of terrestrial primary magmatic gas — is correct, and if this notion is also applicable to the Moon, then the absence of water need not be embarrassing — at least as far as the driving of explosive eruption processes is concerned.

The Moon has probably never had a permanent atmosphere. The loss of volatiles from a magma is inhibited on Earth by the pressure of the atmosphere; on the Moon there is virtually no retaining pressure applied to a magma near the surface and it is to be expected that even some of the more volatile elements — such as sodium and potassium — may be lost as gases from the surface of a lunar lava flow.

In summary, both the present and future compositions of the atmospheres of the terrestrial planets are closely linked with the products of volcanic processes. The lack of measurements of the compositions of uncontaminated volcanic gases is the main obstacle to all attempts to produce a more coherent picture. Study of the atmospheres of Mars and Venus gives some indication of the relative importance of the various processes that can modify planetary atmospheres, but there can be no substitute for large numbers of detailed analyses of gases obtained from a variety of different magmas. All volcanologists are now aware of this need, and it must be hoped that modern technology will soon enable scientists to overcome the severe problems encountered in the collection of gases in the field.

Armed with the background of volcanic processes presented in the last three chapters, it is now appropriate to return to the central thesis of this book and discuss the shapes of volcanoes, their relation to structures at depth, and their origin.

Suggestions for Further Reading

Krauskopf, K. B., 1967 *Introduction to Geochemistry,* McGraw-Hill, New York.

Kniper, G. P., (Ed.) 1952 *The Atmospheres of the Earth and Planets,* Chicago University Press, Chicago.

Macdonald, G. A., 1972 *Volcanoes,* Prentice Hall, Englewood Cliffs, New Jersey.

6 Shield Volcanoes

Introduction

There are two major morphological types of volcanic eminence — the shield and the cone. Shield volcanoes are so called because of their resemblance to the shields of early, north-European warriors, presenting a convex surface and having, commonly, either a central prominence (Figure 6.1) or depression. Other common features of shield volcanoes are small cones arranged either in radial chains, or in circular arrays symmetrically disposed about the summit. The flanks of these volcanoes normally slope at between 1° and 10° to the horizontal; but in extreme cases — for example, the shield volcanoes of the Galapagos Islands — the outer walls can attain slopes of up to 35°.

What distinguishes a shield volcano from the more readily recognisable volcanic cone? Primarily, it is the shape of the volcano. Other criteria for distinguishing shields from cones are that shields are normally composed of not less than 90 per cent lava— (a) by volume (in those cases where representative samples are available); and (b) by surface area (in cases where the interior of the volcano is not accessible for examination).

On the Earth, large numbers of shield volcanoes are predominantly confined to three areas — the Hawaiian Islands, Iceland and the Galapagos Islands. When the heights and diameters of the shield volcanoes from these three places are related graphically (Figure 6.2) it can be seen that the volcanoes of each locality fall into groups. Accurate data for generating such plots are in short supply.

Figure 6.1 Summit region of Mauna Kea shield, Hawaii. The shield volcano is capped with numerous cinder cones (some with craters visible); and lava flows may be seen in the foreground (Photo, S. Larson)

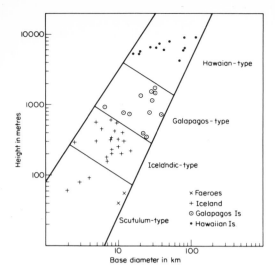

Figure 6.2 Height-diameter relation for terrestrial shields

Figure 6.3 Profiles of Olympus Mons and Hawaii. The Pacific sea level is indicated by the broken line. Note that the vertical scale is exaggerated.

This is particularly true of the submarine portions of oceanic volcanoes. The parameters commonly listed are the height of the summit of the volcano above sea-level and the width of the shield or cone above this level. Mauna Loa (Hawaii) has some 16 km of its height beneath the sea; and its base on the sea floor is some 35 km across. Clearly, it is important to attempt to correct the dimensions quoted in the literature in those cases in which the parts of a volcano below sea-level have been ignored and this has been done for the appropriate points in Figure 6.2. Only then can oceanic volcanoes be compared with those that discharge their deposits on dry land.

Types of Shield Volcano

It is possible to subdivide the shield volcanoes of Figure 6.2 into five groups. The smallest of the volcanoes — those at the lower left-hand side of the graph — have been called shield volcanoes of the scutulum type. The type examples of this subgroup were first described in the Faeroe Islands where each volcano has a slope of less than 1°. The next, and larger, volcanoes are those of Icelandic type. Iceland is entirely volcanic, containing over 45 shields. The majority of the points representing the Icelandic shield volcanoes fall into the more restricted group which provides the name for the type.

Still larger are the shield volcanoes of the Galapagos Islands. These tend to be steeper than those from other areas and present slopes of up to 35°.

Amongst the largest of the terrestrial shield

volcanoes are those from the Hawaiian Islands; the volcano Mauna Loa — which makes up the bulk of the Hawaiian profile in Figure 6.3 — has dimensions that are comparable to those of Mount Everest. In spite of their enormity by terrestrial standards, the Hawaiian shields are dwarfed when compared with the giant volcano Olympus Mons on Mars (Figure 6.4). This martian shield — probably the biggest volcano known in the Solar System — appears to stand some 20 km above its base-level and has a basal diameter of perhaps 2000 km. A new term 'macroshield', may be used to describe the giant martian volcanoes of this order of size.

The Shapes of Shield Volcanoes

Why does a shield volcano assume the characteristic, domed form? To answer this question it is necessary to consider what factors influence the distribution of material erupted from a volcano.

The majority of terrestrial shield volcanoes — like those of Hawaii — are composed of basalts with SiO_2 contents of about 45 to 50 per cent. Some, like Hayli Gub (Ethiopia), are much more acidic, having an SiO_2 content in excess of 55 per cent, and are more properly classed as being andesitic. Clearly, then, the chemical composition of the erupted material is not the only factor which results in the formation of a shield volcano. A more important factor may be the viscosity of the erupted material.

The viscosity of freshly erupted lava is controlled by several factors in addition to its composition. The presence of either bubbles or crystals increases the viscosity of the lava.

The formation of bubbles at great depth in a given magma is controlled by the acceleration due to gravity. Bubbles will tend to form at greater depths on a planet with lower gravity — assuming other conditions are the same — because the overburden, or weight of overlying rock, will be less. As the magma nears the surface the atmospheric pressure (if an atmosphere is present) takes over the role of controlling the bubble growth, a higher pressure reducing the growth rate. Thus, bubbles in a magma

Figure 6.4 Olympus Mons — one of the largest known shield volcanoes in the Solar System. (Mariner 9, NASA) The outline of England and Wales is shown on the same scale for comparison.

of given composition and gas content should be formed at the greatest depths on the Moon (which has no atmosphere and a low value of gravity — see Table 6.1), at smaller depths on Mars (which has a thin atmosphere and somewhat higher gravity) and at the least depths on Earth. It has been found that Hawaiian shield volcanoes erupt material which has a gas content of 0.5 to 1 per cent; whereas cone volcanoes (described in detail in Chapter 7) are formed from lavas having gas contents in excess of 1 per cent. However, the shape of a volcano is not uniquely related to the gas content of its lavas.

The nucleation and growth rate of crystals is very difficult to measure and is usually estimated in terrestrial cases by examining the texture of cooled rock specimens. A major problem remains, however: geologists do not know at what post-eruption stage crystals nucleate and grow, or what factors initiate nucleation.

In addition to the effects of the rheological properties of lavas on the dimensions of lava flows, the lengths and shapes of lava flows are also controlled by the rate of eruption of material (Chapters 3 and 9). It is possible that the rate of eruption is the most important factor in determining whether or not a shield volcano is generated by a given eruption. This would explain the preponderance of shields of basic composition. Basaltic lavas of low

Table 6.1 Some parameters controlling the shapes of shield volcanoes

	Approx. acceleration due to gravity (cm/s²)	Approx. atmospheric pressure (bar)	SiO_2 content of lavas (% by wt.)	Approx. viscosity of lavas at 1300°C (poise)
Earth	980	1	45 to 50 (Hawaii)	200
Moon	160	$<10^{-13}$	40 to 45 (Maria)	20
Mars	370	6×10^{-3}	45 ?	?

viscosity are commonly erupted rapidly, whereas acidic magmas can only rise as quickly in those rare cases where a magma chamber is able to transmit hot material to the surface through a short, wide conduit. However, if basaltic lavas are erupted extremely rapidly, flood lavas will be deposited (Chapter 3).

The relationships between the rate of eruption of a lava, its physical properties and the length and shape of the resulting flow are discussed in Chapter 9; but the details of the way in which the shapes of individual flows determine the overall profile of a shield volcano still have to be elucidated. The extent of such unresolved problems is reflected in the fact that Skjaldbreithur (Iceland) appears to have been the product of a single, voluminous eruption from a single vent whilst other shield volcanoes, like those of the Hawaiian Islands, are the products of many hundreds of separate flows from both summit and flank vents.

Extreme Types of Shield

The very low silica content of the mare lavas on the Moon is one of the factors which resulted in their having a low viscosity. Some of the mare lavas appear to have travelled distances in excess of 1000 km; and this may be understandable in terms of low viscosity factors and high volume rates of eruption which led to fairly thick flows. Under these conditions, the flows spread out rapidly and did not sustain the steeper slopes needed to build typical shield volcanoes. Terrestrial shields with exceptionally gentle slopes are known in the Idaho basin and in the Faeroes; so it is possible that some parts of the lunar maria are composed of extremely low-angle ($\sim1°$) coalescing shield volcanoes.

Some shields, like Efstadalsfjall (Iceland), are circular where their lavas terminate and make contact with the country rocks whilst others, like Kohala (Hawaii) are elongate. Calderas are found in the summits of some shields — for example, Olympus Mons (Mars, see Figure 6.4) and Mauna Loa (Hawaii) — whilst others do not even have summit craters. Some shields like Haleakala (Hawaii), have rifts which are radial to the summit whilst others, like Arsia Mons (Mars, see Figure 6.8) have rifts which are concentric with the rim crest of the summit caldera. Yet other shields have been dissected by faults, some of which have effected down-dropping of segments of the volcano.

A special type of shield with an uncommon profile has been called an eldborg after the volcano of that name in Iceland. It consists of a small shield with a steep wall at the summit enclosing a crater — the whole resembling a mediaeval English castle sited on a hill. In fact, many of the large shield volcanoes have summit regions which differ in composition from the main body of the volcano. This is because, over a long period of time, the lava tends to become more acidic. Under these conditions, steep cones may be built up on the volcano.

Distribution of Volcanoes

A distinction is commonly made between terrestrial volcanoes situated at plate boundaries (Figure 2.6) and those occurring within a plate. Shield volcanoes occur in both places (Figure 6.5), those occurring along plate boundaries being exemplified by the shield volcanoes of, for instance, Japan and Iceland and those within plates by the oceanic volcanoes such as Réunion or continental volcanoes like Nyamuragira. Shield volcanoes appear to predominate amongst those volcanoes not directly related to plate margins, especially if the many hundreds of submarine prominences thought to be shield volcanoes are included. If the continental volcanoes do not owe their origin to plate tectonics, what, then controls their gestation?

Figure 6.5 Identification of some terrestrial shield volcanoes

1. Jan Mayer Is.
 Beerenberg

2. Iceland
 Almannagja
 Arnarsetur
 Asbyrgi
 Baldheithi
 Bjarnarfell
 Bjornsfell
 Blafjoll
 Blagnippa
 Borgarholar
 Burfell
 Dyngjuhåls
 Eftstadalsfjall
 Eldborg
 Geitahlith
 Haleyjarbunga
 Hestvatn
 Kerlingardyngja
 Ketildyngja
 Kjalhraun
 Lagafell
 Lambahraun
 Langhóll
 Leggjabrjotúr
 Lulli-hratur
 Lyngdalsheithi
 Mithdalsfjall
 Ok
 Rauthamelskulur
 Sandfell
 Selvogssheithi
 Skalapnes
 Skersli
 Skjaldbreithur
 Skoflungur

2. Cont'd.
 Skrithan
 Skuggadyngja
 Solkath
 Trolladulur
 Trölladyngja
 Vatnsheithi

3. Faeroe Is.

4. Azores

5. Canary Is.

6. St. Helena

7. Sudan
 Jebel Marra

8. Ethiopia
 Alayta
 Erta Ale
 Hayli' Gub

9. Congo
 Nyamuragira

10. Camores
 Anjouan
 Karthala
 La Grille

11. Réunion

12. Mauritius

13. British Columbia
 Mt Edziza

14. Oregon
 Mt Newberry

15. Idaho
 Snake River Plains

16. California
 Badger Mt
 Black Mt
 Crater Lake Mt
 Harkness Peaks
 Medicine Lake
 Prospect Peak
 Raker
 Red Mountain
 Simcoe complex
 Table Mt.
 Whaleback

17. Mexico
 Tancitaro

18. Nicaragua
 Masaya

19. Galapagos Is.
 Abingdon
 Alcedo
 Bindloe
 Cape Berkeley
 Cerro Azul
 Charles
 Culpepper and
 Wenmann
 Darwin
 Indefatigable
 James
 Narborough

 Sierra Negra
 Tower
 Wolf

20. Hawaii
 Hualalai
 Kilauea
 Kohala
 Mauna Kea
 Mauna Loa

21. Oahu
 Koolau
 Waianea

22. Maui
 East Maui
 West Maui

23. Molakai
 East Molakai
 Kalaupapa
 West Molakai

24. Kahoolawe

25. Lanai

26. Kauai

27. Niihau

28. Society Is.

29. Raratonga

30. Samoan Group
 Matavanu

31. Niuafo'ou

32. New Zealand
 Akaroa
 Pirogia
 Pukekawa
 Pukekohe Hill
 Lyttleton
 Rangitoto
 Whatitiri
 Karioi

33. New Hebrides
 Aoba

34. Australia
 Mt Porndon
 Tweed

35. New Guinea
 Mt Giluwe

36. Emperor of China

37. Bali
 Batur

38. Japan
 Hakusan

70

A possible explanation of their origin is that they are over deep fractures or faults which tap a magma-producing region of the Earth's interior. Another possible solution is that there exist unique upwellings of mantle material — termed 'mantle plumes' — above which volcanoes are constructed. A further possibility is that, when the plates move around the non-spherical Earth, cracks are produced in a plate when it encounters an area of different global curvature. Where the plate cracks, volcanoes are produced. Further unresolved problems are encountered in the case of regions, such as Iceland, thought by some to owe their origins to both a plate-tectonics and a mantle plume mechanism.

Two particular areas where shield volcanoes are found in abundance — Iceland and Hawaii — are also those areas which are thought to be type localities for mantle plumes. But it cannot yet be argued that shield volcanoes originate only over mantle plumes.

On the Moon there are a number of features called domes (Figure 2.7) for which various modes of origin — including gas blisters, laccoliths, expansion of minerals as a result of a phase change, and shield volcanoes — have been proposed. None of the Apollo missions returned material from any of these domes, so there is no direct evidence that they are composed of lava. However, in the lunar Marius Hills area (Figure 6.6) probable lava flows can be identified near domes and, in this area and elsewhere, there is certainly an association of lunar sinuous rilles and domes (Figure 2.7); and sinuous rilles are believed to be channels carved by hot, turbulent lavas. Both facts point to the possibility that the domes are volcanic; and, in form, they are comparable to shield volcanoes. One of the larger lunar domes is illustrated in Figure 6.7.

The majority of the smaller lunar domes occur on plateaux within Oceanus Procellarum along a central

Figure 6.6 Domes and flows near to the lunar crater Marius. Calderas capping domes are arrowed (Lunar Orbiter 2, NASA).

Figure 6.7 Large lunar dome, or shield, called Gruithuisen γ. It has a diameter of 20 km (Lunar Orbiter 5, NASA)

zone of mare ridges which run in a meridional direction — a situation perhaps comparable with that of Iceland on the mid-Atlantic ridge. Other domes are concentrated around the edges of the maria and, with other volcanic and tectonic features, they may be related to some lunar equivalent of terrestrial plate tectonics.

On Mars, the distribution of major volcanoes (see Figure 2.8) is restricted in an interesting way: the majority occur within the Tharsis and Elysium regions. Olympus Mons (Figure 6.4) is apparently the largest of these volcanoes and its morphology points to its being a shield volcano. All other martian volcanoes described in the literature to date have also been identified as shields. It has been argued that there are no plate tectonic movements on Mars and that the martian shields developed in a crust which was stationary with respect to an underlying magma source. Consequently, these martian shields were able to grow to an exceptionally great size. Alternatively, it is possible that a line of martian shields such as that including the volcanoes Ascraeus Mons Pavonis Mons and Arsia Mons (Figure 6.8), may be set in a zone of crustal weakness and that the crust on which they lie may be a plate which has moved relative to an underlying heat source. This is partly supported by the observation that the volcanoes at the south-west end appear to be more denuded than those to the north-east. The more denuded ones may be the older;

and a general progression in age from one end of a chain of volcanoes to the other — as in the case of the Hawaiian Islands — provides debatable evidence for martian crustal movement.

Post-Eruption Modification of Shields

The heights and basal diameters of shield volcanoes on the Earth, Moon and Mars are presented in Figure 6.9. It may be noted that the average slopes of shields (given approximately by the ratio of height to basal radius) on all the planets are similar, as long as the height is less than about 10 km. Furthermore, the spread in slope values is also similar for all three planets. It is tempting to use comparisons of this sort to argue that among those factors which control the slopes of shield volcanoes, gravity and atmospheric pressure are not very important since they, unlike the average slope, vary widely between the three planets.

For shield volcanoes, or indeed for volcanoes of other types, with heights greater than a few kilometres, forces other than those already considered become important. The pressure forces at the base of a large pile of lava flows will, if great enough, cause the rocks to behave like very viscous liquids and 'flow' outwards, over a very long time period, thus reducing the height of the pile. The critical height of the volcanic pile needed to initiate flow at its own base depends on the average density of the rock and the local gravity. For common volcanic rocks the critical heights are likely to be about 3 km, 10 km and 20 km on the Earth, Mars and Moon, respectively; though these values may easily be in error by a factor of 3.

The time scale for reduction of height from twice the critical value to near the critical value is long — of the order of a few tens of million years on all three bodies. So one would only expect to see volcanoes much higher than the critical values if such structures had been enlarged by extrusive activity within the last 10 million years. Since some terrestrial domes do exceed the critical height (3 km) for the Earth, it can be concluded that they must be recent features, and this is borne out by age measurements. No lunar domes exceed or even approach the critical height (about 20 km) for the Moon, presumably because such large structures were never built up. On Mars, however, it is found (Figure 6.8) that most of the large shields have maximum heights quite close to the limiting value of 10 km. If we accept that there has been fairly recent activity (and also little erosion) at volcanoes such as Ascraeus Mons — which seems

(a)

(b)

(c)

Figure 6.8 Three major shield volcanoes on Mars: (a) Ascraeus Mons (North Spot); (b) Pavonis Mons (Middle Spot); (c) Arsia Mons (South Spot) (Mariner 9, NASA)

Figure 6.9 'Height-diameter relation for different groups of planetary shield volcanoes.

quite likely in view of the fresh appearance of their lava flows — it must be concluded that the activity has not increased a volcano's height at a rate greater than a few kilometres in a few million years. If it has been constant over the lifetime of Acraeus Mons the rate of construction would not be greater than about 0.1 km^3; and the age of the volcano, taking account of its geometry, would be between 10^7 and 10^8 years. These values, though very approximate, are close to those estimated for the Hawaiian Island chain, where the average rate of extrusion from vents on Hawaii is now 0.1 to 0.2 km^3 per year and the age of the complete chain is up to 4×10^7 years. Olympus Mons, the highest of the martian shield, has a height much greater than the expected upper limit of 10 km, suggesting that, at some time during the last few tens of millions of years, its eruptions have extruded material at rates considerably in excess of 0.1 km^3 per year.

When making morphological comparisons of volcanoes on the Earth, Moon and Mars, the effects of erosion must be taken into account. On the Earth, erosion of subaerial volcanoes takes place as a result of the action of hydrological, atmospheric and biological agents which combine, within 10^7 years, to reduce a volcano to a form in which it is not immediately recognisable, the exact time depending on the volcano's original size. Thus, all that remains of the Miocene volcano Tweed (Australia) is an array of scattered outcrops of lava flows and rocks representative of the vent.

On the Moon, where the present rate of erosion — (mainly as a result of meteoric impact) is very slow — of the order of 1 mm per 10^6 years — volcanic edifices (such as that shown in Figure 6.7) in excess of 3×10^9 years old may still retain the essentials of their original shapes.

Erosion mechanisms, and the erosion rate, on Mars are, at present, poorly understood. Wind-blown dust, ice, and possibly even flowing water appear to have been important erosive agents within certain areas at various times. It seems that denudation on Mars takes place much faster than on the Moon but less rapidly than on the Earth.

Suggestions for Further Reading

Macdonald, G.A. and Abbott, A.T., 1970 *Volcanoes in the Sea — The Geology of Hawaii,* University of Hawaii Press, Honolulu.

McBirney, A.R. and Williams, H., 1969 'Geology and petrology of the Galapagos Islands,' *Geol. Soc. Amer. Memoir* No. 118.

Menard, H.W., 1964 *Marine Geology of the Pacific,* McGraw-Hill, New York.

Stearns, H.T., 1966 *Geology of the State of Hawaii,* Pacific Books, Palo Alto, California.

7 Cone Volcanoes

Introduction

Like shield volcanoes, cone volcanoes are so designated because of their characteristic shape; and cones, too, can be sub-divided on the basis of morphology and composition (Table 7.1). Table 7.1 gives the relation between cone composition and cone height. For example, it shows that cinder cones tend to be composed entirely of pyroclastics with no lava, and tend to be higher than tuff cones and ash cones.

Lava Cones

Most eruptions that are entirely of lava produce the rounded profile of a shield volcano. The cone (Figure 7.1) formed entirely of lavas is a rare form of volcano. Indeed, many of the landforms cursorily classed as lava cones are probably pyroclastic cones with an outer coating of lava. True lava cones do exist, reaching heights of over 30 m and having summit craters that, commonly, have been enlarged by post-eruption collapse.

A peculiar form of lava cone, perhaps better described as a lava cumulus or tower (Figure 7.2), is produced by repeated emissions of short, thin, cylin-

Figure 7.1 Lava cone with mantling flows

Table 7.1 Composition of volcanic cones

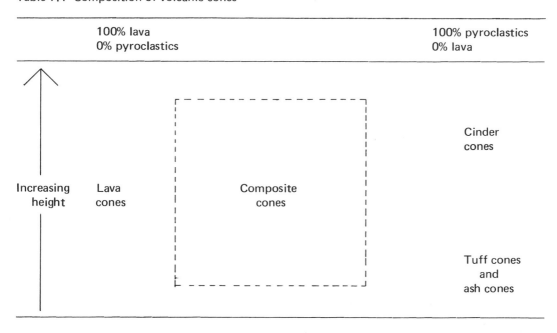

100% lava 0% pyroclastics		100% pyroclastics 0% lava	
Increasing height	Lava cones	Composite cones	Cinder cones
			Tuff cones and ash cones

75

Figure 7.3 Ash cone in Iceland (Photo, R. Todhunter)

Figure 7.4 Cinder cones in Mexico (Photo, S. Larson)

drical lava flows resembling flexible drainpipes. These flows have built cones up to 20 m in height.

Pyroclastic Cones

The cones within this group are subdivided on the basis of the particle size and chemical composition of the rocks which form the walls of the volcano. Cones of small-sized, solid ejecta are called ash cones (Figure 7.3) and those of coarse, solid ejecta, cinder- or scoria-cones (Figure 7.4).

Ash cones are commonly cemented by secondary material deposited by percolating groundwater or, in some cases, by palagonitisation which is a process of hydration and oxidation whereby volcanic glass is converted to palagonite.

In most pyroclastic eruptions (Chapter 4) the bulk of the finer material tends to be transported to relatively great distances from the vent, and the net result is the concave surface of the cone volcano. When a volcano erupts in shallow water molten rocks making contact with the water generate steam explosively and, as a consequence of the occurrence of near-horizontal velocities of ejecta (Figure 7.5), a flatter structure is produced called a hyaloclastite- or tuff-ring (Figure 7.6).

Another kind of pyroclastic cone is composed of a material called spatter (Figure 7.7). Spatter cones are built up when hot clots of material — which may or may not weld together when they land on the rim unit of the volcano — are ejected. Cones produced by spatter can be steeper than cinder cones but rarely exceed heights of 30 m.

Figure 7.5 Model explosions in powder showing the relationship between explosion depth (a: 6.4 mm; b: 12.7 mm; c: 26 mm; d: 307 mm) and distribution of angles of ejection of particles (Photos, G. Fielder)

Figure 7.6 Tuff ring in Ethiopia (After F. Barberi and J. Varet, from *Bull. Volc.*, **34**, no. 4, (1970), Intern. Ass'n of Volcan. and Chem. of the Earth's Interior)

Figure 7.7 Spatter cone with 'rootless' lava flows (arrowed)

Figure 7.8 Ruffed cone showing lava spillover

Figure 7.9 Composite cone in Tenerife (Photo, J. Whitford-Stark)

Ejection of gas enriched lava

Hornito

2 metres

Solid lava crust

Direction of flow

Liquid lava

Base of lava

Baked ground surface

Hornito

(a)

(b)

Figure 7.10 (a) Mechanism of hornito formation (b) Hornito in Arizona (Photo, G. Fielder)

Figure 7.11 Phreatic eruption cones in Iceland (Photo: Mats Wibe Lund, Reykjavik, Iceland)

Figure 7.12 Shapes of cones viewed from above

Symmetric cone

Elliptical cone

Asymmetric cone

Elongate cone

Breached cone

Multiple cone

Figure 7.13 Double-cratered cinder cone in Arizona (Photo, S. Larson)

• Volcano

/ Faults

Figure 7.14 Volcanoes of the Eastern Rift System, Africa

Figure 7.15 The relationships between volcanoes and faults: (a)-(d), elevations; (e), plan

Figure 7.16 Distribution of volcanoes on Tenerife, Canary Islands

Figure 7.17 Central peak and elongate summit crater (arrowed) of the 136 km diameter lunar crater Albategnius (Lunar Orbiter 4, NASA)

Composition Cones

This group includes all those volcanoes which are composed of a mixture of pyroclastics and lava (Table 7.1). Very commonly, volcanoes start life as cinder cones but, as the eruption proceeds, the ejected material may become more fluid, at first building a collar of spatter, or small lava flows, around the crater (Figure 7.8) and, eventually, producing a complete lava covering.

In instances in which the process of alternating lava and pyroclastic eruptions is repeated many times, volcanic eminences over 3.5 km high can be produced. Some authors describe this type of volcano (Figure 7.9) as a stratovolcano, since it is composed of successive layers, or strata; but shield volcanoes are also composed of layers, so, taken literally, the term stratovolcano fails to distinguish between the two forms. A number of authors retain the term stratovolcano to describe the largest composite cones (Table 7.1).

Volcanic Cones which are Not Themselves Volcanoes

Cones of lava which are not true volcanoes can be generated on cooled lava flows when, for example, hot, gas-enriched, viscous lava is squeezed up through an orifice in the solid surface of a flow. These cones, called hornitos (Figure 7.10), can be quite steep but rarely exceed a height of 5 m.

When a hot lava flow makes direct contact with

Figure 7.18 'Moon Crater' — a nested cone in Mexico (Photo, S. Larson)

water, or crosses a waterlogged surface, the water can penetrate to the hot interior of the flow and expand as it is converted to steam. If it occurs sufficiently rapidly, the expansion produces a phreatic explosion which forms a crater or a cone on the surface of the lava flow. Some of these cones are quite large; that of Puu Hou (Hawaii) achieved a height of 80 m and those of Skútustathir (Iceland) are about 10 m high and 80 m wide (Figure 7.11).

Cone Shape

There is a monotony in the evolution of slope in passing from the steepest cones to the shallowest shields: indeed, a volcano such as Skjalbreithur (Iceland) is described, in the literature, both as a lava cone and as a shield volcano. However, the walls of a cone tend to slope at a constant angle to the horizontal, or at an angle that increases towards the summit; whereas the subaerial slopes of a shield generally show the reverse tendency. The profile of a volcano is an indicator — although not invariably so — of the composition of the rocks defining that profile. Thus shape, composition and size are useful criteria in the identification of cone volcanoes. However, since study of extra-terrestrial volcanoes hinges almost entirely on the interpretation of photographs, the criterion of chemical composition is of less general use than one based entirely on morphology (Figure 7.12).

The simplest form of cone is the symmetric one which has a circular base, and slopes rising to a summit crater at the apex of the cone. In practice, this ideal form is not prevalent in nature: asymmetric

Figure 7.19 The somma-cone of Tyatya Volcano (Kurile Islands) (Reproduced, by permission of Plenum Publishing Corporation, from G. S. Gorshkov's *Volcanism and the Upper Mantle*)

cones are the more typical. The final shape of a cone will depend, clearly, on the shape of the volcanic vent, which is commonly elongate because of its close association with a crustal fracture. Again, it is well known that, on the Earth, winds may disperse pyroclastic materials while they are in the air and that, if the wind prevails in a fixed direction during the greater part of a pyroclastic eruption, the deposits are likely to construct a cone that is markedly asymmetric. One might also expect to find wind-sculptured cones on Mars and Venus.

Lava forming a crater-lake may flood over and destroy the rim of a cinder cone; the weight of pent-up lava may cause it to break out through the wall of a cone and the resulting lava flow may carry a part of the wall with it (for example, Heimaey in 1973); or a particularly violent explosion could destroy part of the wall. The form left, following the operation of any of these processes, is described as a breached cone.

Finally, two (or more) vents that arise — either simultaneously or sequentially — in close proximity have the potential of building a composite volcano with two (or more) summit craters and, commonly, an outline (in plan) like a figure '8' (Figure 7.13).

The Distribution of Volcanic Cones

The relationship between terrestrial volcanoes and plate boundaries was discussed in Chapter 6: other points or areas of weakness in the Earth's crust provide pathways by which hot materials at depth can find ready access to the surface (see Figure 7.14). The loci of such areas of weakness are commonly faults or fractures which may themselves form part of a global fracture system.

The position of a vent with respect to a fault depends upon the angle of dip of the fault. The more steeply is the fault inclined to the horizontal, the

DISTRIBUTION OF VOLCANIC CONES
IN THE MARIUS HILLS REGION

MARIUS

● = Cone
▦ = Wrinkle ridge 0 15 30 km
■ = Rille

N

1979 / LWS

Figure 7.20 Distribution of cones in the Marius Hills region of the Moon

nearer are the volcanic vents to the fault trace (Figure 7.15, a to e). Thus in the San Franciscan volcanic field (Arizona), where the major faults are inclined to the vertical, chains of volcanoes parallel the faults but are laterally displaced from them. In the case of the lunar volcano La Hire (Figure 3.12) the largest summit crater is displaced from the associated fault trace towards the downthrown block of country.

Some volcanic islands carry faults along the planes of which the greater bulk of the islands appear to be slipping into the sea. On Tenerife (Figure 7.16) in the Canary Islands, the volcanoes are concentrated in a Y-shaped pattern corresponding to the higher parts of the island. The locus of the volcanic vents appears to be identified with the arcuate fault traces along which the island is slipping towards the sea (Figure 7.15 d).

The cinder cones on the crest and flanks of the shield volcano Mauna Kea (Hawaii) are situated along three rift zones which converge on the summit of the shield. The cinder cones lie in both peripheral and radial belts with respect to the main structure of Mauna Kea (Figure 7.15 e). The greatest density of these cinder cones occurs where the traces of several faults intersect. Radial and concentric patterns of cinder cones are also found on the Galapagos shield Cerro Azul. The central peaks of some lunar craters are elongated along the direction of their controlling fracture; some such peaks carry a summit crater (Figure 7.17) which is also elongated in the direction of the axis of the peak.

Apart from faults, fractures and joints, volcanic materials sometimes find low impedance pathways to the surface along the routes followed by previous melts. Thus the craters of many large volcanoes become the sites of renewed activity after some intervening period of quiescence. Later events of progressively smaller magnitude may construct a nested cone (Figure 7.18). The so called somma-type of nested cone (Figure 7.19) is named after Mount Somma, a residual portion of the encircling volcanic rim unit which was the precursor of the present, centrally disposed, Vesuvius.

In addition to the central cone, there are also, in some cases, smaller cones on the flanks of large, composite cones. These are produced by volcanic materials following routes that branch from the principal stem supplying hot materials to the surface. The reason is again found in the universal rule that the route of easiest access to the surface will always be taken. In some circumstances the principal vent of a volcano becomes plugged with congealed materials, or the height of the volcano is so great that the hydrostatic pressure in the main conduit is greater than the driving pressure from beneath. Such cones are normally evolved during the later phases of the eruption of a volcano. For example, probable shield volcanoes in the lunar Marius Hills appear to have subsidiary cones on their flanks.

There are no lunar or martian cone volcanoes equal in size to the largest terrestrial composite cones such as Mount Fuji (Japan). With the high resolution photographs provided by the Ranger, Orbiter and Apollo spacecraft it became possible to see small, volcanic cones in the lunar maria, particularly in the Marius Hills (Figure 7.20) and in the Taurus-Littrow area near to the Apollo 17 landing site. In the lunar highlands, volcanoes are more difficult to distinguish because of the greater complexity of the terrain and the photographic problems associated with the extreme range of brightness encountered there. Nevertheless, some cones volcanoes, like the small cone occurring on the wall of the crater Alphonsus, have been noted. With the advent of higher resolution photography, it may become possible to distinguish small volcanic cones on the surface of Mars, too, in the future.

In the foregoing chapters, mention has repeatedly been made of the control of volcanoes by planetary crustal fractures. In order to extend the superficial data drawn from an analysis of volcanic landforms and processes it is now time to examine, in more detail, the factors which control the distribution and birth of volcanoes.

Suggestions for Further Reading

Macdonald, G. A., 1972 *Volcanoes,* Prentice Hall, Englewood Cliffs, New Jersey.

Ollier, C., 1969 *Volcanoes,* M.I.T. Press, Cambridge, Mass.

8 Faults, Graben, Rifts and Calderas

Introduction

A glance at almost any aerial photograph of mountainous terrain will reveal the presence of numerous straight, or nearly straight, features in the landscape. They may express themselves in any of many ways: cliffs, river valleys, abrupt changes in shape of the ground, lines of volcanic vents, ridges, and so on. Viewed from the ground, such lineaments are generally much less impressive. Careful work by cartographers has given us a detailed picture of the shape of our planet. Yet new insight into the overall shape of the Earth has come, only recently, from the analysis of artificial satellite observations.

Faults

An extremely large proportion of terrestrial lineaments is found in the surface expression of fractures and faults in the Earth's crust. Not all lineaments can be so classed: for example, a line of sea cliffs would not generally be ascribed, directly, to faulting. However, by acting as a zone of weakness along which two blocks of crust can move relative to one another to produce a fault, a crustal fracture can divert rivers, generate cliffs, delimit areas where erosional forces are exceptionally active and, by opening, produce a fissure which may act as a conduit along which volcanic material can reach the surface, and so on. The study of fracturing and faulting has grown into a major field in its own right, the investigation of the trend, type, distribution, structure, origin and effects of fractures and faults being known as tectonics.

The cracks which occur in rocks do not all arise from the same cause, nor are they all of similar magnitude. Microfractures may affect only single crystals; joints may affect only individual beds of rocks; larger fractures may pass through many beds and be of great length. Finally geofractures may penetrate the entire crust and may continue for some depth into the mantle. These fractures are generally of continental dimensions in horizontal extent.

A fracture along which there has been no relative movement is termed a fissure; any relative movement changes a fissure into a fault. Thus tension without shear is a necessary condition for fissure formation. Fissures give rise to many types of volcanism (Chapter 3).

Figure 8.1 (a) Normal and (b) reverse dip-slip faults

The plane of a fault or fracture intersects the local horizontal surface of a planet in a line termed the strike (Figure 8.1). The supplement of the largest angle between the horizontal and the fault plane is termed the dip of the fault.

The strike, the dip and its compass direction uniquely define the orientation of a fault plane. A dip-slip fault is one in which movement has been along the dip plane. A strike-slip fault is one in which the relative displacement has been along the strike. Dip-slip faults may be either normal, or reverse (Figure 8.1).

An impressive example of a strike-slip fault occurs in the United Kingdom: the Great Glen Fault traverses Scotland from Mull to the Moray Firth. The

fault has generated a broad belt of intensely crushed rocks along the zone bordering its strike and it is the erosion of this damaged area which has produced the valley that we observe today.

Figure 8.2 The lunar Straight Wall (Photo, Catalina Obseveratory)

A lunar dip-slip fault is illustrated in Figure 8.2; isolated faults of this nature rarely show a direct connection with volcanism. The stresses to which the crust has been subjected in volcanically active regions are usually such that complex fault systems are created locally. When a regional view is taken, however, a remarkable degree of uniformity of structure may be observed. It is on the regional and global scales that the underlying major processes which govern the distribution of volcanicity across the Earth's surface may be discovered.

Even within major volcanic belts, volcanic events are not distributed at random but are arranged in a manner which is strongly controlled by the regional tectonic framework. In many instances, the framework consists primarily of two or more closely parallel dip-slip faults which, together, have created a major trough or graben.

Graben and Rift Valleys

The type example is the Rhine graben, a depression some 36 km in width and 300 km long trending a few degrees east of north, through southern Germany. The graben, which lies in the crest of a major upwarp, or dome, bifurcates at its northern end (Figure 8.3).

Figure 8.3 European and African rifts: areas of rifting or rift-like faulting are shown in black

The upper reaches of the river Rhine occupy the depression, giving it its name. The inner walls of the graben are steep but, outside the graben, the slope away is only from 1° to 3° on average.

The analogy between the Rhine graben and the keystone of an arch which descends as the sides of the arch are separated was suggested more than a century ago. The concept is not amenable to direct confirmation since erosion and deposition have obscured any fault faces that may once have existed. When drill cores of the valley floor became available, it was discovered that the sediments were both folded and faulted. This was erroneously interpreted as indicating that compression, rather than tension, had been acting on the floor: reverse faults, containing and forcing down an upward-tapering block, were suggested. The dilemma was resolved only when a railway tunnel was driven through the Lorettoberg near Freiburg on the Black Forest side of the valley. The fault plane was encountered in a position which demonstrated conclusively that the boundary fault, at least at this position, was a normal fault dipping in towards the valley centre. Subsequently, experiments with clay models undergoing slow stretching in a horizontal plane were used to demonstrate that graben-type structures occur very readily: the ultimate response of the Earth's crust to tension would

tend to be a pair of normal faults, dipping towards each other, rather than a single fissure.

This model is satisfactory except in that there is no explanation of the presence of the raised flanks of the graben. This final difficulty was overcome by H. Cloos during clay-stretching experiments which involved arranging the clay on the curved surface of a rubber bottle which was slowly inflated. The inflation caused both a raising and a stretching of the clay layer with the result that a graben having steep inner walls and gently sloping outer walls was produced. Moreover, at the ends of the protuberance the experimental 'graben' bifurcated in the manner of the Rhine graben. By analogy it is suggested that the Rhine graben is a consequence of the presence of the dome upon which it is situated and that the graben structure is symptomatic of some process which has the effect of doming the surface.

The presence of faults which penetrate the crust would imply that major graben should be the sites of extensive volcanic activity. This is commonly the case, though the volcanism is not invariably centred on the flanking faults since the weight of the sinking, central block will tend to keep most of the fractures closed. Commonly, however, secondary fractures act as conduits for the eruption of gases and lavas.

In the case of the Rhine graben many volcanic remnants may be found. Some occur in the graben itself but many may also be found on the flanks and beyond the ends of the main graben in the Hesse Depression and the French Massif Centrale. The type of volcanism associated with this graben varies from extensive fissure basalts to central volcanoes. Both are very denuded. Even where the lavas are highly basic, they are notable in that they are extremely rich in the alkalis sodium and potassium. For example, the Kaiserstuhl and Hegau volcanoes are rich in nepheline and other feldspathoids; the tholeiites and alkali basalts are found in the Vogelsberg. The parent magma is thought to originate from the upper mantle but to include material from the crust. This is consistent with the assumption that the principal faults penetrate the entire crust.

One difficulty with this hypothesis is that is has proved impossible to trace the faults, associated with the graben, deeper than 7 km (using reflection seismology); whereas it is known that the average depth of the Mohorovicic discontinuity, measured outside the graben, is some 30 km. Indeed, measurements of the heat flow from, and temperature gradients in the crustal block within the graben indicate that fractures would not currently form, or

Figure 8.4 The Lake Victoria/Lake Kyoga/Lake Albert drainage system, with present flow directions shown by arrows. Lakes and rivers not connected with the system are omitted.

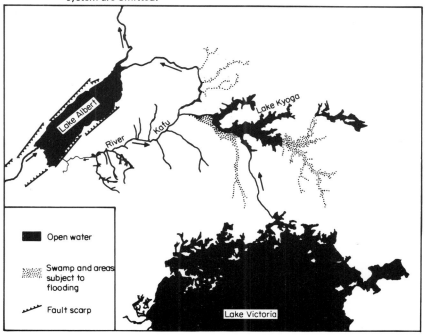

persist, below about 10 km since, at greater depths, the rocks would be too plastic. However, earthquakes centred beneath the eastern escarpment of the southern Rhine graben commonly originate at depths of 15 to 20 km. Under the graben proper, on the other hand, the earthquake foci are rarely deeper than 8 km. Volcanism seems to have been active during the mid-Tertiary and continued in places up to the 11 000 BC. It would seem, therefore, that the present high thermal gradient is a relatively recent development and did not antedate the initiation of the graben.

It has been argued by J. H. Illies that the Rhine graben should not be considered in isolation but as part of a much larger system of related structures, stretching from Scandinavia to the Orange River in South Africa (Figure 8.3). The system can readily be traced across the Mediterranean and into Libya, but is less easy to locate across central Africa (possibly because of lack of data rather than an absence of features). In East Africa, however, the system again becomes pronounced, with a number of large-scale components. The graben, here, are on an even larger scale than in Germany, widths of 40 to 50 km being common.

Once again, the graben occur along the crests of broad, topographic swells. Lakes Kyoga and Victoria lie in the shallow basin between two such swells. (Despite its area of 67 850 km^2, Lake Victoria nowhere exceeds 90 m in depth.) Lake Kyoga (Figure 8.4) occupies what were once the headwaters of the river Kafu, the drainage of which has been reversed: because the land has been tilted away from the graben containing Lake Albert, water now flows along the river channel in the direction opposite to that of its original course.

Fault movement and active volcanism are still occurring in some parts of the East African Rift System. Some of the fault scarps are deeply eroded; others are relatively sharp and fresh. In the eastern part of the rift system (the Eastern Rift) the older lavas have themselves been faulted. The current period of faulting and volcanism appears to have started approximately 2.3×10^7 years ago, though there is evidence that there has been orogenic activity in this region for considerably longer.

Volcanism associated with the graben of the East African rift may be classed as of either the fissure or central type (Chapter 2). The fissure eruptions may be sub-divided into two compositional classes: (a) basaltic, and (b) phonolitic. The basaltic eruptions occur primarily during periods of crustal stability whereas the phonolitic volcanism coincides with periods of faulting. Carbonatites are found in the western part of the rift system (Western Rift). The fissure eruptions are more widespread, and more uniform in composition, than are the central eruptions. These latter have products which are characteristically peralkaline.

The sites of the central eruptions and, to a smaller extent, of the fissure eruptions have migrated, generally, eastward with time from their original position within, or on the flanks of the graben. The relationship between present volcanism and tectonism is unclear, probably reflecting the progressively increasing complexity of the total fault pattern.

The structure of the graben floors is complex, with local faulting superimposed upon long-wavelength undulations along the lengths of the floors. The major lakes which occupy parts of the graben lie in the basins of this undulating system and are separated by long, low arches. Great thicknesses of sediments — more than 1.7 km in the Albert Rift (part of the Western Rift) — cover this 'true' floor. Volcanism has also played its part in the filling of the troughs, and it has been estimated that there are 10^5 km^3 of volcanic materials in the Eastern Rift alone. Many of these volcanics have proved to be ignimbrites.

Intense study of the Rhine graben and East African Rift System have led to the following currently visualised sequence of events:

(i) Major fractures in the crust and upper mantle are formed, or rejuvenated, by processes operating deep within the Earth (see Chapter 9). These fractures provide pathways for volatile-rich magma to penetrate the crust.

(ii) This process increases the heat flow above the fractures and dyke injection causes the crust to expand locally and initiate the doming process alluded to earlier. The arching also tends to open near-surface fractures.

(iii) A pillow of mantle-derived material is introduced along the boundary between the mantle and crust, causing further doming. The graben forms as a consequence of the crustal tension, the fault block subsiding into the plastic pillow. The width of the trough is of the same order as the thickness of the crust.

(iv) Eruption of volatile-rich magma gives rise to the volcanicity.

It can be seen that the graben structures and domal

Figure 8.5 Map showing distribution of all continental rift systems (stippled) (Modified from R. E. Snead)

uplifts that have been discussed are simply the surface expressions of extremely large-scale, and deep-seated processes affecting substantial parts of the Earth. It is customary to refer to such graben structures topping major upwarps by a special term, rift valley, and to distinguish them from the analogous, but much smaller, features than can be seen wherever crustal blocks have dropped in response to tension as, for example, over an ascending salt dome or laccolithic intrusion.The major terrestrial continental features of this type are shown in Figure 8.5.

Oceanic Rifts

When the East African Rift System is followed north and east it can be traced as far as the junction of the Red Sea with the Gulf of Aden. Here the nature of the system changes markedly.

The Red Sea has borders that are remarkably uniform in separation (Figure 8.3); but the distance between them is much greater than the 50 km, or so, typical of rift valleys. The sub-oceanic topography of the Red Sea depression, however, consists of two, wide, coastal benches, at a depth of less than 1 km, separated by a trough which is over 2 km deep, in places, and which has a maximum width of the order of 50 to 60 km. Most of the islands on the coastal shelves consist of volcanic materials. It is therefore tempting to regard the Red Sea as an enormous, double graben.

This view is not supported by the geophysical evidence. An examination of the force of gravity within and around the East African rift valley reveals that, gravity is slightly lower over the rift than elsewhere. This implies that under the rift, the materials are less dense than those under the immediately adjacent areas. This mass deficiency arises from the displacement of dense, mantle material by less dense, crustal material in the down-dropped block.

A contrary situation exists in the case of the Red Sea, where a positive gravity anomaly is found over the central trough and slight, negative anomalies are found over the shore benches. The indication is, therefore, that the central trough represents an area underlain by relatively dense material. The central trough could represent an area where the crust parted and mantle-derived material approached the surface.

If this theory were correct, Africa and Arabia would have drifted apart for a distance of the order of 50 km. However, when the coastal benches were drilled (during searches for oil) a layer of up to 5 km of Miocene evaporite was found where continental crust had been expected. Seismic studies support the conclusion that no continental crust underlies the Red Sea but that, except in places near to the central trough, low-density evaporite layers (giving a negative gravity anomaly) tend to mask the presence of high density ocean floor material (which itself would produce a strong positive anomaly). Thus, the crustal separation represented by the Red Sea stretches from coast to coast and it should be possible, by a suitable relative shift, to fit the coasts back together again. Figure 8.6 demonstrates that this can be done convincingly. The central trough is revealed, it seems, to be the result of the final phase of opening.

If this rifting axis is followed southward it can be traced through the Gulf of Aden and, ultimately, out into the Indian Ocean where it becomes part of a world-wide system of oceanic ridges (Figure 2.6). The investigation and interpretation of this ridge system

Figure 8.6 Map showing fit of shores of Red Sea. Eastern edge also shown dotted, adjacent to Western edge, for comparison of shapes.

Figure 8.7 Schematic diagram of possible mechanisms of caldera formation (Modified from H. Williams)

has provided one of the major successes of modern geology — the establishment of seafloor spreading as a real and continuing process. This subject will be dealt with in Chapter 9; suffice it to say that many of the individual segments of the oceanic ridge system are surmounted by what appear, on first examination, to be well-developed rift valleys. The dimensions of these troughs are comparable to those of the East African rift valley. The dimensions of the broad swells that the respective rifts surmount are also similar. As is the case for the Red Sea the oceanic rifts are known to be spreading centres where new tholeiitic ocean floor is being created. Tholeiites have not been found in the East African rift system.

The dimensions of these troughs are comparable to those of the East African rift valley. The dimensions of the broad swells that the respective rifts surmount are also similar.

Calderas

Another example of the effects of faulting lies in the phenonenon of caldera formation. A caldera has been defined as a large basin-shaped volcanic depression, more or less circular in form, the diameter of which is many times greater than that of the included volcanic vent or vents, no matter what the steepness of the walls or form of the floor. Explosion calderas may be produced when the upper portions of a volcano are

removed and broadcast by a violent explosion; but such features are uncommon and do not generally exceed a kilometre or two in size. The usual mechanism of formation of a caldera is the foundering of the surface material into some space which became available, at depth, following the lateral movement, or extrusion, of materials (see Figure 8.7). Six types of caldera, in two groups, may be distinguished (Table 8.1).

The mechanism by which the necessary space is made available for the collapsing material will vary from caldera to caldera. For instance, the main caldera of Kilauea, on the island of Hawaii, has a floor the level of which is governed by the level of lava within the body of the volcano. Changes in the level of the floor of 170 m or more have occurred since scientific observation commenced in 1823, the floor being built up by lava erupted into the caldera and lowered, following subterranean lava withdrawal, by collapse either *en masse* or piecemeal. Bodily uplift of the solid floor of the caldera has not been unknown.

In the case of the Hawaiian calderas, which cap some of the shield volcanoes, sudden changes in level of the contained lava are almost invariably attributable to flank eruptions, many beneath the Pacific Ocean. Much more violent space-creating can occur when the underlying magma contains gas at very high pressure. Possibly the most famous example of this process was the eruption of Krakatoa in 1883. During

Table 8.1 Classification of calderas

(based on G. A. Macdonald, H. Williams and A. R. McBirney)

Group I. Calderas associated with explosive eruptions of acidic material.

A. Krakatoa type. Collapse follows the eruption of large volumes of pumice in flows and falls, partly through the summit vent of an existing major volcano.

B. Katmai type. Collapse follows discharge of the contents of the central conduit or magma reservoir of a volcano through other conduits not in the volcano.

C. Valles type. Collapse occurs after very extensive pyroclastic flow eruptions from arcuate fissures unrelated to previous volcanoes.

Group II. Calderas associated with effusive basaltic eruptions.

A. Masaya type. Collapse of several separate blocks occurs within a large region which contains all the vents.

B. Hawaiian type. The summit block of a large basaltic shield volcano collapses along a near-vertical ring fracture after intrusion of magma and its later drainage into peripheral rift zones.

C. Galapagos type. Collapse during late stages of growth of a large basaltic shield after injection of sills and eruption of lava from circumferential fractures near the summit.

the period May-August of that year, and notably on August 27th, two thirds of the island of Krakatoa, of area about 20 km², disappeared to be replaced by a deep, submarine hollow. Examination of the deposits of the eruption revealed that less than 5 per cent could have derived from the missing rock. The remaining deposits were glassy ash and pumice, derived from the magma. About 18 km³ of magma was flung out during the eruption and the resulting void was sufficient to engulf most of the island and a large amount of seabed. The area is now a nested caldera, the southern basin being irregular (8 km NE-SW; 5 km N-S; and 12 km E-W) and representing the true caldera of 1883. A prehistoric caldera is probably represented by an adjacent, irregular basin with a diameter of approximately 4.5 km. The new caldera has a series of islands on its rim, but the older basin is completely submerged. Volcanic activity continues in the area; a volcanic island near the ridge dividing the two basins continues to erupt periodically.

Krakatoa is remarkable only for the fact that it occurred at a time when observations could be made. Much larger eruptions of a similar nature have occurred. Crater Lake, Oregon, occupies a caldera almost 10 km in diameter. Various evidence indicates that, about 8000 years ago, a composite cone some 4 km high occupied the same site. It disappeared during an eruption which engulfed more than 70 km³ of the cone and emitted 50 km³ of ignimbrites and pumice. Mount Tambora, on the island of Sumatra, Indonesia, erupted in 1815, discharged at least 100 km³ of andesitic tephra and engulfed at least 30 km³ of the cone to produce a caldera 6 km in diameter.

Still larger examples of similar processes can be found. The formation of the Toba depression in northern Sumatra, for example, appears to have been accompanied by the eruption of more than 1000 km³ of ignimbrites. In this case, however, it was not a single cone that was engulfed but a major section of the Barisan Mountains in an area that had been updomed by a batholith. Again, updoming preceded the formation of the Askja caldera in the plateau basalts of Iceland.

Calderas preceded by updoming but unrelated to specific cones have been described as volcano-tectonic depressions. The distinction is useful though rather artificial since, normally, volcanic eruptions are preceded by some degree of upheaval and followed by some degree of subsidence. The term should therefore be restricted to those collapse features which differ markedly from the circular shape specified in the definition of a caldera. Thus, the Toba depression mentioned above is a volcano-tectonic depression rather than a caldera since its approximate dimensions are 96 km by 30 km.

Finally, mention of two extreme types of caldera should be made. Volcanic activity does not necessarily end with the period of caldera collapse. This has already been illustrated in reference to the Kilauea caldera. However, it may well be that a caldera floor is unable to ascend and descend with the ease observed at Kilauea. The result may be the

updoming of a caldera floor to yield a central rise of up to 1 km. The surface of the dome may be stretched and, hence, graben may form in the normal way. A caldera in which this process has occurred is known as a resurgent caldera.

At the opposite end of the scale are the so called erosional calderas. In these features a large, bowl-shaped depression — superficially resembling a true caldera — is caused by erosional forces of one type or another, rather than by collapse. Other, classical calderas may exist on the site, but the depression in question does not result from the normal processes of caldera formation. The term caldera might, therefore, be applied inappropriately in some cases, and should be treated with caution.

Graben and Calderas of the Moon and Mars

Turning to the Moon, it is easy to locate examples of well developed graben structures. The examples shown in Figure 8.8 are known as linear rilles. The identification seems to be unambiguous, all the expected morphological characteristics (parallelism of walls, relation to other structure and to topography, and so on) being present. Lunar rilles are commonly, but not invariably, associated with craters (Figure 8.9) of probable collapse or volcanic origin. When one examines the distribution of graben (including rilles) across the lunar surface, however, a very marked non-randomness in position can be seen (Figure 8.10). Almost all lunar features identifiable as graben cluster very closely around the edges of the maria and must, therefore, be linked directly or indirectly with these features. It is known that the maria are composed of dense, basaltic rocks and, hence, will tend to sink slowly into the less dense lunar crust under the force of gravity. Under certain conditions this will cause tension and bending in the outer parts

Figure 8.8 Linear rilles (lunar graben) striking through the 60 km diameter crater Goclenius (Apollo 8, NASA)

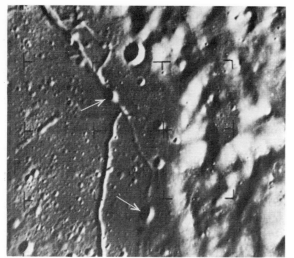

Figure 8.9 Elongated craters of collapse (arrowed) in peripheral rilles (graben) in the lunar crater Alphonsus. Note dark material (Chapter 4) surrounding arrowed craters (Ranger 9, NASA)

of the maria and the surrounding highlands — in other words, conditions that might be ideal for graben formation. In the absence of any obvious updoming, therefore, the lunar rilles cannot be taken as direct evidence of rifting of the type found in East Africa.

One lunar feature which bears the appearance of a rift valley on the scale of terrestrial examples is shown in Figure 8.11. Known as the Alpine Valley, this generally flat-floored trough is bounded by high walls. Its floor appears to be a down-dropped block which has been covered by lavas. Whether it can be classed as a rift valley is debatable since there is no evidence that it is situated on the crest of an anticline.

Various features have been identified as possible examples of lunar calderas and a number of these are illustrated in Figure 8.12. It remains debatable as to whether or not many of the large craters of the Moon are calderas or are the result of the impacts of meteoroids. The calderas that cap many of the lunar domes — probably shield volcanoes (Figures 6.6 and

Equator

0°

Figure 8.10 Schematic map of distribution of graben on the near side of the Moon. The shaded areas define the maria.

Figure 8.11 The lunar Alpine Valley looking south west (Lunar Orbiter 5, NASA)

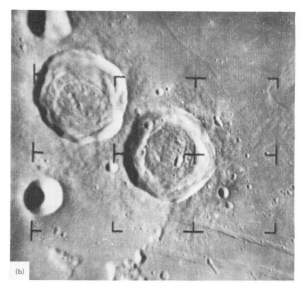

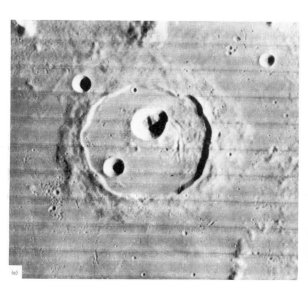

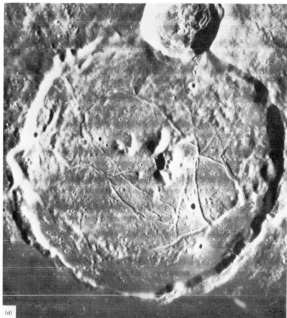

Figure 8.12 Possible examples of lunar calderas: (a) Marius R (longer axis 6.5 km) and a 2 km diameter 'dimple' crater to the north (Lunar Orbiter 4, NASA); (b) Sabine and Ritter (diameters 30 km) (Ranger 9, NASA); (c) Cassini (55 km) (Lunar Orbiter 4, NASA); (d) Gassendi (110 km) (Lunar Orbiter 4, NASA)

6.7) – range up to 15 km in diameter.

On Mars, linear graben structures, similar to linear lunar rilles, may be identified (Figure 8.13). A large proportion of the martian graben appear to be sub-radial to a major upwarp in the Tharsis region (0° N, 110° W). Others are strongly influenced by local topography; and a minor, radial system is centred at about 40° N, 250° W. These graben do not appear to have been the sites of major volcanism. The Tharsis system of subradial graben is not situated on the crest of the upwarp where maximum crustal stretching should have taken place. Instead, this crest is occupied by two types of feature: (a) three massive shields and (b) an interconnecting canyon-like system (Figure 8.14). These latter features, like the sub-radial graben, probably represent the response of the martian crust to tension. They also indicate that the

Figure 8.13 Probable martian graben structures (Mariner 9, NASA)

Figure 8.14 Interconnecting canyons (graben structures) near the centre of the Tharsis dome (Mariner 9, NASA)

Figure 8.15 Part of biggest known valley on Mars (and in Solar System). It has been termed, unofficially, the Coprates Canyon. (Mariner 9, NASA)

Figure 8.16 Collapse features which run parallel to the valley shown in Figure 8.15 (Mariner 9, NASA)

Tharsis dome was probably formed by upwarping of a pre-existing crust rather than by the construction of an eminence by successive lava flows.

On the eastern slopes of the Tharsis dome, and interconnecting with the canyon system, is an enormous valley (Figure 8.15). Its length is 2500 km or more, its width 100 to 150 km, on average — but it reaches 250 km — and it is possibly up to 6 km deep in places. These dimensions exceed those of the East African Rift. It appears likely that the martian structure is a rift valley, in the strict sense of the word, since there are indications that the Tharsis dome might extend along the length of the rift. The walls of the rift (Figure 8.15) are steep and clearly defined; and they are seemingly unaffected by constructive volcanism. Apparently collapse craters have been formed along fractures paralleling the rift (Figure 8.16). No major volcanic landforms exist on its immediate flanks.

Nevertheless, the Tharsis upwarp has been the site of volcanism on a colossal scale. This volcanism has

Figure 8.17 Calderas capping martian shields: (a) a circular caldera 13 km in diameter; (b) nested calderas, the biggest of which measures 11 km x 9 km; (c) nested calderas up to 54 km x 48 km. The associated volcanoes are labelled a and b (Elysium area), and c in Figure 2.8. (Mariner 9, NASA).

resulted in at least three, large, well formed shield volcanoes with single or nested calderas in their summits (Figure 6.7). To the north-west, but off the uplifted area, is the now well-known feature Olympus Mons (Figure 6.4) which is also a caldera-crested shield. Similar, but smaller, examples of calderas capping volcanoes (Figure 8.17) may be found elsewhere on Mars.

The relation between volcanism and faulting, rifting, or internal activity has now been demonstrated for the Earth, Moon and Mars. To trace volcanic rocks still deeper, it will be necessary, finally, to discuss what is known about the interiors of these planets.

Suggestions for Further Reading

Holmes, A., 1965 *Principles of Physical Geology,* Nelson, Edinburgh.

Illies, J. M. and Mueller, St. (Eds.) 1970 *Graben Problems,* E. Schweizerbart'sche Verlagsbuchhandlung, Stuttgart.

Runcorn, S. K. (Ed.) 1967 *Mantles of the Earth and Terrestrial Planets,* John Wiley and Sons, London.

9 Planetary Interiors and Volcanism

Introduction

In the preceding chapters, attention was paid to the appearance and distribution of volcanic forms on the Earth, Moon and Mars and also to the solid, liquid and gaseous products of volcanoes. It was shown how certain details of an eruption were related to physical conditions, such as the presence or absence of an atmosphere or a supply of water, near to the surface of a planet. But, ultimately, volcanoes owe their existence and their form to the internal state of the planet on which they occur; for, the type of material which issues from a volcanic vent depends upon conditions far below the surface. In addition, an eruption incurs the release of a great deal of energy, and this energy is supplied largely by the planet itself.

Again, the sites of terrestrial volcanic eruptions are related to the internal structure of the Earth. Clearly, then, information about the composition, temperature and structure of the interior of a planet can be gained from a study of its volcanoes.

Composition of Magma

Volcanoes are far from being great boreholes which provide samples of a planet from great depths. Firstly, the precise depth at which magma originates in an eruption is not known in the vast majority of cases. Secondly, it cannot be assumed that the magma which is erupted in a particular instance is identical to the material from which it derived.

To understand why magma differs in composition from its source rock it is necessary to consider what happens when a rock melts. A rock is usually composed of several minerals, each with a different melting point. The melting temperature of a mineral is not fixed but depends on the pressure to which it is subjected and on the concentration of water and other volatiles in it. As the temperature of a rock is raised there comes a point at which some of the minerals will melt but others will not. This phenomenon is known as partial melting. It can also be caused by changes in pressure or in the concentration of volatiles. Magma produced by partial melting may be only a small fraction of the total volume of rock involved and the composition of the magma may be very different from the bulk composition of the source rock. The primary magma may be altered even more before it reaches the surface. It may incorporate some of the rock through which it passes while ascending and it may undergo further changes in a magma chamber beneath a volcano.

Magma may remain in a chamber for a long time before an eruption occurs and, during this time, it cools by contact with the sides of the chamber. Cool magma is denser than warm magma and so it sinks to the bottom of the chamber. Convection currents are established and thus all the magma is gradually cooled. Cooling may induce crystallisation of part of the magma. If the minerals which crystallise are denser than the melt, which is generally the case, they tend to settle and the composition of the remaining magma is thereby altered. This process, which tends to separate magma into its different mineral components, is known as differentiation. The magma of an eruption may tend to change in composition as the eruption proceeds. This may be the result of the emptying, from the top, of a differentiated magma chamber.

In spite of the possible differences in composition between a magma at the surface and its parent rock, there is a link between them and, with certain information, it is possible to deduce the depth and composition of the source rock — especially if information on the planet's internal structure is also taken into account.

Internal Structure of the Earth

Most information about the Earth's interior has been gained from seismology — the study of earthquakes.

Earthquakes send out vibrations in all directions through the surrounding rocks. The velocity with which these vibrations travel depends on the properties of the material through which they pass. Reflection and refraction of seismic waves may occur at boundaries between materials of different compositions. There are two principal types of seismic waves — P waves and S waves. P waves, so called because they are the primary arrivals at a seismometer and hence travel fastest, are longitudinal waves and their velocity depends on a rock's resistance to compression. S waves, or secondary waves, are transverse waves. They travel more slowly than P waves and the velocity of S waves depends on a rock's resistance to shear.

Seismic wave velocity increases with pressure and, therefore, with depth in the Earth. The velocity of a wave travelling into the Earth generally increases with depth, and this effect causes the wave to be refracted. The wave bends away from the centre of the Earth and returns to the surface where it may be detected by a seismometer. The time between the occurrence of an earthquake and the arrival of a wave at some distant point depends on how far and how fast the wave has travelled. Seismologists have built up a picture of the Earth's interior (Figure 9.1) from earthquake data recorded over many years.

Figure 9.1 Internal structure of the Earth

The velocity of seismic waves increases sharply at a relatively small depth in the Earth. This depth is termed the Mohorovicic discontinuity, or Moho. A discontinuity is the boundary between two regions of sharply differing seismic velocity. Normally, seismic velocity increases gradually with depth but at a discontinuity there is a sudden change. A discontinuity is interpreted as a change in composition of the rocks. This may be a chemical change or a phase change, in which elements are re-ordered to form a medium of different density. The Moho defines the base of the Earth's crust. It is only 5 km below the ocean floor, on average, but its average depth beneath continents is 35 km and it is as deep as 60 km in some localities. Continents alone represent the upper part of the crust, which is composed of relatively light rocks of granitic composition. The lower crust, or intermediate layer, includes the oceanic crust as well as the lower part of the continental crust and is of basaltic composition. It is composed of denser rocks which contain a greater proportion of heavy minerals incorporating elements such as iron and magnesium.

The mantle, encountered beneath the Moho, is composed of even denser rocks such as olivine but, strictly speaking, of uncertain composition; and the core of the Earth is found beneath the mantle. The core-mantle discontinuity occurs at a depth of 2900 km. In the core, the velocity of P waves is appreciably less than in the mantle, whilst S waves are completely damped out, showing that the core is not resistant to shear — that is, it behaves like a liquid. There is thought to be a region at the centre of the core, the inner core, which is solid. The liquid core is probably composed mainly of iron with some nickel and other heavy metals included. It is a good thermal and electrical conductor and fluid motion in the core is believed to be the source of the Earth's magnetic field.

Seismic research indicates that most volcanoes originate in the upper part of the mantle. The structure is very complicated in this region. The seismic velocity, which increases steadily down to a depth of about 50 km, decreases thereafter (Figure 9.2). It increases again below about 100 km and, by about 250 km, returns to its original trend. The detailed variation of seismic velocity in the 50 to 250 km region is even more complex. There are several layers of alternating higher and lower velocities and, also, horizontal variations in velocity; but, taken as a whole, the region from 50 to 250 km deep is known as the low velocity layer. This zone is closely associated with the origin of volcanoes. The low velocity zone harbours the heat sources that feed volcanoes so it is appropriate, at this point, to examine the thermal state of the Earth's interior.

Figure 9.2 P and S wave velocity-profiles through the outer layers of the Earth

Thermal State of the Earth

Volcanism on a planet implies that, at some depth, the temperature is high enough to melt rock. The temperature distribution inside the Earth is not known accurately but there are close limits on the possible distributions. In attempts to estimate the internal temperature of the Earth, many measurements have been made of the rate of flow of heat up through the Earth's surface. These measurements are very difficult to make. A deep borehole must be drilled and the temperature measured at two depths. The borehole has to be sufficiently deep (several hundred metres on land) to allow investigators to avoid temperature fluctuations due to long period climatic effects, and it is difficult to allow for the temperature disturbance introduced by the drilling. The thermal conductivity of the rocks has to be known, since heat flux is the product of temperature gradient and conductivity. Thermal conductivity is again difficult to measure accurately and may vary widely over short distances. In one sense, it is easier to measure the surface heat flux through oceanic sediments than on land because, in the case of ocean-floor boreholes, the ambient physical conditions are relatively uniform and drilling need not penetrate as far as on land.

Measurements show that the average surface heat flux is the same from continents and ocean floors. It is about 0.05 W/m^2, but there are regions where it may be over six times this value. These regions of high heat flux include oceanic ridges and the continental sides of island arcs (Figure 2.5). Low values of the heat flux are found in stable continental shield areas. In addition to small-scale anomalies, there are thought to be less pronounced, large-scale variations

in the heat flowing from the interior of the Earth as a result of horizontal temperature differences in the upper mantle. The total heat loss over the whole surface of the Earth is far greater than the energy loss due to earthquakes and volcanoes.

Measurements show that the average temperature gradient in the surface layers of the Earth is about 25 K per kilometre. If this were to persist to greater depths the Earth would be molten below about 40 km. Seismology shows, on the contrary, that the mantle is solid and so the temperature cannot go on increasing with depth at the rate observed at shallow depths in the crust. Methods employing the principles of electromagnetic induction have been used to measure the electrical conductivity of the mantle to a depth of a few hundred kilometres. Electrical conductivity is very sensitive to temperature and, subject to assumptions about the composition and other electrical properties of the rocks, a temperature profile of the mantle can be deduced. A likely temperature distribution in the outer part of the Earth is shown in Figure 9.3.

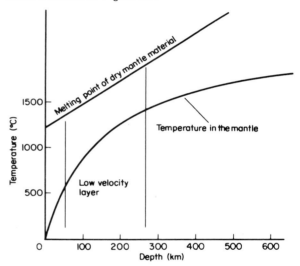

Figure 9.3 Temperature and melting point variation in the Earth's mantle

The melting point of the mantle is shown in the same figure. The melting point increases with depth because of the corresponding increase in pressure. It can be seen that there is a region, not far from the surface, where the temperature of the mantle is much closer to the melting point than elsewhere. This is believed to be the explanation of the low velocity layer. Although the low velocity layer is not molten, S-wave transmission within it is very poor in some regions — particularly along oceanic ridges and the

105

continental sides of island arcs. This is probably because of partial melting in these regions — an hypothesis made the more plausible because the distribution of earthquake epicentres and volcanoes across the Earth's surface is closely correlated with areas of high heat flow and poor S-wave transmission. The cause of partial melting in these regions will be clearer following a discussion of the modern theory of the structure of the Earth's crust.

Plate Tectonics

The lithosphere is the name given to all the material above the low velocity layer and so includes all of the crust and some of the mantle. The lithosphere behaves as a set of rigid plates moving around the surface of the Earth, and the study of their movements is termed plate tectonics. The lithospheric plates carry the continents along with them as they move.

It had long been suspected that the continents had moved, relative to one another, because of the similarity of the shapes of the coastlines on each side of the Atlantic Ocean. It was not until the methods of palaeomagnetism were developed in the 1950s that observational evidence became available to support the concept of continental drift. Palaeomagnetism involves measuring the magnetism induced in rocks by the Earth's magnetic field at the time the rocks were formed. It is possible to deduce both the direction of geographical north and the latitude of the site at the time when the Earth's field was frozen into the rocks as they were formed. When data are collected for rocks of different age but from a single continent it is possible to plot the motion of the geographical pole relative to that continent.

All the continents have moved relative to the pole; but the apparent paths of the pole are different for different continents, showing that the continents have moved relative to each other. It was thought that continents were like icebergs floating on the mantle but this idea was modified when detailed magnetic surveys were made over the ocean.

Systematic anomalies were found, appearing on maps as stripes of varied widths. The direction and sense of the magnetisation of some stripes were essentially that of the present magnetic field of the Earth. In other stripes, however, the induced magnetism was in the direction opposite to that normally measured. Generally, the stripes were parallel to oceanic ridges; and the patterns of stripes on opposite sides of the ridges were mirror images. It was found that the succession of positive and negative anomalies

which the stripes represented was essentially the same as the vertical succession of anomalies both in cores drilled from the ocean floor and in samples taken from thick layers of multiple lava flows on dry land. The cores and lava samples showed that the polarity of the Earth's magnetic field had reversed at unequal intervals and that these reversals had been recorded horizontally along the ocean floors.

The interpretation is that ocean floors spread with time. Hot material from inside the Earth comes to the surface at an oceanic ridge where it acquires magnetisation as it cools in the Earth's field. It is then displaced laterally as fresh material rises up to the surface. The result is that, in a direction towards an oceanic ridge, the magnetisation of the ocean floor reflects the variation of the Earth's magnetic field with time.

As the sea floors spread, the continents move apart. The material which rises at a mid-oceanic ridge behaves as one part of a rigid plate which moves but does not wrinkle or fold. Now if materials rise, at oceanic ridges, to add to plates, there must be other regions where plates are destroyed or forced downwards. The ocean trenches, on the seaward side of island arcs, are recognised as such regions. As an oceanic plate moves towards and meets a continental plate, the ocean floor is forced underneath the continental plate. It is known, from seismic studies, that the plate moves downwards into the mantle at an angle of 45°.

The active regions of the Earth's surface are mainly the edges of the various plates. Plate margins may be of three basic types — constructive, conservative and destructive. Constructive margins, where plates are created, are to be identified with oceanic ridges. Destructive margins are subduction zones where plates are forced downwards. When one of the plates is oceanic, the subduction zone is characterised by oceanic trenches and island arcs whereas, on the continental side, a chain of volcanically active mountains is formed. When two continental plates collide the subduction zone is overlain by fold mountains and very little volcanic activity is present. Finally, conservative margins occur where adjacent plates move parallel to one another in the horizontal direction and a transform fault develops along their common margin.

Terrestrial Volcanoes

Most terrestrial volcanoes are situated on constructive or destructive oceanic plate margins, although a significant number occur well away from plate

margins. What, then, is the reason for the close connection between terrestrial volcanoes and plate tectonics?

The low velocity layer, where partial melting may most easily occur, is world-wide but, from the evidence of volcanism, partial melting occurs preferentially at plate margins. It is easy to see how partial melting may occur at constructive margins. Here, hot mantle material is rising to the surface. This accounts for the increase in heat flux at the surface which is commonly observed in these regions. The hotter material finds itself in a region of lower pressure which causes the melting points of all its minerals to be lowered. Partial melting may thus occur for one or more minerals above the depth at which the lowered melting point is equal to the actual temperature of the rock. All the volcanoes along oceanic ridges produce basaltic lava, and it is believed that basalt is the immediate product of partial melting of mantle material.

At destructive plate margins, where mantle material is descending, there is also an increase in surface heat flux and partial melting. It is thought that descending currents in the mantle will be narrower and more rapid than rising currents. Much frictional heating might occur and this could account for the extra heat flux from the surface. It is possible that frictional heating might also cause partial melting; but a more important factor might be that the descending plate takes with it sediments which contain volatiles. The mixing of volatiles with the material at depth may then lead to partial melting. Volcanoes above subduction zones produce andesitic lava. This contains more silica than basalt, possibly as a result of the inclusion of sedimentary rocks in the melt which provides the lava. As the distance of the volcanoes from the destructive margin increases the lavas that are erupted contain more potassium. This is presumably because the depth of partial melting increases as the downgoing plate penetrates deeper and the different conditions under which melting occurs engender differences in composition.

As mentioned before, some volcanoes do not lie over plate margins. There are many isolated islands, or chains of islands, which are volcanic but are not associated with oceanic ridges or subduction zones. It is thought that they overlie isolated mantle plumes.

The effusion of flood basalts also occurs away from plate margins. This is seen in the North West United States and possibly in the Deccan in India. Flood basalts and a whole range of more silicic lavas occur in the East African rift valley. This is not a typical plate margin, although the volcanism might be caused by the upwelling of mantle material in this region.

Source of Volcanic Energy

Every volcanic eruption represents a liberation of energy from the interior of the Earth. At plate margins a small fraction of the energy of motion of the plates is converted into thermal energy, some of which reaches the surface through volcanoes. The plates themselves are driven by thermal convection within the mantle. Convection is a slow flowing of the mantle caused by its lower layers being hotter than the upper ones. Hence the prime source of energy for mantle convection, plate motion, earthquakes and volcanism is the internal heat of the Earth.

It is hard to imagine fluid motion in the mantle when seismology shows that the whole mantle is solid. However, under the stresses which act on the mantle material, even solid rock will flow appreciably over long periods of time. A typical rate of flow of mantle material is about 1 cm per year. The mantle is unlikely to behave as a Newtonian liquid (Chapter 3) and so it will not have a unique viscosity. The effective viscosity will depend on the shear stress to which the rock is subjected. The effective viscosity is also very strongly dependent on temperature. These facts combine to explain why the relatively cool, crustal plates remain rigid over long periods while, not far below, the slightly warmer mantle flows like a liquid.

If a block of mantle material is raised, the pressure on it decreases and it expands and cools slightly as a result of this expansion. If it then remains warmer than its surroundings by a sufficient amount, it will be less dense and so will continue to rise: conditions will, in fact, be favourable for convection to occur. If, on the other hand, the raised block is not warmer than its surroundings by a sufficient amount, it will not continue to rise and, as a result, any convection will be damped out. The net result is that, if the temperature of the mantle increases with depth somewhat faster than a certain critical rate called the adiabatic gradient, convection will occur.

Accepting the theory of plate tectonics, it seems a necessary condition that the mantle is undergoing thermal convection. The exact form of the flow and the fraction of the mantle involved are unknown; nor is it known whether the flow is steady or transient. It seems most likely that upward currents lie beneath oceanic ridges and downward currents are to be found beneath subduction zones. The supposed existence of

mantle plumes implies that the flow is not steady; nor can it have a regular spatial pattern.

Thermal convection transfers heat upwards through the mantle very much faster than thermal conduction (or radiation). The Earth therefore cools more rapidly when convection is present. If convection were very rapid the convecting part of the mantle would become thoroughly mixed and would tend to achieve a uniform temperature. Convection would then cease. With no convection a temperature gradient would be re-established in the mantle as a result of the generation of heat within it, by radioactivity, and thermal conduction of heat from the core. Convection would eventually recommence. It is therefore likely that, on average, convection takes place just fast enough to remove heat from the mantle at the same rate at which it is generated.

The present temperature of the Earth is a result of three factors: its initial temperature when it was created (Chapter 1), the amount of heat that has been generated within it since its creation and the rate at which it has cooled. The early Earth would have been a fairly uniform mixture of all its present components but, following heating — mainly by radioactive decay and gravitational settling — the heavier elements and compounds would have tended to sink under gravity. The Earth would have become layered with the least dense material on the outside and the densest at the centre. This rearrangement would have caused much heating due to frictional dissipation.

Some elements in the Earth have radioactive isotopes which decay spontaneously, with the emission of energy, to become stable isotopes. The amount of radioactivity in the Earth is therefore continuously decreasing. The rate of decay varies widely among isotopes and is measured in terms of the half life, which is the time taken for a given amount of a radioactive isotope to decay to half that amount. The quantity of heat produced depends on the concentration of the isotope and on how quickly it releases energy. Initially there were many radioactive isotopes, but those with short half lives as compared with the age of the Earth, have all disappeared. The initial high rate of radioactive heat generation would help to warm the Earth early in its life. There are now only three isotopes (Table 9.1) which account for almost all the radioactive heat generation in the Earth.

The early, warm Earth would have cooled rapidly at the surface by the radiation of heat into space. At first there would have been a sharp temperature gradient near the surface with a large surface flux of heat and a rapid cooling rate. As time passed, the

Table 9.1 Isotopes and heat generation (after W.M. Kaula)

Isotope	Half Life (10^9 year)	Heat Generation (μW/kg)	Granite		Basalt		Dunite from mantle	
			Concentration (g/10^6 g)	Heat Generated (10^{-10} W/kg)	Concentration (g/10^6 g)	Heat Generated (10^{-10} W/kg)	Concentration (g/10^6 g)	Heat Generated (10^{-10} W/kg)
U^{238}	4.5	94	4.75	4.5	0.6	0.6	0.001	0.001
Th232	13.9	27	18.5	5.0	2.7	0.7	0.004	0.001
K^{40}	1.3	28	4.5	1.3	1.0	0.3	0.001	0.0003
TOTAL				10.8		1.6		0.002

solid, cool skin would thicken, reducing the temperature gradient and the rate of cooling, so that the rate of thickening of the skin would decrease with time. Even over the whole life of the Earth, the cold, surface skin could hardly have become more than 100 km thick. Convection would occur in the molten region and this would keep the temperature gradient close to the adiabatic gradient. The temperature of the interior would fall rapidly at first and then become steady when the loss of heat through the surface was equal to the rate of heat generation in the interior. It is believed that the temperature distribution in the Earth would have become similar to the present distribution very early in the Earth's life. Before this happened differentiation occurred and the mantle and inner core became solid.

It so happens that the radioactive isotopes of uranium and thorium have such large atoms that they do not readily fit into the usual minerals which form when solidification begins. As a result, when solidification was nearly complete the residual liquid was rich in radioactive materials. The less dense liquid became separated from the solids and, in this way, radioactive material was fractionated out of the mantle. Solidification of the mantle and core would begin at the bottom because the adiabatic temperature gradient, maintained by convection, was less steep than the melting point gradient. This is shown in Figure 9.4. As the overall temperature was lowered

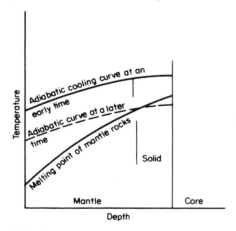

Figure 9.4 Schematic diagram showing the evolution of the adiabatic cooling curve within the Earth during progressive cooling of the mantle.

the first part of the mantle to reach a temperature below its melting point would be the bottom; the same would be true of the core. The radioactive materials would therefore be concentrated in the upper parts of the mantle and would collect in the

last region to solidify — presumably the low velocity layer. Partial melting in the low velocity layer, and volcanism, would again fractionate the radioactive isotopes. The present situation is that igneous rocks close to the Earth's surface have a much higher concentration of radioactive, heat-generating material than the rocks of the interior of the Earth. This is shown in Table 9.1. The result is that most of the heat generated within the Earth at the moment is produced very close to the surface.

It has been shown that terrestrial volcanism is closely linked with internal conditions and processes in the Earth. Many aspects of volcanism are not yet fully understood and it is appropriate to seek wider experience of the volcanic process by examining the Moon and Mars. This may, in turn, lead to information about the interiors of these planets.

Volcanism on the Moon

The surface of Mare Imbrium (Chapter 3) is composed of lavas and it seems probable that all the maria consist of lava. The mare lavas have been sampled during the Apollo programme and have been found to resemble terrestrial oceanic basalts with rather less silica and more of the mineral ilmenite. When molten lunar lavas are held at their melting points their viscosities appear to be lower than those of terrestrial basaltic melts and this may explain the very high eruption rates and the formation of vast areas of flood basalts on the Moon. In their solid form, lunar lavas have densities which are close to the overall density of the Moon — namely, 3.34×10^3 kg/m^3. It is not possible for the whole Moon to be composed of material similar to the lavas, however, because at depths below 200 km the basalts would undergo a pressure-induced phase change to a rock of density 3.7×10^3 kg/m^3. The basalts are thought to be the product of partial melting of the interior rocks and may come from a depth of a few hundred kilometres.

The returned lavas, which have been dated directly, are probably all more than 3×10^9 years old; but it is thought that some lunar volcanic rocks are much younger than that. The most recent flows (Figure 3.7) in Mare Imbrium are, from crater measurements, inferred to be 2.5×10^9 years old, while other regions, such as the Marius Hills and Rumker, may be younger. An indirect dating method has been applied by R. G. Strom and G. Fielder to show that lava flows as young as 10^8 years may exist in the lunar highlands.

For a long time lunar observers have recorded intermittent, localised activity on the Moon. These

events have taken the form of glows, obscurations or discolourations of small patches of the Moon. Some of the events may be volcanic whilst others may be related to purely gaseous discharges. Taken as a whole, such events tend to occur at periods when the rate of change of the tidal stresses in the Moon are greatest. This links them with lunar seismic activity which shows the same association with tidal stress. The Moon is extremely quiet, seismically, compared with the Earth; and most of the larger earthquakes occur in a few, small localities buried deeply in the Moon. The depths vary from 600 to 900 km and the source regions seem to be arranged along two belts. It is also observed that seismic waves from events on the far side of the Moon are attenuated at depths greater than 1000 km, so there may be partial melting at this depth.

Thermal State of the Moon
The heat flux through the lunar surface has been measured at only two places and each is close to the edge of a region of dark mare material. The values found — about 0.03 W/m² — are mutually similar, and are somewhat more than half of the mean value of the heat flux through the Earth's surface. It is not known whether 0.03 W/m² is representative of the whole lunar surface; though there is some indirect evidence, from radio measurements of sub-surface temperatures, that a high heat flux does pass out from the interior of the Moon. The radioactive content of lunar surface igneous rocks is comparable with that of terrestrial surface igneous rocks and so, as in the case of the Earth, most of the heat lost through the surface is generated at shallow depths. It follows that the lunar radioactive isotopes have been fractionated and transported to the surface, as in the Earth. Together with the evidence for differentiation of minerals in the Moon, this shows that a large part of the Moon has been molten in the past.

It is not known whether the Moon has formed a metallic core. It can hardly contain a core larger than 100 km in radius, for it is known that the Moon is of almost uniform density throughout. The weight of overlying rocks in an initially uniformly dense Moon would not be sufficient to generate a significant core by compression, since the pressure at the centre of the Moon is equal to that at a depth of only 130 km on the Earth.

As in the case of the Earth the primitive, warm Moon would cool quickly, by radiation to space, and develop a cold skin. The Moon has more surface area per unit volume than the Earth and its cool, outer

parts would therefore grow more quickly. Even so, the cool outer part of the Moon is probably less than 300 km thick at the present time. Measurements of the electrical conductivity deep in the Moon indicate that the cool layers are of this order of thickness and that the temperature of the deeper interior is roughly uniform at about 1000°C. The region in which material is closest to its melting point will be deeper and will cover a wider range of depths in the Moon than in the Earth, because of the lower melting point gradient (Figure 9.5). This expectation correlates well with seismic findings which indicate possible partial melting at 1000 km or deeper.

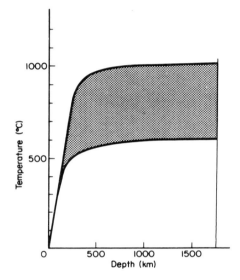

Figure 9.5 Estimated temperature distribution in the Moon. The shaded region defines the spread in the estimates (Based on D.C. Tozer, D. L. Turcotte, A.T. Hsui, K.E. Torrance and E.R. Oxburgh; and on C.P. Sonett and others).

Although the Moon is probably almost completely solid, it is still warm enough to allow convection. Since the Moon has no sizeable core it is possible that the convection currents have a relatively simple flow pattern involving the bulk of the Moon's interior. As far as can be seen from laboratory modelling experiments, the rising, warm currents will be broad and slow; but the downgoing, cooler currents will tend to be more rapid and restricted in extent. The simplest flow pattern is one which consists of a single cell (Figure 9.6) in which there is only one region of downgoing material. A more complex flow pattern has been proposed by S. K. Runcorn to account for some of the observed peculiarities in the motion of the Moon. Frictional heating might well occur in the

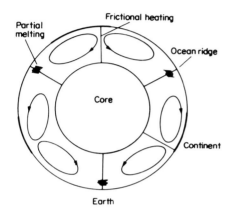

Figure 9.6 Possible convective patterns in Earth and Moon

might be the reason why there is no strong evidence for lunar plate tectonics; and why the Moon is only weakly active, seismically. Linear features on the Moon form an overall, tectonic pattern which might be related to stresses, in the crust, generated by convection at depth. The strong crust may inhibit volcanism, the massive lava effusions of the past having occurred at a time when the crust was thinner than it is now. The ancient volcanism is related to fracturing but shows little sign of having been connected with plate movement. The bulk of the mare volcanism was the type of activity similar to that which caused flood basalts and shield volcanoes to develop on the Earth. This type of volcanism is not linked with plate margins; rather, it is likely to be triggered by events in the mantle such as rising plumes, in the case of the Earth, or sharp, downgoing currents, in the Moon. The single-celled convection pattern postulated for the Moon might explain why the principal volcanic areas (the maria) all occur in a fairly restricted region on the Moon's nearside.

downward currents and this could lead to partial melting, volcanism and seismic events. Friction causes the temperature to rise which, in turn, reduces the viscosity. This has the effect of speeding up the flow and, thus, it leads to more heating. This is a runaway process which could lead to sudden, rapid movements and lunar earthquakes. A similar process may operate within the Earth, also. Convective flow patterns in the Earth are likely to be much more complicated than those in the Moon because the convecting region of the Earth's mantle has a much greater horizontal extent compared with its vertical extent, a fact which favours the establishment of several cells (Figure 9.6).

Tectonics on the Moon

Because of the greater cooling rate of the Moon, its crust is much thicker than the terrestrial crust. Because of the smaller radius of the Moon, its crust may be comparatively more resistant to shear and greater forces may be required to fracture it. This

Volcanism on Mars

Of the various volcanoes that have been recognised on the Mariner 9 pictures of Mars, the most notable are the macroshields which are similar to terrestrial shield volcanoes. The resemblance indicates that the lavas which formed the respective shields on Earth and Mars had similar rheological properties and were erupted at similar rates. The lavas of the martian shields are, therefore, probably basalts; and Mars may be chemically more like the Earth than like the Moon. Analyses of Mariner 9 pictures provide good evidence that volcanism has been important in the evolution of Mars. Mars may be divided (Figure 2.8) into two hemispheres, one containing all the volcanoes and the other consisting of densely cratered plains, thought to be ancient parts of the crust. In this respect Mars is similar to the Moon. It is difficult to estimate the ages of martian volcanoes but it seems that activity of all ages, from early in Mars' history almost to the present time, is represented. No active martian volcanoes were recorded by Mariners 6, 7 and 9, but they may exist.

The volcanic types of Mars are those, such as shield volcanoes and flood basalts, which are not, on the Earth, generally associated with plate margins. Additional evidence for the existence of plate margins is slight; and it seems that very little crustal motion has occurred on Mars.

No thermal measurements, apart from those pertaining to surface temperature, have been made on

111

Mars. The planet will probably have a distribution of temperature with depth similar to that of the Earth and Moon, with a cold, outer layer, in which the temperature increases rapidly downward to a region with a temperature which allows solid state convection to occur at a rate determined by the rate of production of heat. Indirect evidence for the existence of convection is provided by measurements of the oblateness of Mars. All spinning planets are oblate (that is, their shape is such that their equatorial radii are greater than their polar radii) but Mars is more oblate than the Earth — which has essentially the same rotation period.

One interpretation is that this could be due to internal convection currents. It also seems probable that the depth at which material is closest to melting will be intermediate between that pertaining to the Earth and the Moon; and that the crust of Mars will be of intermediate thickness. In fact, it would seem that the martian crust was strong enough to inhibit plate movement. On the other hand, the martian volcanic features are associated with crustal deformation. There is the system of radial fractures around the Tharsis volcanoes (Chapters 6 and 8); and one end of the great Coprates Canyon, which may mark the inception of crustal movement, is in this region. Furthermore, the volcanic regions of Tharsis and Elysium are higher than the average surface.

The simple planet-wide distribution of martian volcanism points to a relatively simple, internal convection pattern. It is known that Mars has a concentration of mass at the centre: the planet probably has an iron core. This core is smaller in relation to the diameter of Mars than the Earth's core is in relation to the diameter of the Earth, and so, of the two planets, Mars seems to have the thicker mantle relative to the overall size of the planet. The geometry of the martian mantle favours a simpler convection pattern than on Earth but, possibly, a more complex one than that of the Moon.

More data on the deep interior of both Mars and the Moon, together with further theoretical analyses of the processes involved in convection and tectonism, will be needed before viable models of their interiors can be devised.

Suggestions for Further Reading.
Carr, M. H., 1973 'Volcanism on Mars', *J. Geophys. Res.,* **78,** 4049-4062.
Gass, I. G., Smith, P. J., and Wilson, R. C. L. (Eds.) 1972 *Understanding the Earth,* Artemis Press, Sussex.
Tozer, D. C., 1972 'The Moon's thermal state', *The Moon,* **5,** 90-105.

Editors' Epilogue

The discussion in Chapter 1 introduced the concept of the volcano as a planetary surface feature of some importance. Volcanoes are indicators of the internal heating of a planet and of the forces acting in its crust. On the Earth, they locate both the traces of regional fractures and the boundaries of major, tectonic plates. Since the distribution of mineral deposits in the Earth depends on the internal re-arrangement and the subsequent altering of rocks it is important to attempt to improve our understanding of these processes.

Major steps forward have been made, recently, in understanding volcanic processes such as explosive eruptions and lava flows. What can be done to help the people whose towns are threatened by volcanic events? First, if the eruptive process were to become fully understood, it would become possible to issue advance warnings of explosions. This can be achieved, now, at certain volcano observatories which are equipped with continuously recording devices to monitor the movement of magma at depth; but the warning period is short, and much more research is required. Secondly, lava flows can, in principle, be controlled in a number of ways, such as by creating unnatural, local physiography using explosives, or — as the residents at Heimaey did, recently — by pumping large volumes of water on a flow. The most efficacious manner of tackling these formidable tasks can be evaluated, through an understanding of the theory of lava flows, for particular circumstances as they arise.

At least some of the terrestrial planets have suffered outgassing as a result of volcanic activity. This outgassing has been a consequence of the heating, and stirring, of the planetary interiors — although the pattern of internal circulation probably differs from planet to planet. Thus, the Earth owes its peculiar distribution of volcanic zones to plate tectonics resulting from a complicated, and, as yet, ill-understood convective pattern; whereas the Moon and Mars have volcanic landforms associated, rather, with fracture patterns which may or may not have been produced by convection. Just how important the specifically volcanic outgassing process has been is debatable: the terrestrial planets might have out-gassed in other ways. Samples from the Moon, in particular, are characteristically low in their pro-portion of volatile elements judged by comparison with terrestrial rocks; and this fact seems to indicate that, during accumulation, the Moon was never imbued with a large proportion of each volatile element. Possibly, volatiles escaped from the Moon, during its accretion, as a result both of heating pro-cesses and of the small mass of the Moon.

Whatever the details of the planetary outgassing processes, it is clear that volcanoes are presently contributing to the atmosphere of the Earth, and, possibly, to the atmospheres of Mars and other planets. With so much discussion about man-made pollution it is of the greatest importance, in our view, to attempt to assess the overall contribution of volcanic 'pollutants' to the Earth's atmosphere.

Bibliography

Aramaki, S., 1957 'The 1783 activity of Asama Volcano. Part II,' *Japan. J. Geol. and Geog.,* **28,** 11-33.

Barberi, F., and Varet, J., 1970 'The Erta Ale volcanic range', *Bull. Volc., 34,* 848-917.

Bullard, E., 1969 'The origin of the oceans,' *Sci. Amer.,* **221,** 66-75.

Chaigneau, M., Tazieff, M., and Fabre, R., 1960 'Composition des gas du lac de lave du Niragongo,' *Comptes Rendus Acad. Sci. Paris,* **250,** 2482-2485.

Cloos, H., 1939 'Hebung-Spaltung-Vulkanismus,' *Geol. Rundschau, 30,* 405-527.

Delsemme, A., 1960, 'Spectroscopie de flammes volcaniques,' *Bull. de l'academie royale des sciences d'Outre-Mer, 6,* 507-519.

Elvius, A. (Ed.) 1972 *From Plasma to Planet,* John Wiley and Sons, New York

Fielder, G. (Ed.) 1971 *Geology and Physics of th₁ Moon,* Elsevier Publishing Co., Amsterdam.

Gorshkov, G.S., 1970 *Volcanism and the Upper Mantle: Investigations in the Kurile Island Arc,* Plenum Press, New York, London.

Guest, J. E., and Fielder, G., 1968 'Lunar ring structures and the nature of the maria', *Planet. and Space Sci., 16,* 665-673.

Illies, J.H., 1970. 'Graben tectonics as related to crust-mantle interaction', in *Graben Problems* (Proc. Internat. Upper Mantle Project No. 27), E. Schweizerbart'sche Verlagsbuchhandlung, Stuttgart.

Kaula, W.M., 1968 *An Introduction to Planetary Physics: The Terrestrial Planets,* John Wiley and Sons, New York.

McBirney, A. R., and Williams, H., 1969 'A New look at the classification of calderas (abst.),' in *Intern. Assn. Volcanology and Chem. Earth's Interior, Symposium on Volcanoes and Their Roots,* Oxford University, Oxford.

McGetchin, T.R., and Ullrich, G.W., 1973 'Xenoliths in Maars and Diatremes with inferences for the Moon, Mars and Venus, *J. Geophys. Res.,* **78,** 1833-1853.

Moore, J. G., and Melson, W. G., 1969, 'Nuées Ardentes of the 1968 eruption of Mayon Volcano, Phillipines', *Bull. Volc.* **35,** 600-620.

Murray, J.B., 1971. 'Sinuous Rilles', Chapt. 3 in Fielder, G. (Ed.). *Loc. cit.*

Naughton, J.J., Heald, E.F., and Barnes, I.L., 1963, 'The Chemistry of volcanic gas, I : Collection and analysis of equilibrium mixtures by gas chromatography,' *J. Geophys. Res.,* **68,** 539-544.

Pai, S.I., Hsieh, T., and O'Keefe, J.A., 1972 'Lunar ash flows: isothermal approximation', *J. Geophys. Res.,* **77,** 3631-3649.

Runcorn, S.K., 1962 'Convection in the Moon,' *Nature,* **195,** 1150-1151.

Schaber, G.G., 1973 'Lava flows in Mare Imbrium: Geologic evaluation from Apollo orbital photography,' Paper presented at the Fourth Lunar Science Conference, Houston, Texas, 5-8 March, Lunar Science Institute.

Shepherd, E.S., 1925, 'The analysis of gases from volcanoes and from rocks,' *J. Geol.,* **33,** 289-370.

Snead, R.E., 1972 *Atlas of World Physical Features,* John Wiley and Sons, London and New York.

Sonett, C.P., Colburn, D.S., Dyal, P., Parkin, C.W., Smith, B.F., Schubert, G., and Schwarz, K., 1971 'Lunar electrical conductivity profile,' *Nature, 230,* 359-362.

Sparks, R.S.J., and Walker, G.P.L., 1973, 'The ground surge — A third type of pyroclastic rock', *Nature Phys. Sci.,* **241,** 62-64.

Strom, R.G., and Fielder, G., 1971, 'Multiphase eruptions associated with the craters Tycho and Aristarchus', Chapt. 5 in Fielder, G. (Ed.). *Loc. cit.*

St. Claire Deville, C., 1856, *Bull. Soc. Geol. de*

France, (Ser. 2) Volume 13.

Streckeisen, A.L., 1967, 'Classification and nomenclature of igneous rocks,' *Neus. Jahrb. Mineral. Abhandl.,* **107,** 144-240.

Taylor, G.A., 1958 'The 1951 eruption of Mount Lamington', *Austral. Bur. Min.es. Geol. and Geophys. Bull.,* Volume 38.

Tozer, D.C., 1972 'The Moon's thermal state, *The Moon,* **5,** 90-105.

Turcotte, D.L., Hsui, A.T., Torrance, K.E., and Oxburgh, E.Rv, 1972 Thermal structure of the Moon,' *J. Geophys. Res.,* **77,** 6931-6939.

Verhoogen, J., 1939 'Les eruptions 1938-1940 du volcan Nyamuragira,' *Amer. J. Sci.,* **237,** 656-672.

Walker, G.P.L., 1971, 'Grain-size characteristics of pyroclastic deposits' *J. Geol. Volc.* **79,** 696-714.

Walker, G.P.L., and Croasdale, R., 1970, 'Two plinian-type eruptions in the Azores', *Quart. J. Geol. Soc. Lond.,* **127,** 17-55.

Whitford-Stark, J.L., 1973, 'Vesicles and related structures in lavas', *Geol. J.,* **8,** 317-332.

Williams, H., 1941 'Calderas and their origin', *Univ. Calif. Berkeley Pub. Geol. Sci.,* **25,** 239-346.

Wilson, L., 1973 'A photometric investigation of the packing state of Apollo 11 lunar regolith samples', *Planet. Space Sci.,* **21,** 113-118.

Glossary

Aa lava — (Pronounced ah-ah). Rough clinkery flow material.

Acidic lava — Lava rich in silica: see also Figure 2.3.

Adiabatic compression/ expansion — Change in volume of a material involving no net loss or gain of heat.

Albite — Mineral consisting of sodium aluminium silicate.

Alkali-rock — Igneous rock rich in any of the alkali-metals (principally sodium and potassium).

Alumina — Aluminium oxide.

Amplitude — Maximum displacement from mean value.

Andesite — Fine-grained, extrusive, igneous rock, intermediate in composition between that of acidic and basic rock.

Anticline — Uparched fold in rocks.

Areal — Relating to surface area.

Aseismic ridge — Ridge disassociated with seismic activity.

Ash — See 'volcanic ash'.

Ash flow — Flow of pyroclasts.

Atomic lattice — Arrangement of atoms in a solid.

Basaltic rock — Fine-grained, igneous rock poor in silica.

Basic lava — See text associated with Figure 2.3.

Batholith — Large mass of intrusive, igneous rock.

Bimodal distribution — Distribution showing two peaks.

Block lava — Flow material consisting of angular fragments having relatively smooth faces.

Bomb — See 'volcanic bomb'.

Breccia — Rock composed of mutually adhering fragments.

Caldera — A depression, normally larger than 2 or 3 km in size, caused by collapse.

Carbonatite — Intrusive rock, associated with alkaline igneous rocks, similar in composition to sedimentary rocks such as limestone and largely or wholly free of silicates.

Cinder cone — Volcanic cone composed of cinders.

Clasts — See 'lithic clasts'.

Composite cone/volcano — See Figure 2.1

Conduit of volcano — Feeding pipe of a volcano: see Figure 2.1.

Continenal drift/migration — The relative movement of continents.

Continental shield — Very old, stable portion of a continent.

Convection cells — Regions of fluid, normally within larger bodies of fluid, which have self-contained flows commonly resulting from temperature inhomogeneities in the fluid in a gravitational field.

Core of a planet — Spheroid of higher than average density situated at, or near to, the centre of a planet.

Country rocks — Indigenous rocks in the field.

Crater — Circular or sub-circular depression.

Crust — Outermost, solid layer of

Dacite	a planet Quartz-rich andesite.		planet vertically above the centre of an earthquake disturbance.
Degassing	Liberation of gas from material.	**Equipotential figure of planet**	Shape of planet of mass M on the surface of which the gravitational potential GM/r of a unit mass is the same whatever the distance r of the surface from the centre, where G is the constant of gravitation.
Denudation	The wearing down and exposure of lower layers of rock.		
Diatreme	Near-vertical column of tuffaceous, mantle-derived igneous material and its associated crater materials brought suddenly from great depths.		
		Erosion	Process of fragmenting (or dissolving) rocks.
Differentiation	The separation of a mass of material into portions with distinctly different chemical or physical properties.	**Evaporite**	Salt deposit formed as a result of evaporation.
		Exogenous process	Process resulting from a cause originating outside a planet.
Dip of fault	Supplement of the maximum angle between the plane of a fault and the horizontal.	**Exothermic process**	One liberating heat.
		Explosion	Sudden onset of release of energy. (The period of time during which the release occurs may be long or short).
Discontinuity	Abrupt change in physical or chemical property of a rock.		
Dissociate	Split up into atomic, or molecular, components.	**Extrusive rock**	One extruded (pushed out) on to the surface of a planet.
Dome (lunar)	Sub-circular, igneous topographic high with slopes normally of no more than a few degrees.	**Fault**	Fracture in a rock body along which there has been relative movement of adjacent blocks of the body.
Dyke	Normally a sub-vertical, igneous intrusive sheet.		
Effusion	Welling out of material on to a surface.	**Feldspar**	One of a group of silicates containing aluminium and sodium, potassium or calcium.
Ejecta	Particles propelled away from a centre of disturbance.		
Electrical conductivity	Ratio of the current flowing through unit area of a conducting medium to the electric field maintaining the current.	**Feldspathoid**	One of a group of rock-forming minerals similar to feldspars but relatively deficient in silica.
		Fissure eruption	Volcanic eruption deriving from a fracture the sides of which have been separated.
Electromagnetic induction	Production of electric currents in materials as a result of the presence of a changing electric or magnetic field.	**Flow unit**	Tongue of lava which issued from the front or flanks of a major lava flow.
Eocene	Part of the tertiary period, lasting from 3.8 to 5.4×10^7 years ago.	**Fluidisation**	Support of solid particles by a stream of liquid or gas, resulting in fluid-like
Epicentre	Point in the surface of a		

Fractionation	properties for the whole system. Separation of components of a mix.		the case of the Andes, at least one arc is part of the continent).
Fumarole	A secondary volcanic vent from which hot gases or vapours are released.	**Isotope**	One of a group of elements all of which have the same numbers of protons and electrons in their atoms (and hence the same chemical properties) but different numbers of neutrons.
Gas chromatography	Special process of identifying any substance, which can be vaporised, in a mixture.		
Geofracture	Major fracture traversing a planetary crust.	**Joint**	Commonly one of a series of sub-parallel, small scale fractures.
Geological time scale	0 to 4.6×10^9 years, subdivided into named intervals of time.	**Jurassic**	Geological period extending from about 1.4 to 2.0×10^8 years ago.
Graben	Downfaulted block of planetary crust, generally long compared with its width. Also, the depression so formed.	**Laccolith**	Lens-shaped igneous intrusion which can uparch a planet's surface.
Granitic rock	Coarse-grained, acidic, igneous rock.	**Laminar flow**	Flow of fluid in which all motion is parallel to the local average flow direction.
Gravity anomaly	Increased or decreased strength of gravity relative to the local, mean gravity of a planet.	**Lapilli**	Volcanic, stony ejecta mostly in the size range of peas to walnuts.
Half-life of radioactive element	Time taken for the rate of release of radioactive energy to fall to half its initial value.	**Lava** **Lava channel**	Extruded igneous material. Channel produced by the flow of a stream of lava.
Igneous	Pertaining to rocks formed from a melt.	**Lava tube**	Tunnel formed when a stream of lava vacates the space it occupied.
Ignimbrite	Volcanic rock resulting from deposition of rock fragments transported in a hot, fluidised flow.	**Levée**	Raised flank of a lava channel.
Inert gas	One which does not readily take part in chemical reactions.	**Lineament**	Any linear feature of a planetary surface.
Intrusive rock	One injected into pre-existing rocks.	**Lithic clasts**	Rock fragments, commonly angular.
Ionised gas	One containing atoms or molecules some, or all, of which have lost, or gained, electrons.	**Lithosphere**	The rocky, relatively rigid, outer layer, including the crust, of a planet.
Island arc	Normally an arcuate island, or series of islands forming an arc, close to a continent and with the concave side of the arc facing the continent. (In	**Longitudinal waves**	Compressional or tensional waves in which particle motions are parallel to the direction of the wave propogation.
		Low velocity layer	Zone, in the Earth, in which the velocity of seismic waves is lower than that expected on

Maar the assumption that velocity increases steadily as depth increases.

Maar Volcanic structure, primarily explosive in origin, produced in the presence of water.

Magma Molten rock beneath (some authorities also say on) a planetary surface.

Magnetic anomaly Increased or decreased magnetisation of rocks relative to that expected on the basis of the known mean strength of the planet's regional magnetic field.

Mantle Spheroidal shell of planet lying between the crust and the core and of distinct average composition.

Mantle plume Anomalous (and hypothetical) localised, upward flow of material within the mantle.

Mare (plural maria) Designation applied to certain dark areas of the Moon, Mars and Mercury.

Mare ridges Ridges, in the lunar mare-type of terrain, of extrusive (and possibly also, intrusive) basaltic rock.

Metamorphic rock One that has changed its character as a result of external influences.

Meteoric Pertaining to meteoroids (or to meteors).

Meteoroid Object — other than a star, satellite or comet — in interplanetary space.

Microfracture Term normally applied to small, and microscopic, fractures in rock specimens smaller than hand-size.

Mineral Solid, inorganic substance of given chemical composition.

Miocene Part of the tertiary geological period extending from 0.7 to 2.6×10^6 years ago.

Mohorovicic discontinuity (Moho) See Figure 9.1.

Molecular weight The weight of a molecule relative to that of the oxygen atom which is assigned weight 16.

Molecule Stable group of chemically combined atoms having a specific structure and specific chemical properties.

Morphology Shape (applied to planetary surface features).

Nebula Cloud of material in space.

Neck of volcano Upper parts of the principal feeding pipe of a volcano.

Nepheline Sodium-rich feldspathoid mineral.

Nested caldera/cone Series of calderas/cones, one within the other.

Normative minerals Chemically relatively simple minerals in terms of the proportions of which the composition of an igneous rock can be expressed conveniently.

Nucleation Process in which bubbles (or crystals) first form in a fluid medium.

Nuée ardente High speed flow of incandescent, solid fragments fluidised by released gas.

Oblateness (of a planet) Difference between the equatorial and polar radii of an oblate, spheroidal planet expressed in units of the equatorial radius.

Oceanic trenches Areas of the oceanic floor, in the proximity of certain continents, where the basaltic, oceanic crust is depressed and sinking and, at the same time, accumulating the overlying sediments.

Orogenic process One of mountain building.

Orthoclase	Potassium-rich feldspar.	**Plinian**	Type of explosive eruption in which solid fragments are propelled from a vent by a steady stream of gas.
Outgassing	See 'degassing'.		
P waves	Longitudinal, seismic waves.		
Pahoehoe lava	(Pronounced 'pah-hoh-ee-hoh-ee'). Basaltic flow material having smooth, billowy, or ropy, surface.	**Plutonic activity**	That relating to heat within a planet.
Palagonitisation	Process of formation of palagonite, a yellowish- or reddish-brown substance formed by the addition of water to, and thus the alteration of, basaltic glass.	**Polymer**	Long molecular chain composed of repeated chemical groups.
		Protoplanet	Collection of solid (mainly), and gaseous, materials that subsequently form a planet.
Paleomagnetism	Magnetism acquired by rocks, normally on cooling in a magnetic field at an earlier period.	**Pumice**	Glassy, pyroclastic rock containing large numbers of vesicles.
		Pyroclastic breccia	Hardened rock formed of larger pyroclasts embedded in a matrix (medium) of finer pyroclasts.
Partial melting	Melting of only some of the minerals of a rock.		
Peralkaline	Very alkaline.		
Petrology	Study of rock composition, texture, structure and origin.	**Pyroclast**	Detrital material that has been ejected from a volcanic vent.
Phase	State of matter, each phase of a compound having the same chemical composition but different molecular structure.	**Radioactive decay**	Spontaneous disintegration of the nuclei of certain elements.
Phonolitic volcanism	That involving alkali-rich trachytes containing sodium-rich feldspathoids.	**Reflection seismology**	Use of artficially generated, seismic waves to determine rock contrasts at depth by reflection techniques.
Phreatic explosion	Explosion involving water, normally occurring near to, or at, the surface of the Earth.	**Refraction**	Change of direction of a wave on passing through the common interface of two media.
Pillow lava	Lava that assumes the shape of pillows, normally formed under water.	**Regolith**	Layer of rock detritus on the solid surface of a planet.
Pipe of volcano	See 'conduit of volcano'.	**Rheology**	Study of the deformation of materials.
Plate margin	Constructive (divergent), destructive (convergent) — See Chapter 9.	**Rhyolite**	Fine-grained, acidic lava.
		Rift valleys	Large-scale graben occurring on the crests of crustal upwarps.
Plate tectonics	See 'continental drift'; 'tectonic'; and Chapter 2.	**Rille**	Type of linear, collapse structure found on the Moon and on Mars; not to be confused with 'Sinuous rille'.
Plateau basalt	Basalt forming a large plateau.		
Pleistocene	Most recent period of the geological time scale from 0 to 10^6 years ago.	**Ring structure**	Sub-circular formation in a planetary surface.

120

Rope	Small-scale, narrow, raised ridge, commonly arcuate with the convex side pointing in the flow direction, on the surface of a pahoehoe lava flow.	Solfatara gases	Volcanic gases, released from fumaroles, containing large proportions of sulphurous compounds
S waves	Transverse seismic waves.	Sorting of particles	Physical separation of particles of various sizes.
Saturation	See text accompanying Figure 2.3.	Spatter	Clots of ejected lava still molten on landing.
Scarp	Abrupt slope occurring on a surface.	Specific gravity	Density (mass per unit volume) of a substance relative to that of water.
Sea-floor spreading	Movement, and widening, of certain parts of the terrestrial, oceanic crust as a result of internal processes.	Spectroscopy	Study of electromagnetic radiation separated according to its wavelength.
Sedimentary rock	One formed by the deposition and compaction of disconnected fragments settling under gravity (and, on the Earth, commonly in water).	Strain	Fractional change in volume or length.
		Strato volcano	See 'composite volcano'.
		Stress	Force per unit area in a specified direction.
Seismic ridge	One associated with earthquake epicentres.	Strike	Direction defined by the intersection of a structural plane with the horizontal surface of a planet.
Seismology	Study of earthquakes and associated pressure waves in a planetary crust.	Subduction zone	That in which crustal material is being transported to greater depths in the Earth.
Shard	Angular, commonly disc-shaped or elongate, glassy, volcanic rock fragment.	Sub-horizontal	Nearly horizontal.
		Sublimates	Solid substances deposited (near volcanic vents) directly from cooling volcanic gases.
Shear	Relative movement of parts of a mass of material along planes of contact.	Sub-radial	Nearly radial.
		Tachylyte	Glassy basalt.
Shield volcano	One shaped like a spherical cap. (See Chapter 6.)	Tectonic	To do with the structure of a planet's crust.
Silica	Silicon dioxide.	Tephra	See 'pyroclasts'.
Silicate	A compound containing silica and metallic oxides.	Tertiary	Geological time period from 1.5×10^6 to 6.5×10^7 years ago.
Sill	Igneous intrusion, normally sub-horizontal and occurring between pre-existing layers of rock.	Thermal conductivity	Rate of flow of heat per unit cross-sectional area per unit temperature gradient in the direction of flow.
Sinuous rille	Meandering channel found on the surfaces of the Moon and, possibly, Mars; and probably produced by the turbulent flow of lava.	Thermal diffusivity	Ratio between the amount of heat conducted through a region and the heat which remains to increase the temperature of the

Tholeiite	Basalt rich in silica.
Trace of fault	Curve defined by the intersection of a fault plane with the surface of a planet.
Trachyte	Fine-grained, saturated, alkaline igneous rock.
Transform fault	Fault connecting two segments of oceanic ridge.
Transverse wave	That in which particle motions are perpendicular to the direction of propagation of the wave.
Tuff	A rock formed of compacted, volcanic fragments generally much smaller than pea size. Non-welded tuffs are soft, welded tuffs hard prior to any subsequent alteration.
Ultra-vulcanian	Type of explosion in which debris of earlier eruptions is blown from a vent by a sudden release of gas.
Upwarp	Uparching (particularly of surface rocks) in a planetary crust.
Vesicle	Cavity, produced by gas pressure in a magma or lava.
Vesiculation	Process of production of vesicles.
Viscosity	Resistance of a material region. It is a measure of the rate of spreading of heat by conduction.
	to shear forces (See Chapter 9.)
Vitreous/vitric rock	One entirely of glass.
Volatiles	Elements or compounds that become gaseous at relatively low temperatures.
Volcanic ash	Uncemented, pyroclastic material having particles mostly smaller than pea-size.
Volcanic bomb	Fragment of lava that was liquid or plastic at the time of its ejection and characterised by the form and structure acquired during flight or on impact.
Volcano-tectonic depression	Large, irregular collapse structure associated with volcanism and controlled by crustal fractures.
Welded	Applied to rock formed from individual particles by their mutual cementation, during cooling, assisted by the application of the pressure of the overburden.
Wrinkle ridges	See 'mare ridges'.
Xenolith	Fragment of rock, derived from the wall of the feeding conduit, included in an igneous rock.
Yield stress	Stress which must be applied to a material before permanent deformation occurs.

Index

124

126